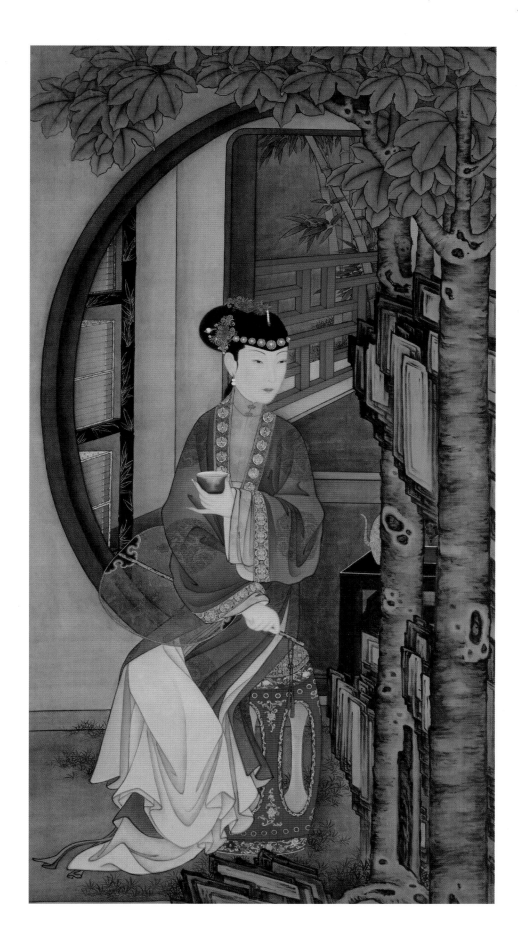

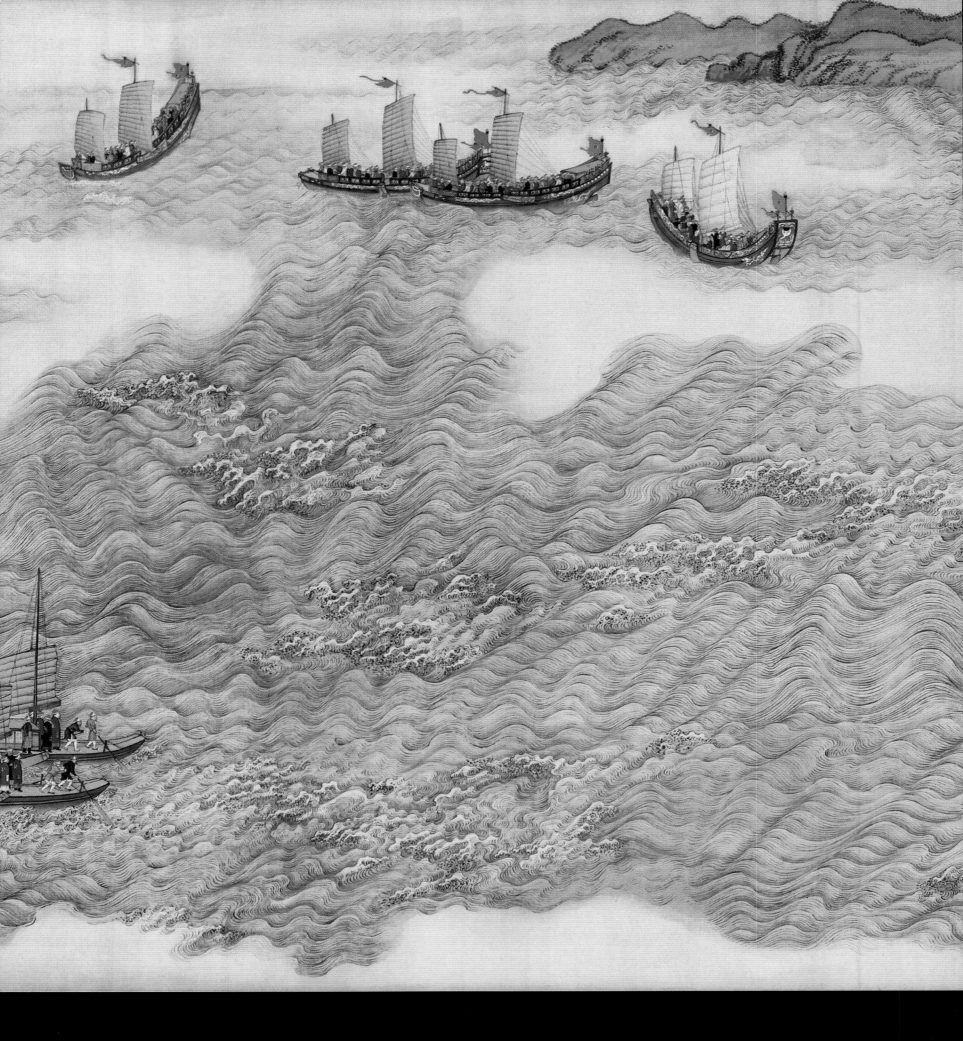

WELCOME BOOKS
NEW YORK • SAN FRANCISCO

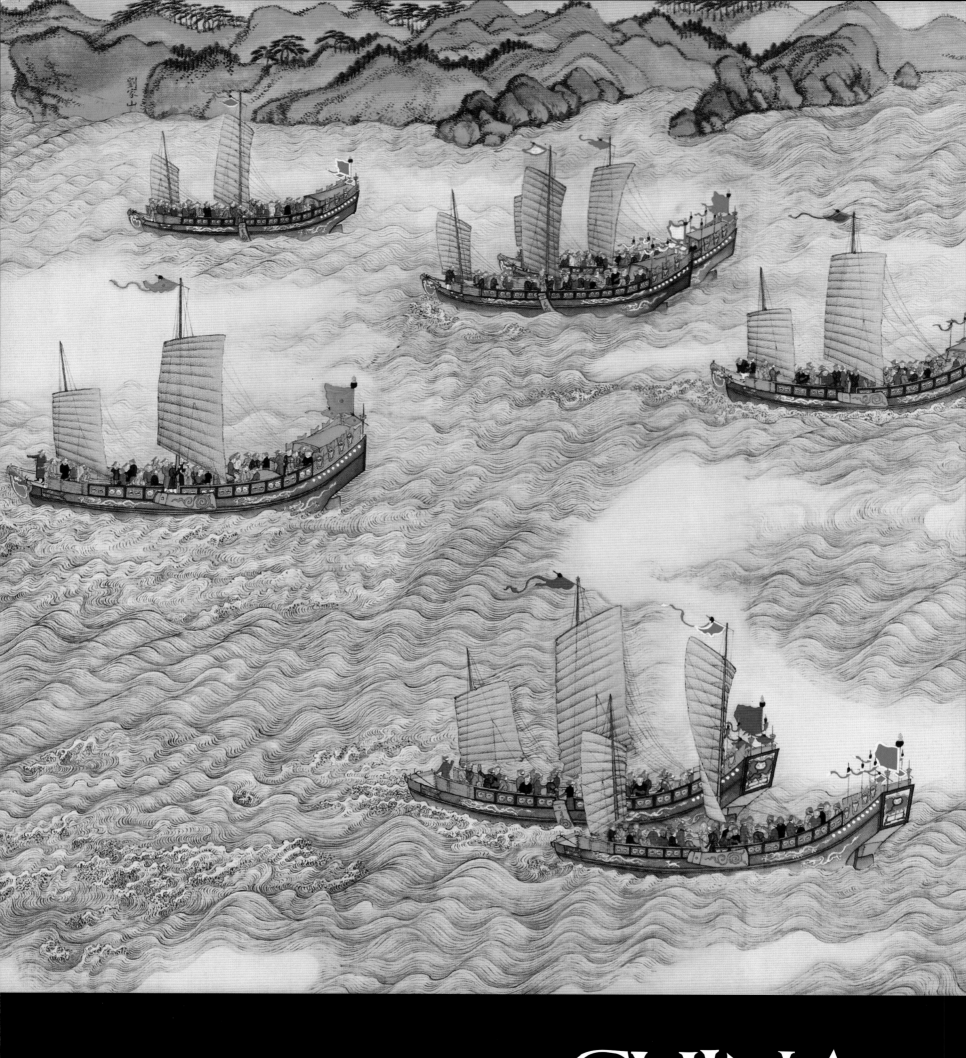

CHINA
3,000 Years of Art and Literature

EDITED BY JASON STEUBER

ACKNOWLEDGMENTS

I thank Jonathan Hay for suggesting my name for this project. At Welcome Books, I offer my sincere gratitude to Alice Wong, Naomi Irie, and Kara Mason for their tremendous leadership and publication expertise. I owe a great deal to the individuals at the following museums: Stacey Sherman, Roberta Wagener, Lihui Xiong, Ling-en Lu and Xiaoneng Yang (The Nelson-Atkins Museum of Art); Betsy Kohut (Freer Gallery of Art and Arthur M. Sackler Gallery, Smithsonian Institution); Shawn Eichman, Pauline Sugino and Rachel Farkas (Honolulu Academy of Arts); Erin M.A. Schleigh and Joseph Scheier-Dolberg (Museum of Fine Arts, Boston); Beatrice Epstein (The Metropolitan Museum of Art); Kathleen Kornell (The Cleveland Museum of Art); Piper Wynn Severance (Los Angeles County Museum of Art); He Li and Aino Tolme (Asian Art Museum of San Francisco); Robert Mowry, Melissa Moy and David Sturtevant (Arthur M. Sackler Museum, Harvard University); Hannah Seger and Stephen Goddard (Spencer Museum of Art); Gabrielle A. Ganther (University of Michigan Museum of Art); Martha Lund Smalley (Yale Divinity School Library, Yale University); Yuan Zhou (The University of Chicago Library); Anna Stathaki (Victoria and Albert Museum); Carol Michaelson and Axelle Russo (British Museum); Graham Hutt and Martin Mintz (The British Library); Norbert Ludwig (Bildarchiv Preußischer Kulturbesitz); Bettina Clever and Evelyn Bertram-Neunzig (Museum of Far Eastern Art Cologne, Rheinisches Bildarchiv); Frannie Blondheim (University of Alberta Museums); Satoko Aida (DNP Archives for Tokyo National Museum); Zhang Ying (The Palace Museum, Beijing); Stefan R. Landsberger and Frank de Jong (Leiden University, International Institute of Social History IISH; www.iisg.nl/~landsberger); and Michelle Andringa (Art Gallery of New South Wales). My gratitude goes to the following private collectors, artists and galleries for generously sharing their time, images and information: Frederick L. Gordon; Howard Farber (China Avant-Garde); Hung Liu; Xing Danwen; Xu Bing and Jesse Coffino-Greenberg (Xu Bing Studio); Michael Goedhuis, Christine Barberi and Marina Chao (Goedhuis Contemporary); Ludovic Bois and Katie Grube (Chinese Contemporary Gallery); Adrienne Chanson (Contrasts Gallery); and Elizabeth Kerr and Michael Wolf (Camera Press Limited). I am grateful to Judy Nielsen for the China map (International Mapping Associates) and David Goodrich for the Chinese characters (Birdtrack Press). I thank Nick Pearce and Alison Yarrington (Glasgow University) for their insights, suggestions and support. Finally, I offer the book as my heartfelt thank-you to Ines for everything.

Published in 2008 by Welcome Books®
An imprint of Welcome Enterprises, Inc.
6 West 18th Street, New York, NY 10011
Tel: 212-989-3200; Fax: 212-989-3205
www.welcomebooks.com

Publisher: Lena Tabori
Project Director: Alice Wong
Designer: Naomi Irie
Project Assistant: Kara Mason

Printed in China

10 9 8 7 6 5 4 3 2

Library of Congress Cataloging-in-Publication Data
China: 3,000 Years of Art and Literature / edited by Jason Steuber.
 p. cm.
Includes bibliographical references and index.

ISBN 978-1-59962-030-5 (alk. paper)
1. Arts, Chinese. I. Steuber, Jason.
NX583.A1C45217 2007
700.951--dc22

2007011309

ISBN: 978-1-59962-030-5

PAGE 1: *Beauty at Leisure* (18th century). Ink and color on silk.

PRECEDING SPREAD: *Emperor Kangxi's Southern Inspection Tour*, Wang Hui (1632–1717). Handscroll, color on silk. Detail.

BELOW: *Illustration of Military Strategy and Tactics* (19th century). Album leaf, ink and color on paper.

TABLE of CONTENTS

INTRODUCTION

中國, 國中, 國, ZHONG GUO. CHINA. THE MIDDLE KINGDOM

THROUGHOUT THE CENTURIES, China has long occupied a prominent place in the imaginations of those outside its borders. And, of course, such a distant, mysterious muse arouses the urge to journey there and experience it firsthand, as it did with such early explorers as the Venetian-based merchant Marco Polo, who, during the thirteenth century, traveled China's ancient trade routes. Upon their return home, he and his party captivated their fellow Venetians with fantastic, vivid tales of the Middle Kingdom.

While China's history is continuously being revised by new archaeological discoveries, it is clear that respect for the past has always been of great cultural importance. Some of the earliest cultural traits associated with China, such as images of dragons, date back to about 2800 BCE. Through historical records, we know that the Shang dynasty (ca. 1600–1046 BCE) was followed by a succession of royal leaders and, with the Qin dynasty (221–207 BCE), the eventual establishment of the First Emperor of China, instead of a king for each region. This systematic rule over a unified China by an emperor would last from the Qin through the Qing dynasties (1644–1911).

The earliest known inscribed Chinese texts have been traced back to the Shang dynasty, during which time Shang rulers realized the vital importance of communicating their ideas in writing. Thus began the crucial connection between power and the arts in China.

It is in this spirit that *China: 3,000 Years of Art and Literature* introduces this extraordinary civilization through its literature and visual arts, from the traditional to the contemporary. The stories and images contained here have been chosen for their ability to capture this rich culture; they are the artifacts that people throughout history have returned to time and time again to define, influence, and understand life in China.

Through its thematic organization of eight chapters, this book offers a fresh, inviting overview of China's hopes, dreams, aspirations, and fears relating to the human experience—from birth to death and the afterlife—as seen through the eyes of artists and authors. I hope that on its pages, traditions dating back several thousand years come to life for the reader.

PAST TO PRESENT

The artistic and literary works of China comprise one of the world's longest unbroken cultural histories. It is no surprise, then, that this book visits particular themes and imagery repeatedly. One such theme is elucidating our relationship with nature, in terms of both individual lives and society in general. Another centers on authors' and artists' use of historical ideas to communicate with and influence their peers.

Whether writing about dreams and butterflies or painting a misty mountain waterfall, Chinese authors and artists saw in the immediacy of nature a guide to living, and the customary use of landscapes and seasonal changes in their work reflects upon ideals of how one should conduct one's activities, from birth to death. Whether they appear on silk scrolls thousands of years old or are applied directly to the human body by a contemporary artist, landscapes exhort the viewer to embrace the human–nature relationship along with their creators. An object as simple as a rock can be transformed through text and artwork into a commentary on tradition.

Knowledge of the cultural heritage of China has long inspired authors and artists to attempt to transcend the past to achieve a better life—as mentioned earlier, by appropriating and interpreting long-held beliefs for their contemporaries' enrichment. Each artist reevaluates and presents traditional culture to the public through his or her individual circumstances. The long-standing relationship between nature and written Chinese characters may be explored by either developing new characters that ask the viewer to think about how we communicate in today's world, or by using red ink to create a vibrant calligraphy of the character for the heart—the emotional source for all human feelings.

THREE WAYS OF LIVING

Three schools of thought—Confucianism, Daoism and Buddhism—are critical to understanding Chinese literature and art.

Confucius (*Kongzi*) (551–497 BCE) remains among the most influential teachers and thinkers in history. A native

of Shandong province, he lived in China during a period of political turmoil. Touching upon all aspects of human life, from birth to death, Confucius meant for his doctrines to be accessible to all segments of society. His *Lunyu* (Analects) offers a biographical and philosophical portrait of the teacher. Here we learn that in order to produce communal harmony, Confucius advocated an understanding that placed individuals in specific social roles and circumstances. His discussions of the proper behavior in various relationships—such as parent/child, young/old, female/male, subject/government minister—relied upon not only his own insight, but also on classic literature. He and his followers often cited earlier sources, including the *Yijing* (Classic of Changes), *Shujing* (Classic of Historical Documents), and *Shijing* (Book of Odes; Classic of Poetry). Examples from these texts are found throughout the book's chapters.

Like Confucianism, Daoism (Taoism), a mystical philosophy that emphasizes keeping one's balance with nature, is viewed as an indigenous Chinese creation with roots that predate the arrival of foreign Buddhist missionaries by almost seven centuries. With nearly simultaneous origins, Daoism and Confucianism were pervasive in nearly all aspects of life throughout China's history—and they remain very much intertwined with Chinese culture today.

It's important to note that Daoism arose during an era of tumult in China. As mentioned above, Chinese dynastic histories begin with the establishment of the Shang dynasty—and with it, bronze technology. Bronzes became the means to power in China—both political and religious.

Shang thought included the concept of the "Supreme Deity" (*Shang Di*); and this dynasty's overthrow by the Zhou saw the replacement of the Supreme Deity with the idea of the right to rule via "heaven's mandate" (*Tian ming*). The last phase of Zhou dynastic rule—traditionally divided into the Spring period, the Autumn period, and the Warring States period—is where we can find the earliest semblances of what would come to be called Daoism.

It is during this time—amid continuously changing political alliances and military battles for local and regional supremacy—that the work titled *Daodejing* (The Classic of the Way and Its Virtue) supposedly first appeared, and has been puzzling interpreters and translators ever since. Attributed to Lao Dan (sixth century BCE), also known as Laozi ("Old Master"), the *Daodejing* (commonly referred to as the *Laozi*) is one of the world's most translated works, its concise lines of poetry addressing the complexity of reality and the human condition. Divided into two parts—the *Daojing* (The Classic of the Way) and the *Dejing* (The Classic of the Virtue)—this remarkable compilation's eighty-one chapters touch upon numerous topics, including philosophy, politics, sexuality, gender relations, nature and environment, time, war, and the essence of life.

During the late first through second centuries, Buddhist missionaries began traveling the Silk roads from India through Central Asia and into the western regions of China, bringing with them not only their theology, but also their literature and art. Buddhist paintings, for instance, attracted artistic attention while simultaneously raising awareness of new religious ideals. The Buddha image was central, but the missionaries also utilized Bodhisattva ("Being of Wisdom") figures—compassionate and enlightened beings who have attained enlightenment but choose to delay their entry into Nirvana to help others become Buddhas. The availability of these two types of figures allowed Buddhist missionaries to adapt their theology to the specific needs of individual regions. Bodhisattvas may have seemed more approachable and accessible than the Buddha to individuals looking for guidance in their everyday concerns.

A JOURNEY BEGINS

I strongly believe that through familiarization with the literature and art of a land such as China, we not only increase our understanding of its people but also ourselves. People are born, live, and die. People laugh and cry, hope and fear. People imagine and compose texts and images to document what it means to be human for those around them and those who follow. And so this book offers gifts from China's greatest writers, philosophers, and artists to all of us. The selected classic and contemporary masterpieces here serve as guideposts to learning about and appreciating the millennia-old traditions of the mysterious muse called China. Enjoy the rhythms and sights along the way!

— Jason Steuber

A Note to the Reader
This volume incorporates scholarly translations that have appeared over several centuries. It is thus important to note that the spelling of Chinese terms via the Roman alphabet (romanization) has changed through the years. Following the example of the Library of Congress, I have used Pinyin spellings throughout in order to maintain consistency.

Chinese painting and calligraphy often use the handscroll format. These horizontal scrolls are unrolled from right to left for viewing, mimicking the way Chinese texts were originally written and read. Paintings are therefore interactive and unrolled for specific occasions, such as to share with close friends. Unrolling allows the painting to progress as a narrative, much like reading a story. Hanging scrolls, on the other hand, are connected to Buddhist religious banners, suggesting ceremonial usage and the idea, again, of art for particular events. Finally, artists and collectors often composed texts that were written directly upon Chinese paintings. Some applied red seals indicating their names and their viewing of the scrolls.

白雲如帶束山腰
磴飛空細路遙攔倚
杖藜舒眺望欲因鳴
澗咨吹簫沈周

BIRTH AND LIFE

CALLING TO THE RECLUSE

Zuo Si (ca. 253–ca. 307)

I leaned on my staff and called to the recluse

whose weed-grown path is blocked now as ever.

No structures are built in the caves on cliffs,

yet a harp is playing among the hills.

A white cloud halts on the shadowed ridge,

red petals gleam in sunlit groves.

Stony streams scour their agates and jades,

fine fins rise to the surface and sink.

There is no need here for harps or flutes,

hills and streams make their own clear notes.

And why depend on whistling or song,

when tree clumps hum so movingly?

Dried grains are mixed with fall's chrysanthemums,

hidden orchids inserted in folds of gowns.

As I pace here, pausing, my feet grow weary —

I would cast down the pins of my officer's cap.

PRECEDING SPREAD:
Poet on a Mountaintop,
Shen Zhou (1427–1509).
Album leaf mounted
as handscroll, ink on
paper. Detail.

RIGHT: *Scholar with
Staff and Brush*, **Chen
Hongshou (1598–1652).**
Album leaf, ink and
color on silk.

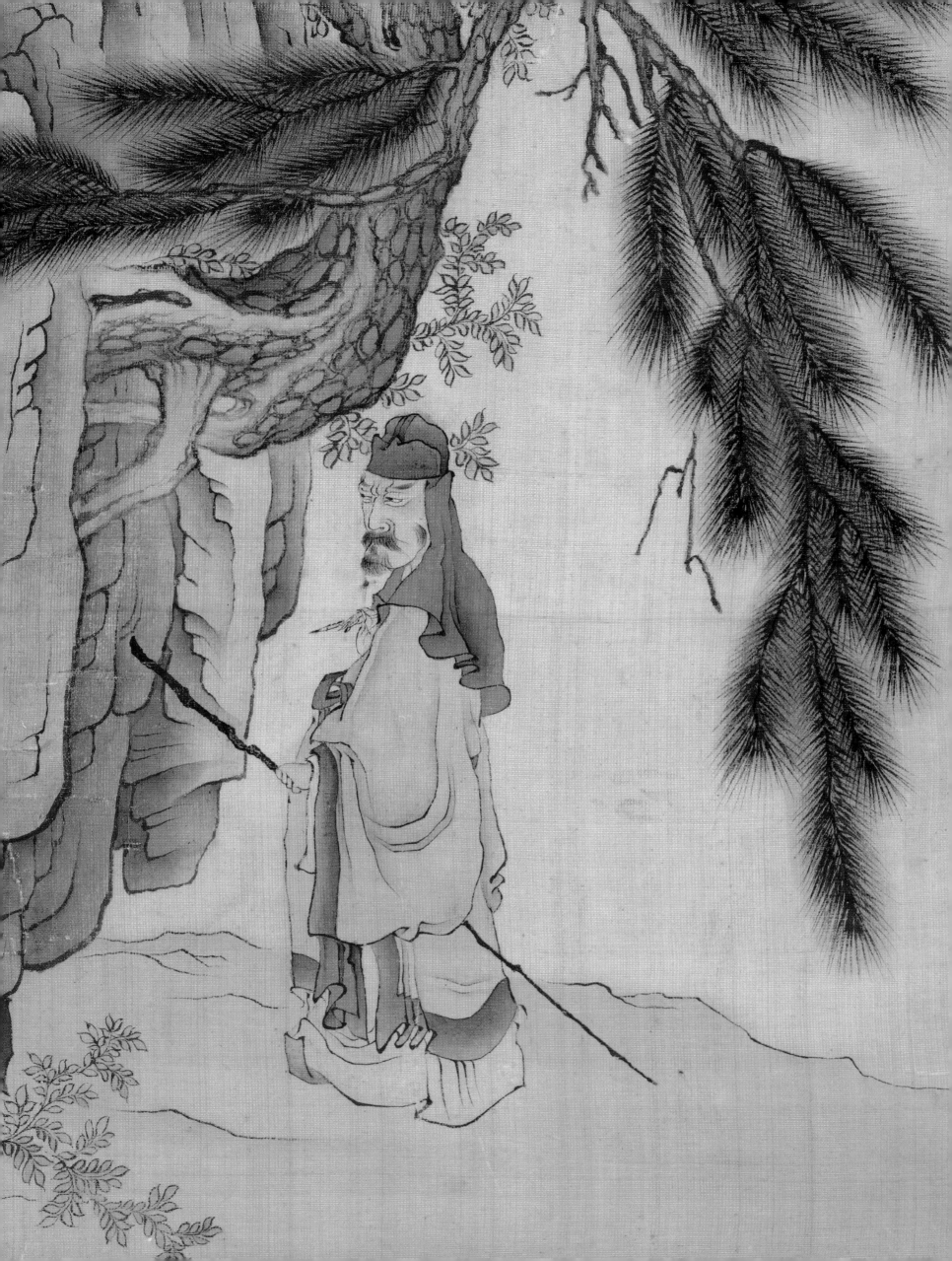

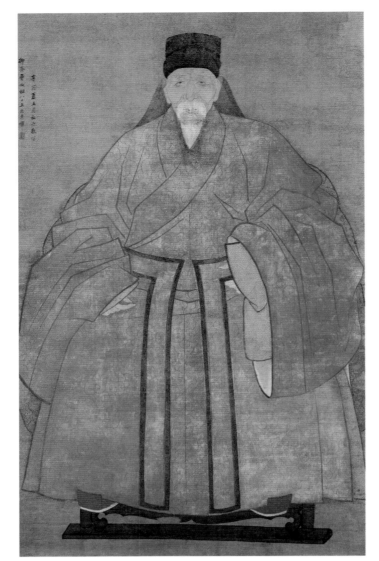

Portrait of Artist's Great Grand Uncle Yizhai at Age Eighty-Five, Zude (active mid–16th or early 17th century). Hanging scroll, ink and color on silk.

ON HIS BALDNESS

Bo Juyi (772–846)

At dawn I sighed to see my hairs fall;

At dusk I sighed to see my hairs fall.

For I dreaded the time when the last lock should go…

They are all gone and I do not mind at all!

I have done with that cumbrous washing and getting dry;

My tiresome comb for ever is laid aside.

Best of all, when the weather is hot and wet,

To have no top-knot weighing down on one's head!

I put aside my dusty conical cap; and loose my collar-fringe.

In a silver jar I have stored a cold stream;

On my bald pate I trickle a ladle-full.

Like one baptized with the Water of Buddha's Law,

I sit and receive this cool, cleansing joy.

Now I know why the priest who seeks Repose

Frees his heart by first shaving his head.

The great Tang dynasty poet Bo Juyi reflects on aging and its physical transformations, particularly the loss of hair. Although at first he sighs at the daily departure of his locks, he learns to appreciate the aging process as a natural freeing of spirit. Zude's accompanying formal portrait of his great-grand-uncle Yizhai suggests the same affirmation of the spirit that Bo wrote about seven hundred years earlier. The painting reflects the uncle's gentle retirement in the wonderful informal blue robe and cap he wears while his image is captured on silk.

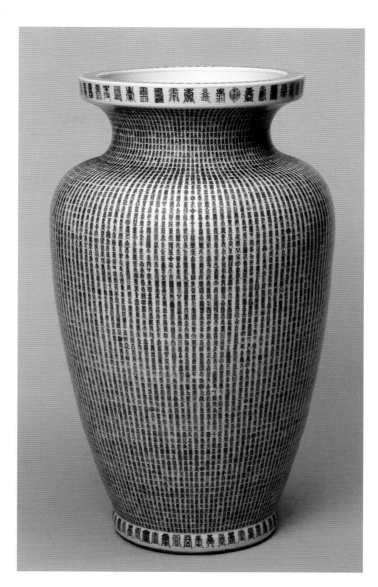

Jar with Ten Thousand Variations of "Long Life" Character, **anonymous court artists (1662–1722). Porcelain with cobalt-blue underglaze.**

ON BEING SIXTY

Bo Juyi (772–846)

Between thirty and forty, one is distracted by the Five Lusts;

Between seventy and eighty, one is prey to a hundred diseases.

But from fifty to sixty one is free from all ills;

Calm and still — the heart enjoys rest.

I have put behind me Love and Greed; I have done with Profit and Fame;

I am still short of illness and decay and far from decrepit age.

Strength of limb I still possess to seek the rivers and hills;

Still my heart has spirit enough to listen to flutes and strings.

At leisure I open new wine and taste several cups;

Drunken I recall old poems and sing a whole volume.

Mengde has asked for a poem and herewith I exhort him

Not to complain of three-score, "the time of obedient ears."

Again writing on the journey and experiences of growing older, Bo Juyi designates three distinct periods of life in this poem, which he wrote for his close friend Liu Mengde. Bo particularly rejoices in the years between fifty and sixty — the same decade that Confucius famously noted as the time when he was finally able to understand and act on the truths he had heard throughout his life. The monumental blue-and-white jar, too, addresses aging and the desire to enjoy long life. A birthday gift for the Qing dynasty Emperor Kangxi (1654–1722; r. 1662–1722), the vessel features the character shou *(long and eternal life) written ten thousand times in various forms.*

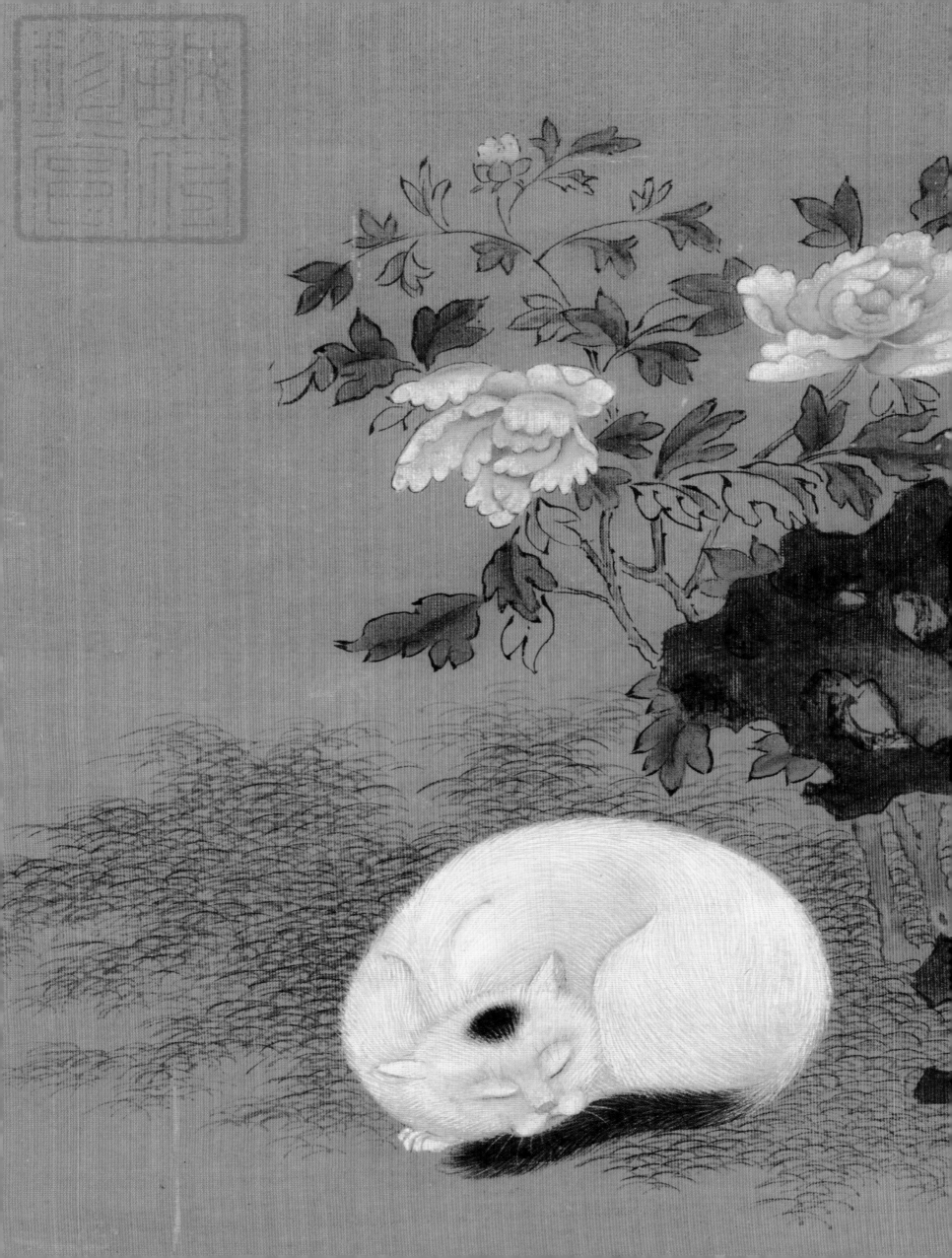

AN OFFERING FOR THE CAT

Mei Yaochen (1002–1060)

Since I got my cat Five White

the rats never bother my books.

This morning Five White died.

I make offerings of rice and fish,

bury you in the mid-river

with incantations — I wouldn't slight you.

Once you caught a rat,

ran round the garden with it squeaking in your mouth;

you hoped to put a scare into the other rats,

to clean up my house.

When we'd come aboard the boat

you shared our cabin,

and though we'd nothing but meager dried rations,

we ate them without fear of rat piss and gnawing —

because you were diligent,

a good deal more so than the pigs and chickens.

People make much of their prancing steeds;

they tell me nothing can compare to a horse or donkey —

enough! — I'll argue the point no longer,

only cry for you a little.

Cat, Rock, and Peonies,
Qing dynasty (1644–
1911). Album leaf, color
on silk.

Mei Yaochen's poem details his everyday life with and grief over losing his cat Five White. Written in a plain, colloquial style, Mei's intimate and straightforward words capture a calm and reflective sense of noticing the minor yet moving details of life.

CALLIGRAPHY PRACTICE

Ouyang Xiu (1007–1072)

*P*racticing calligraphy, not noticing night had come,

I only wondered why the west window was so dark.

My tired eyes were blurry to begin with,

I can't tell if the ink is thick or thin.

All man's life has this same unawareness —

he toils and slaves, not really minding,

when all he gets is an empty name,

a thing that shines the space of an hour.

There's a truth here not confined to calligraphy practice;

let me write it in big letters for future warning!

Emperor Kangxi in Informal Dress Holding a Brush, anonymous court artists (1662–1722). Hanging scroll, ink and color on silk.

Ouyang Xiu reminds us to pursue goals beyond mere titles and employment, and reflects on how quickly life passes. In the portrait, Qing dynasty Emperor Kangxi (1654–1722; r. 1662–1722) is depicted enjoying the pastime of calligraphy practice. The brilliant plain white paper awaits his commemoration of the day, the moment.

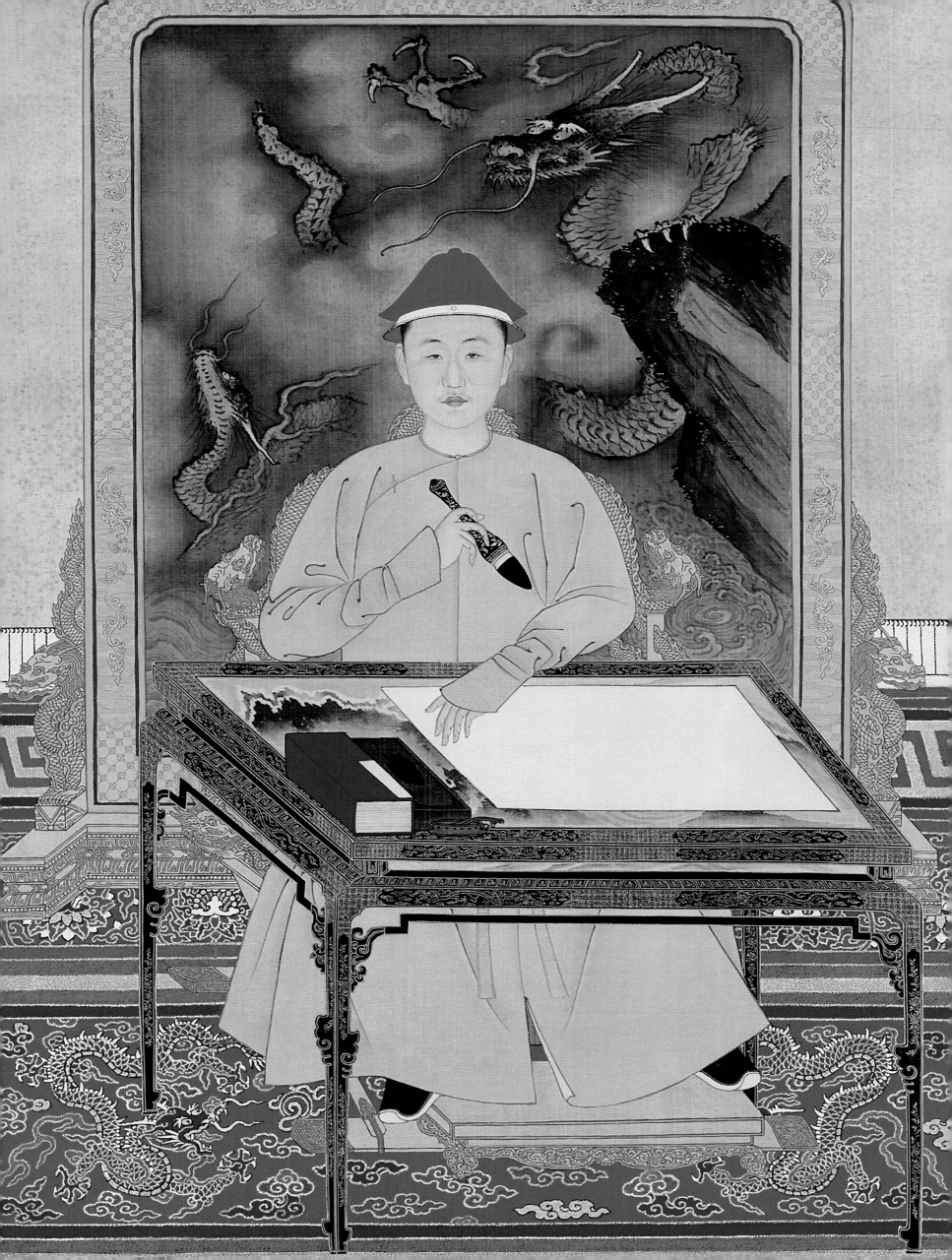

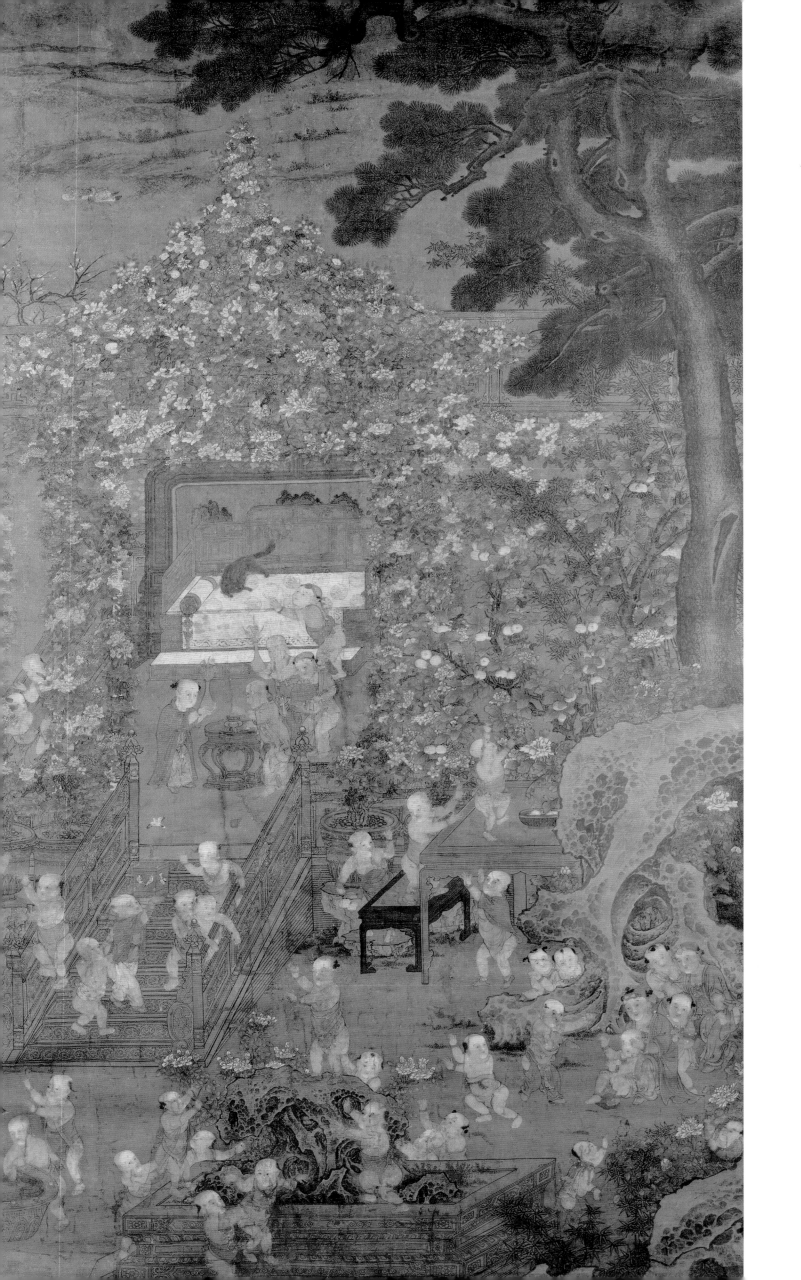

ON THE BIRTH OF HIS SON

Su Shi (Su Dongpo, 1037–1101)

*f*amilies, when a child is born
Want it to be intelligent.
I, through intelligence,
Having wrecked my whole life,
Only hope the baby will prove
Ignorant and stupid.
Then he will crown a tranquil life
By becoming a Cabinet Minister.

Children at Play in a Garden, Southern Song dynasty (1127–1279). Hanging scroll, ink and color on silk.

THE MERCHANT'S JOY

Lu You (1125–1210)

The wide wide Yangzi, dragons in deep pools;

wave blossoms, purest-white, leap to the sky.

The great ship, tall-towered, far off no bigger than a bean;

my wondering eyes have not come to rest when it's here before me.

Matted sails: clouds that hang beyond the embankment;

lines and hawsers: their thunder echoes from high town walls.

Rumble rumble of ox carts to haul the priceless cargo;

heaps, hordes to dazzle the market — men race with the news.

In singing-girl towers to play at dice, a million on one throw;

by flag-flown pavilions calling for wine, ten thousand a cask;

the Mayor? the Governor? we don't even know their names;

what's it to us who wields power in the palace?

Confucian scholar, hard up, dreaming of one square meal;

a limp, a stumble, prayers for pity at His Excellency's gate;

teeth rot, hair falls out — no one looks your way;

belly crammed with classical texts, body lean with care —

See what Heaven gives me — luck thin as paper!

Now I know that merchants are the happiest of men.

The Knickknack Peddler, Li Song (active 1190–1230). Album leaf, ink and color on silk.

A prolific writer with more than ten thousand poems and prose works to his name, Lu You took as his themes the status of the nation and the celebration of everyday life. Here the poet is interested in the latter, focusing on how a merchant enjoys the hustle and bustle of a city inundated with visitors and tourists, such as politicians and scholars. "Luck thin as paper" suggests the merchant's bumper crop of cash, harvested from those newly arrived to his city. Li Song's Knickknack Peddler captures a seller swamped with young customers. A Song dynasty contemporary of the great poet, Li Song captures the joy of the merchant and the excitement of his eager child patrons.

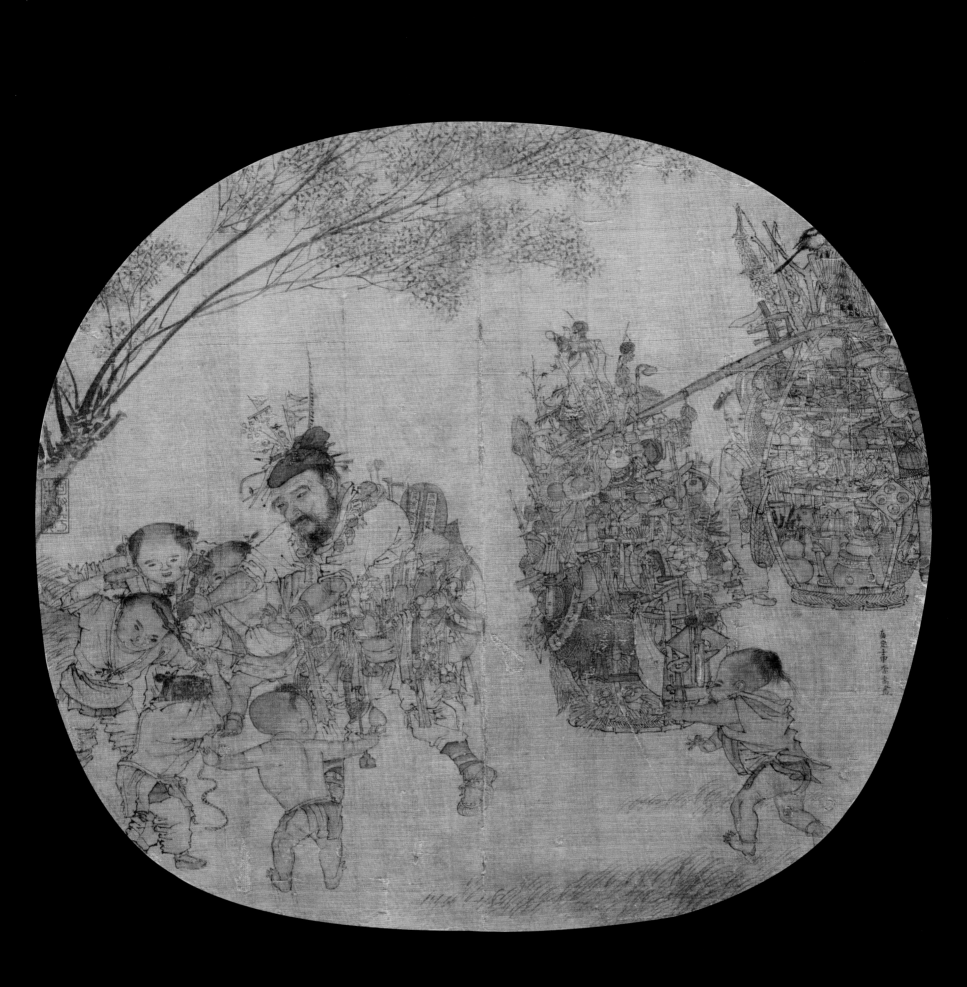

THE ARTS OF LIVING

Li Yu (Li Liweng, 1611–1680)

There are many ways of enjoying life that are hard to hold down to any one theory. There are the joys of sleeping, of sitting, of walking, and of standing up. There is the pleasure in eating, washing up, hairdressing, and even in such lowly activities as going about naked and barefooted, or going to the toilet. In its proper place, each can be enjoyable. If one can enter into the spirit of fun and take things in his stride anywhere any time, one can enjoy some things over which others may weep. On the other hand, if one is a crude person and awkward in meeting life or taking care of one's health, he can be the saddest person amidst song and dance. I speak here only of the joys of daily living and of the ways in which advantage may be taken of the commonest occupations.

THE ART OF SITTING

No one knew the art of living better than Confucius. I know this from the statement that he "did not sleep like a corpse and did not sit like a statue." If the Master had been completely absorbed in keeping decorum, intent on appearing like a gentleman at all hours and being seen as a sage at all times, then he would have had to lie down like a corpse and sit like a statue. His four limbs and his internal system would never have been able to relax. How could such a stiff wooden statue expect to live a long life? Because Confucius did not do this, the statement describes the ease of the Master in his private life, which makes him worthy of worship as the father of all cultured gentlemen. We should follow Confucius' example when at home. Do not sit erect and look severe as if you were chained or glued to the chair. Hug your knee and sing, or sit chin in hand, without honoring it with the phrase of "losing oneself in thought." On the other hand, if a person sits stiffly for a long time, head high and chest out, this is a premonition that he is heading for the grave. He is sitting for his memorial portrait!

Emperor Yongzheng in Costume, anonymous court artists (1722–1735). Album leaf, color on silk.

Li Yu proposes that mundane activities are not automatically to be dismissed. Rather, we should engage life in all its aspects during our lifetimes. The detailed album leaf depicting Qing dynasty Emperor Yongzheng (1678–1735; r. 1722–1735) is one of thirteen portraits of the ruler in various costumes and activities.

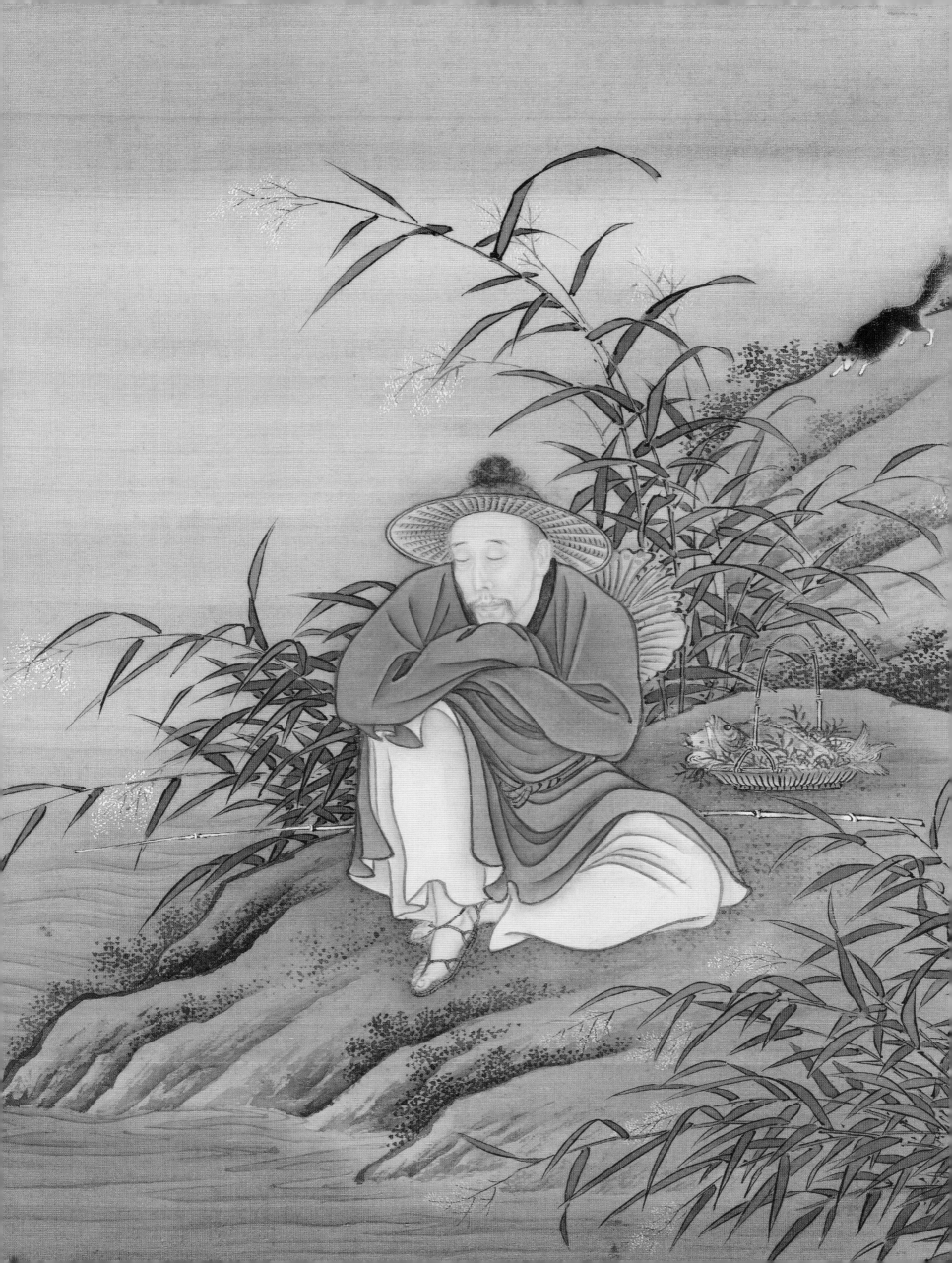

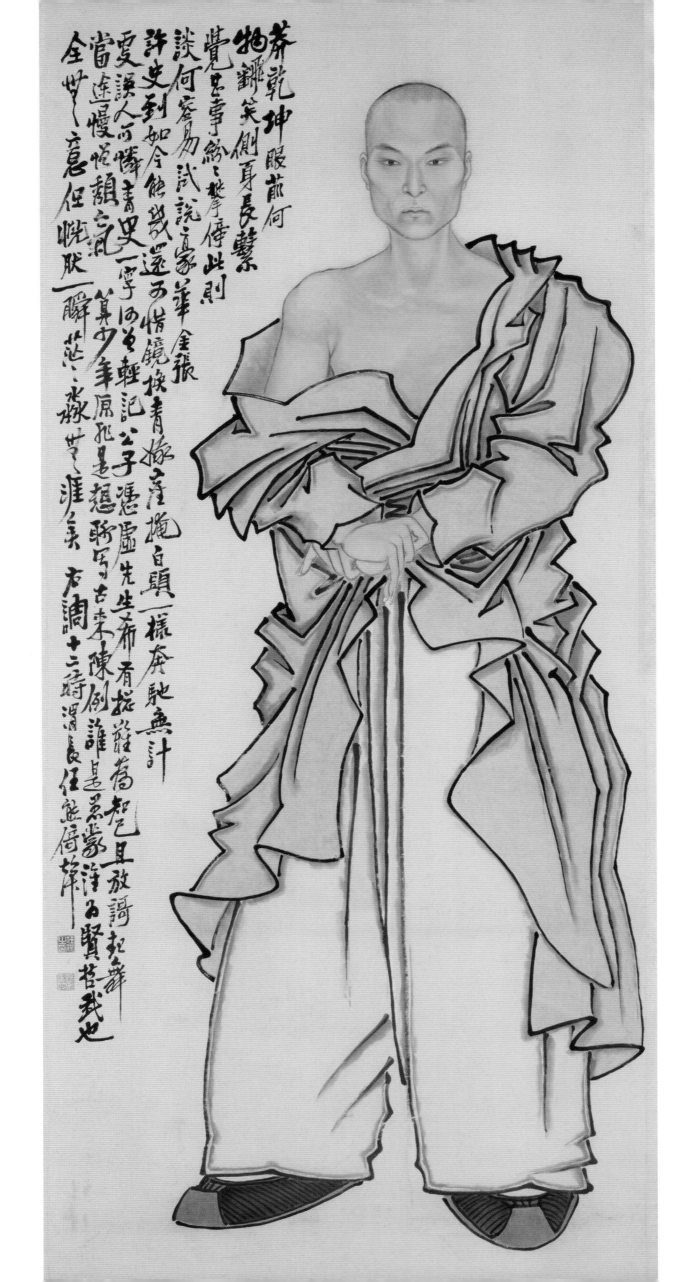

莽乾坤眼前何
物雄嘲笑側身長繫
覺雲亭絲竿擊偉此則
談何容易試説之家華金張
許史到如今能裁還子惜鏡換青橡辜擲掩白頭一樣奔馳無計
更誤人而傺青史一字問算少年原孔是惹懷野寫古來陳倒誰是怨家淮多賢哲我也
當途慢惶賴之亂起且放謡起舞
全世意氣任恍狀一瞬慈永涤世芝涯莫君調十三時滑長任庵偃舿

THE MOONLIT LOTUS POND

Zhu Ziqing (1896–1948)

These past few days I have been exceedingly restless. This evening, as I sat in my courtyard enjoying the cool night air, I suddenly thought of the lotus pond along which I was used to taking daily walks, and I imagined that it must look quite different under the light of this full moon. Slowly the moon climbed in the sky, and beyond the wall the laughter of children playing on the road could no longer be heard. My wife was inside patting [our child] Runer as she hummed a faint lullaby. I gently threw a wrap over my shoulders and walked out, closing the gate behind me.

Bordering the pond is a meandering little cinder path. It is a secluded path; during the day few people use it, and at night it is even lonelier. There are great numbers of trees growing on all sides of the lotus pond, lush and fertile. On one side of the path there are some willow trees and several varieties of trees whose names I do not know. On moonless nights this path is dark and forbidding, giving one an eerie feeling. But this evening it was quite nice, even though the rays of the moon were pale. Finding myself alone on the path, I folded my hands behind me and strolled along. The stretch of land and sky that spread out before me seemed to belong to me, and I seemed to transcend my own existence and enter another world. I love noise, but I also love quiet; I love crowds, but I also love seclusion. On a night like tonight, all alone under this vast expanse of moonlight, I can think whatever I wish, or think of nothing if I wish. I feel myself to be a truly free man. The things I must do and the words I must say during the daytime I need not concern myself with now; this is an exquisite secluded spot, a place where I can enjoy the limitless fragrance of the lotuses and the light of the moon.

On the surface of the winding and twisting lotus pond floated an immense field of leaves. The leaves floated high in the water, rising up like the skirts of a dancing girl. Amid the layers of leaves white blossoms adorned the vista, some beguilingly open and others bashfully holding their petals in. Just like a string of bright pearls or stars in a blue sky, or like lovely maidens just emerging from their bath. A gentle breeze floated by bringing with it waves of a crisp fragrance like strains of a vague melody sent over from distant towering buildings. When that happened the leaves and blossoms trembled briefly, as though a bolt of lightning had streaked across the lotus pond. The leaves themselves were densely crowded together, pushing back and forth, and they seemed to be a cresting wave of solid green. Beneath the leaves restrained currents of water flowed, imprisoned beneath them, the color forever hidden, while the stirrings of the leaves were even more pronounced.

Lotus, Chen Shun (1483–1544). Handscroll, color on paper. Detail.

This essay by Zhu Ziqing captures his thoughts on returning to the natural surroundings that lie just beyond the border of his home. Grappling with what it means to be alive at this moment beside the pond, the writer juxtaposes various scenes of his life before, during, and after his walk along the bank. This idea of time as past, present, and future is also highlighted by Chen Shun's Lotus. Chen depicts the life cycle of the plant, from small green shoots to full blossoms to plants withering away while new green shoots emerge from below.

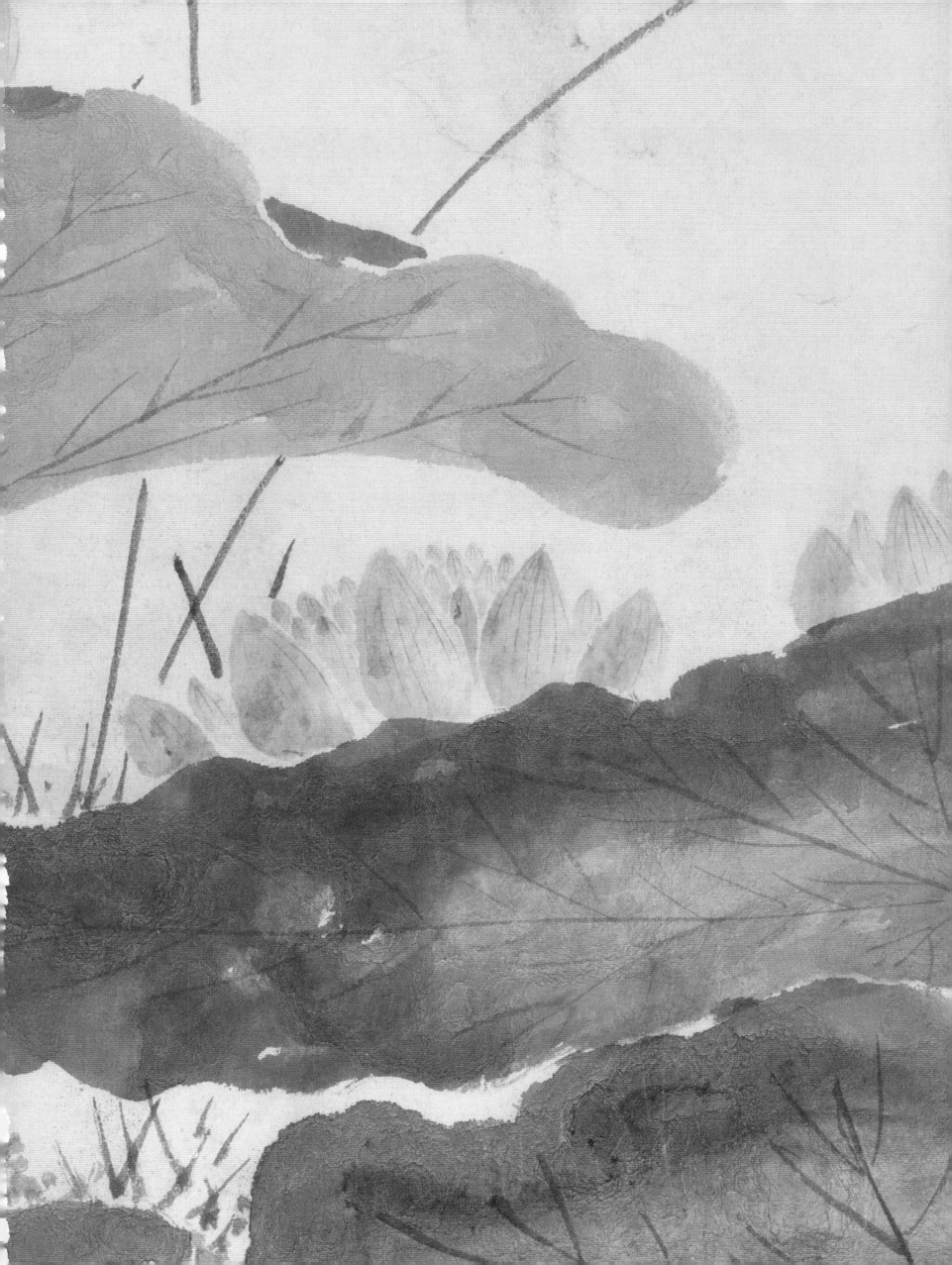

Images of Today,
Ding Cong (b. 1916).
Handscroll, ink and color
on paper. Detail.

worthless? As for childishness, that is nothing to be ashamed of, any more than children need be ashamed of comparison with grown-ups. The childish can grow and mature; and as long as they do not become decrepit and corrupt, all will be well. As for waiting till you are mature before making a move, not even a country woman would be so foolish. If her child falls down while learning to walk, she does not order him to stay in bed until he has mastered the art of walking.

First our young people must turn China into an articulate country. Speak out boldly, advance fearlessly, with no thought of personal gain, brushing aside the ancients, and expressing your true thoughts. Of course, to be truthful is far from easy. It is not easy to be truly oneself, for instance. When I make a speech I am not truly myself — for I talk differently to children or to my friends. Still, we can talk in a relatively truthful way and express relatively truthful ideas. And only then shall we be able to move the people of China and the world. Only then shall we be able to live in the world with all the other nations.

SILENT CHINA

Lu Xun (Zhou Shuren, 1881–1936)

\mathcal{B}ecause we use the language of the ancients, which the people cannot understand and do not hear, we are like a dish of loose sand — oblivious to each other's sufferings. The first necessity, if we want to come to life, is for our young people to stop speaking the language of Confucius and Mencius, Han Yu, and Liu Zongyuan. This is a different era, and times have changed. Hong Kong was not like this in the time of Confucius, and we cannot use the old sage's language to write on Hong Kong. Such phrases as "Hong Kong, how great thou art!" are simply nonsense.

We must speak our own language, the language of today, using the living vernacular to give clear expression to our thoughts and feelings. Of course, we shall be jeered at for this by our elders and betters, who consider the vernacular vulgar and worthless, and say young writers are childish and will make fools of themselves. But how many in China can write the classical language? The rest can only use the vernacular. Do you mean to say that all these Chinese are vulgar and

Lu Xun calls for the "living vernacular" — not the language of the ancients — to clearly and truthfully express the thoughts of the present. Only in this way can the people of China truly exist in the world. Trained as a comic artist, Ding Cong painted his Images of Today *on a scroll-like paper to be read right to left, just like a traditional handscroll. Vignettes right to left detail how the student and professor are unable to study and teach; warmongers profit from wartime destruction; soldiers lie dying at the feet of the rich, who turn their eyes and noses away; authors and poets are censored and not allowed to publish; rats feast on government rations meant for the starving; and the reporter is gagged by official reports that he must regurgitate to the masses. The conclusion is clear: All lives are disrupted or ruined by war.*

SELF-PORTRAIT INSCRIPTION

Ren Xiong (1820–1857)

"What thing from within the vast cosmos is this

 before my eyes, with fleeting smile and body awry?

I have long been aware of and anxious about

 important affairs but am confused about what

 to grasp hold of and rely upon.

But this is so easy to talk about! Let us examine

 the gallant and splendid Jin, Zhang, Xu and Shi.

But how many of them could

 reach those heights today?

To return to the past would be a pity, for then the

 mirror would change to a dark moth-browed

 beauty and dirt-covered old man, both alike in

 running about without a plan.

But what deludes people still further

 are the pitiable histories, for when have they

 ever recorded a single word

 about such inconsequential people!

Lord Ping Xu was someone hoped for by the Master,

 but in the end it is difficult to know even oneself.

So lift up your voice in song

 and rise up to dance, for the path of

 officialdom is that of contempt and decadence.

When I sum up my youthful years and my original

 thoughts on right and wrong, which to a certain

 extent I wrote out in sequence from

 antiquity onward, who was the stupid

 fool and who the worthy sage?

I too have no idea at all, but, there it is — a single glance

 at what is undefined, vague, and boundless.

Composed by Ren Xiong, called Weichang,

to the tune of 'The Twelve Daily Periods.'"

Self-Portrait, **Ren Xiong (1820–1857). Hanging scroll, ink and color on paper.**

The poetic inscription by Ren Xiong alongside his self-portrait captures the artist's thoughts as he studies his mirrored image for painting. He reflects on his own journey up to the close of his life, circa the mid-1850s. Cloaked in mountainous piles of blue drapery folds, a slender yet fit upper body emerges with a strong visage and shaved head. Ren Xiong asks himself, and the viewer, what we see in him — and thus how we see and imagine ourselves in our own lives.

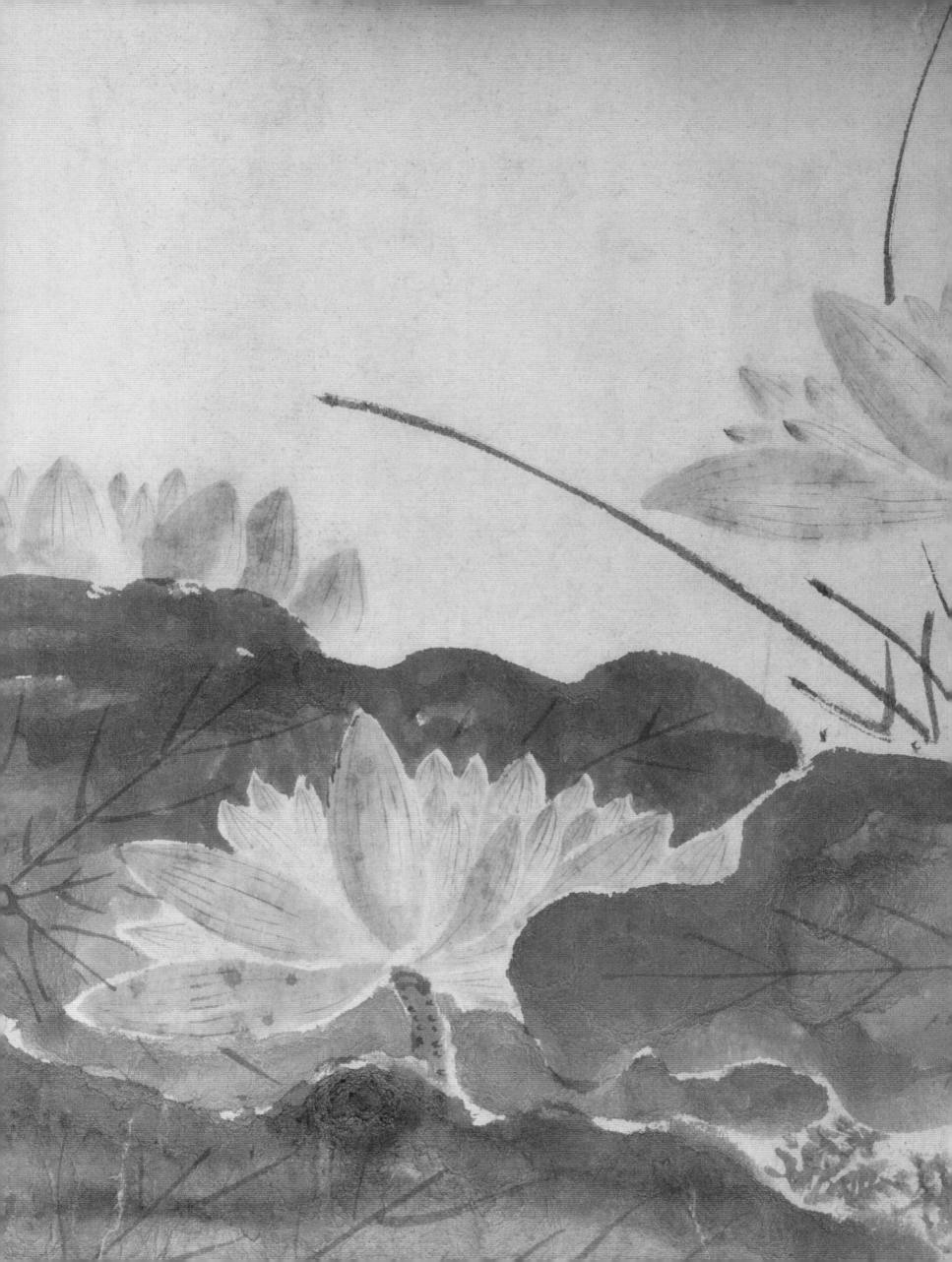

VIEWING THE OCEAN

Cao Cao (155–220)

East looking down from Jieshi,

I scan the endless ocean:

waters restlessly seething,

mountained islands jutting up,

trees growing in clusters,

a hundred grasses, rich and lush.

Autumn wind shrills and sighs,

great waves churn and leap skyward.

Sun and moon in their journeying

seem to rise from its midst,

stars and Milky Way, brightly gleaming,

seem to emerge from its depths.

How great is my delight!

I sing of it in this song.

The North Sea, Zhou
Chen (ca. 1455–after
1536). Handscroll, ink
and light color on silk.
Detail.

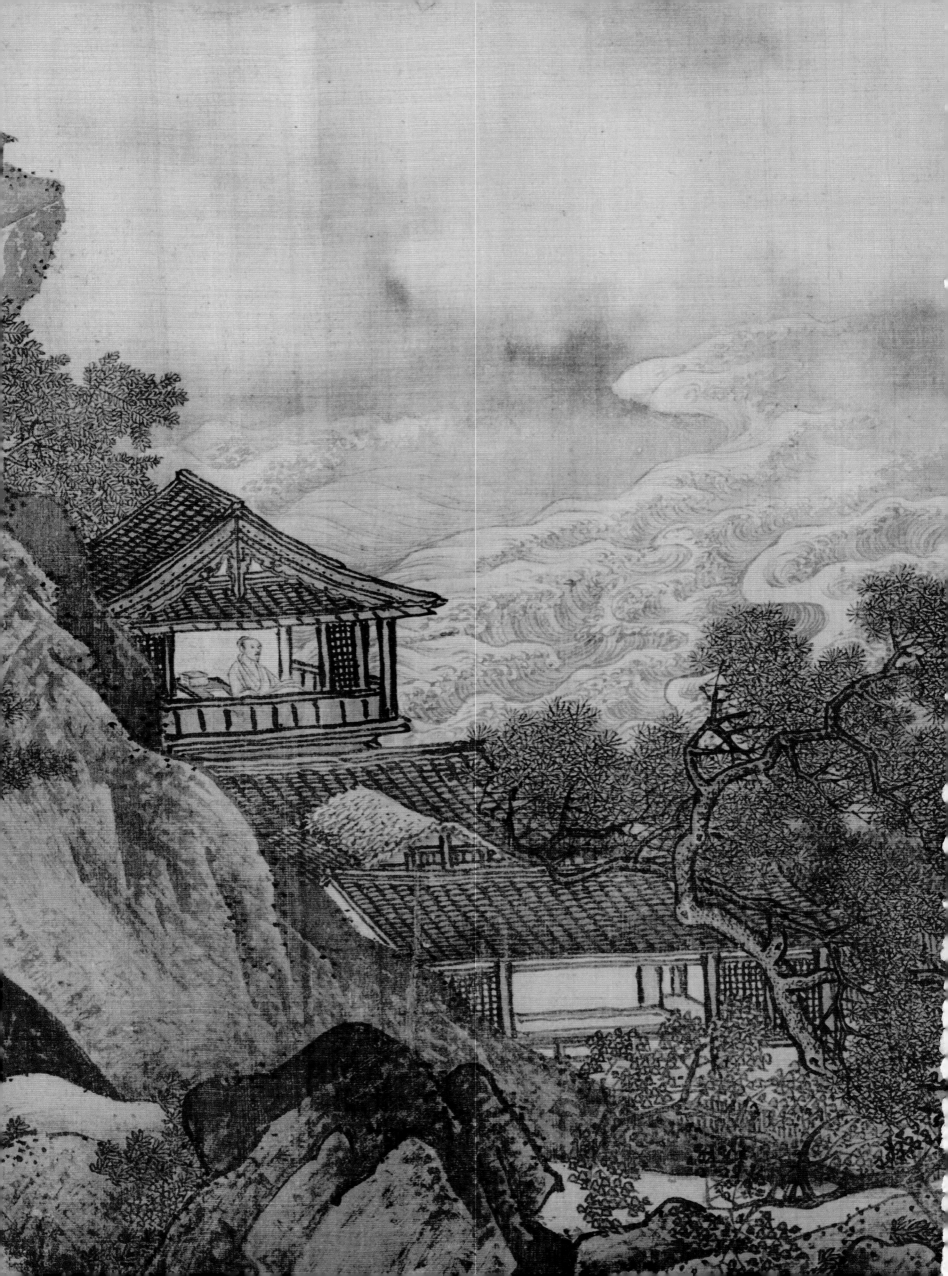

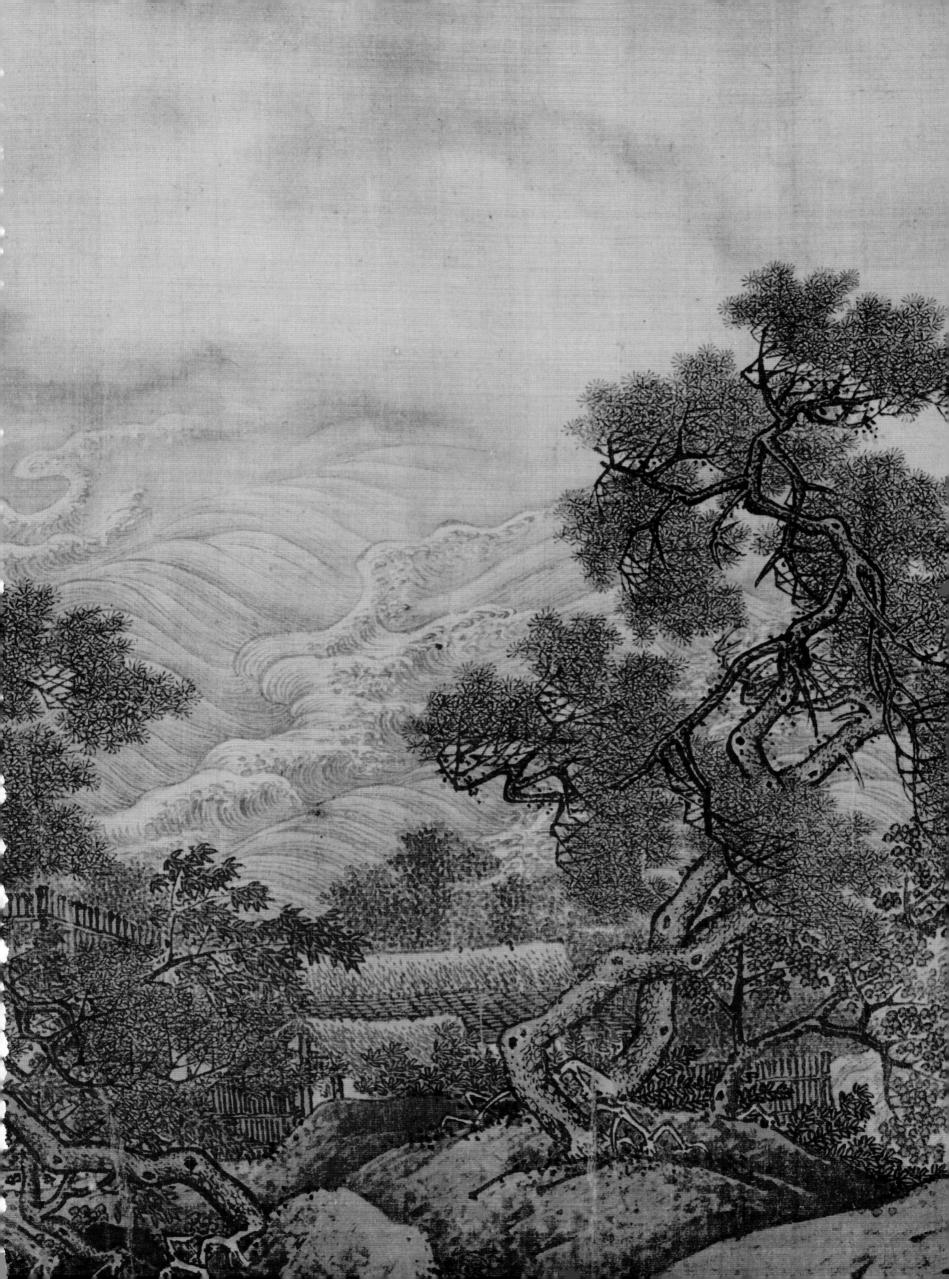

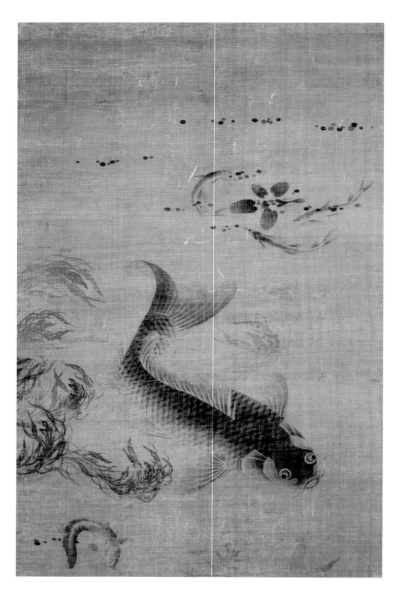

Fish and Water Grasses,
Southern Song dynasty
(1127–1279). Hanging
scroll, ink on silk.

ZHUANGZI

Zhuang Zhou (mid–3rd century BCE)

Zhuangzi and Huizi were strolling along the dam of the Hao River when Zhuangzi said, "See how the minnows come out and dart around where they please! That's what fish really enjoy!"

Huizi said, "You're not a fish — how do you know what fish enjoy?"

Zhuangzi said, "You're not I, so how do you know I don't know what fish enjoy?"

Huizi said, "I'm not you, so I certainly don't know what you know. On the other hand, you're certainly not a fish — so that still proves you don't know what fish enjoy!"

Zhuangzi said, "Let's go back to your original question, please. You asked me *how* I know what fish enjoy — so you already knew I knew it when you asked the question. I know it by standing here beside the Hao."

One of the most famous passages from the Zhuangzi, this dialogue contrasts human knowledge with human understanding of the natural world. The Daoist fascination with looking to nature for the answers to life's problems is at the heart of this scene between the philosoper Zhuang Zhou and his colleague Huizi.

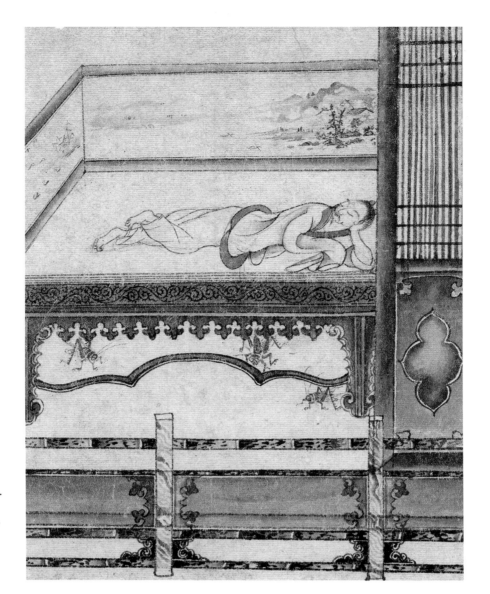

PRECEDING SPREAD:
Lotus, Zhang Daqian (1899–1983). Scroll, mounted and framed, ink and color on paper.

RIGHT: *Seventh Month*, Southern Song dynasty (1127–1279). Handscroll, ink on paper. Detail.

SEVENTH MONTH

Shijing (ca. 11th century–221 BCE)

*I*n the fifth month, the locust moves its legs;

In the sixth month, the spinner sounds its wings.

In the seventh month, in the fields;

In the eighth month, under the eaves;

In the ninth month, about the doors;

In the tenth month, the cricket

Enters under our beds.

Chinks are filled up, and rats are smoked out;

The windows that face [the north] are stopped up;

And the doors are plastered.

"Ah! Our wives and children,

Changing the year requires this:

Enter here and dwell."

Seventh Month *is from the* Odes of Bin *found in the* Shijing. *The* Shijing *(Book of Odes; Classic of Poetry) contains ballads, hymns, and poems that were passed orally from generation to generation until finally being written down, by the third century* BCE. *The* Odes of Bin *describe how fully Zhou dynasty life was regulated according to a natural calendar.*

NATURE AND ENVIRONMENT

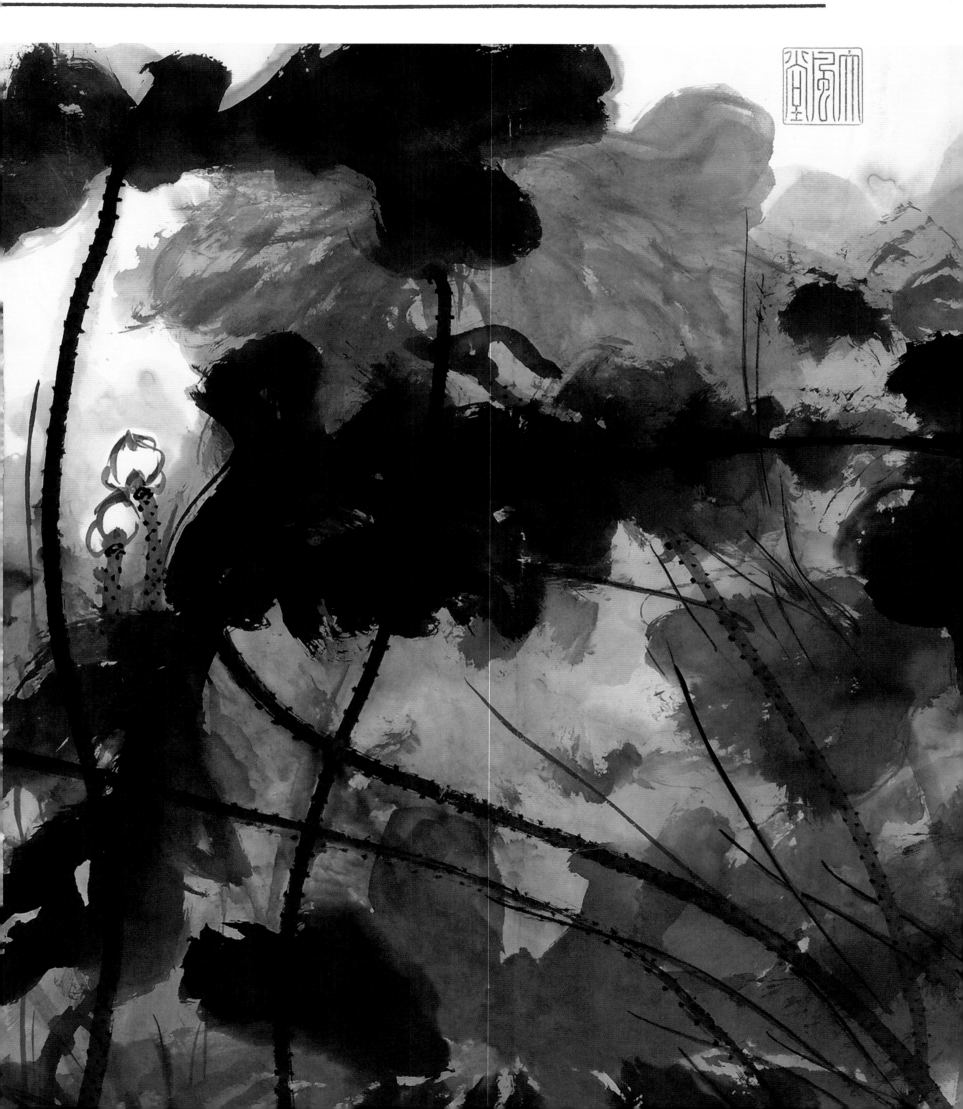

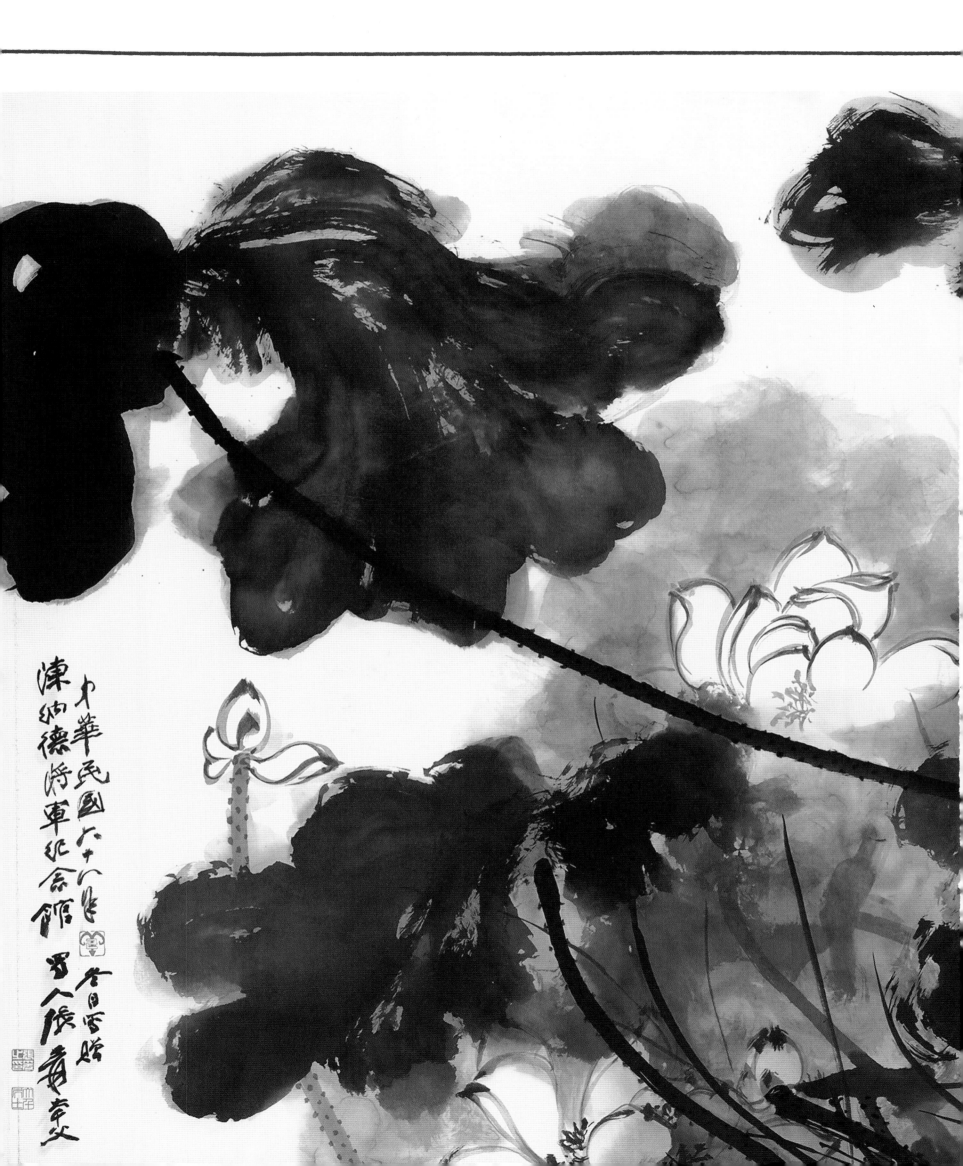

DOG

Ba Jin (Li Feigan, 1904–2005)

I don't know how old I am or what my name is. I'm like a stone that was cast into this world one day and came alive. I have no idea who my parents are. I'm like a lost object that no one ever bothered to come looking for. I have a squat, skinny body, yellow skin, black hair, black eyes, and a flat nose. I'm just one in the multitude and am destined to go on living among them.

Every person has a childhood, but mine was different from other people's. I've never known what it feels like to be warm, well fed, or loved. All I've known is cold and hunger.

One day — I can't remember exactly when — a tall, thin, wrinkled old man standing before me said earnestly, "A boy your age should be in school. Getting a good education is the most important thing in life."

After that, I forgot my cold and hunger and began a search. I looked everywhere. I found grand and imposing buildings as well as plain and simple ones. People told me they were all schools. Head held high, I walked through the gates because I remembered that getting an education is the most important thing in life.

Whether the building was simple or ornate, whether the face I met at the gate was friendly or menacing, invariably I was greeted by, "Get lost! You don't belong here!" The words lashed at me like a whip, until my body burned. I lowered my head and left, but the sound of laughter from children inside rang in my ears. For the first time I began to wonder if I really was a human being at all.

My doubts grew stronger every day. I didn't want to think about it, but a voice in my head kept asking, "Are you really human?"

Inside the abandoned temple stood a statue of the temple god. Gods can do anything, I thought to myself. Since there was no curtain to cover the shrine, the god's dignified image was fully exposed. Even though the gold had peeled off his body, and one of his hands was missing, he was still a god. I knelt in front of the crumbling altar and prayed, "Holy One, please give me a sign. Am I really a human being?"

He didn't answer my prayer. He didn't even give me a sign in my dreams. But in the end, I solved the problem myself. I reasoned, "How could I possibly be a person the way I am? Isn't that an insult to the sanctity of the word itself?" After that I understood that I could not possibly be a person, and the kind of life I had been living suddenly made sense to me. I begged for scraps like a dog because I wasn't human. I was a dog, or something like it.

A thought occurred to me one day: "Since I'm an object, I should be able to sell myself. I can't live a decent life, so I might as well sell myself to someone who will take care of me. I would be his beast of burden if he took me into his household." After I had made up my mind, I stuck a sign on my back to show that I was for sale. I walked slowly through the street markets with my head held high for the sake of prospective buyers. I didn't want to set a price. I would serve anyone as faithfully as a dog so long as he took me in and gave me a few bones to gnaw on.

But not a single person showed any interest in me from sunrise to sunset — nothing but faces twisted with sinister laughter, and a few children who played with the sign on my back.

I was exhausted and hungry. I had no choice but to go back to the dilapidated temple. At the side of the road, I picked up a discarded bun. It was hard and covered with dirt, but I managed to force it down. That made me happy, since it proved that my stomach could handle anything, just like a dog.

The temple was deserted. It occurred to me that my inability to sell myself proved that I was totally useless, worse than not being human. I began to cry, then realized that while human tears were precious, the tears of a useless object were worthless.

I knelt in front of the altar table and cried. I wanted to cry it all out, not so much because I still had tears left, but because tears were all I had. After crying my eyes out in the temple, I ran over to wail at the gate of a lordly mansion. Cold and hungry, I hid in a corner of the wall in front of the gate. I cried in order to swallow my tears; that way the sound of my sobs would drown out the rumblings in my stomach.

The boy who sticks out his tongue, **Zhang Xiaogang (b. 1958). Oil on canvas.**

Ba Jin's writings are rich with compassion for those outside the mainstream who have little or no hope for securing a traditional life. Written in 1931, this piece uses the experiences of a boy alone on the streets to symbolize the plight of China during the 1930s. Zhang Xiaogang's painting immediately challenges the viewer to try to understand the emotions behind a face that remains silent. Both pieces give voice to those without voices.

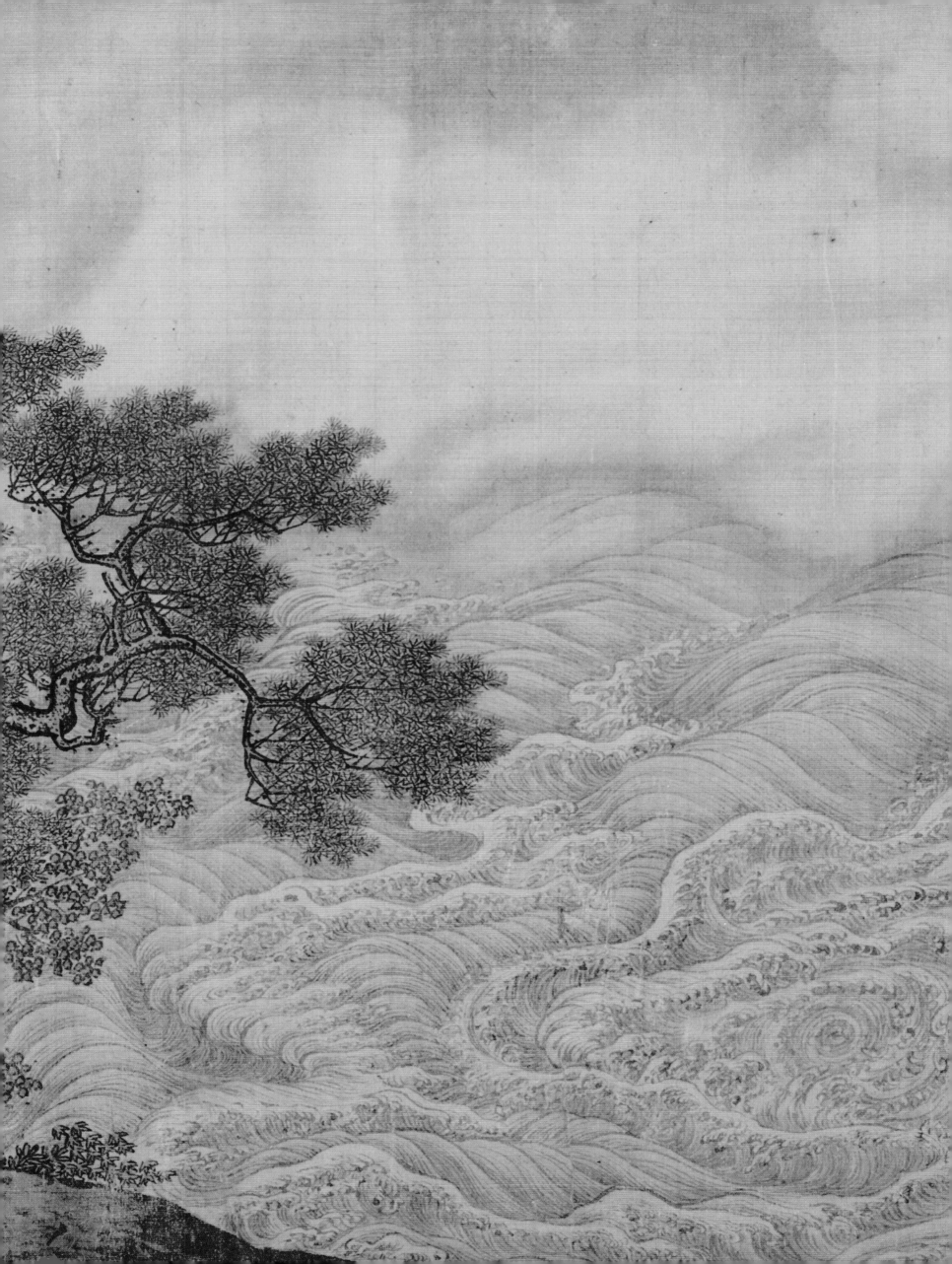

THE COCK FIGHT

Cao Zhi (192–232)

*O*ur wandering eyes are sated with the dancer's skill,

 Our ears are weary with the sound of "gong" and "shang."

 Our host is silent and sits doing nothing:

 All the guests go on to places of amusement.

 On long benches the sportsmen sit ranged

 Round a cleared room, watching the fighting-cocks.

 The gallant birds are all in battle-trim:

 They raise their tails and flap defiantly.

 Their beating wings stir the calm air:

 Their angry eyes gleam with a red light.

 Where their beaks have struck, the fine feathers are scattered:

 With their strong talons they wound again and again.

 Their long cries enter the blue clouds;

 Their flapping wings tirelessly beat and throb.

 "Pray God the lamp-oil lasts a little longer,

 Then I shall not leave without winning the match!"

**Tang dynasty Emperor
Minghuang Watching
a Cockfight, Li Song
(active 1190–1230).
Album leaf, ink and
color on silk.**

As the son of the military warlord Cao Cao, Cao Zhi endured the hardships of war and the intellectual activities promoted by his father. Much as we see in his father's poems (see pages 40 and 162), Cao Zhi looked to nature to explain his experiences. As he discusses the battles played out by dueling animals, the poet addresses the world of his own youth.

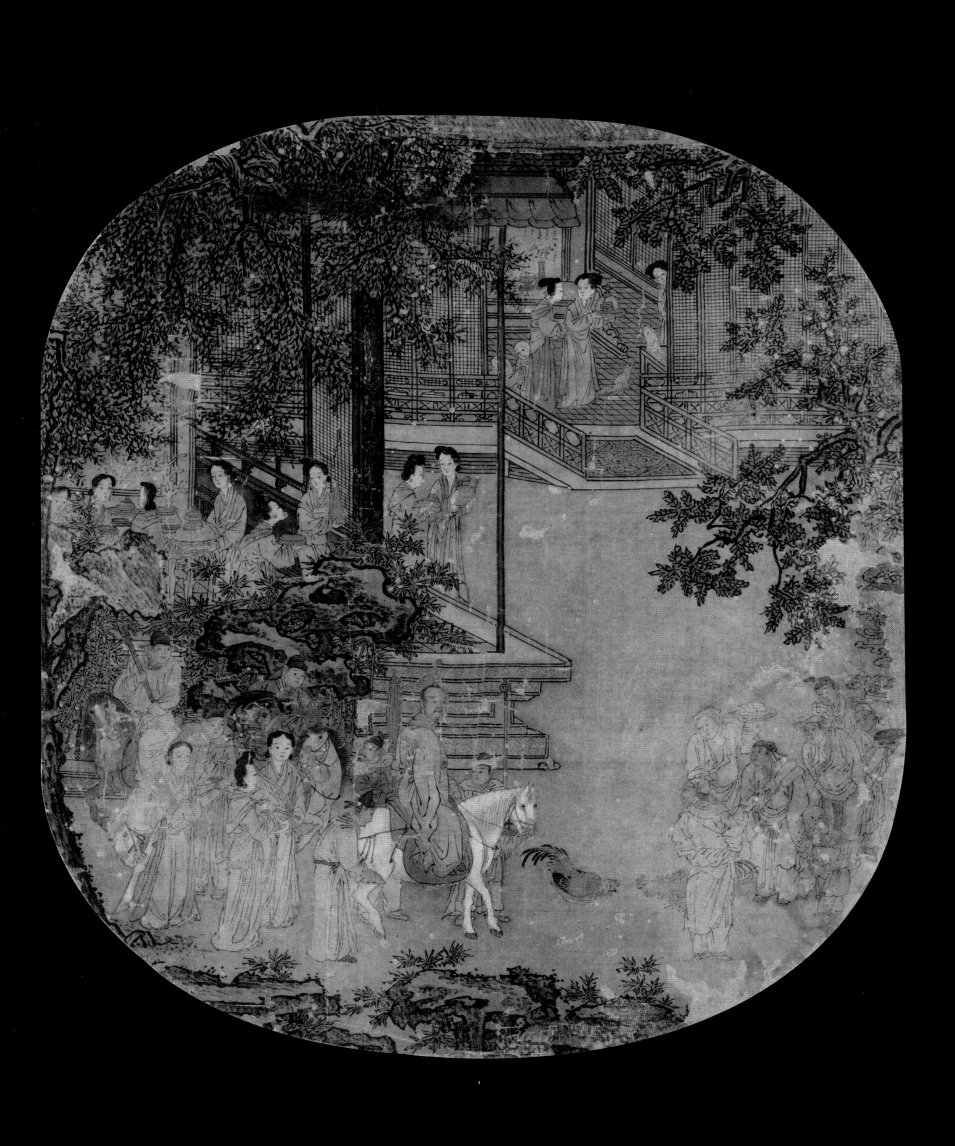

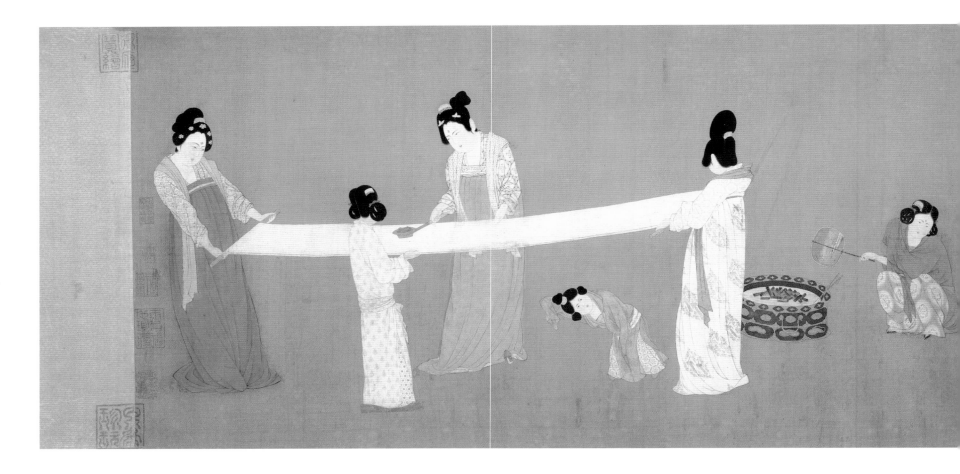

FULLING CLOTH FOR CLOTHES

Xie Huilian (397–433)

The stars Heng and Ji never halt their courses,

the sun runs swiftly as though pursued.

White dew wets the garden chrysanthemums,

fall winds strip the ash tree in the court.

Whirr whirr go the wings of the grasshopper;

shrill shrill the cold crickets' cry.

Twilight dusk enfolds the empty curtains,

the night moon enters white into chambers

where lovely women put on their robes,

jeweled and powdered, calling to each other.

Hairpinned in jade, they come from northern rooms;

with a clinking of gold, they walk the southern stairs.

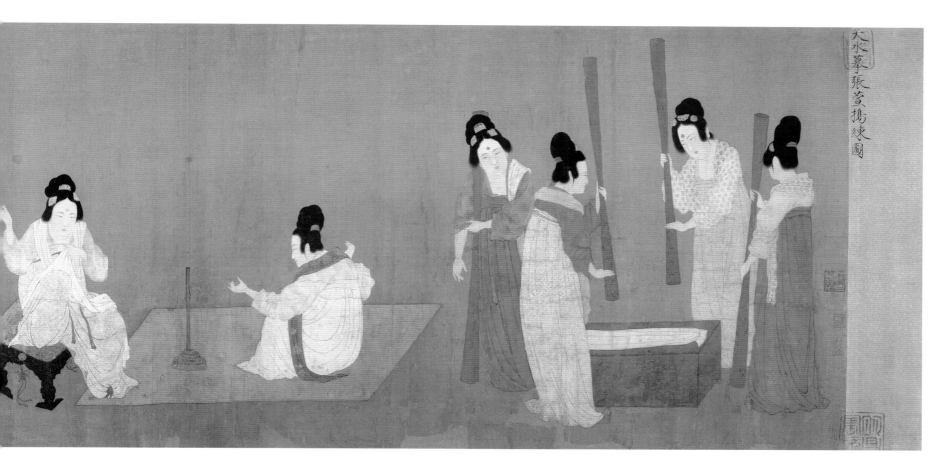

***Court Ladies Preparing
Newly Woven Silk,*
Emperor Huizong
(1082–1135).
Handscroll, ink, color,
and gold on silk. Detail.**

Where eaves are high comes the echo of fulling mallets,

where columns are tall, the sad sound of their pounding.

A faint fragrance rises from their sleeves,

light sweat stains each side of the brow.

"My cloth of glossy silk is done;

my lord is wandering and does not return.

I cut it with scissors drawn from this sheath,

sew it to make a robe you'll wear ten thousand miles.

With my own hands I lay it in the box,

fix the seal that waits for you to break.

Waist and belt I made to the old measure,

uncertain if they will fit you now or not."

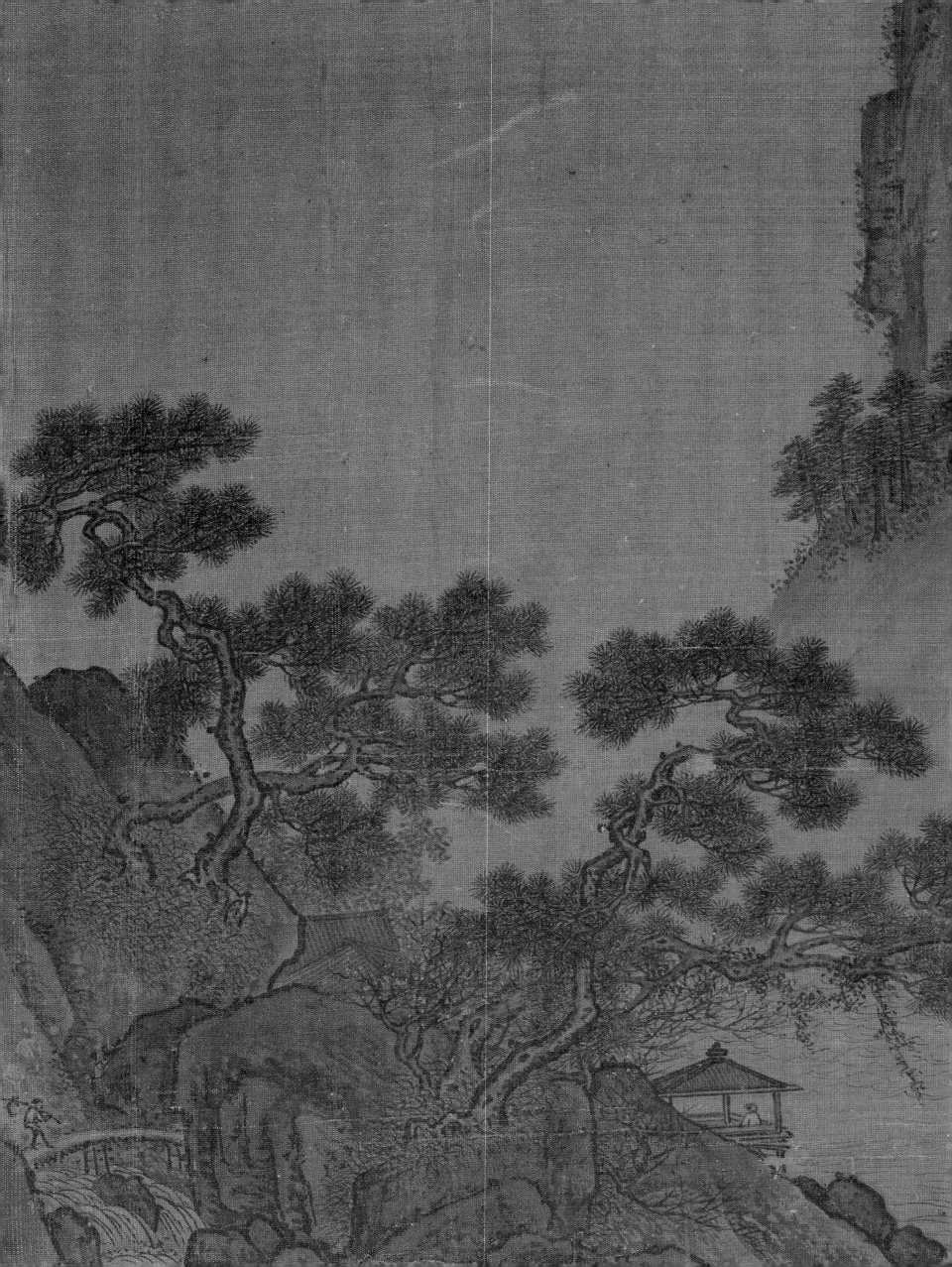

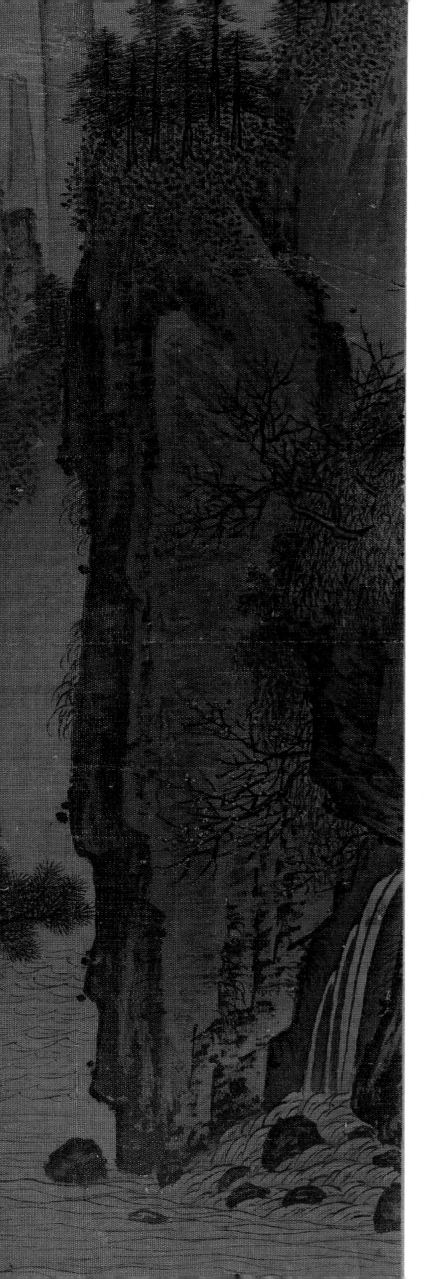

VIEWING THE WATERFALL AT MOUNT LU

Li Bo (701–762)

Sunlight streaming on Incense Stone kindles violet smoke;
far off I watch the waterfall plunge to the long river,
flying waters descending straight three thousand feet,
till I think the Milky Way has tumbled
from the ninth height of Heaven.

**Gazing at the Waterfall
(late 12th century).
Album leaf, ink and
color on silk.**

*The attributed author of more than a thousand poems, Li Bo remains one of the most important
figures in Chinese literature. Unequaled in his ability to draw from traditional folk songs and
oral histories, Li Bo moved beyond repeating the past and succeeded in bringing the past to life
again in the present — even beyond his own time and place to readers today.*

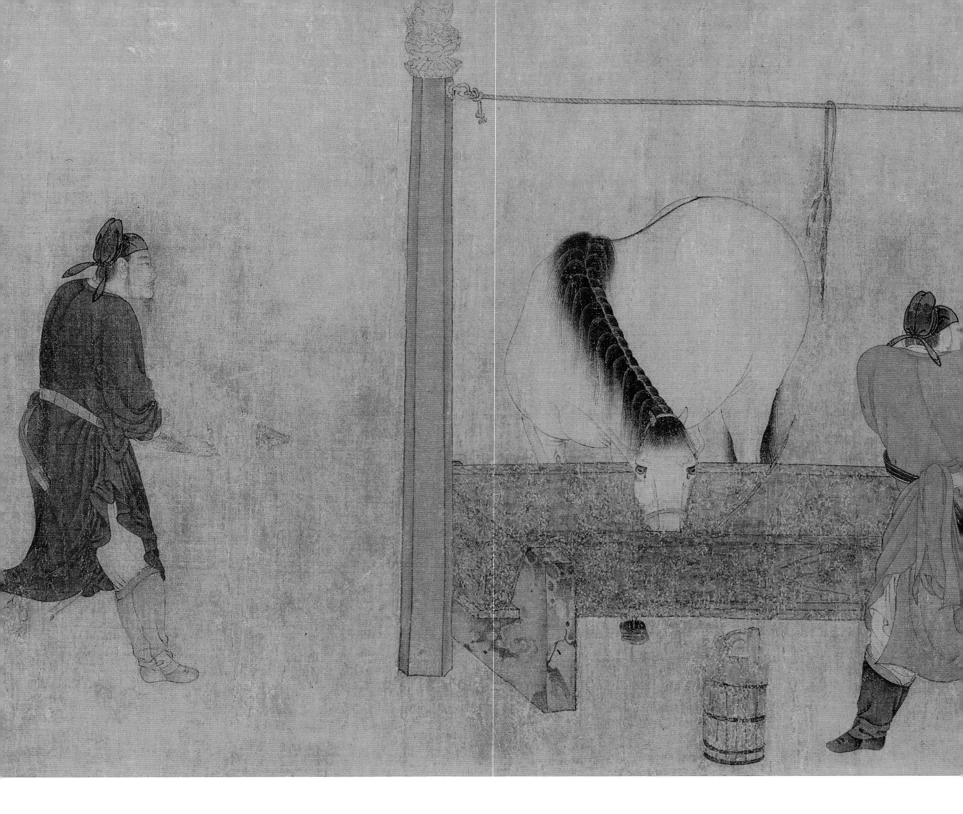

ON SEEING A HORSE-PAINTING BY CAO BA

Du Fu (712–770)

*A*mong painters of saddle-horses who have won recognition since the beginning of our dynasty, the Prince of Jiangdu was for long the only one who could be reckoned an inspired painter. Then, thirty years after General Cao first won a name for himself, the world once more beheld a true Chenghuang in its midst.

On one occasion, when he painted our late Imperial Majesty's grey, Night Shiner, thunders rolled for ten days over the face of the Dragon Pool. Ladies-in-waiting conveyed an Imperial Command and maids-of-honour made search for a certain dish of dark red agate in the Inner Treasury.

The dish bestowed, our grateful General performed his dance of obeisance and returned home, soon followed by a rain of fine silks and satins from the households of the

Imperial kinsmen and all the most powerful in the land, who felt that their screens would acquire no lustre until graced with some sample of his handiwork.

Two famous horses, one, Taizong's dun horse Curly, of former times, the other, Guo Ziyi's dappled grey Lion, of more recent date, are now to be seen in this new painting of the General's, drawing cries of admiration from the connoisseur and looking, both of them, a match for ten thousand in mounted combat. The white silk ground behind them seems to open out into a vast expanse of wind-blown sand.

The other seven horses in the painting are also magnificent specimens. Remote above them, sunset and snow commingle in a wintry sky. Their frosty hooves paw

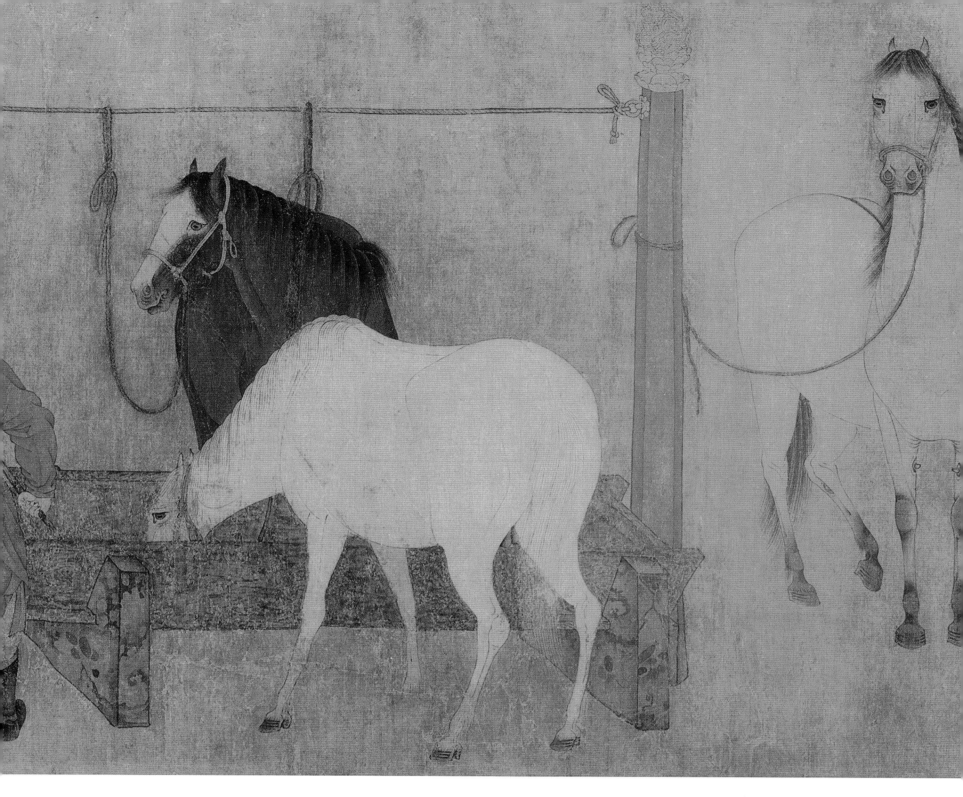

Nine Horses, Ren Renfa (1255–1328). Handscroll, ink and color on silk. Detail.

and trample a road lined with tall catalpa trees. By them, in rows, stand their grooms and stableboys.

Nine splendid horses, close-matched in godlike mettle, their glances proud and free, their spirits firm and deep-seated! And who have been the most devoted lovers of these creatures? Wei Feng in latter times; in earlier days, Zhi Dun.

I remember the Imperial progress to the palace at Xinfeng in the old days, the halcyon banner brushing the sky on its eastward journey and the undulating throng on throng of the thirty thousand trotting horses, each bone for bone and sinew for sinew a peer of the horses in this painting. But since the state visit to the River Lord and the offering of precious things, there has been no more shooting of dragons in the waters. Have you not seen? The Dragon's Messengers have all departed from amidst the pines and cypresses that stand in front of the Hill of Golden Grain. Only the birds are left, crying on the wind.

One of the great Tang dynasty poets, Du Fu wrote several ballads on various horse paintings that he viewed. He composed this piece for Wei Feng, an official in Chengdu, Sichuan province, regarding artist Cao Ba's famous Nine Horses. *Du Fu places the work in context with previous and contemporary horse portraits. Great legendary and real-life steeds of the past, such as Chenghuang and Night Shiner (see page 53), are also noted. Ren Renfa's magnificent scene of horses at the stable with grooms is among the most celebrated horse paintings.*

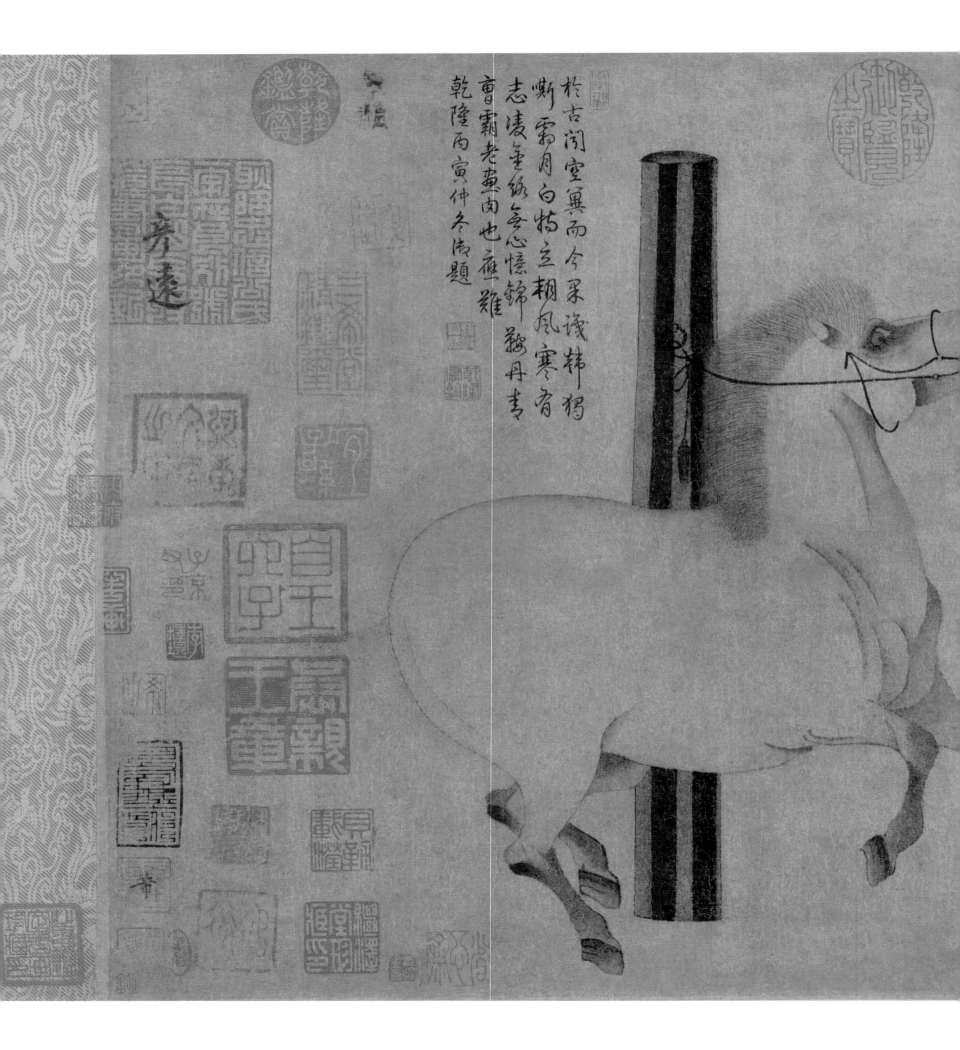

NIGHT-SHINING WHITE

Lu Guimeng (d. ca. 881)

\mathcal{S}nowy tadpoles dapple the light charge,

his paces are like flight;

A single routine of soaring brilliance,

plumes that let moonlight pass through.

I smile in response to King Mu,

who rejected the honor of ten thousand vehicles,

to tread the wind and whip up the dew,

heading for the Turquoise Pond.

**Night-Shining White,
Han Gan, attributed
(active 742–756).
Handscroll, ink on
paper. Detail.**

In this poem Lu Guimeng details his response to Han Gan's painting. The piece describes not only the imposing horse owned by Tang dynasty Emperor Xuanzong (685–782; r. 712–756) but also how it relates to Western Zhou dynasty King Mu (r. 956–918 BCE), who embarked with his illustrious steeds on a journey to Mount Kunlun to see the Queen Mother of the West (see page 220) at Turquoise Pond.

FOUR UNTITLED POEMS

Han Shan (Tang dynasty, 7th–9th century)

Today I sat before the cliff,

sat a long time till mists had cleared.

A single thread, the clear stream runs cold;

a thousand yards the green peaks lift their heads.

White clouds — the morning light is still.

Moonrise — the lamp of night drifts upward.

Body free from dust and stain,

what cares could trouble my mind?

Have I a body or have I none?

Am I who I am or am I not?

Pondering these questions,

I sit leaning against the cliff while the years go by,

till the green grass grows between my feet

and the red dust settles on my head,

and the men of the world, thinking me dead,

come with offerings of wine and fruit to lay by my corpse.

So Han Shan writes you these words,

these words that no one will believe.

Honey is sweet — men love the taste;

medicine is bitter and hard to swallow.

What soothes the feelings brings contentment;

what opposes the will calls forth anger.

But I ask you to look at the wooden puppets,

worn out by their movement of play on stage!

Do you have the poems of Han Shan in your house?

They're better for you than sutra-reading!

Write them out and paste them on a screen

where you can glance them over from time to time.

Han Shan and Shi De,
Luo Ping (1733–1799).
Hanging scroll, ink and
light color on paper.
Detail.

Although three hundred poems are associated with the poet Han Shan, scholars continue to debate whether the collection of untitled works attributed to him was in fact by a single author or instead accumulated over the years. Very little concrete evidence is available regarding the supposed scholar-turned-hermit-farmer who took up residence at Han Mountain (Han Shan in Chinese — hence the name). What has come down through oral and written histories is that he enjoyed friendships with Buddhist monks at the local monastery, particularly one known as Shi De. A long-standing popular iconographic theme for painters and stone carvers, Han Shan and Shi De are here depicted in a lighthearted manner by Luo Ping. Luo, a monk at the Huazhi Temple, uses ink and slight color to capture the pair of free-spirited religious recluses who looked to nature for spiritual enlightenment.

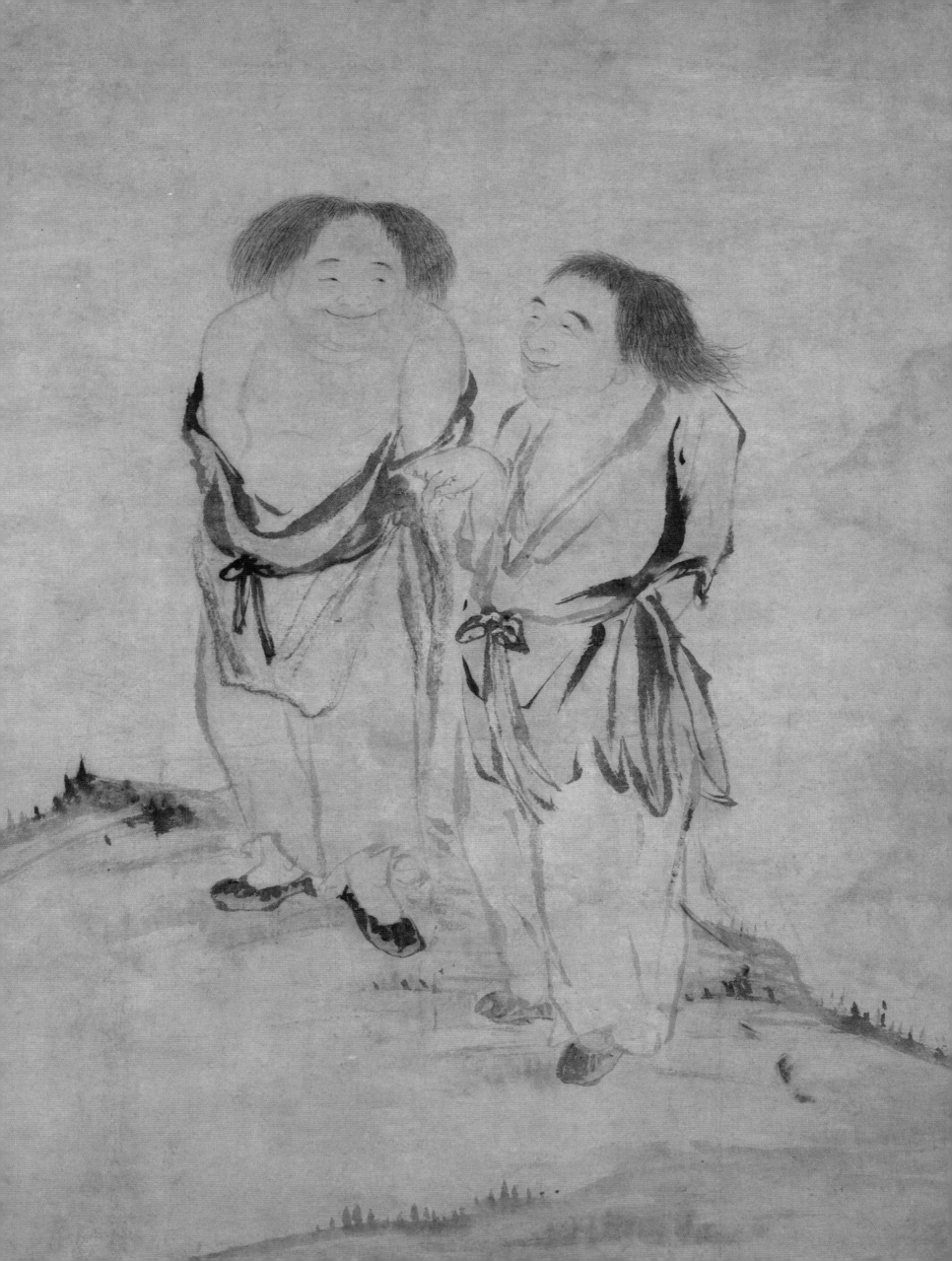

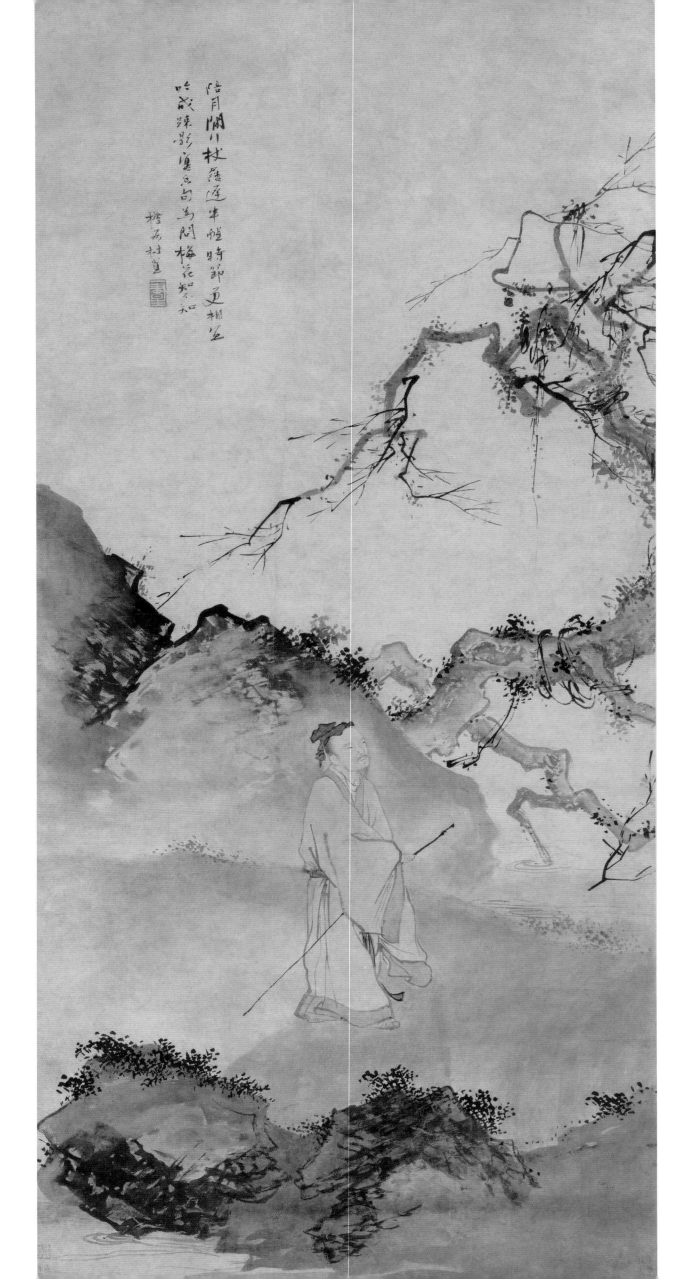

A SMALL PLUM TREE IN MY MOUNTAIN GARDEN

Lin Bu (965–1026)

The abundant fragrance [of the flowers] shakes and falls, but it alone is beautiful,

It completely monopolizes the romantic mood in my small garden.

Sparse shadows crisscross the water, pure and shallow,

The hidden fragrance floats and moves as the moon darkens.

In the frost, birds want to descend, but first take a stealthy look,

The dusty butterflies, if they knew, would be spellbound.

Fortunately there is my insignificant chanting, with which we can approach each other,

There's no need to clap boards together or raise gold cups.

The Poet Lin Bu Wandering in the Moonlight, Du Jin (ca. 1465–ca. 1509). Hanging scroll, ink and color on paper.

Lin Bu was a reclusive poet who lived alone all his life and never married. He made his home on an island known as Lone Mountain in the West Lake region of Hangzhou, Zhejiang province. Lin dedicated his writing to capturing the simple natural wonders that he encountered during excursions around the lake as well as in his secluded private gardens.

OX

Ouyang Xiu (1007–1072)

As the sun comes over the eastern hedge,
　　brown sparrows fly up in alarm;
the snows melt and springtime stirs
　　the sprouts of plants to growth.
Earthen embankments stretch level,
　　the paddy fields are vast;
bearing a young boy stretched on its back
　　and leading a calf, it walks.

Herd-boys with Water Buffaloes under Willow Trees, Yuan dynasty (1271–1368). **Hanging scroll, ink and color on paper. Detail.**

BLACK MUZZLE

Su Shi (Su Dongpo, 1037–1101)

When I came to Danzhou, I acquired a watchdog named Black Muzzle. He was very fierce, but soon got used to people. He went with me to Hepu, and when we passed Chengmai, he startled everyone on the road by swimming across the river. So as a joke I wrote this poem for him.

*B*lack Muzzle, south sea dog,

how lucky I am to be your master!

On scraps growing plump as a gourd,

never grumbling for fancier food.

Gentle by day, you learn to tell my friends;

ferocious by night, you guard the gate.

When I told you I was going back north,

you wagged your tail and danced with delight,

bounced along after the boy,

tongue out, dripping a shower of sweat.

You wouldn't go by the long bridge

but took a short cut across the clear deep bay,

bobbing along like a water bird,

scrambling up the bank fiercer than a tiger.

You steal meat — a fault, though a minor one,

but I'll spare you the whip this time.

You nod your head by way of thanks,

Heaven having given you no words.

Someday I'll get you to take a letter home —

Yellow Ears was your ancestor, I'm sure.

Dog and Bamboo,
Emperor Xuanzong
(1399–1435). Hanging
scroll, ink and slight
color on paper.

Similar to Mei Yaochen's eulogy for his cat (see page 17), Su Shi's poem considers his own pet. Su compares Black Muzzle to Yellow Ears, whom the poet Lu Zhi (261–303) had carry a letter to his family concealed in a bamboo tube. Song dynasty poets like Su were inspired by an appreciation for the familiar, allowing them to find the extraordinary in the everyday. Emperor Xuanzong's Dog and Bamboo exemplifies his noted artistic skill in depicting animals in nature. Although created 427 years after the poem, Xuanzong's dog captures Black Muzzle's physical and comic characteristics. As a patron of the arts as well as a gifted painter of animals, the Ming dynasty Emperor may have been inspired by Black Muzzle.

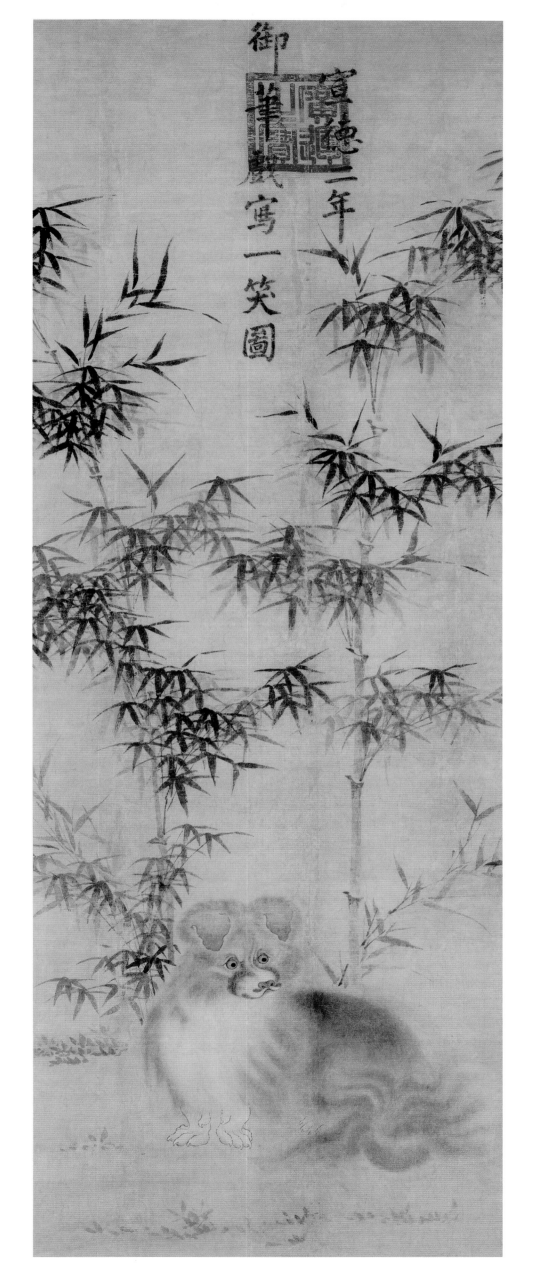

ON THE TIERED BLUFFS AND
THE MISTY RIVER PAINTING

Su Shi (Su Dongpo, 1037–1101)

A sad heart upon the river,
 hills in a thousand tiers,
azure masses adrift in sky
 as if they were clouds and mist.

Whether a mountain or whether a cloud
 from afar no one can tell,
then in misty skies clouds scatter,
 the mountain remains as it was.

I see only two slopes, slate gray,
 that darken sheer valley below,
and into it go a hundred courses
 of streams cascading down;

They wind through forests, encircle stones,
 now hidden, now seen again,
wending on down to the valley's mouth
 forming a rushing river.

The river grows level, the mountains divide,
 the forested foothills end:
there a small bridge and a wilderness inn
 rest before the mountain.

Someone walking has passed just a bit
 beyond the towering trees;
there's a fishing boat, like a single leaf,
 where river swallows the sky.

From where did the governor
 get hold of a work like this?
adorned by the finest brushwork,
 so clearly fresh and fine.

I know not where in this mortal world
 one might find such scenery,
but I would want to go there at once
 and buy a two-acre field.

Have you ever seen that spot so remote
 at Fankou in Wuchang
where I, the Master of Eastern Slope,
 remained for five long years?

There spring breezes shook the river,
 the sky spread opening wide;
and when twilight clouds rolled away rain,
 hills showed their winsome charms.

Crows beat their wings through red maples,
 companions of nights spent afloat,
and snow-loads falling from tall pines
 woke me sharply from drunken sleep.

Peach blossoms and flowing water
 do exist in the world of men;
Wuling's dwellers need not be all
 gods and the undying.

The rivers and hills are empty and pure,
 but I belong to the dust;
though there may be a path to reach them,
 it is not my fate to follow.

So I give you back this painting
 and I sigh repeatedly,
Yet I'm sure
 old friends in the hills will write
 poems calling me to come home.

Ranking Ancient Works in a Bamboo Court, **Qiu Ying (1494–1552). Album leaf, ink and color on silk.**

In this, Su Shi's most famous poem on the subject of viewing a painting, Su first takes us on a journey through the painting; he then enters a recollection of memories and dreams. Qiu Ying's album leaf illustrates three scholars in a bamboo garden grove, viewing paintings and objects from antiquity.

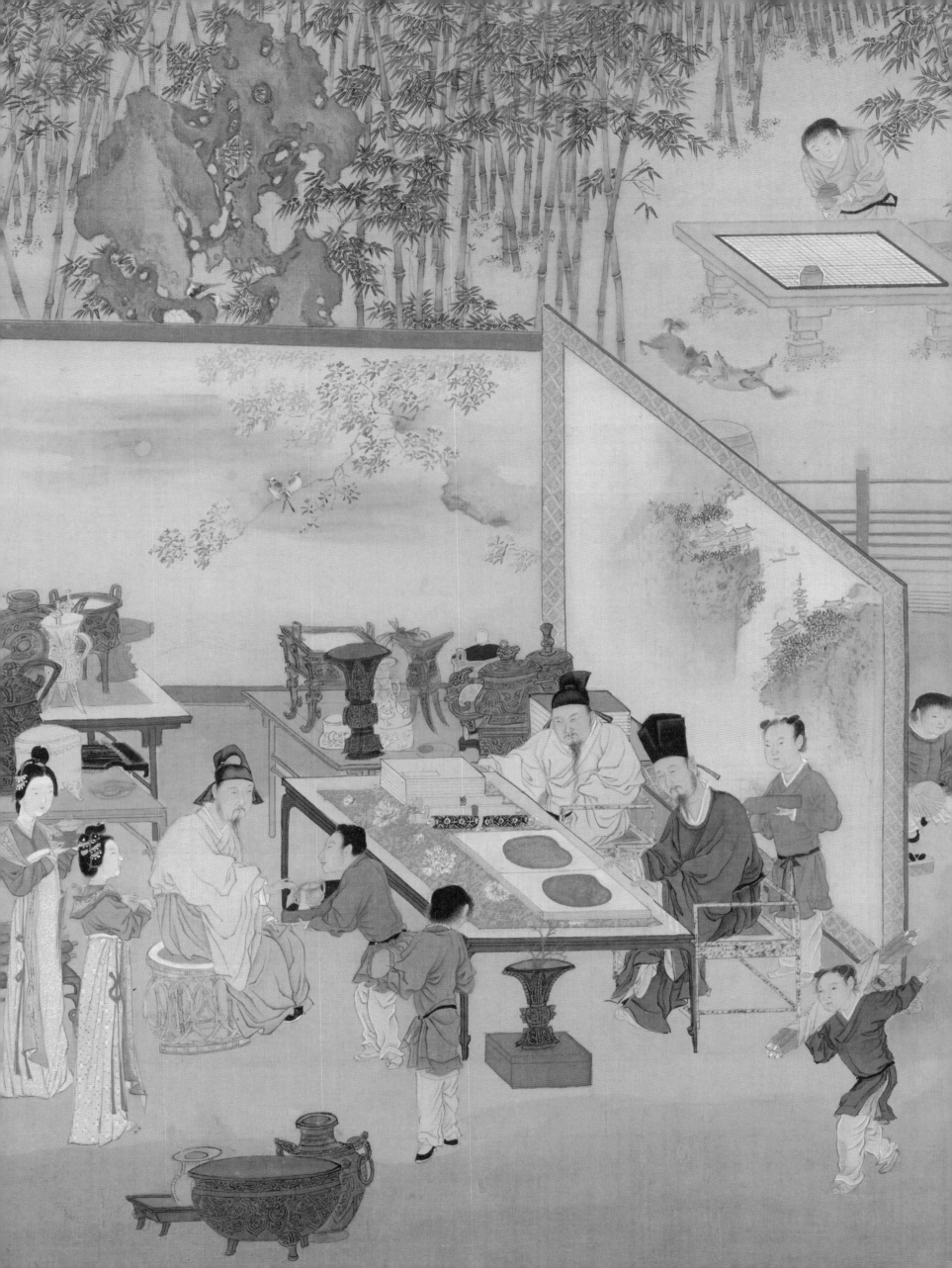

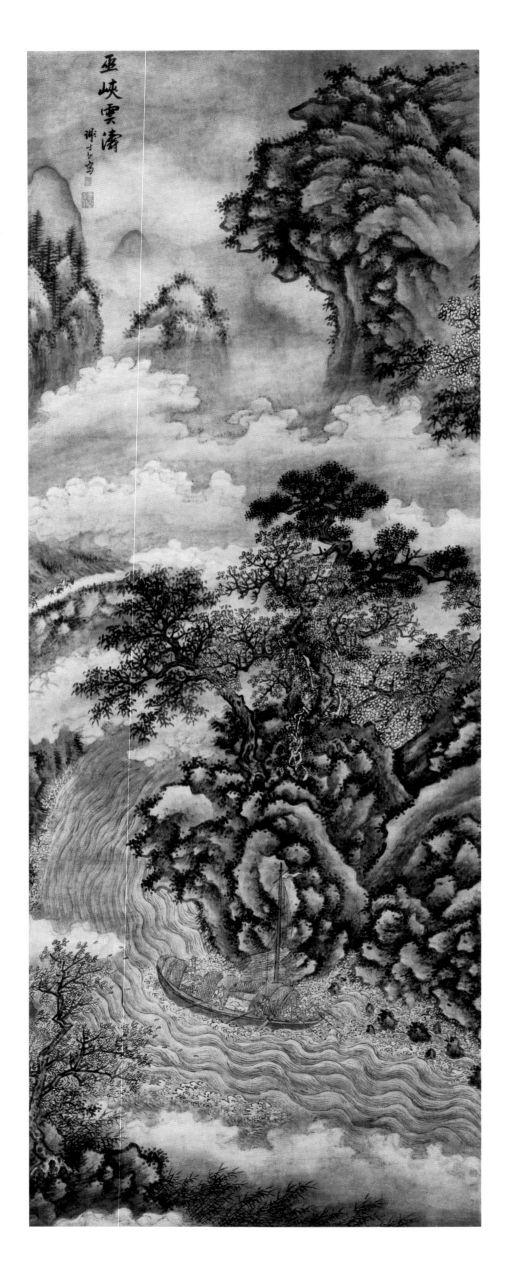

MY OLD TRIP
THROUGH THE YANGZI GORGES

Lu You (1125–1210)

*L*ong ago I made that journey, fall rain coming down lightly,

 reached the east wall of Jianping just as gates were closing.

 Host at the inn met me with greetings, words rambling on and on,

 his young wife grinding and cooking in her cheap white robe.

 Old boatmen who work the river, some drunk, some sobered up;

 merchants from Shu, peddlers of the gorges, clever at closing a deal;

 soon lamps went dark, people getting ready for bed,

 though outside we could still hear boats tying up, baggage being unloaded from horses.

 Mountains steep, rivers treacherous, barbarian tribes close by;

 often I saw their mallet-shaped hairdos mingling with city folk.

 Now, counting on my fingers, I find it's been forty years! —

 sad memories held in my heart, truly from another incarnation.

Clouds and Waves in the Gorge of Wushan, Xie Shichen (1487–ca. 1560). Hanging scroll, ink and light color on paper.

Deemed one of the greatest Southern Song dynasty literary figures, Lu You wrote more than ten thousand poems and prose works. Major themes include the disruptions caused by the Chinese government and the search for refuge in nature. Here we find the latter concern, as Lu recalls a trip he made upstream on the Yangzi River.

THE STONE ON THE HILLTOP

Lu You (1125–1210)

Autumn wind: ten thousand trees wither;

spring rain: a hundred grasses grow.

Is this really some plan of the Creator,

this flowering and fading, each season that comes?

Only the stone there on the hilltop,

its months and years too many to count,

knows nothing of the four-season round,

wearing its constant colors unchanged.

The old man has lived all his life in these hills;

though his legs fail him, he still clambers up,

now and then strokes the rock and sighs three sighs:

how can I make myself stony like you?

Sculpture in the Form of a Nine-Hole Scholar's Rock, **Zhan Wang (b. 1962). Stainless steel with wooden base.**

SPIDER-FIGHTING

Yuan Hongdao (1568–1610)

To my knowledge the technique of fighting spiders never existed in earlier times. My friend Gong Sanmu invented the sport. Sanmu was staying in the same lodgings as myself, and whenever the weather grew mild in spring, each of us would catch several small spiders, ones with rather long legs, raise them in a window, and, to amuse ourselves, make them fight for victory. Spiders are usually found in the shadowy spots on walls or under tables. Catch them when they have just formed a few long strands of their webs without cross-strands, taking care not to move too quickly, because if you move too quickly, they'll become frightened; and once frightened, they'll never be able to fight. You should take the females and not the males, because the male flees when he encounters an adversary. The male's legs are shorter and his belly thinner — it's quite easy to tell them apart.

The way to train them is this: take the offspring of another spider that has not yet hatched and stick it on a piece of paper in the window; when the female spider sees it, she will take it as her own offspring and protect it fiercely. When she sees the other spider coming, she will think it has come to take her own young and will do everything she can to fight the other off. You shouldn't use spiders who still have their eggs in their belly or whose young have already hatched. When they come on the field, they first grab one another with their legs; then after a few preliminary skirmishes, their ferocity intensifies, and they go at it tooth and nail until you can't see their bodies. The victor wraps her enemy up in threads and doesn't give up until the other is dead. There are also those who get frightened and run off in defeat in the middle of the battle; and there are some cases when the strengths are so equally matched that they quit after several rounds.

Sanmu is always able to determine ahead of time which ones will win and which ones will lose. When he catches them, he'll say that this one will be a good fighter and that one won't be a good fighter and that these two are well matched — and it always works out just like he says. The jet black ones are the best; the ash gray ones second best; and the ones with mottled colors are the worst. We also have many special names for the types: "purple-black tiger," "hawk-talons," "tortoise-shell belly," "black Zhang Jing," "night prong," "cheery lass," "little iron lips," in each case named for what they resembled. You feed them flies and large black ants. We both knew how they looked when they were hungry or well fed, happy or enraged — but this gets into a lot of little details that I'm not going to include here. Sanmu was very clever and good at poetry; as soon as he saw some skill or technique practiced deftly, he understood it — but also on this account he neglected his studies.

Clouds of Spider Threads, **Sun Liang (b. 1957). Oil on canvas.**

China enjoys a long tradition of leisurely pursuits centered on nature and insects, such as rearing singing and fighting crickets as well as fighting spiders, as noted by Yuan Hongdao. Sun Liang's brightly painted Clouds of Spider Threads *celebrates nature's freedom of movement by depicting airy webs in flight.*

EPIGRAPH

Lu Xun (Zhou Shuren, 1881–1936)

When I am silent, I am fulfilled; when I am about to speak, I then feel empty.

My past life is dead. At this death I greatly rejoice, because I know from this death that my life once existed. The dead life has decayed. I greatly rejoice, because I know from this decay that my life was not empty.

The soil of life has been cast upon the surface of the land. Tall trees do not grow from it, only wild grass. For this I am to blame.

Wild grass has no deep roots, it bears no pretty flowers, no pretty leaves. But it drinks in dew and water, sucks in the flesh and blood of long dead corpses, and wrests its existence from each and every thing. When it is alive, it is always trampled on, cut down, until it dies and decays.

But I am at ease, joyful. I will laugh; I will sing.

Naturally I love my wild grass, but I hate the ground that uses it for decoration.

Under the crust the subterranean fire is blazing. When it erupts, its lava will consume all the wild grass, all the tall tress. Whereupon nothing will be left to decay.

But I am at ease, joyful. I will laugh; I will sing.

Heaven and earth are so still and silent, I cannot laugh or sing. Even if heaven and earth were not so still and silent, perhaps I still would not be able to do so. At this juncture of light and darkness, life and death, past and future, I offer this clump of wild grass before friends and foes, men and beasts, the loving and the unloving as my witness.

For my sake, and for the sake of friends and foes, men and beasts, those loving and unloving, I hope that death and decay will come speedily to this grass. If not, then *I* will not have lived, and this would be an even greater misfortune than death and decay.

Perish, wild grass, and with it, my epigraph.

Chinese Landscape:
Face Painting, Summer,
Huang Yan (b. 1966).
Photograph.

Epigraph *is from Lu Xun's collection of prose poems, published under the title* Wild Grass. *Dark, somber, and introspective, Lu — like poets of old — describes the passing of his life through imagery drawn from nature. Here, he compares himself to wild grass, which is not as beautiful or strong as flowers and trees. Huang Yan's photograph* Chinese Landscape: Face Painting, *a revisits traditional Chinese landscape painting using the human body as canvas. The bright colors of summer vegetation emerge from the contours of the face, while the closed eyes suggest the projection of a mental image of nature by the subject.*

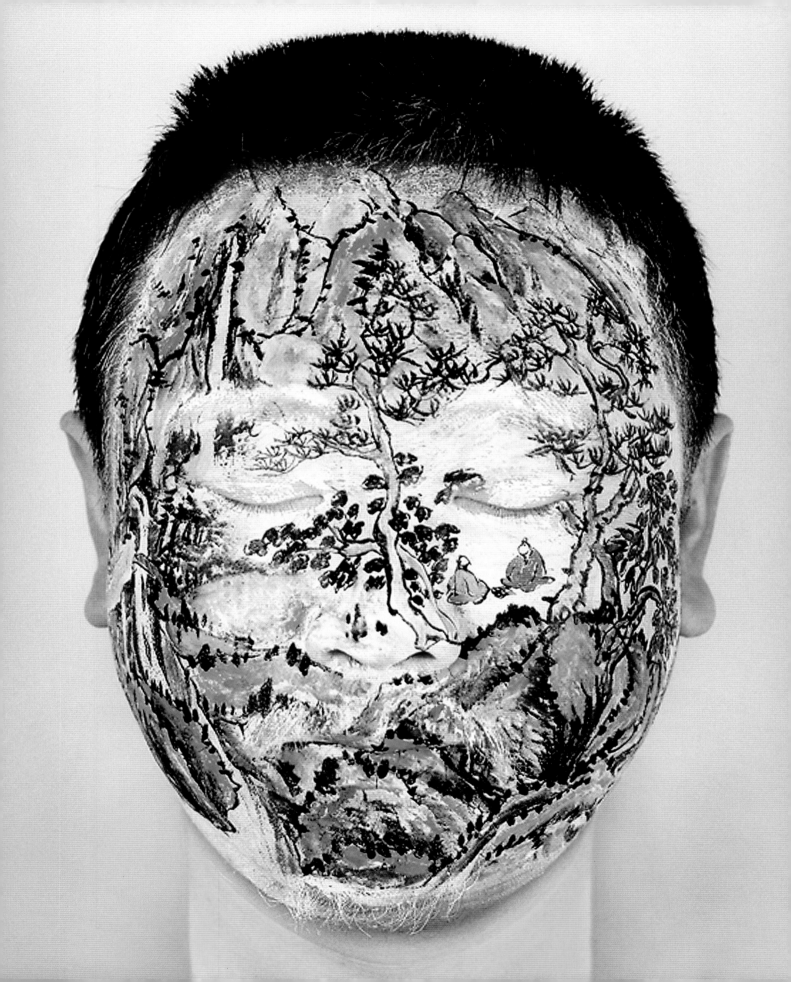

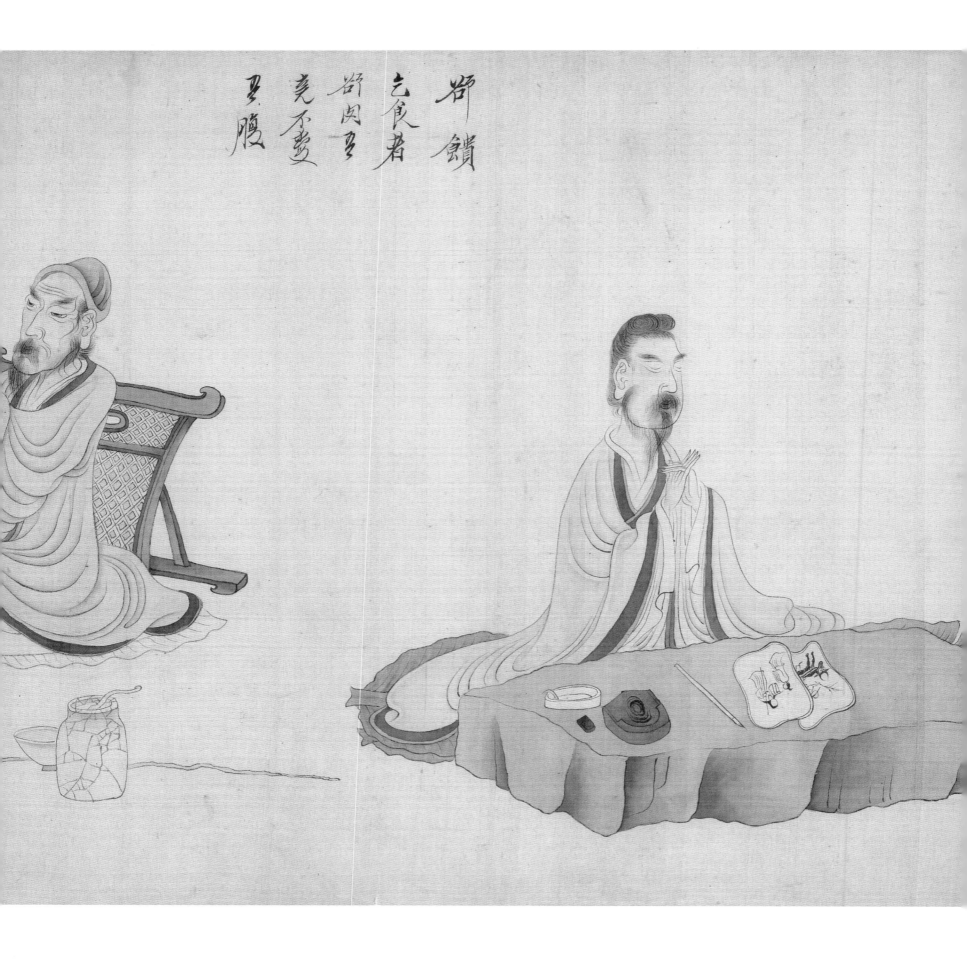

RETURNING TO MY HOME

Tao Yuanming (Tao Qian, 365–427)

So long since I've enjoyed the hills and ponds,

the boundless pleasures of woods and fields —

I take my sons and nephews in hand;

parting brushwood, we walk through the tangled site of a village,

strolling among the knolls and grave mounds,

lingering lingering where people lived long ago.

Here and there are traces of their wells and cooking ranges,

rotting stumps of mulberry and bamboo still remaining.

We asked someone gathering firewood,

"Where are all these people now?"

The wood gatherer turned to us and said,

"They're dead and gone, none of them left!"

In one generation both court and city change —

be assured, that's no idle saying.

Man's life is a phantom affair,

and he returns at last to the empty void.

PRECEDING SPREAD:
Summer Afternoon by the Lotus Pond (18th century). Ink and color on paper.

LEFT: *Returning Home*, Chen Hongshou (1598–1652). Handscroll, ink and color on silk. Detail.

Chen Hongshou's handscroll illustrates several scenes inspired by Tao's homecoming poems. Chen has depicted an episode of the poet's life in which he calmly meditates prior to inscribing the two painted fans. The accompanying inscription reads: "I entrust my life to the Jin and Song [dynasties], but am hand-in-hand with the Shang and Zhou. Thus, with pine-soot ink and crane-feather brush, I can write out my sorrows." Both poem and illustration reiterate the yearning for familial roots.

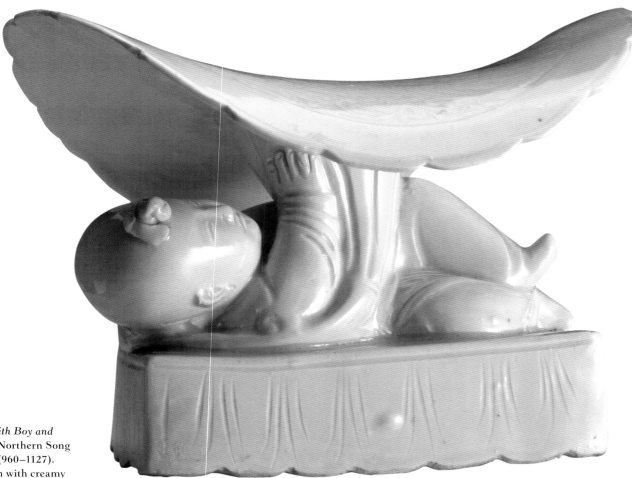

Pillow with Boy and Fungus, **Northern Song dynasty (960–1127). Porcelain with creamy glaze.**

SENT TO MY TWO LITTLE CHILDREN

Li Bo (701–762)

Wu land mulberry leaves grow green,
already Wu silkworms have slept three times.
I left my family in the east of Lu;
who sows our fields there on the dark side of Mt. Gui?
Spring chores too long unattended,
river journeys that leave me dazed —
south winds blow my homing heart;
it soars and comes to rest before the wine tower.
East of the tower a peach tree grows,
branches and leaves brushed with blue mist,
a tree I planted myself,
parted from it these three years.
The peach now is tall as the tower

and still my journey knows no return.
Pingyang, my darling girl,
picks blossoms, leaning by the peach,
picks blossoms and does not see me;
her tears flow like a welling fountain.
The little boy, named Boqin,
is shoulder high to his elder sister;
side by side they walk beneath the peach —
who will pat them with loving hands?
I lose myself in thoughts of them;
day by day care burns out my heart.
On this piece of cut silk I'll write my far-away thoughts
and send them floating down the river Wenyang.

MOONLIT NIGHT

Du Fu (712–770)

Tonight in Fuzhou my wife will be watching this moon alone.

I think with tenderness of my far-away little ones,

too young to understand about their father in Chang'an.

My wife's soft hair must be wet from the scented night-mist,

and her white arms chilled by the cold moonlight.

When shall we lean on the open casement together

and gaze at the moon until the tears on our cheeks are dry?

Drinking in the Moonlight, **Ma Yuan (active before 1189–after 1225). Album leaf, ink on silk.**

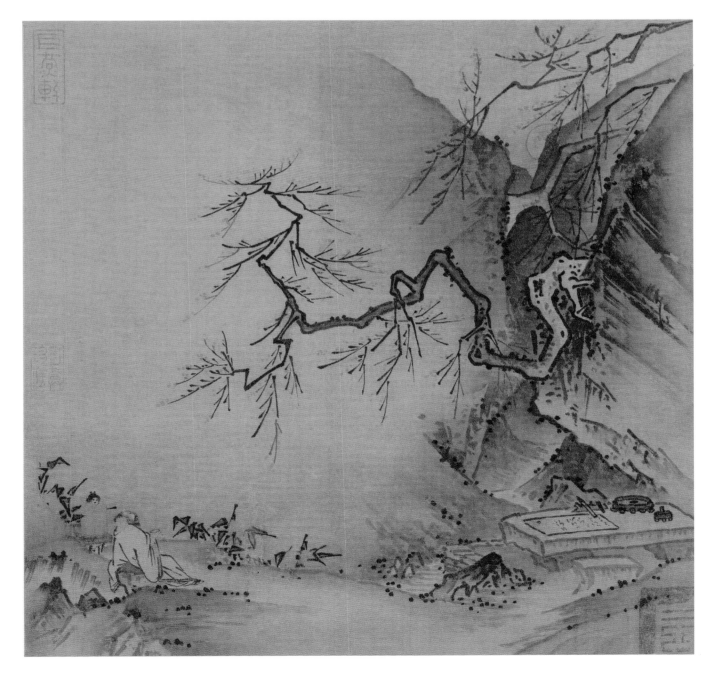

SONG OF LASTING PAIN

Bo Juyi (772–846)

*H*an's sovereign prized the beauty of flesh, he longed for such as ruins domains;

for many years he ruled the Earth and sought for one in vain.

A daughter there was of the house of Yang, just grown to maturity,

raised deep in the women's quarters where no man knew of her.

When Heaven begets beauteous things, it is loath to let them be wasted,

so one morning this maiden was chosen to be by the ruler's side.

When she turned around with smiling glance, she exuded every charm —

in the harem all who wore powder and paint of beauty then seemed barren.

In springtime's chill he let her bathe in Hua-qing Palace's pools

whose warm springs' glistening waters washed flecks of dried lotions away.

Those in attendance helped her rise, in helplessness so charming —

this was the moment when first she enjoyed the flood of royal favor.

Tresses like cloud, face like a flower, gold pins that swayed to her steps;

it was warm in the lotus-embroidered tents where they passed the nights of spring.

And the nights of spring seemed all too short, the sun would too soon rise,

from this point on our lord and king avoided daybreak court.

She waited his pleasure at banquets, with never a moment's peace,

their springs were spent in outings of spring, he was sole lord of her nights.

In the harems there were beauties, three thousand there were in all,

but the love that was due to three thousand was spent on one body alone.

Her make-up completed in chambers of gold, she attended upon his nights,

when in marble mansions feasts were done, their drunkenness matched the spring.

Her sisters and her brothers all were ennobled and granted great fiefs;

a glory that any would envy rose from her house.

This caused the hearts of parents all the world through

to care no longer for having sons, but to care to have a daughter.

The high places of Mount Li's palace rose up into blue clouds,

where the music of gods was whirled in winds and everywhere was heard.

Songs so slow and stately dances, notes sustained on flutes and harps,

and all day long our lord and king could never look his fill.

Then kettledrums from Yuyang came making the whole earth tremble

and shook apart those melodies, "Coats of Feathers, Rainbow Skirts."

Yang Guifei Mounting a Horse, **Southern Song dynasty (1127–1279). Round fan mounted as album leaf, ink and color on silk.**

From nine tiers of palace towers dust and smoke were rising:

a thousand coaches, ten thousand riders moving away southwest.

Swaying plumes of the royal banners were moving ahead, then stopped

west of the gates of the capital, just over a hundred miles.

The six-fold army would not set forth, nothing could be done,

and the fragile arch of her lovely brows there perished before the horses.

Her flowered hairpins fell to earth, and no one picked them up,

the kingfisher wing, the sparrow of gold, the jade pick for the hair.

Our lord and ruler covered his face, unable to protect her;

he looked around, and blood and tears were flowing there together . . .

The politically charged Song of Lasting Pain portrays the Tang dynasty Emperor Xuanzong's (685–762; r. 712–756) infatuation with his beautiful consort Yang Yuhuan (or Yang Guifei). With a rebellion on the horizon, the emperor and consort fled. It was later claimed that Yang's family assisted the rebel forces, and officials demanded death for the consort. Emperor Xuanzong painfully concurred and watched as Yang was executed before him in an episode that was to inspire generations of poets and painters. Yang Guifei Mounting a Horse *depicts the flight from the coming rebellion as the mounted emperor awaits his consort.*

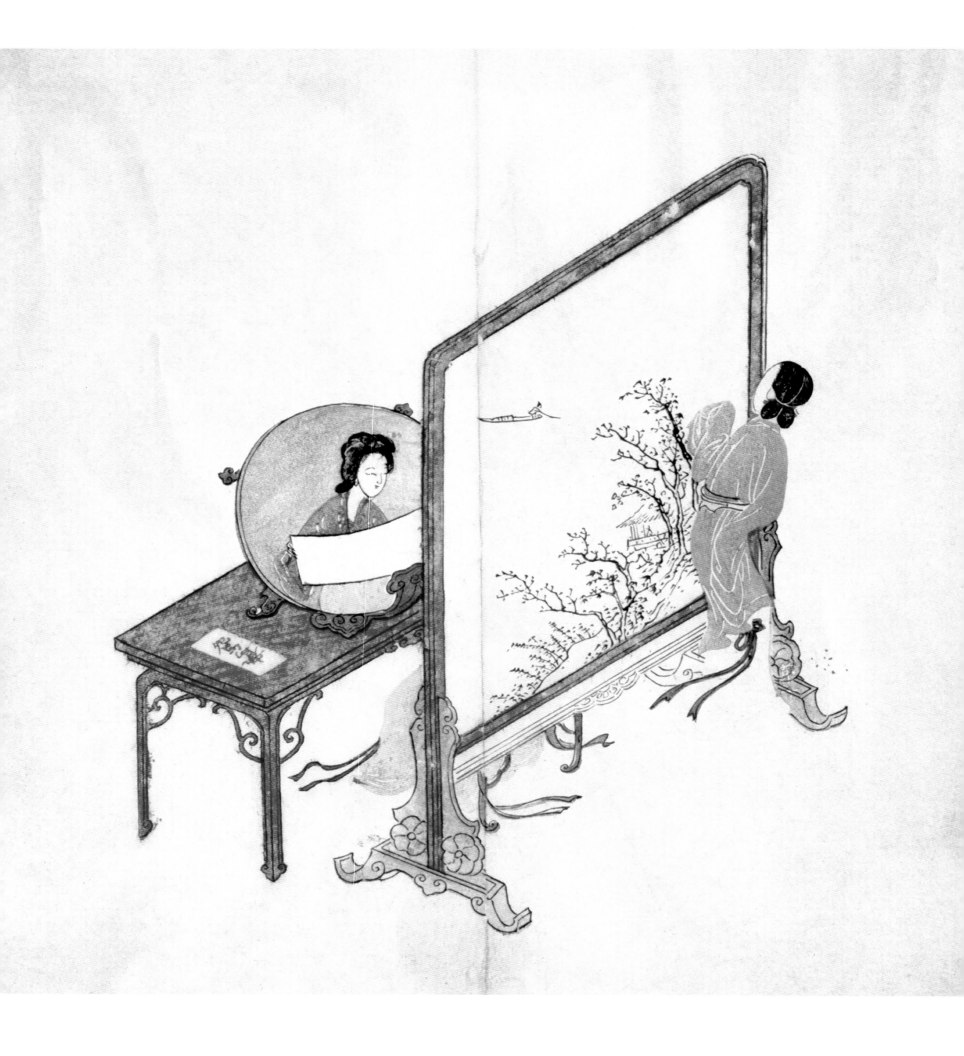

MASTER DONG'S
WESTERN CHAMBER ROMANCE

Dong Jieyuan (fl. ca. 1189–1208)

Once more Zhang explained to Hong Niang the meaning of Yingying's poem. Hong Niang then said: "Please wait here, sir. I shall announce your arrival to my young mistress."

Shortly, Hong Niang reappeared, running. Without waiting to catch her breath she cried: "My mistress is coming; my mistress is coming!"

Zhang was overjoyed, thinking that his wishes would soon be gratified. Yet, when Yingying did appear, she had on a sombre dress, and her expression was serious and forbidding. With severity she scolded Zhang:

"By saving our lives, you have rendered us a great favor; thus, my mother entrusted my brother and myself to your protection. But now, why do you deliver to me, with the help of an insubordinate maid, such a lascivious letter? In the beginning, when you rescued me from the rebels, you acted out of a sense of justice, but now you are yourself using corrupting words as a means to achieve the same goal as that of the mutinous mob. The rebels clamored; you resort to a devious scheme: the methods are different but your aims are the same. I had originally wanted to keep to myself the knowledge of your misconduct, but it became clear to me that a chaste woman must not conceal people's licentiousness. I also had thought of acquainting Mother with what you had done, but that would have been repaying good with evil. If I had asked a maid to reprimand you, I could not have been sure she would express fully the extent of my distress. Had I referred you to some moral essay, in the hope that you would discover the appropriate lesson therein, I would have been afraid you might be unwilling to take the trouble to read it. In the end I decided to entice you hither with a base and suggestive poem. Are you not ashamed of your impropriety? Allow me to remind you, Brother, to keep an upright mind and to avoid all that is immoral and incorrect so that I may safeguard my chastity and continue in my womanly virtue."

The Romance of the Western Chamber, **Min Qiji (1580–ca. 1661). Woodblock album leaf, ink on paper.**

Master Dong's Western Chamber Romance *by Dong Jieyuan is a fine example of a twelfth-century performance medley that intersperses narrative prose with drama. Based on* Yingying's Story — *a famous Tang dynasty short story attributed to Yuan Zhen (779–831) — the* Romance *tells the forlorn love story of Zhang Gong and the beauty Yingying.*

THE ROMANCE OF THE WESTERN CHAMBER

Wang Shifu (ca. 1250–1300)

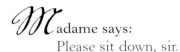adame says:
Please sit down, sir.

Mr. Zhang says:
It is my duty to remain standing by your side. How could I dare sit down in your presence!

Madame says:
Don't you know the old saying: Politeness is not so good as obedience?

> (Mr. Zhang, asking to be excused, sits down.)
> (Madam tells Hong Niang to ask her Young Mistress to come.)

> Yingying enters, and says: "Now that our enemies, like mist and wind, have been rapidly dispersed and peace has been restored to the land, both the Sun and Moon will illumine our splendid feast."

She sings:
"Had it not been that the graduate Zhang had such a wide acquaintance how could any other person have made the armed bandits retreat? The banquet is spread, and arrangements have been made for music and song. The delicate, twirling smoke of the incense and the subdued fragrance of the flowers are wafted by the east wind around the curtains. To him who has rescued all of us from disaster it is but just and proper to show special attention, and right and fitting to treat him with every respect."

Hong Niang says:
My Young Mistress, you have got up very early this morning.

Yingying sings:
"I have just painted my eyebrows near the window curtained with green gauze, and wiped away the fragrant powder which was soiling my silk robes, and with the tip of my fingers I have gently adjusted my hair-pin. If I had not been disturbed and awakened, I would still be asleep under my embroidered coverlet."

Hong Niang says:
My Young Mistress, you have finished your toilet very early. Have you washed your hands? Your complexion appears to me to be so delicate that even to breathe on it or touch it would hurt it. What a lucky man you are, Mr. Zhang.

Amorous Meeting in a Room Interior, Qing dynasty (1644–1911). Ink and slight color on silk panel.

The Romance of the Western Chamber *is a Yuan period drama written as a series of five plays.* Like *Master Dong's Western Chamber Romance (see page 81), it was inspired by the Tang dynasty* Yingying's Story *of Yuan Zhen (779–831), but it draws a different conclusion. Here Zhang Gong is a scholar who meets and falls in love with Yingying during a chance encounter at a Buddhist monastery. She, however, is already engaged to be married. When local rebels surround the monastery, Yingying's mother, Madame Cui, vows to wed Yingying to whichever man can save them. Zhang succeeds, but Madame Cui does not keep her promise. Hong Niang assists the couple, while Madame Cui tries to marry Yingying off. The excerpt found here depicts the meeting of the lovers after the rebel defeat. In the end, Zhang and Yingying marry.*

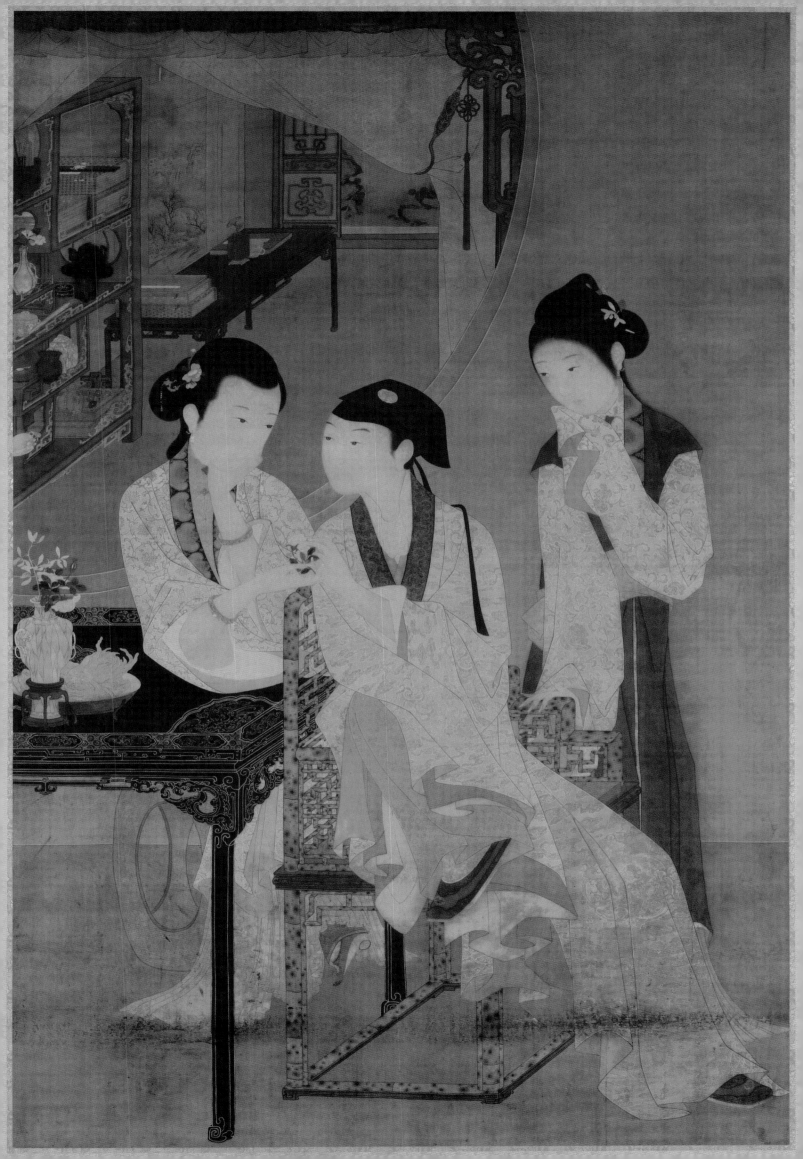

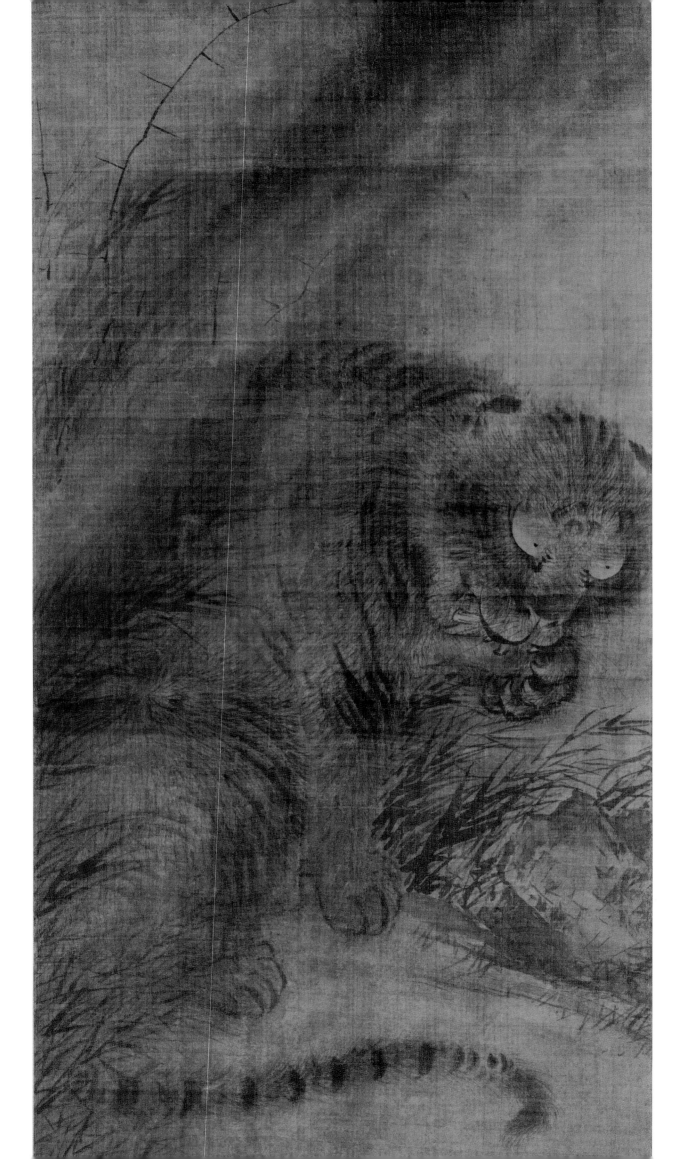

WATER MARGIN

Anonymous (16th century)

for clouds, as we all know, originate with dragons, and wind is associated with tigers.

When the gust had passed, he heard something crashing through the trees and out sprang an enormous tiger, with bulging eyes and a white forehead. When Wu Song saw this a horrified "Aiya!" broke from his lips. He rolled off the boulder and grabbing his cudgel dodged behind it.

Now the tiger was ravenous. It struck the ground with two paws and sprang upwards, intending to land on its prey like a thunderbolt. Wu Song had such a shock that he felt all the wine start out of him in an icy sweat!

It's slow in the telling, but happens in a flash. When he saw the tiger spring, Wu Song leapt out of the way, ending up behind it. That's exactly what the tiger didn't like, to have a man at its back. Thrusting upward off its front paws, it flexed its back and twisted round to pounce again. But again Wu Song dodged to one side. Failing to grasp its prey, the tiger gave a roar like half the heavens exploding, a roar that seemed to shake the very mountains, and lashed out at Wu Song with its tail, rigid as a steel bar. Once more Wu Song leapt aside.

Now when the tiger attacks a man, it generally has these three strategies: the spring, the pounce and the tail-swipe. When all these three methods failed, this tiger's spirit was half broken. After failing to catch Wu Song with its tail it gave a loud roar and turned away. Seeing the tiger had turned its back on him, Wu Song grasped his cudgel in both hands and brought it down with all the strength of his body. There was a resounding crash.

But what he had done was demolish a whole tree, branches and all. He looked for the tiger. His staff had not even touched it. He'd rushed his stroke and all he'd achieved was to bring down a dead tree. Now his cudgel was broken in two and he was left with only the broken half in his hand.

The tiger roared, it was enraged, it turned and sprang at him again. Wu Song leapt back, covering ten paces in a single bound. The tiger reared up on its hind legs and came at him with all its claws out. Wu Song threw away his broken stick and suddenly grabbing the tiger's striped neck with his bare hands began forcing it down to the ground. The beast tried to struggle, but all Wu Song's strength was employed against it, not for a moment did he relax his grip. With his legs he delivered fearful kicks to its nose and eyes. The tiger roared furiously, and as it thrashed about under this onslaught its paws churned up two mounds of mud. Wu Song thrust the beast's head down into the mud and irresistibly its power began to ebb. Still gripping the striped coat tightly with his left hand, Wu Song managed to work his right hand free and began raining down blows with an iron fist, hammering the beast with all his might. He got in fifty or sixty blows, till from the tiger's eyes, mouth, nose and ears the red blood began to gush.

Tiger, **Muqi (Southern Song dynasty, 1127–1279). Hanging scroll, ink and slight color on silk.**

With 120 chapters, Water Margin (Shuihu Zhuan) *has seen numerous translations and printings since its original publication during the early sixteenth century. From the beginning the work was popular in China thanks to its vernacular style — that is, everyday language and descriptive phrases. The chapters follow the adventures of 108 bandit-outlaws who live as a family. This tightly knit group fights the oppressive government's military forces, steals from the rich in Robin Hood–like fashion, and endures human–beast struggles including this famous combat between a tiger and Wu Song.*

SONG OF WHITE LINEN

Lu Qingzi (fl. 1590s)

They begin to sing,

To move their red lips.

Hair fixed high, eyebrows just painted,

Beauties of Handan, worth whole cities,

Their glamour outshines springtime itself.

For gentlemen, sleeves twirl to the song of white linen,

Fine and delicate fabrics float in the breeze.

As the sun sets behind blue hills, sadness intensifies.

Seated Woman, Lin Fengmian (1900–1991). Hanging scroll, ink and color on paper.

The daughter of noted government official Lu Shidao (1511–1574) — and a student of her father's friend Wen Zhengming (1470–1559), a famous ink artist — Lu Qingzi was an acclaimed poet. During the Ming dynasty, a courtesan culture flourished in which both female and male escorts could be hired for learned accompaniment as well as prostitute services. Song of White Linen contrasts the beauty of the courtesans with suggestions of their sorrow.

JINPINGMEI

Anonymous (late 16th century)

ow this Ximen Qing was the sort of man of whom it is said:

> If you hit him on the top of his head,
> The soles of his feet will ring.

He had been a habitué of the world of breeze and moonlight for so many years that there wasn't much he didn't know about anything. Therefore, on this particular day, the fact that the woman was opening up a wide avenue of approach to herself was not lost on him.

His face wreathed in smiles, he laughed, saying, "How can you talk that way, Sister-in-law? Really! What are friends for, anyway? I'll certainly do my best to admonish my brother. You can rest assured, Sister-in-law."

The woman bowed to him again to express her thanks and also directed a young maidservant to bring out a cup of tea, flavored with fruit kernels, in a carved lacquer cup with a silver spoon.

When Ximen Qing had finished the tea, he said, "I'd better be on my way. Be careful not to let anyone into the house."

Whereupon, he took his leave and went home.

From this time on, Ximen Qing made up his mind that he would contrive to make a conquest of this woman. Time and again he saw to it that Sponger Ying, Tagalong Xie, and the rest of that crowd detained Hua Zixu in the licensed quarter, carousing all night long, while he slipped out and made his way back to his own home. Once there, he would stand around in front of the gate until the woman and her two maidservants appeared at the front gate next door. She noticed that it was Ximen Qing, who gave a discreet cough as he passed in front of her door. First he would head east, then turn around and go west, or come to a halt in front of the gateway across the street and stare fixedly in the direction of her door. The woman would show herself in the doorway and then, when she saw him coming, duck inside, only to stick her head out again as soon as he had passed by. As for:

> The messages in their eyes and the expectations in
> their hearts;
> There was no longer any need to express them in
> words.

One day, as Ximen Qing was standing in front of his gate, the woman sent her young maidservant, Xiuchun, to invite him over.

"What are you inviting me for, Sister?" Ximen Qing pointedly asked. "Is your father at home or not?"

"Father's not at home," Xiuchun replied. "It's Mother that's inviting you, sir. There's something she wants to ask you."

This was just the signal Ximen Qing had been waiting for. He complied with alacrity, was shown into the parlor, and took a seat.

Ximen Selects a Lucky Day to Make Mistress Ping His Sixth Wife, **Qing dynasty (18th century). Album leaf, ink and color on silk.**

The novel Jinpingmei *is an anonymous work penned by an author with the pseudonym Scoffing Scholar of Lanling. Its one hundred chapters — nearly three thousand pages — are generally illustrated with woodblock prints. The complicated characters in this well-structured tale are Ximen Qing and three women, Jin, Ping, and Mei, from whom the title is derived. Erotically charged scenes and sexual innuendo punctuate the allegorical narrative but do not distract from its complex themes of love, family, human nature, sexuality, economics, politics, and religion. It ranks as one of the most important literary works in Chinese and even world history.*

DREAM OF RED TOWERS

Cao Xueqin (ca. 1715–1763)

𝒢entle Reader,

What, you may ask, was the origin of this book?

Though the answer to this question may at first seem to border on the absurd, reflection will show that there is a good deal more in it than meets the eye.

Long ago, when the goddess Nuwa was repairing the sky, she melted down a great quantity of rock and, on the Incredible Crags of the Great Fable Mountains, moulded the amalgam into three hundred and six thousand, five hundred and one large building blocks, each measuring seventy-two feet by a hundred and forty-four feet square. She used three hundred and six thousand five hundred of these blocks in the course of her building operations, leaving a single odd block unused, which lay, all on its own, at the foot of Greensickness Peak in the aforementioned mountains.

Now this block of stone, having undergone the melting and moulding of a goddess, possessed magic powers. It could move about at will and could grow or shrink to any size it wanted. Observing that all the other blocks had been used for celestial repairs and that it was the only one to have been rejected as unworthy, it became filled with shame and resentment and passed its days in sorrow and lamentation.

One day, in the midst of its lamentings, it saw a monk and a Daoist approaching from a great distance, each of them remarkable for certain eccentricities of manner and appearance. When they arrived at the foot of Greensickness Peak, they sat down on the ground and began to talk. The monk, catching sight of a lustrous, translucent stone — it was in fact the rejected building block which had now shrunk itself to the size of a fan-pendant and looked very attractive in its new shape — took it up on the palm of his hand and addressed it with a smile:

"Ha, I see you have magical properties! But nothing to recommend you. I shall have to cut a few words on you so that anyone seeing you will at know once that you are something special. After that I shall take you to a certain

brilliant
successful
poetical
cultivated
aristocratic
elegant
delectable
luxurious
opulent
locality on a little trip."

The stone was delighted.

"What words will you cut? Where is this place you will take me to ? I beg to be enlightened."

"Do not ask," replied the monk with a laugh. "You will know soon enough when the time comes."

And with that he slipped the stone into his sleeve and set off at a great pace with the Daoist. But where they both went to I have no idea.

Red Friend, Lan Ying (1585–ca. 1664). Hanging scroll, ink and color on paper.

Dream of Red Towers (Hongloumeng) *is one of the most extraordinary novels in Chinese literature. With a cast of nearly a thousand characters, its 120 chapters detail the life of an upper-class family during the Qing dynasty. The first eighty chapters are known to have been by Cao, but the remainder were added by an anonymous author. The magical being who changes to jade in this excerpt will later be born into the Jia family as Jia Baoyu (*baoyu *means "precious jade"). Romance, sexual relationships, and drama complicate the lives of the characters and draw readers in.*

A SNOWFLAKE'S DELIGHT

Xu Zhimo (1895–1931)

If I were a flake of snow
 Flitting light and free in the sky,
 I would make sure of my goal —
 I would fly and fly and fly —
 On this earth, I have my goal.

Not to go to that desolate vale,
Not to go to those dreary foothills,
 Nor to feel sad on deserted streets,
 I would fly and fly and fly.
You see, I have my goal.

In the air I blithely dance,
Making sure that is her secluded place.
 I would wait for her in the garden —
 I would fly and fly and fly —
Ah, she has a clear scent of plum blossom!

Then with body airy and light,
I would gently press close to her robe,
 Pressing close to her soft bosom
 I shall melt, and melt, and melt.
Melt into the soft waves of her bosom.

Looking for Plum Blossoms in the Snow, **Gu Luo (1762–after 1837). Hanging scroll, ink and color on paper.**

A TRIFLE

Hu Shi (1891–1962)

I too have wished not to love

That I might escape love's agony,

But now after much appraisement,

I willingly accept love's agony.

Voice of Heart (2000-2006), Yang Yanping (b. 1934). Hanging scroll, Chinese ink on rice paper.

Hu Shi was a writer, philosopher and political activist known for his strong convictions for social reform. Hu's brief poem encapsulates how love is a difficult journey, just like life. Yang Yangping's thick red and black brush strokes animate the characters xin *(heart) and* yin *(voice) in* Voice of Heart.

SPRING SILKWORMS

Mao Dun (Shen Dehong, 1896–1981)

*H*e felt a little panicky as he returned home. But when he saw those snowy cocoons, thick and hard, pleasure made him smile. What beauties! No one wants them? — Impossible. He still had to hurry and finish gathering the cocoons; he hadn't thanked the gods properly yet. Gradually, he forgot about the silk houses.

But in the village, the atmosphere was changing day by day. People who had just begun to laugh were now all frowns. News was reaching them from town that none of the neighbouring silk filatures was opening its doors. It was the same with the houses along the highway. Last year at this time buyers of cocoons were streaming in and out of the village. This year there wasn't a sign of even half a one. In their place came dunning creditors and government tax collectors who promptly froze up if you asked them to take cocoons in payment.

Swearing, curses, disappointed sighs! With such a fine crop of cocoons the villagers had never dreamed that their lot would be even worse than usual! It was as if hailstones dropped out of a clear sky. People like Old Tong Bao, whose crop was especially good, took it hardest of all.

"What is the world coming to!" He beat his breast and stamped his feet in helpless frustration.

But the villagers had to think of something. The cocoons would spoil if kept too long. They either had to sell them or remove the silk themselves. Several families had already brought out and repaired silk reels they hadn't used for years. They would first remove the silk from the cocoons and then see about the next step. Old Tong Bao wanted to do the same.

"We won't sell our cocoons; we'll spin the silk ourselves!" said the old man. "Nobody ever heard of selling cocoons until the foreign devils' companies started the thing!"

Spooling, Wu Jun (late 19th century). Album leaf, watercolor and ink on paper.

Mao Dun, the pen name of Shen Dehong, was among China's greatest twentieth-century literary figures. His writings reflected the nation's tumult during the 1930s and 1940s, marked in particular by the invasion and occupation of Japanese troops. Spring Silkworms *— one of his best-known short stories — deals with a family struggling to survive on their silkworm crop during economic and social changes. The watercolor-and-ink-on-paper album leaf by Wu Jun depicts a family spooling the thread from processed silk cocoons.*

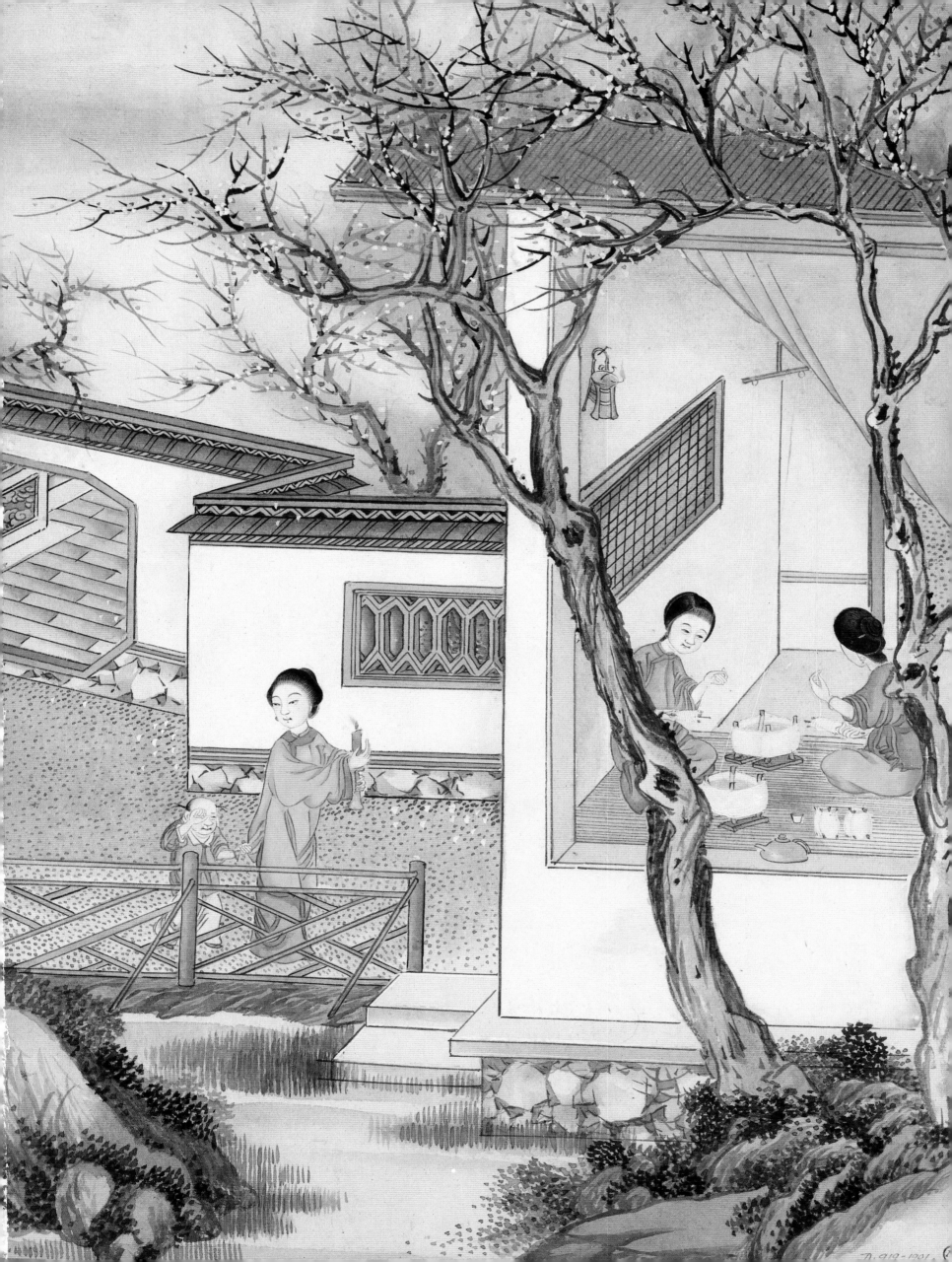

CURVACEOUS DOLLS

Li Ang (b. 1952)

She had yearned for a doll — a curvaceous doll — ever since she was a little girl. But because her mother had died and her father, a poor man, hadn't even considered it, she never got one. Back then she had stood behind a wall every day secretly watching a girl who lived in the neighborhood carrying a doll in her arms. The way the girl left her doll lying around surprised and confused her; if she had a doll of her own, she reasoned dimly, she would treat it lovingly, never letting it out of her sight.

One night as she lay in bed clutching the sheet to her chest, obsessed with the idea of a doll, she figured out a way to get one that she could hug as tightly as she wished. After digging out some old clothes, she twisted them into a bundle, then cinched it up with some string about a quarter of the way down. She now had her very first doll.

The ridicule this first doll brought down upon her was something she would never forget. She recalled it years later as she lay in the warmth and comfort of her husband's embrace. She sobbed until he gently turned her face toward him and said in a relaxed tone of voice that was forced and revealed a hint of impatience:

"It's that rag doll again, isn't it!"

Just when it had become the "rag doll" she couldn't recall with certainty, but it must have been when she told him about it. One night, not terribly late, he lay beside her after they had finished, still somewhat breathless, while she lay staring at the moon's rays streaming in through the open window and casting a fine net of light at the foot of the bed. She had a sudden impulse to reveal everything, to tell him about her first doll; and so she told him, haltingly, blushing with embarrassment, how she had made it, how she had embraced it at night in bed, and how, even though her playmates ridiculed her, she had refused to give it up. When she finished, he laughed.

"Your very own rag doll!"

Maybe that wasn't the first time anyone had called it a "rag doll," but he had certainly used the words that night, and his laughter had hurt her deeply. She failed to see the humor in it, and telling him had not been easy. He could be pretty inconsiderate sometimes.

She never mentioned the doll again, probably because of his mocking laughter, and from that night on she began sleeping with her back to him, unable to bear facing his broad, hairy chest. Although it was the same chest that had once brought her solace and warmth, she now found it repulsive. It seemed to be missing something, although she couldn't say just what that something was.

Later on, her nightly dreams were invaded by many peculiar transparent objects floating randomly in a vast grayness, totally divorced from reality yet invested with a powerful life force. She seldom recalled such dreams, and even when she knew she had been dreaming, they vanished when she awoke.

It was a familiar feeling, the realization that she had obtained something without knowing what it was, and it worried her and drove her to tears. She often wept as she lay in her husband's arms, and he invariably blamed the rag doll. But it's not the rag doll! she felt like shouting. The rag doll had disappeared that night, never to return. But she couldn't tell him, maybe to avoid a lot of meaningless explanations.

Duplication, Image 6,
Xing Danwen (b. 1967).
Photograph.

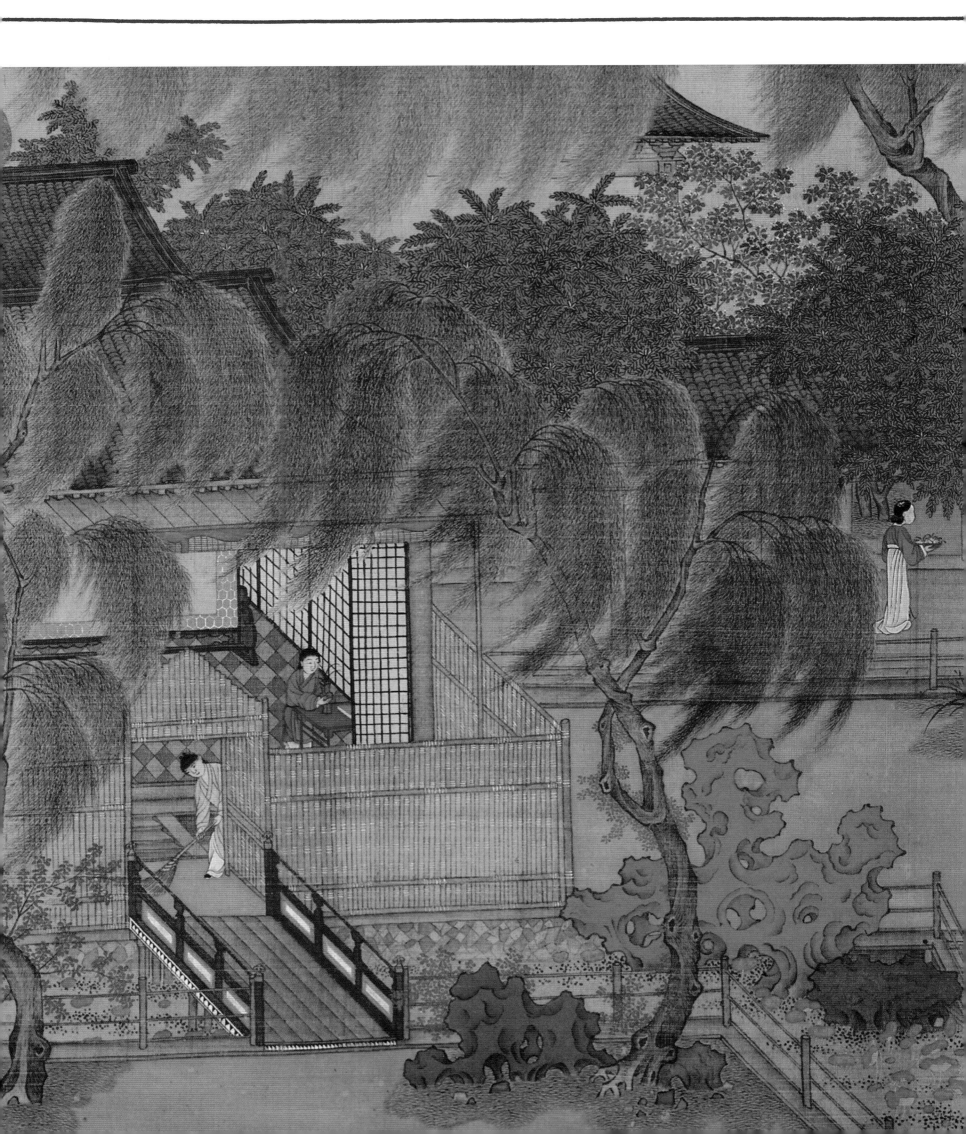

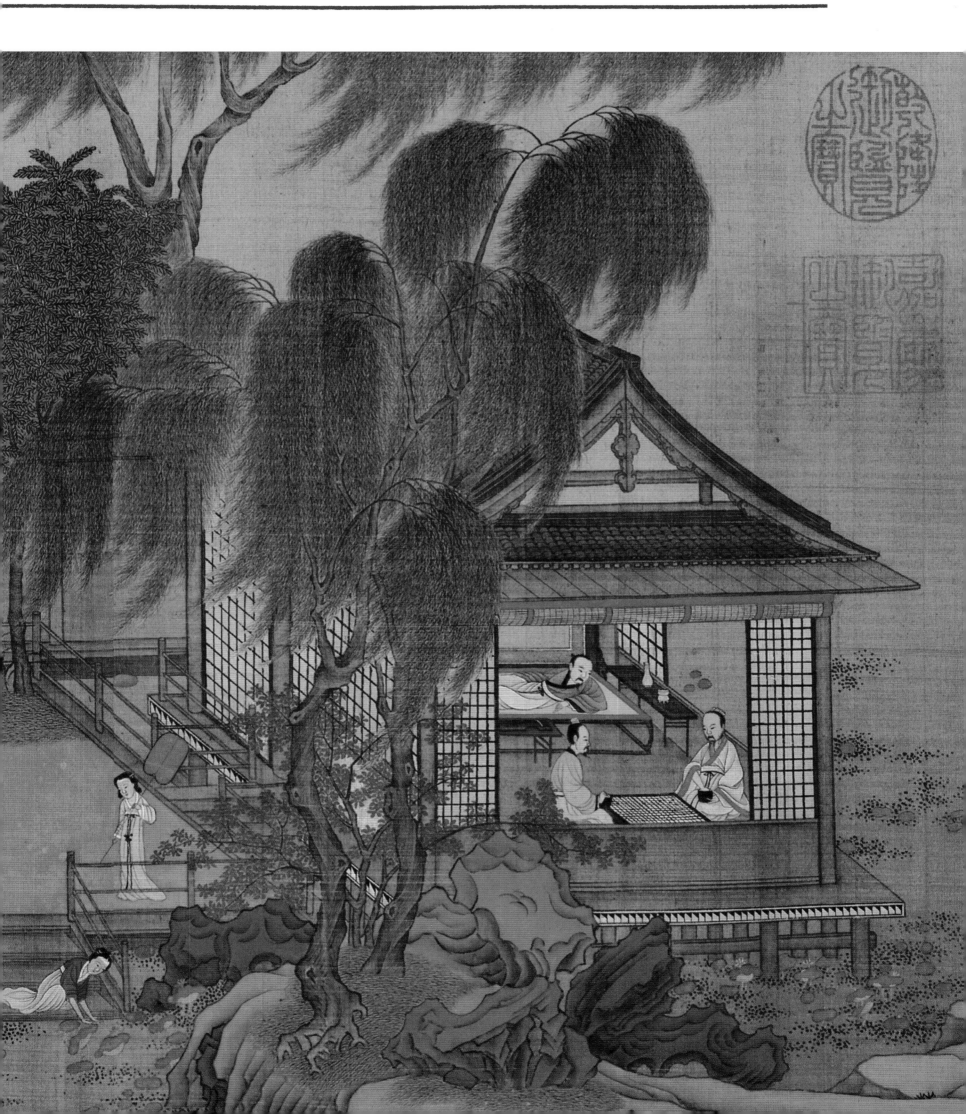

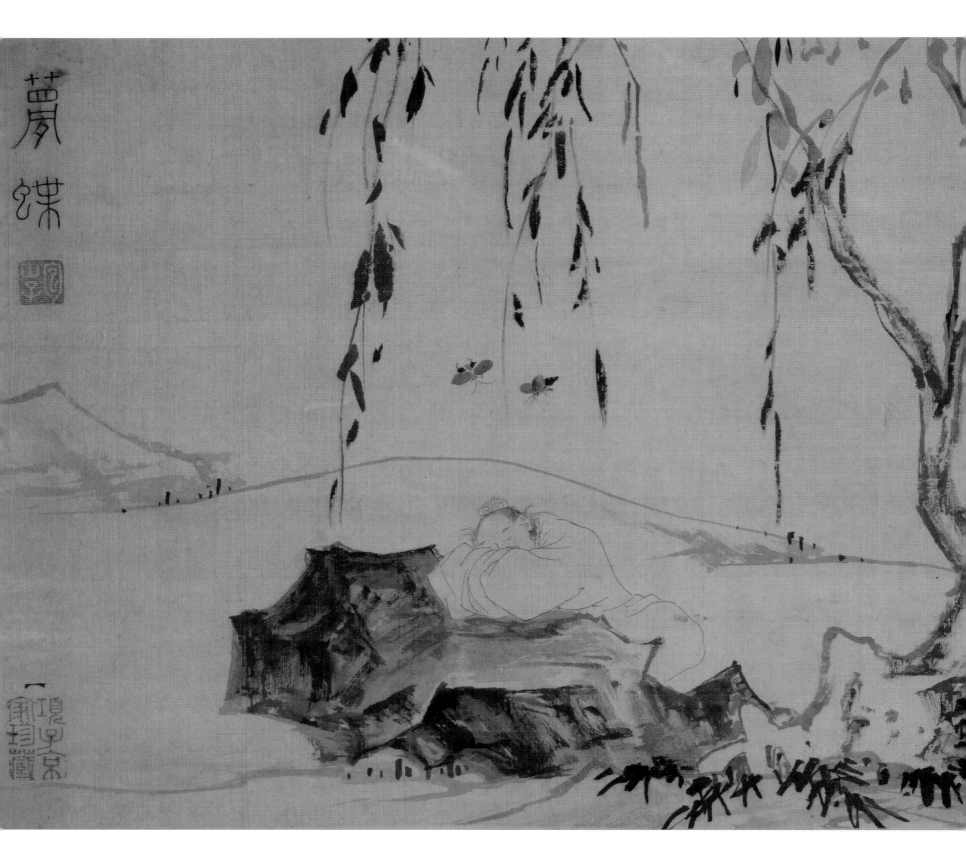

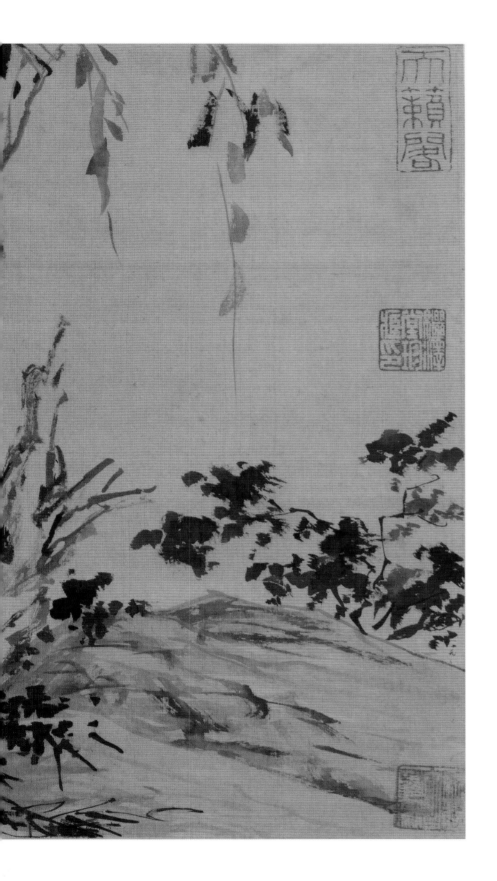

ZHUANGZI

Zhuang Zhou (mid–3rd century BCE)

*O*nce Zhuang Zhou dreamt he was a butterfly, a butterfly flitting and fluttering around, happy with himself and doing as he pleased. He didn't know he was Zhuang Zhou. Suddenly he awoke and there he was, solid and unmistakable Zhuang Zhou. But he didn't know if he was Zhuang Zhou who had dreamt he was a butterfly, or a butterfly dreaming he was Zhuang Zhou. Between Zhuang Zhou and a butterfly there must be *some* distinction! This is called the Transformation of Things.

PRECEDING SPREAD:
Immortals Playing Chess, Qiu Ying (1494–1552). **Detail.**

LEFT: *Zhuangzi Dreaming of a Butterfly,* Lu Zhi (1496–1576). **Album leaf, ink on silk.**

This brief reflection from the Zhuangzi continues to engage the imagination. A simple, straightforward description of Zhuang Zhou dreaming about butterflies is abruptly challenged by an exceptional Daoist-inspired query into the nature of the mind, memory, and reality itself.

MENGZI

Mencius (Meng Ke, ca. 320 BCE)

*M*engzi's disciple Gaozi said, "Human nature is like whirling water. Give it an outlet in the east and it will flow east; give it an outlet in the west and it will flow west. Human nature does not show any preference for either good or bad just as water does not show any preference for either east or west."

"It certainly is the case," said Mengzi, "that water does not show any preference for either east or west, but does it show the same indifference to high and low? Human nature is good just as water seeks low ground. There is no man who is not good; there is no water that does not flow downwards.

"Now in the case of water, by splashing it one can make it shoot up higher than one's forehead, and by forcing it one can make it stay on a hill. How can that be the nature of water? It is the circumstances being what they are. That man can be made bad shows that his nature is no different from that of water in this respect."

Waterfall, Song
dynasty–Yuan dynasty
(960–1368). Hanging
scroll, ink and slight
color on silk. Detail.

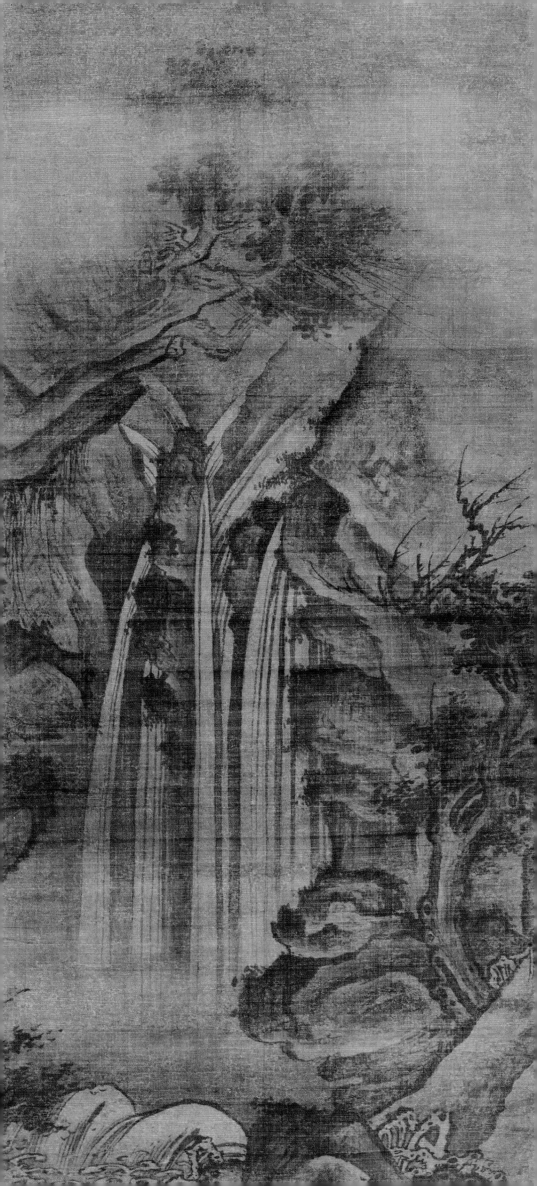

THE LITERARY MIND CARVES DRAGONS

Liu Xie (ca. 465–522)

As an inner power in things, patter (*wen*) is very great indeed, and it was born together with Heaven and Earth. How is this? All colors are combined from two primary colors, the purple that is Heaven and the brown that is Earth. All forms are distinguished through two primary forms, Earth's squareness and Heaven's circularity. The sun and moon are disks of jade that follow one another in succession, showing to those below images that cleave to Heaven. Rivers and mountains are a glittering finery, unfolding shapes that show the order of the Earth. These are the pattern of the Way.

In considering the radiance given off above and reflecting on the loveliness that inheres below, the positions of high and low were determined, and the Two Standards were generated [*Yang* and *Yin*, Heaven and Earth]. Only human beings, who are endowed with the divine spark of consciousness, rank as third with this pair. Together they are called the Triad [Heaven, Earth, and human beings].

Human beings are the flower of the elements: in fact, they are the mind of Heaven and Earth. When mind came into being, language was established; and with the establishment of language, pattern became manifest. This is the natural course of things, the Way.

A Book From the Sky,
Xu Bing (b. 1955).
Photograph on Mylar.

The Literary Mind Carves Dragons (Wenxin Diaolong) *is perhaps China's greatest work of literary aesthetics. Liu Xie looks to nature and the heavens to suggest that discernible patterns exist that human minds can put into written and spoken language.* A Book from the Sky, *Xu Bing's black-and-white (negative) photograph on Mylar, likewise struggles with the nature of writing and communication. Although the book depicted is bound in traditional Chinese fashion, the block-printed characters are intentionally nonsensical. Yet the conceptual ability to create them lies at the heart of Liu Xie's thesis.*

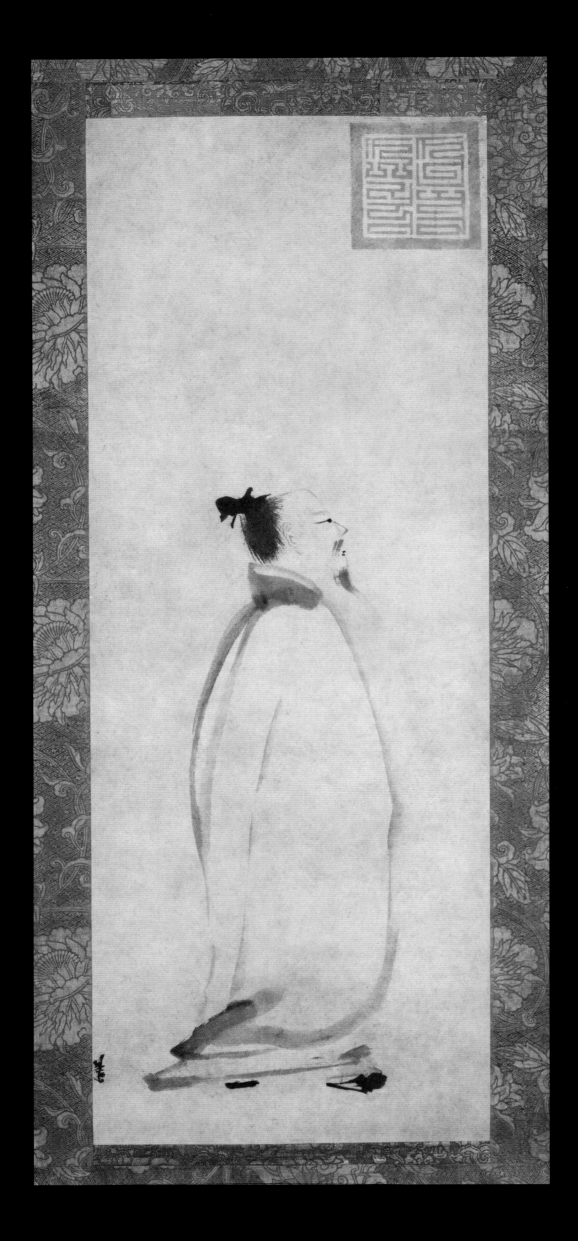

STILL NIGHT THOUGHTS

Li Bo (701–762)

Moonlight in front of my bed —

I took it for frost on the ground!

I lift my eyes to watch the mountain moon,

lower them and dream of home.

Li Bo, Liang Kai (Southern Song dynasty, 1127–1279). Hanging scroll, ink on paper.

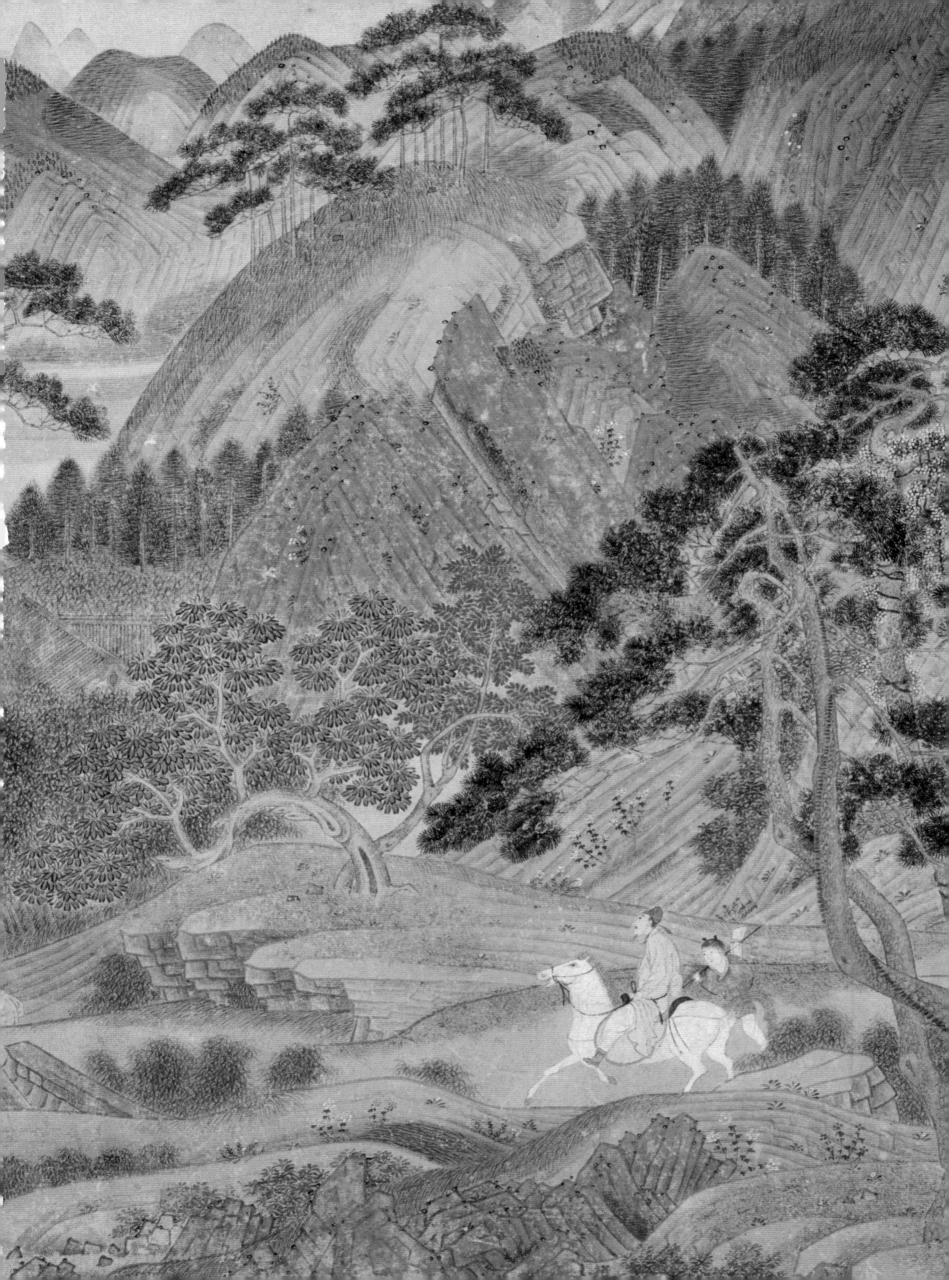

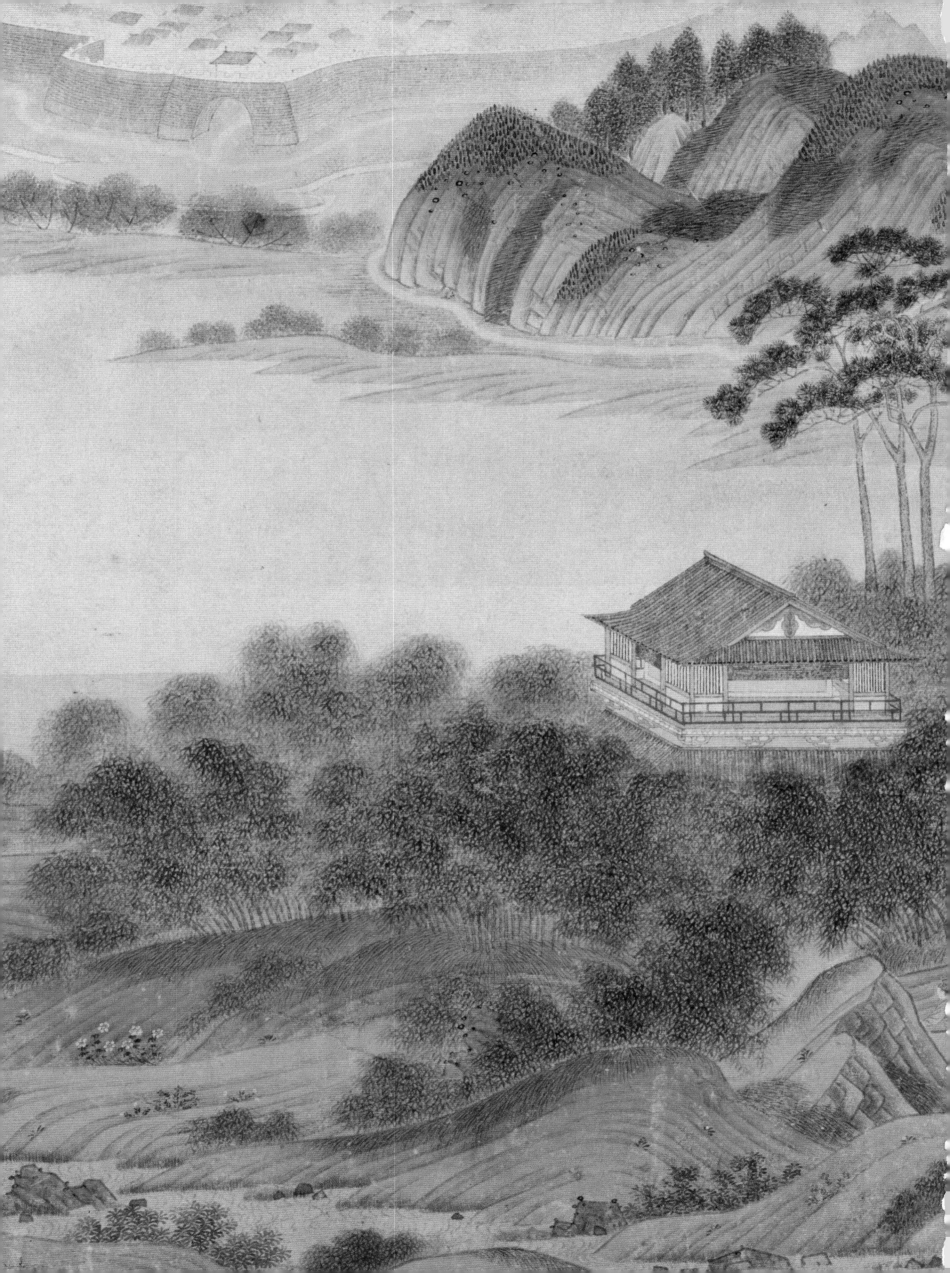

SONG OF THE PIPA LUTE

Bo Juyi (772–846)

In the tenth year of the Yuanhe era [815], I was exiled to the district of Jiujiang with the post of marshal. In the autumn of the following year, I was seeing a visitor off at the Fen River landing when I heard someone on one of the boats playing a [pipa] lute in the night. Listening to its tone, I could detect a note of the capital in its clear twanging. When I inquired who the player was, I found it was a former singing girl of Chang'an who had once studied the lute under two masters named Mu and Cao. Later, when she grew older and her beauty faded, she had entrusted herself to a traveling merchant and became his wife.

I proceeded to order wine and lost no time in requesting her to play a few selections. After the selections were over, she fell into a moody silence, and then told us of the happy times of her youth and of her present life of drifting and deprivation, moving about here and there in the region of the Yangzi and the lakes.

Two years had passed since I was assigned to this post, and I had been feeling rather contented and at ease. But this evening, moved by her words, I realized for the first time just what it means to be an exile. Therefore I have written this long song to present to her. It contains a total of 612 characters and is entitled *Song of the Lute*:

Tonight, though, I've heard the words of your lute,

like hearing immortal music — for a moment my ears are clear.

Do not refuse me, sit and play one more piece,

and I'll fashion these things into a lute song for you.

Moved by these words of mine, she stood for a long while,

then returned to her seat, tightened the strings, strings sounding swifter than ever,

crying, crying in pain, not like the earlier sound;

the whole company, listening again, forced back their tears.

And who among the company cried the most?

This marshal of Jiujiang, wetting his blue coat.

Saying Farewell at Xun-yang, Qiu Ying (1494–1552). Handscroll, ink and full color on paper. Detail.

Bo Juyi's famous poem recalls a time two years previous when he overheard the disquieting sounds of a pipa lute being played while seeing off a visitor. It is important to read the author's preface in connection with the poem, since it establishes Bo's mood while in exile. The intimacy of his own isolation is mirrored tenfold in the woman's difficult life journey. Qiu Ying's colorful handscroll depicts Bo Juyi and a colleague on horseback. The color scheme echoes those of the great Tang dynasty landscape paintings that Bo undoubtedly viewed. Their narrative journey continues on along the scroll from right to left. We see the pair dismount their horses, then reach the boat with the woman playing the pipa, her back to the viewer. Both Bo and Qiu are nostalgic in their respective works, Bo writing about his fond memories while Qiu imitates masters of old.

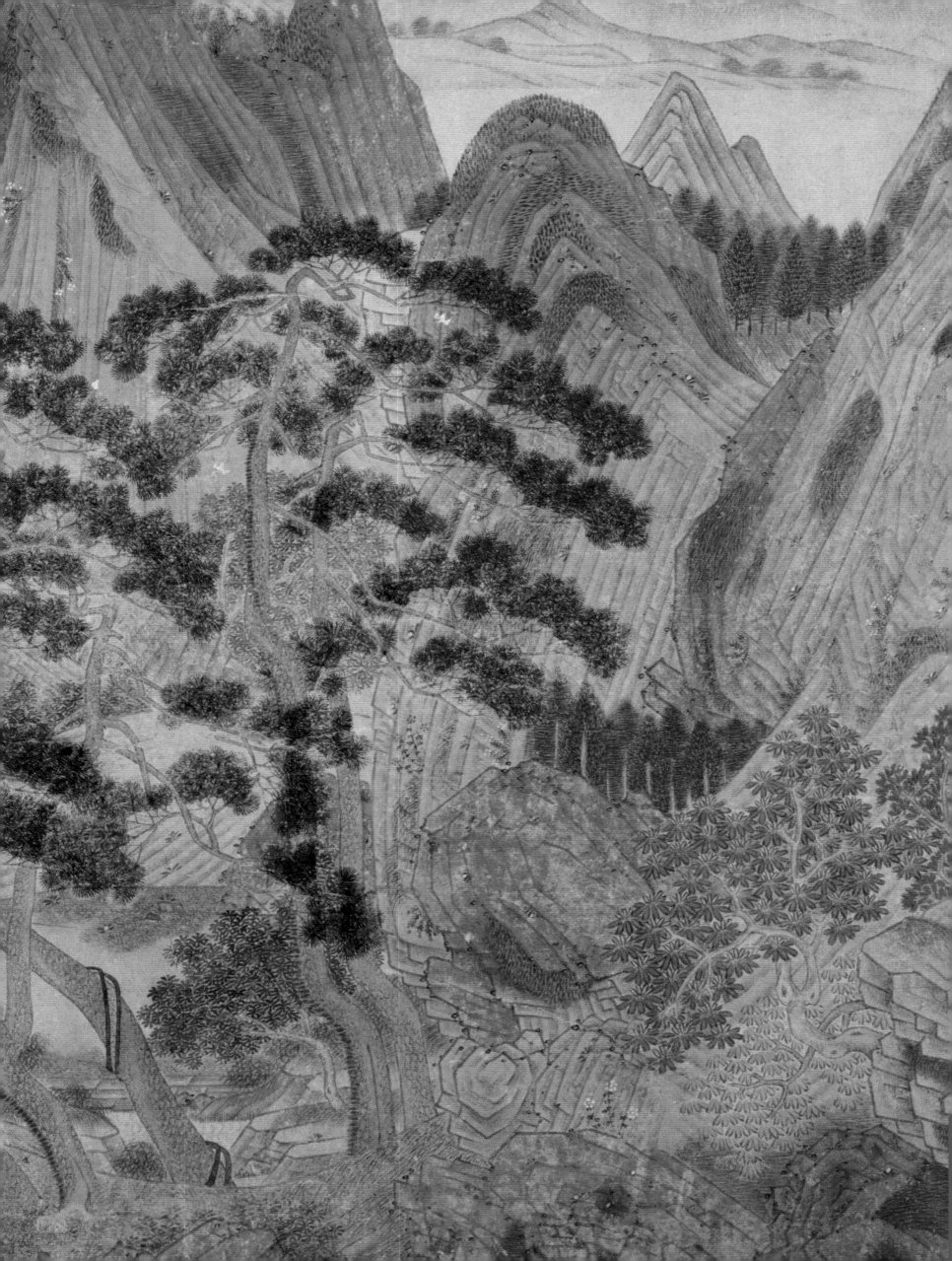

RHAPSODY ON RED CLIFF

Su Shi (Su Dongpo, 1037–1101)

*I*n the autumn of the Renxu year [1082], during the full moon in the seventh month, Master Su and his guests went boating beneath Red Cliff. A cool breeze blew gently and the river had no waves. I raised a toast to my guests and recited "Bright Moon" and sang "The Fair Lady." Shortly, the moon rose over the eastern hills then moved leisurely among Dipper and Ox. White dew fell across the river, and the gleam of the water reached to the sky. Letting our little reed go where it would, we drifted out onto the vast expanse of water. We flew along as if we were borne by the wind up into the sky, not knowing where we would stop; we soared freely as if we had left the world behind, sprouting wings and rising aloft like immortals.

Then we drank wine and enjoyed ourselves, knocking time on the gunwales and singing:

Cassia boat and orchid oar

Strike the water, propelling us through shimmering moonbeams.

How deep is my longing!

I gaze towards the beautiful one at the edge of the sky.

One of my guests could play the flute, and he joined in with the song. His music was plaintive, as if there was something he resented or yearned for, as if someone were weeping or complaining. He continued with frail and tremulous notes, which stretched on and on like a thread. It was music that would stir the hidden dragon in a lost valley and make the widow on a lone boat cry.

Master Su grew solemn and, straightening his robe and sitting upright, asked the guest why he played that way.

The guest replied, "'The moon is bright and stars are few / Magpies fly past us southward.' Are these not lines by Cao Mengde [Cao Cao]? We gaze towards Xiakou in the west and Wuchang in the east. The mountains and river encircle each other, the landscape a dark and luxuriant green. Is this not where Mengde was routed by Master Zhou? After he conquered Jingzhou and took Jiangling, he proceeded eastward down the Yangzi. Bow to stern, his warships stretched a thousand miles; and his banners blocked out the sky. He poured wine as he gazed across the river and composed poetry with his halberd lying across his lap. Without a doubt he was the greatest warrior of his age, and yet where is he today? And what about you and me, we fishermen and woodcutters of the river islets? We keep company with fish and befriend deer. We ride a leaf of a boat and toast each other with gourdfuls of wine. We are May flies caught between Heaven and Earth, a speck of grain in the boundless sea. Grieved by the brevity of our lives, I envy the inexhaustibility of the Yangzi. I would like to grasp a soaring immortal to wander far and wide or embrace the bright moon and live on for all time. Knowing how difficult such feats are, I consign my fading notes to the sorrowful wind."

Master Su answered, "Do you not know about the river and the moon? The former flows on and on but never departs. The latter waxes and wanes but never grows or shrinks. If you look at the things from the viewpoint of the changes they undergo, nothing in Heaven or Earth lasts longer than the blink of an eye. But if you look at them from the viewpoint of their changeless traits, neither the objects of the world nor we ever come to an end. What is there to envy? Furthermore, all objects between Heaven and Earth have their master. As for something we do not own, we do not presume to take the smallest amount of it for ourselves. But as for the Yangzi's cool breeze and the bright moon that shines between the mountains–when our ears are exposed to them, they hear sounds; and when our eyes meet them, they see images. We are not prohibited from taking these for our own, and we can use them without ever exhausting them. They are, in fact, the Transformer's inexhaustible treasuries, given freely for us jointly to consume."

The guest smiled with delight and rinsed our cups and poured some more wine. By the time our snacks were eaten up, our wine cups and plates lay strewn about. We lay down in the boat and pillowed our heads on each other. Before we knew it, the east grew light.

The Red Cliff, Li Song (active 1190–1230). Album leaf mounted as hanging scroll, ink and color on silk.

Su Shi's experiences with a group of his scholarly friends while out on the Yangzi River inspired him to compose two interrelated poetic expositions. This entry and the following both illustrate Su's natural ability to weave an interesting story with tremendous control over specific details and verbal imagery.

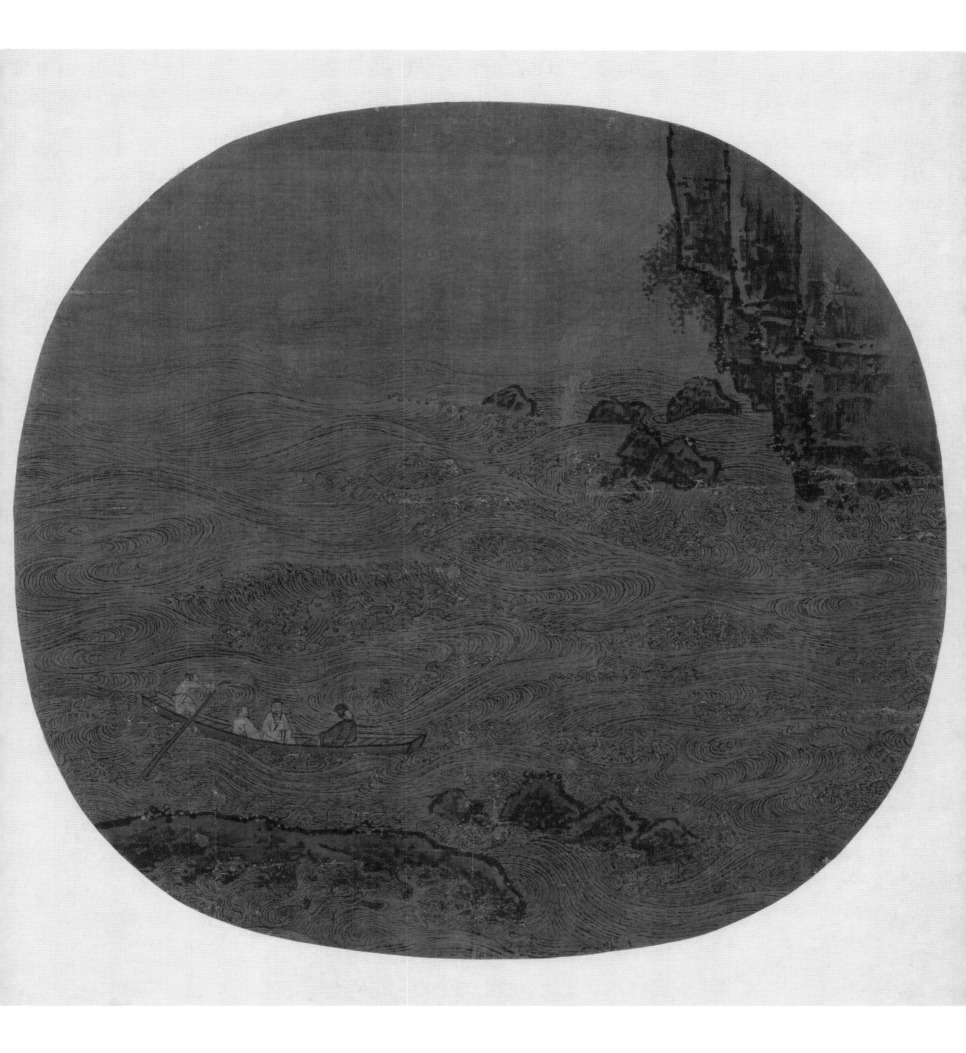

LATER RHAPSODY ON RED CLIFF

Su Shi (Su Dongpo, 1037–1101)

On the fifteenth of the tenth month of the same year [1082] I set out on foot from Snow Hall, intending to return to Lin'gao. Two guests accompanied me as we passed Yellow Dirt Hill. Dew had fallen and the trees had shed all their leaves. Our shadows lay on the ground, and we gazed up at the bright moon. Delighted by our surroundings, we sang back and forth to each other as we walked.

After some time, however, I heaved a sigh. "I have guests but no wine; and even if I had wine, I have no foods to go with it. The moon is bright and the wind fresh. Are we going to waste such a fine evening as this?"

One of my guests said, "Today at sunset I caught a fish in my net. It has a large mouth and tiny scales and looks just like a Song River bass. But where can we get wine to go with it?"

We returned to my house and consulted my wife. She said, "We do have one jug of wine I hid away, keeping it for just such an emergency."

Taking the wine and the fish, we went boating again below Red Cliff. The river made noise as it flowed, and the sheer cliff rose a thousand feet. The peak was towering and the moon tiny. The water level had fallen and rocks on the bottom were exposed. How many months had it been since my last visit? And yet the landscape seemed completely unfamiliar to me. So thinking, I picked up my robe and began to climb. I stepped over jutting rocks, pushed back undergrowth, squatted on tigers and leopards, and climbed along scaly dragons until I could pull myself up to perilous nests of the hawks and look down into the River Lord's palace in the depths. My two guests were quite unable to

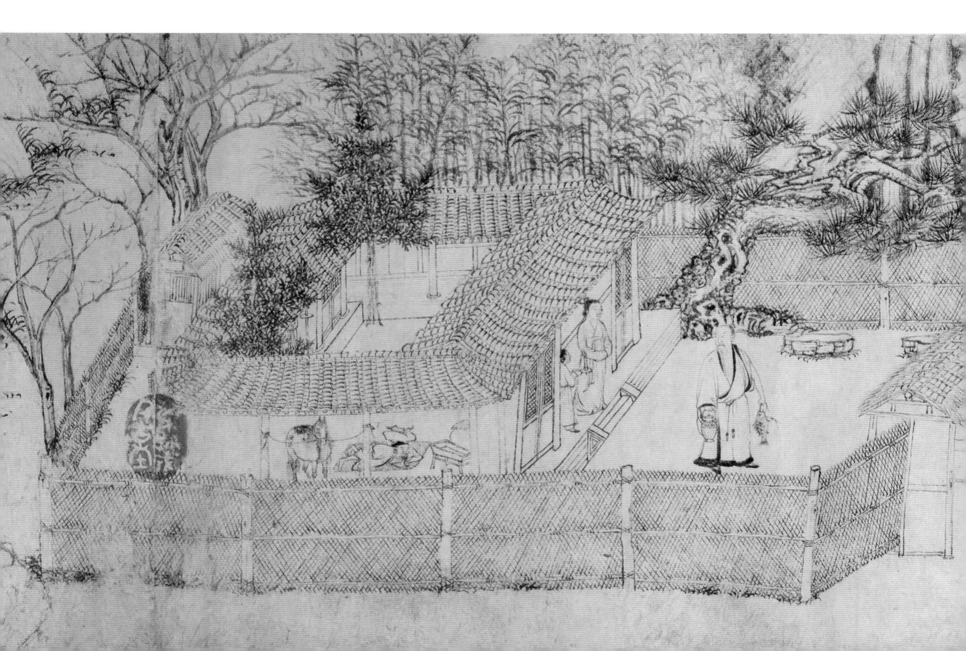

follow me. All at once I let out a long, low whistle. The trees and grasses shook; the mountains sang out and the valleys answered; a wind arose and the water surged. I grew apprehensive and melancholy, humbled and fearful, and felt so cold that I knew I could not remain there long. I climbed down and got back into the boat. We rowed out into the middle of the river, then let the boat drift freely about and come to rest wherever it would. By that time it was nearly midnight and there was no sign of life anywhere around us. Just then a lone crane appeared, cutting across the river from the east. Its wings were as big as cartwheels, and it wore a black skirt and white robe. It let out a long,

grating screech and swooped down over our boat before continuing westward.

A short while later the guests departed, and I, too, went home to sleep. I dreamed of a Daoist dressed in a fluttering feather robe who passed before Lin'gao. He bowed to me and said, "Did you enjoy your outing to Red Cliff?" I asked his name, but he dropped his eyes and made no reply.

"So! Aha!" I said, "Now I understand. Last night it was you who flew screeching over my boat, wasn't it?"

The Daoist turned away with a smile, and just at that moment I woke up. I opened the door to look, but he was nowhere in sight.

Illustration to the Second Prose Poem on the Red Cliff, Qiao Zhongchang (active late 11th–early 12th century). Handscroll, ink on paper. Detail.

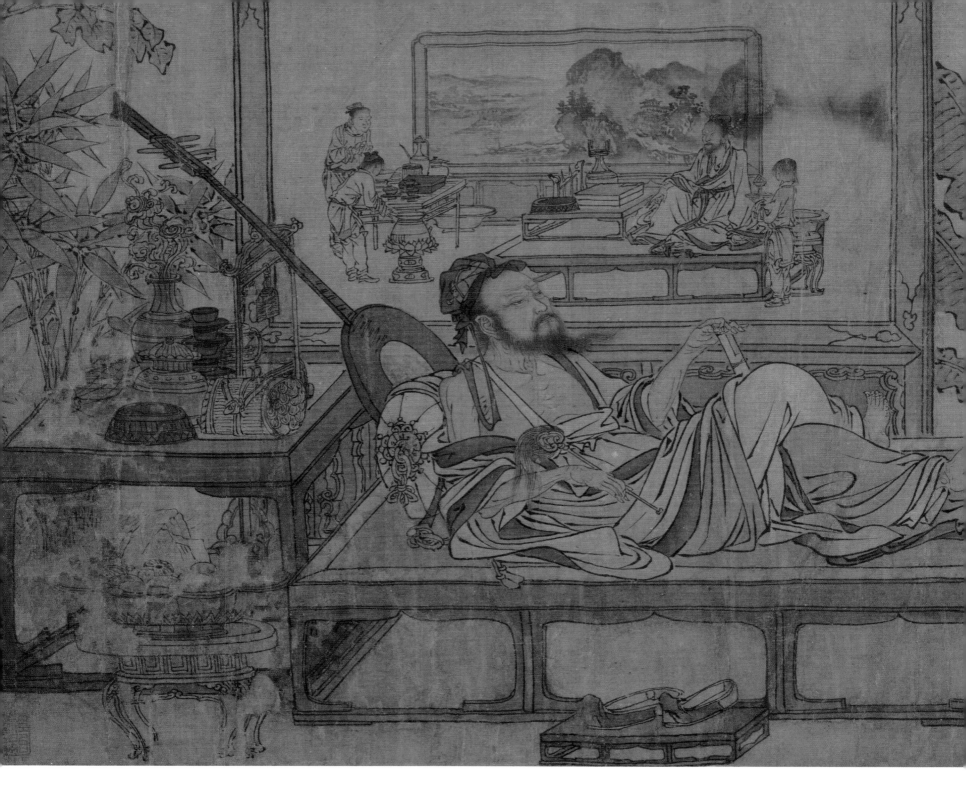

RELAXING IN THE EVENING IN MY STUDY

Yang Wanli (1127–1206)

I shut the door but can't sit down,

open the window, stand in a breath of cool.

Groves of trees shade the bright sun,

the ink stone on my desk gives off a jade-green glow.

I let my hand wander over scrolls of poems,

softly humming three or four verses.

The first scroll I pick up pleases me greatly,

the second suddenly makes my spirit sink.

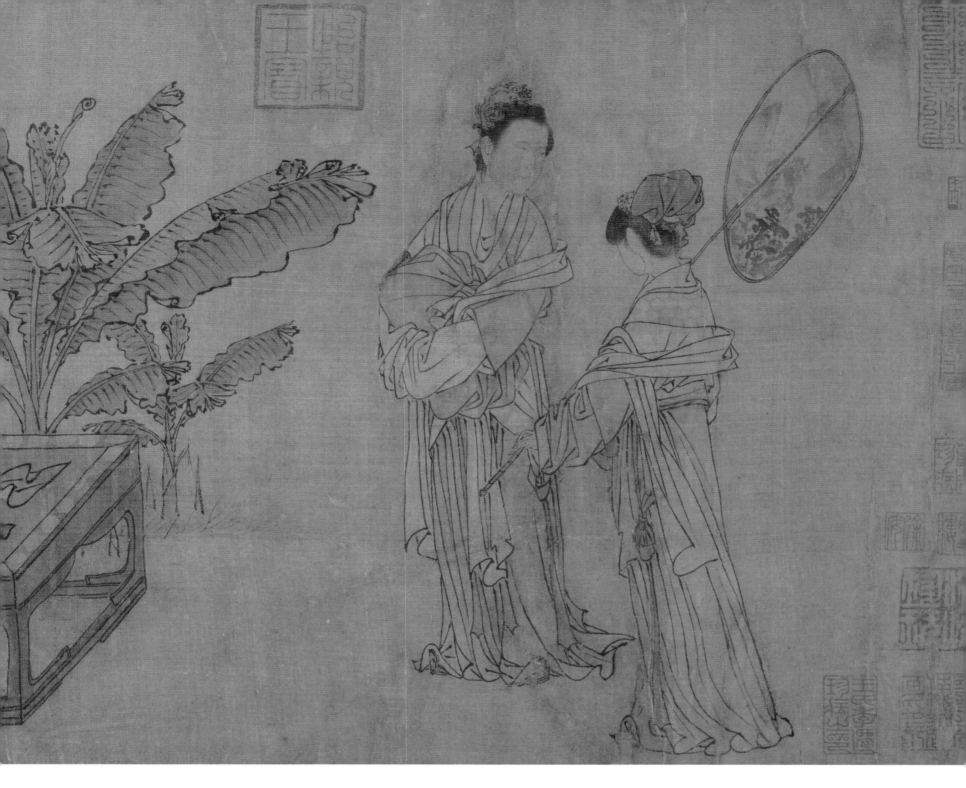

Whiling Away the Summer, Liu Guandao (active ca. 1279–1300). Handscroll, ink and color on silk. Detail.

Throw it aside — I can't go on reading!

I get up and wander around the chair.

The ancients had their mountains of sorrow,

but my mind is calm and clear as a river.

Those people are no concern of mine —

why should I let them break my heart?

The mood is over and instead I laugh;

a lone cicada urges on the evening sun.

STUDENT HUANG'S BORROWING OF BOOKS

Yuan Mei (1716–1797)

The student, Huang Yunxiu, asked to borrow some books from me and I, the master of Sui Garden, gave them to him with the following admonition:

If you don't borrow books, you can't read them. Have you not heard about those who collect books? The "Seven Categories" and the "Four Divisions" were imperial collections, but how many emperors actually read them? Books fill the homes of the rich and the honored to the very rafters, but how many of the rich and the honored actually read them? As for all the fathers and grandfathers who have amassed books only to see their sons and grandsons throw them away, there's no need to discuss it.

But it's not just books that are treated like this; everything under heaven is treated the same way. If we manage to borrow something that is not our own, we worry that someone will force us to give it back and so we fondle it fearfully without end, saying, "Today I have it; tomorrow it may be gone and then I won't see it any more!" If it's something that already belongs to us, then we wrap it up and put it on a high shelf, storing it away and saying, "I'll leave it there for the time being and take a peek at it later on."

When I was young, I loved books but my father was poor, so it was hard to get hold of them. There was a Mr. Zhang who had a rich collection of books; I went to borrow some from him but he wouldn't give me any. When I returned home, I had a dream about my unsuccessful attempt to borrow books, which shows how eager my desire was. Thus, when I did get to read something, I invariably remembered it. After I became an official and was established in my own residence, as I spent out my salary the books came pouring in till they were piled up everywhere in great profusion and the scrolls and tomes were covered with silverfish and cobwebs. Later I would sigh with admiration at the attentiveness with which those who borrowed books read them and think how precious the months and years of one's youth are.

Now, Student Huang, you are poor like I used to be and you borrow books like I used to. It would seem that the only difference is that I share my books with you whereas Mr. Zhang was stingy with his books to me. But was I unfortunate to have encountered Mr. Zhang? And are you fortunate to have encountered me? To know whether someone is fortunate or not, it depends on how diligently he reads the books he has borrowed and how swiftly he returns them. To explain my thoughts on borrowing, I am sending this note along with the books.

The Emperor Kangxi Reading, anonymous court artists (1662–1722). Hanging scroll, color on silk.

As a poet and prose writer, Yuan Mei is celebrated for his ability to imbue his work with mundane and minute details while keeping the reader alert with suggestions of wry wit and humor. Here Yuan scrupulously recounts his experiences with and thoughts on book borrowing. The monumental hanging scroll portrait of the Qing dynasty Emperor Kangxi (1654–1722; r. 1662–1722) captures the grandeur of the Son of Heaven while also emphasizing the Imperial library.

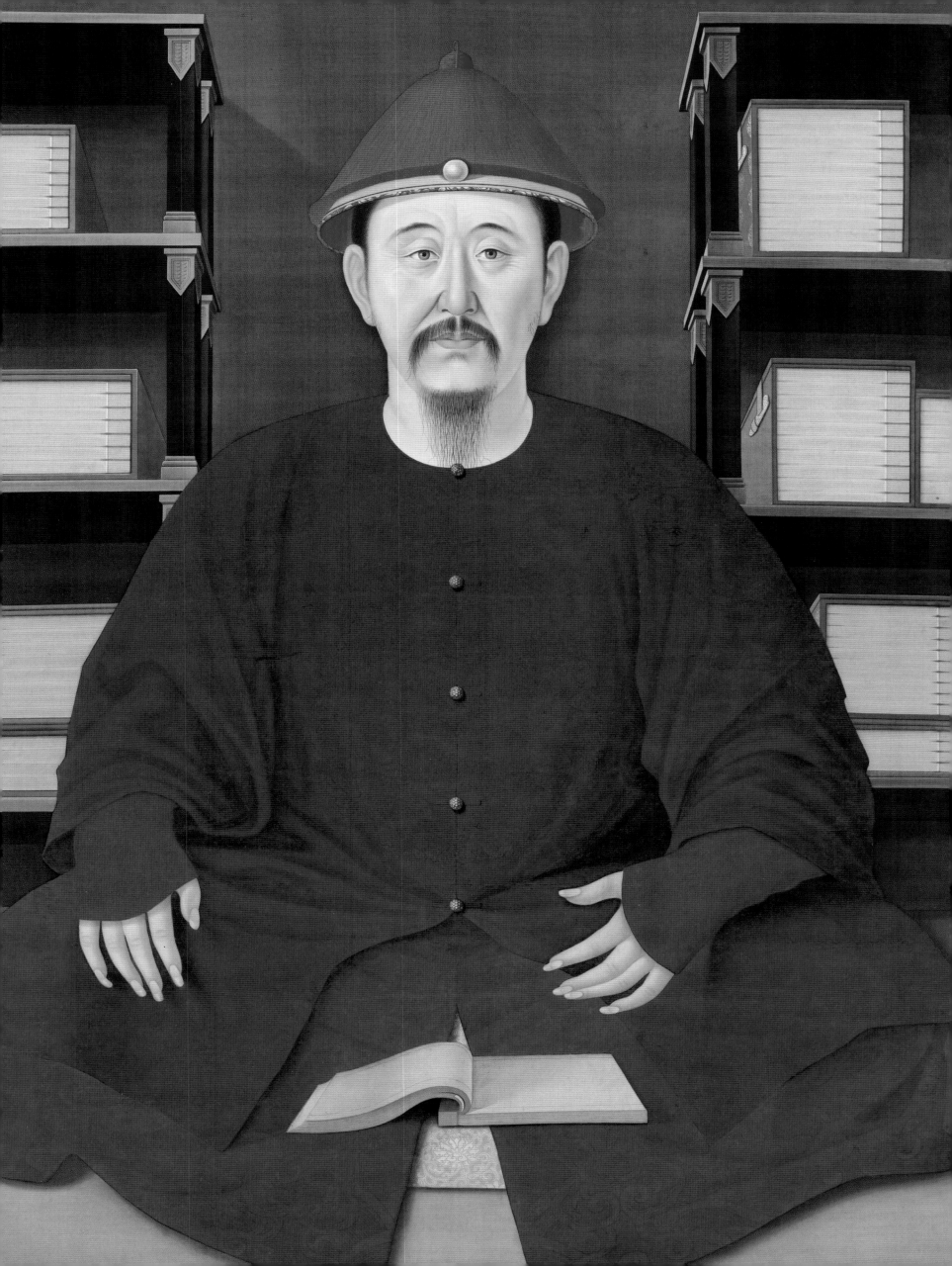

PRAYER

Wen Yiduo (1899–1946)

*P*lease tell me who the Chinese are,

Teach me how to cling to memory.

Please tell me the greatness of this people

Tell me gently, ever so gently.

Please tell me: Who are the Chinese?

Whose hearts embody the hearts of Yao and Shun?

In whose veins flow the blood of Jingke and Niezheng

Who are the true children of the Yellow Emperor?

Tell me that such wisdom came strangely —

Some say it was brought by a horse from the river:

Also tell me that the rhythm of this song

Was taught, originally, by the phoenix.

Who will tell me of the silence of the Gobi Desert,

The awe inspired by the Five Sacred Mountains,

The patience that drips from the rocks of Mount Tai,

And the harmony that flows in the Yellow and Yangzi Rivers?

Please tell me who the Chinese are,

Teach me how to cling to memory.

Please tell me the greatness of this people

Tell me gently, ever so gently.

Resident Alien, Hung Liu (b. 1948). Oil on canvas.

Trained in the Chinese classics, Wen Yiduo became interested in Western literature while at college and studied in the United States during the early 1920s. During this period, he witnessed and experienced the hardships of being Chinese in America — the Chinese Exclusion Act of 1882 was still rigorously enforced at that time. The imperative of defining both self and nation expressed in Wen's work is amplified in the light of Hung Liu's masterpiece Resident Alien. By re-creating the government's immigration card of herself, she poses the question: Who is responsible for identity? The universal issues of how we define ourselves and how we are defined resonate in these two extraordinary works.

ATTACHMENT

Lao She (Shu Qingchun or Shu Sheyü, 1899–1966)

On the thoroughfares of Chengdu's Xiwanglong Street, Beiping's Liulichang District, and Jinan's Buzhengsi Street, we generally notice two kinds of people. Those of the first kind are honest and prudent, just like plain folks. If they are in any way distinctive, it is that they delight in collecting calligraphy, paintings, bronze wares, seals, and the like. Their fondness for collecting, like loving flowers, dogs, or crickets, is nothing extraordinary or remarkable. In terms of profession, these people are perhaps government employees, or perhaps middle school teachers. Sometimes we also find lawyers or doctors, in their leisure time, rummaging about for small treasures. Most of these people have some learning that enables them to make an honest living. Some have good incomes, some not, but whenever they have spare money, they will spend it on things that delight their hearts and enhance their sense of refinement. At times they won't hesitate to borrow a few dollars or to pawn a couple pieces of clothing in order to press their seal of ownership on a cherished collectible, if indeed it is an item that can be inscribed.

The second kind of people, however, are not like this. They collect, but they also peddle. They appear to be refined, but at the core they are no different from merchants. Their collecting is equivalent to hoarding.

Mr. Zhuang Yiya, whom we will introduce now, belongs to the first kind.

. . . .

Although he walks fast, his eyes, which appear preoccupied with his chest or the ground, are in fact always on the lookout. From far away a piece of paper yellowed with age or a fan displayed on a roadside stand can stop him dead in his tracks. Slowly making his way toward the stand, he will stop abruptly before it as if totally by chance. Calligraphy and paintings are what he loves. He will casually browse through this and that, then, with a smile, ask about prices. At long last, he will offhandedly pick up that scrap of old paper or fan, take a look, shake his head, and put it back down. He will walk off a couple of steps, stop, then turn back to ask the price. Or he may come straight out with it, "Fifty cents for this torn fan; how about it?"

He will take home a couple of such eighty-cent treasures, full of insect holes, smudgy, smeared, and crinkled up like an old woman's face. Only at night, after locking the door to his room, will he savor the pleasures of his modest purchases, handling them over and over again. After numbering them, he will carefully press his seal on them, then put them in a large cedar chest. This bit of exertion will send him to bed, happily weary and satisfied. Even his world of dreams will be quaintly ancient.

Viewing Antiquities at the Studio of Humility, Qi Baishi (1864–1957). Album leaf, ink and color on paper.

Written during China's confrontation with Japan during World War II, Lao She's Attachment *centers on collector Zhuang Yiya, who amasses a small but selective assortment of ancient paintings and calligraphy. Ultimately, Zhuang must decide whether to leave his collection to the conquering Japanese or stay with it, thereby serving under the Japanese flag. The theme of the antiquarian collector was indeed very much alive in literature and art during the extreme changes of twentieth-century China. Both Lao She's* Attachment *and Qi Baishi's expressive* Viewing Antiquities at the Studio of Humility *capture the human desire to link with the past.*

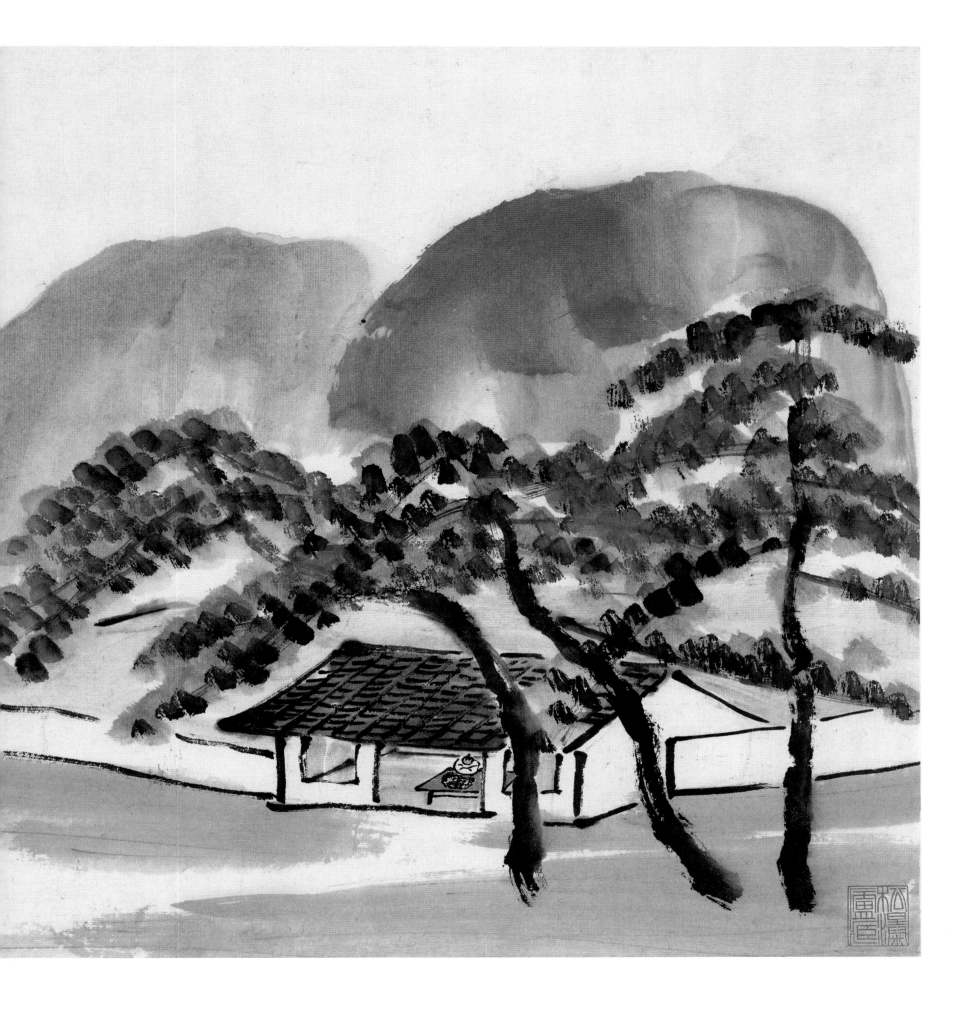

A TAIL

Wang Zengqi (b. 1920)

Old Huang, our personnel consultant, was an interesting fellow. The position of personnel consultant did not exist at the factory until he assumed it. He'd worked in personnel so long he knew pretty much everything there was to know about the employees. But over the last couple of years, as age began to overtake him, his health started to fail, and he was always complaining about aches and pains and rising blood pressure. So he asked to become a consultant, and since most of his consultations came in the area of personnel matters, everyone called him the personnel consultant. Although it started out as a nickname, it had a decidedly formal ring to it. He never missed a meeting concerning personnel matters if he could help it. Sometimes at these meetings he spoke up, sometimes he didn't. Some of the people liked what he had to say, some didn't. He was an eclectic reader and an inveterate storyteller. Sometimes he'd tell one of his stories right in the middle of a very serious meeting. This is one of them.

An engineer named Lin was slated to become chief engineer at the factory, but the leaders were anything but unanimous in their decision. Some approved the promotion, some opposed it, and even after a series of meetings the issue remained unresolved. The opinions of those who approved should be obvious, while those of the opposition can be summarized as follows:

1. Bad background: he came from a capitalist family;

2. Unclear social connections: he had a relative living outside the country — a cousin in Taiwan;

3. He was suspected by some of having had rightist tendencies during the Anti-Rightist campaign;

4. He didn't get along particularly well with the masses — his ideas were sometimes too penetrating.

The strongest opposition came from a personnel-section chief by the name of Dong. This particular fellow was very excitable, and every time the issue arose, he made the same unreasonable comment over and over again as his face turned bright red: "An intellectual! Ptui! An intellectual!"

The personnel consultant listened to him each and every time without taking a stand one way or the other. One day the party secretary asked, "What's your opinion, Huang?" Huang answered in measured tones, "Let me tell you a story —

"Once upon a time there was a man named Aizi. One day Aizi was on a boat that docked alongside a riverbank. In the middle of the night he heard the sound of crying down in the water. He listened carefully. A group of water denizens were crying. 'Why are you crying?' Aizi asked them. 'The Dragon King has given an order,' they said, 'that all animals with tails will be killed. We're crying because we all have tails.' Aizi was greatly moved by their plight. He looked down at each of them and noticed that there was a frog among them. It, too, was crying. Aizi was puzzled. 'Why are you crying?' he asked the frog. 'You don't have a tail.' The frog looked up and said, 'I'm afraid he'll dig up my past as a tadpole!'"

**Tadpoles and Crayfish,
Luo Ping (1733–1799).
Album leaf, ink on
paper.**

A Tail can be read in light of China's Cultural Revolution (1966–1976), a time when familial lineage, social status, and education level were grounds for public humiliations, job dismissals, brutal attacks, even death. The short story tries to put this history into an understandable context through the use of animal analogies. Wang's character Old Huang understood human nature and how history can be used to justify controversial actions. The story of the weeping frog indirectly suggests important ideas.

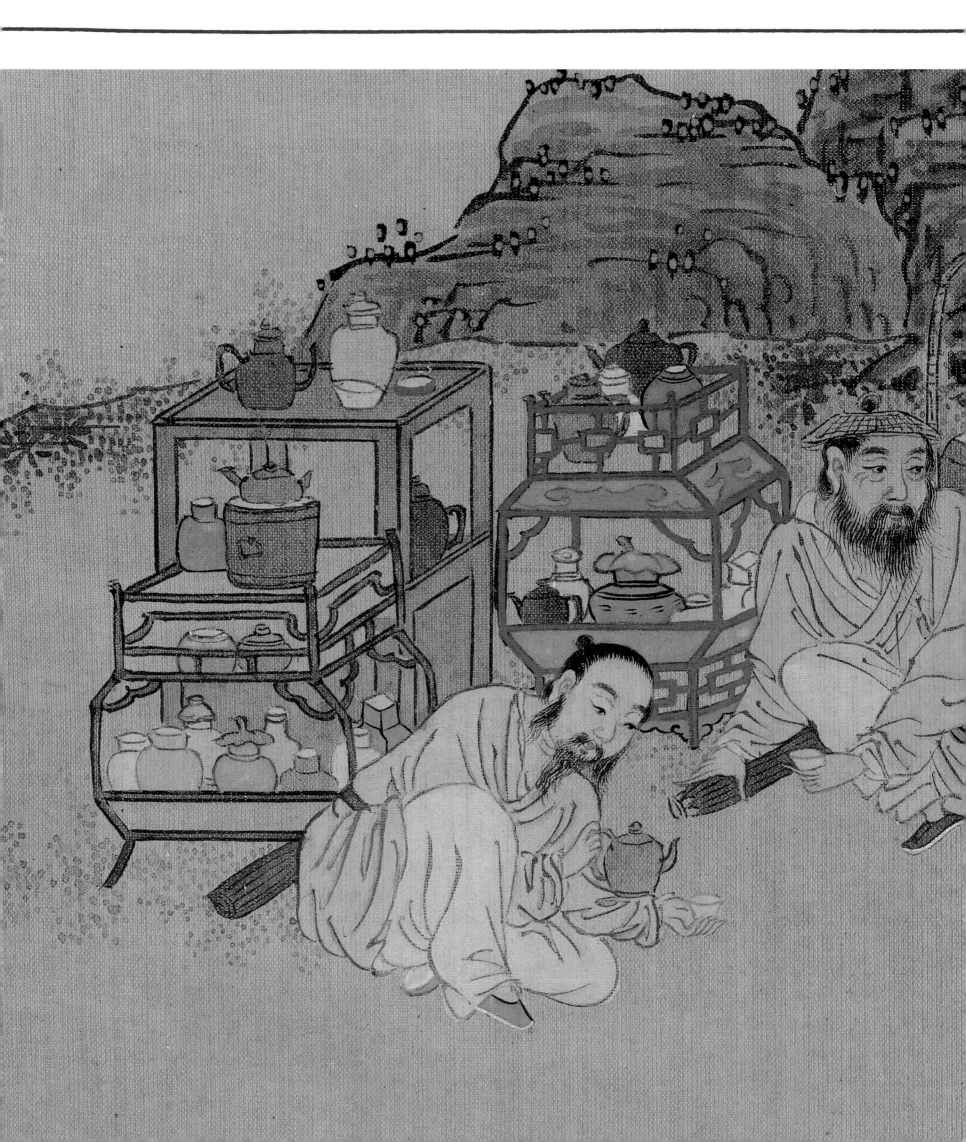

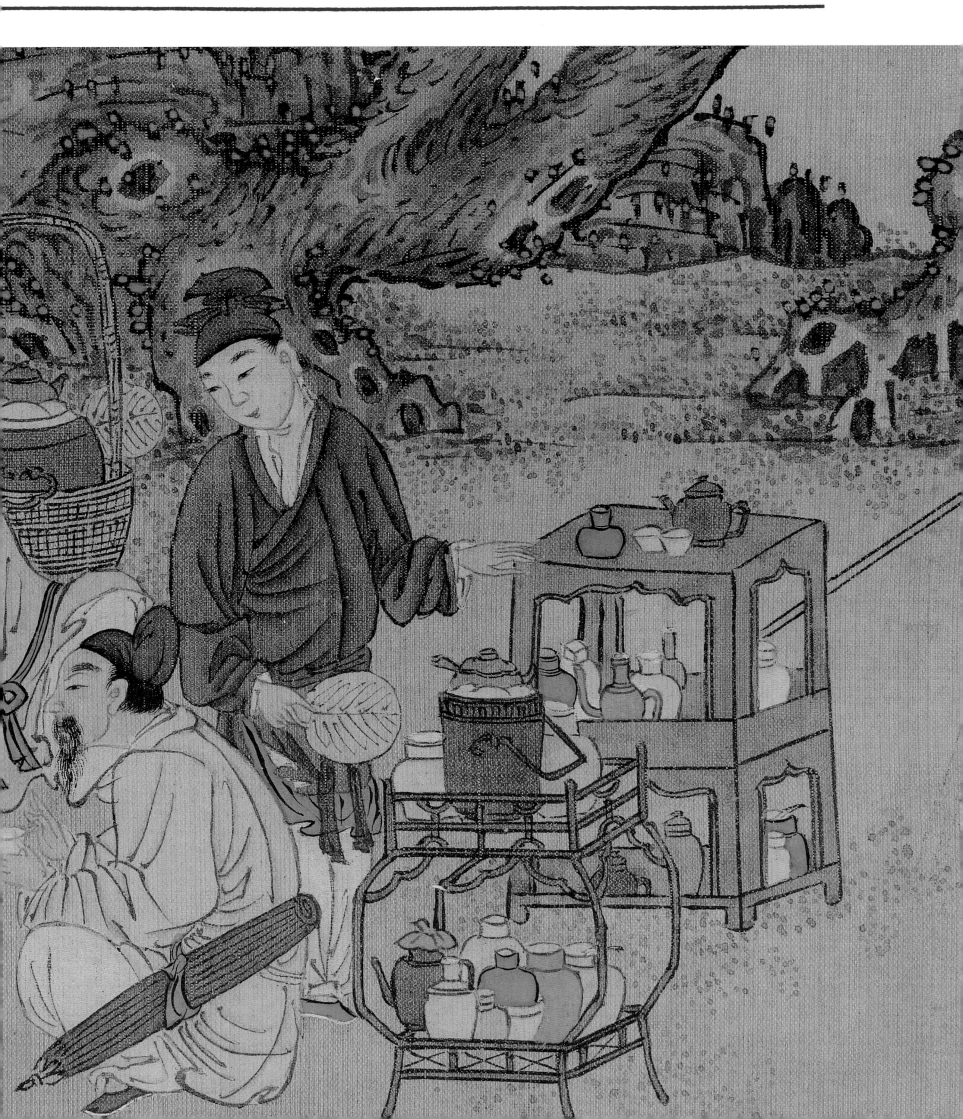

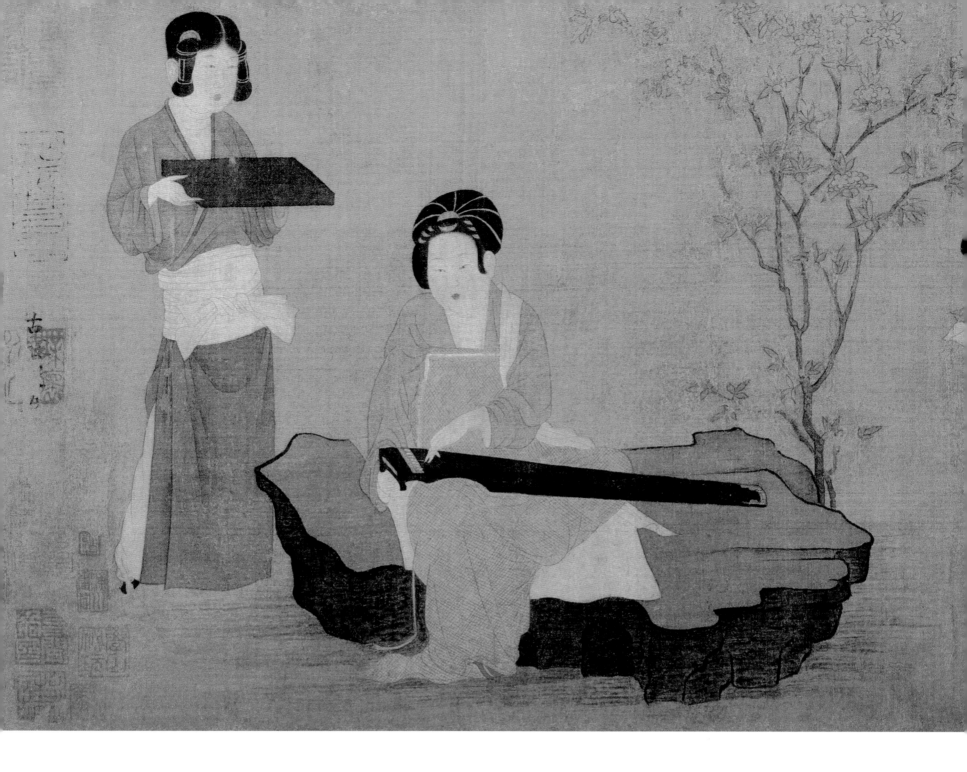

DEER CRY

Shijing (ca. 11th century–221 BCE)

*Y*oo, yoo cry the deer,

eating shoots in the meadow:

play the harp and blow the pipes.

Blow the pipes, trill their reeds,

baskets offered are received.

Men who like me well

show me the ways of Zhou.

The Shijing — an anthology of more than three hundred poems — includes works on daily activities, entertainments, rituals, and social ordering. A classic of world literature, it has inspired poets and artists for generations. Although the original musical accompaniment scores are no longer extant, the majority of the works were meant to be sung. Deer Cry rhythmically welcomes guests to the kind of court feast depicted in Palace Ladies Tuning the Qin Harp-Zither.

Yoo, yoo cry the deer,

eating the cress in the meadow:

Worthy guests are here with me,

their virtue's fame is bright.

They do not look on men with spite,

they are the model for a prince.

And thus I have this fine wine,

for worthy guests to feast and revel.

Yoo, yoo cry the deer,

eating the greens in the meadow:

Worthy guests are here with me

play the harp and psaltery.

Play the harp and psaltery,

bathed in common pleasure.

Thus I have this fine wine,

to feast and delight my worthy guests' hearts.

THE ANALECTS

Confucius (Kongzi, 581–479 BCE)

*C*ai Wo asked about the three-year mourning period, saying, "Even a full year is too long. If the gentleman gives up the practice of the rites for three years, the rites are sure to be in ruins; if he gives up the practice of music for three years, music is sure to collapse. A full year's mourning is quite enough. After all, in the course of a year, the old grain having been used up, the new grain ripens, and fire is renewed by fresh drilling."

The Master said, "Would you, then, be able to enjoy eating your rice and wearing your finery?"

"Yes. I would."

"If you are able to enjoy them, do so by all means. The gentleman in mourning finds no relish in good food, no pleasure in music, and no comforts in his own home. That is why he does not eat his rice and wear his finery. Since it appears that you enjoy them, then do so by all means."

After Cai Wo had left, the Master said, "How unfeeling Yu is. A child ceases to be nursed by his parents only when he is three years old. Three years' mourning is observed throughout the Empire. Was Yu not given three years' love by his parents?"

Ritual Food Vessel,
Western Zhou dynasty
(ca. 1046–771 BCE).
Bronze.

The Analects comprise the teachings and sayings of Confucius. Predominantly concerned with collective hierarchy as a means to social ordering, Confucius demonstrates that the relationships of children to parents, community leaders to constituents, state leaders to citizens, and even the Emperor to the nation are all structured by Confucian doctrine. This extends even into death, as shown by the discussion between Cai Wo (also known as Cai Yu) and Confucius. The Western Zhou ritual gui vessel is an extraordinary example of a large container used to offer food to ancestors. Two large dragons form the handles; beneath the hollow base, a small bronze bell chimes when the bronze vessel is lifted.

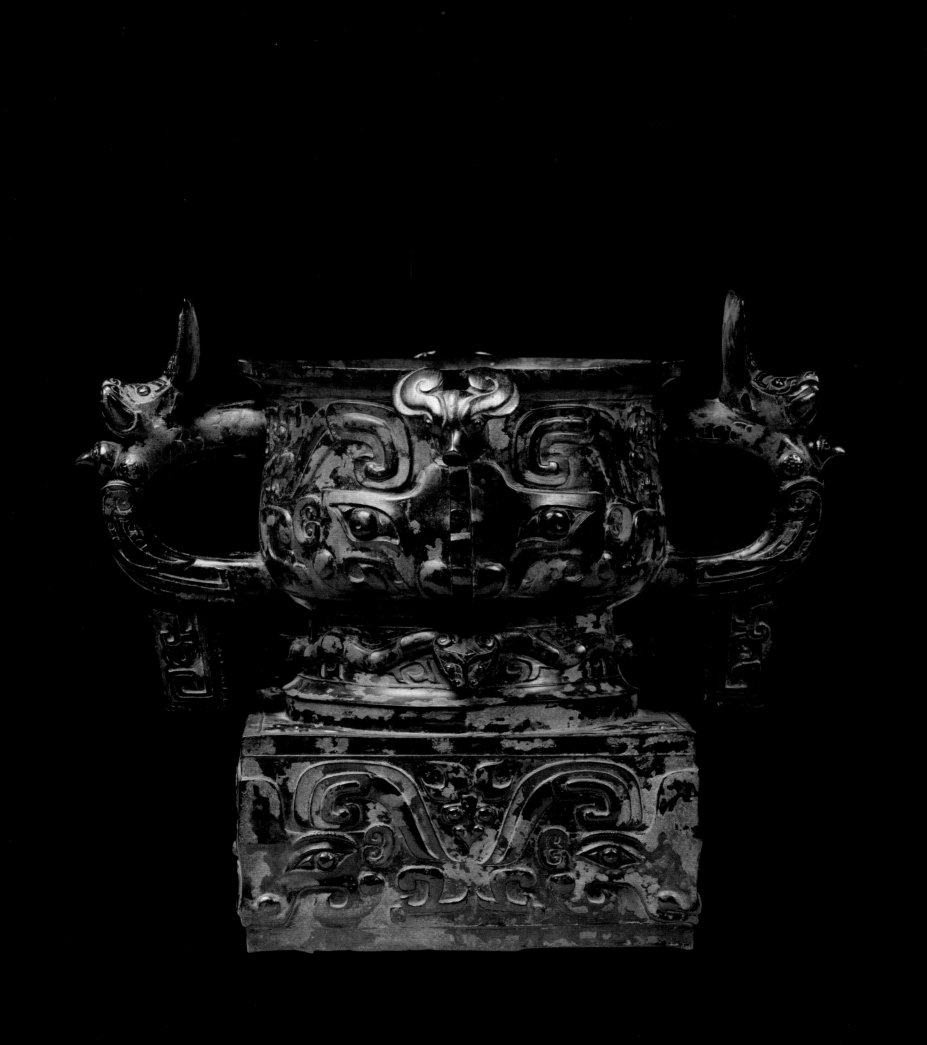

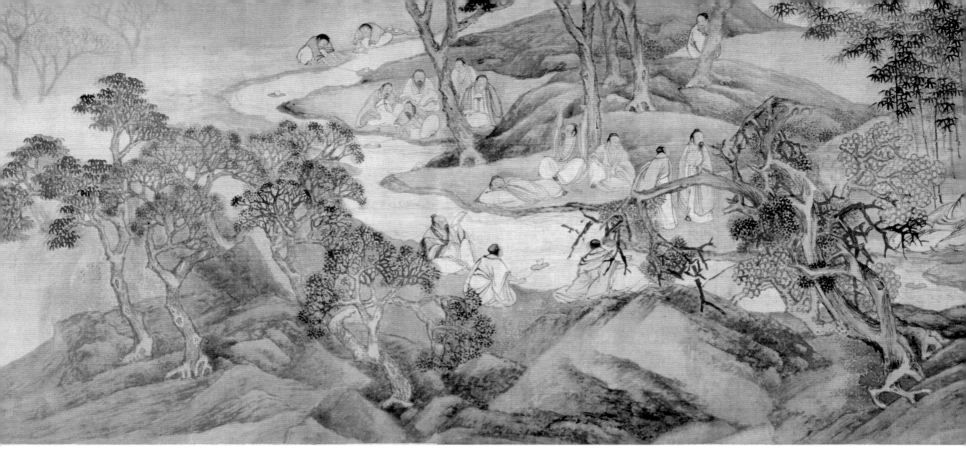

ORCHID PAVILION POEMS

Wang Xizhi (321–379)

In the year 353, the ninth year of the Yonghe Reign, early in the last month of spring, there was a gathering at the Orchid Pavilion on the northern slopes of the Kuaiji Mountains; our purpose, to carry out the spring ceremonies of purification. Many a good man came, the young and old alike. The place was one of mighty mountains and towering ridges covered with lush forests and tall bamboo, where a clear stream with swirling eddies cast back a sparkling light upon both shores. From this we cut a winding channel in which to float our winecups, and around this everyone took their appointed seats. True, we did not have the harps and flutes of a great feast, but a cup of wine and a song served well enough to free our most hidden feelings.

The sky that day was luminous, and the air was clear; gentle breezes blew softly around us. Above us we looked on the immensity of the universe; then, lowering our eyes, we saw nature's infinite variety. And as we let our eyes roam and our hearts speed from thought to thought, we could experience the greatest delights of ear and eye — this was true happiness.

The times that human beings may be together occur within the fleeting glance of a lifetime: some find them in emotions spoken openly, face to face, in a single room; others invest their feelings in something external as they roam free, beyond the body's world. Our inclinations and aversions have a million different forms; the active man and the contemplative man are unlike; but

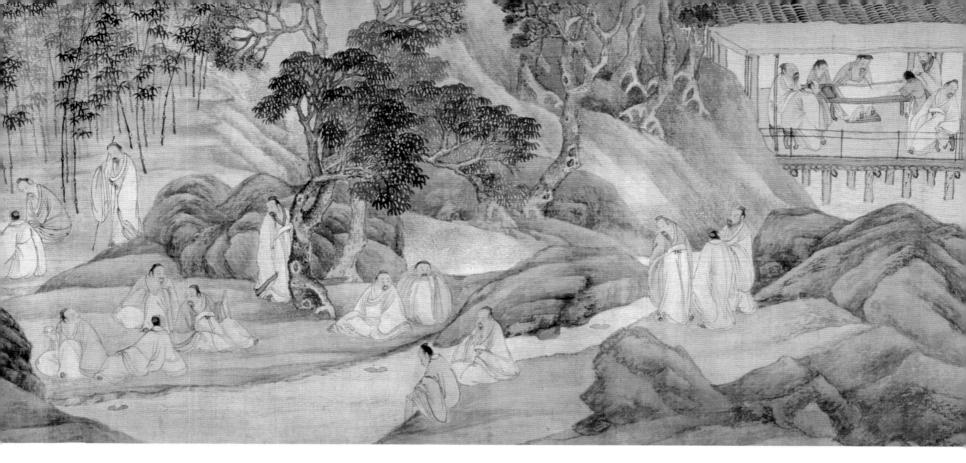

*The Orchid Pavilion
Purification Gathering,*
**Sheng Maoye (active
1594–1640). Handscroll,
ink and color on silk.
Detail.**

still, when joy comes with a chance encounter, there is a brief moment of satisfaction, a cheerful self-containment with never a thought of old age coming on. Then, as we weary of the direction in which we are going, our mood shifts with life's events, and depression inevitably follows. In the blink of an eye the joy that has been becomes an experience past — yet still we cannot help having our feelings stirred by it. Even more there are our lives, whether long or short, changing and transforming, but ultimately bound to an end. As was said long ago, "Life and death are the greatest concerns." No escaping the pain in this.

Each time I examine the causes that brought emotion to men in the past, it is as though I have found there the mirror image of my own feelings. Never have I looked upon such writings without a brooding sigh, nor can I find words adequate to explain to myself why. But this I have learned: the belief that life and death are the same is a grand deception; to say that Ancestor Peng's centuries are no more than the lifespan of an infant who died untimely — this is delusion, a forced conceit. Those in later times will look on today as we today look on the past — there is the sadness! For this reason I have written out the list of those present at that time and copied their compositions. Though ages change and experiences differ, all may share what stirs deep feelings. And those who read this in later times will also be moved by what is in this writing.

Wang Xizhi, one of China's most gifted calligraphers, composed this preface to a group of poems that emerged from a famous literary gathering held at the Orchid Pavilion. As Sheng Maoye's masterpiece illustrates, poets composed while consuming jugs of wine and eating perfumed delicacies. A verse would be written by a colleague upstream, set on a small floating board, and allowed to meander to the next poet, who repeated the scenario. By the time it reached the last author, an entire poem emerged. Wang then gathered the completed works for his compilation.

BEGGING

Tao Yuanming (Tao Qian, 365–427)

Famine came, it drove me off,
I did not know where to go.

I finally came to this village,
knocked at the gate, fumbled with words,

The owner guessed what I had in mind;
he gave — I had not come for nothing.

We joked and chatted through evening;
when a pitcher came, we emptied our cups.

Heart's ease in joys of newfound friends,
as we sang and recited poems.

I was touched by such kindness the washerwoman showed,
and am shamed that I lack the gifts of Han Xin.

So much within me, I know not how to thank you,
I must pay you back from the world beyond.

Beggars and Street Characters, **Zhou Chen (ca. 1450–ca. 1535). Handscroll, ink and color on paper. Details.**

A GUEST COMES

Du Fu (712–770)

North of my cottage, south of my cottage, spring waters everywhere,

And all that I see are the flocks of gulls coming here day after day,

My path through the flowers has never yet been swept for a visitor,

But today this wicker gate of mine stands open just for you.

The market is far, so for dinner there'll be no wide range of tastes,

Our home is poor, and for wine we have only an older vintage.

Are you willing to sit here and drink with the old man who lives next door?

I'll call him over the hedge, and we'll finish the last of the cups.

Elegant Gathering in the Apricot Garden, after Xie Huan (ca. 1370–ca. 1450). Handscroll, ink and color on silk. Detail.

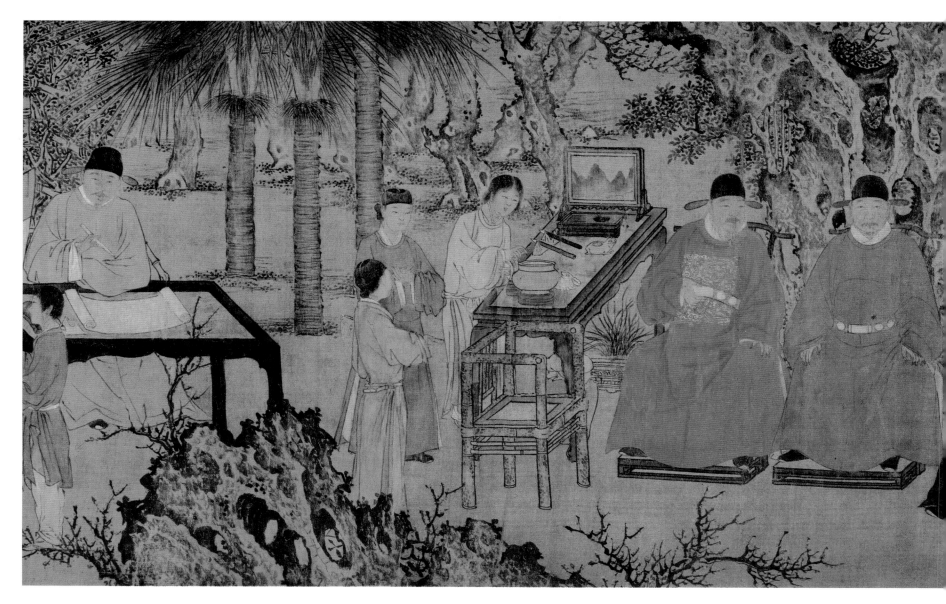

INVITING WRITERS TO DRINK

Meng Jiao (751–814)

Cao Zhi and Liu Zhen could not shun death —
none dare turn their backs on spring's glory.
So let no poet turn down the wine,
for a poet's fate belongs to the flowers.
Han Yu was sent into exile;
Li Bo was prideful by nature.
All time seems suddenly much the same:
in a brief span everyone comes to sighs.
Who says that Heaven's Way is straight? —

It alone skews the shapes of Earth.
The Southerner grieves, being always ill;
the Northerner, joyless at leaving home.
Plum blossom songs pour already through flutes,
and the willows' colors cannot yet hide crows.
So I urge you to cease your songs of the snow,
and in turn drink sadly the rose-cloud wine.
When we sober up, we cannot pass over
this ocean of sorrow, vast without shore.

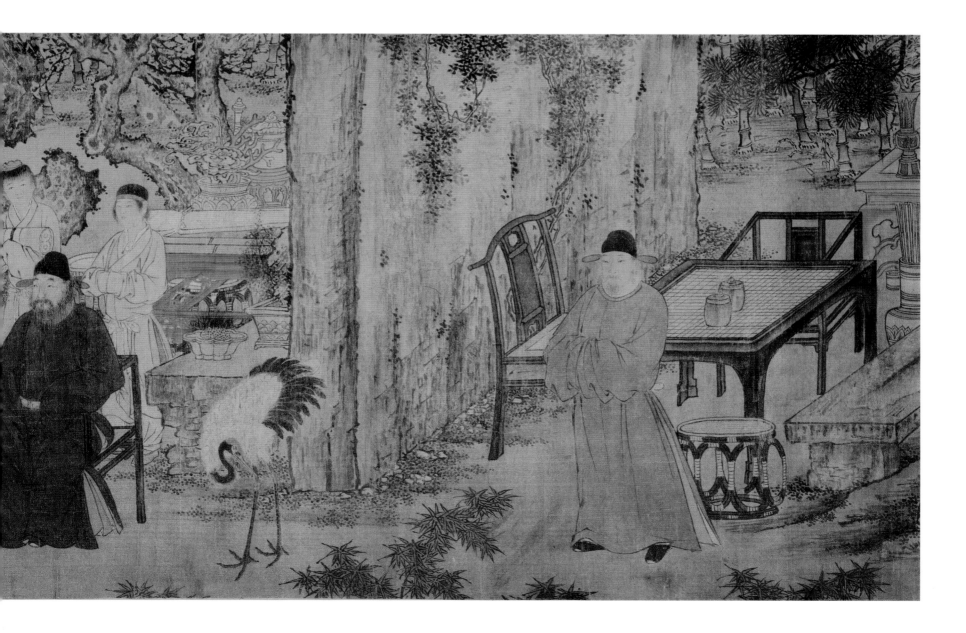

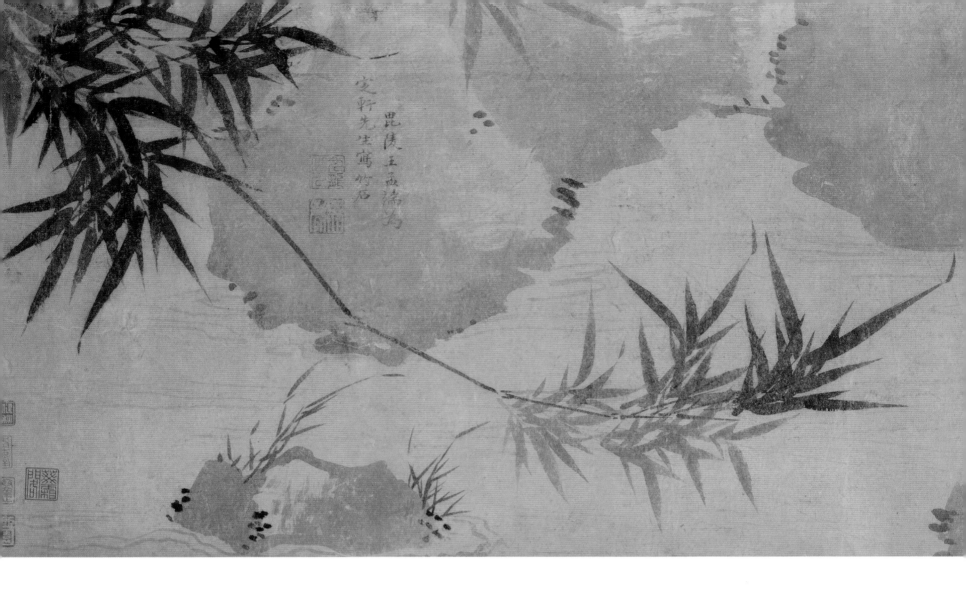

EATING BAMBOO SHOOTS

Bo Juyi (772–846)

This province is truly a land of bamboo,
in spring the sprouts fill hills and valleys.

Men of the hills snap them in armfuls,
and bring them to market as soon as they can.

Things are cheapest when plentiful,
for a pair of coppers a whole bunch can be had.

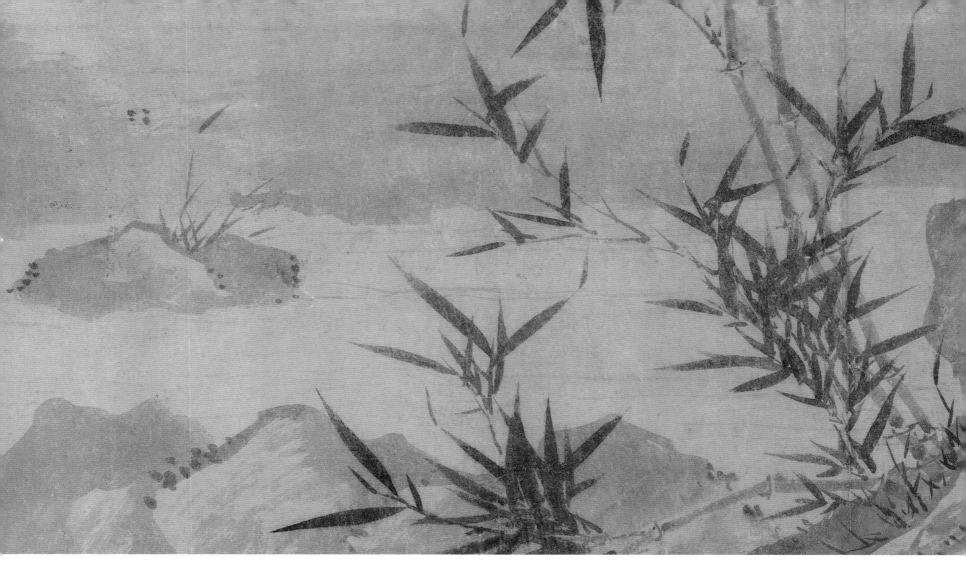

Bamboo and Rocks,
Wang Fu (1362–1416).
Handscroll, ink on
paper. Detail.

Just put them into the cooking pot,

and they will be done along with the rice.

Their purple sheaths, shreds of ancient brocade,

their pale flesh, broken chunks of newfound jade.

Every day I eat them more than I need,

through their whole season I yearn not for meat.

I was long resident in Chang'an and Luoyang,

and never had my fill of the taste of these.

Eat while you can, don't hesitate,

soon south winds will blow them into bamboo.

DIPPING WATER FROM THE RIVER
AND SIMMERING TEA

Su Shi (Su Dongpo, 1037–1101)

*L*iving water needs living fire to boil:

Lean over Fishing Rock, dip the clear deep current;

Store the spring moon in a big gourd, return it to the jar;

Divide the night stream with a little dipper, drain it into the kettle.

Frothy water, simmering, whirls bits of tea;

Pour it and hear the sounds of wind in pines.

Hard to refuse three cups to a dried-up belly;

I sit and listen — from the old town, the striking of the hour.

Brewing Tea, **Wang
Meng (1308–1385).
Hanging scroll, ink and
colors on paper.**

DRAWING WATER FROM THE WELL AND MAKING TEA

Lu You (1125--1210)

I get up sick, done looking at my books,

pull hands into sleeves, clear night stretching on.

All the neighborhood's silent, nowhere a sound,

and the lamp fire now burns chill and low.

My servant boy too is sleeping soundly,

so I go draw water and make my own tea.

There's a sound of the well pulley creaking:

a hundred feet down the ancient well sings.

Inside, my organs shiver from the cold,

then from bone to hair, I'm revived, aware.

I go back; moonlight fills the corridors

and I can't bear to step on sparse shadows of plums.

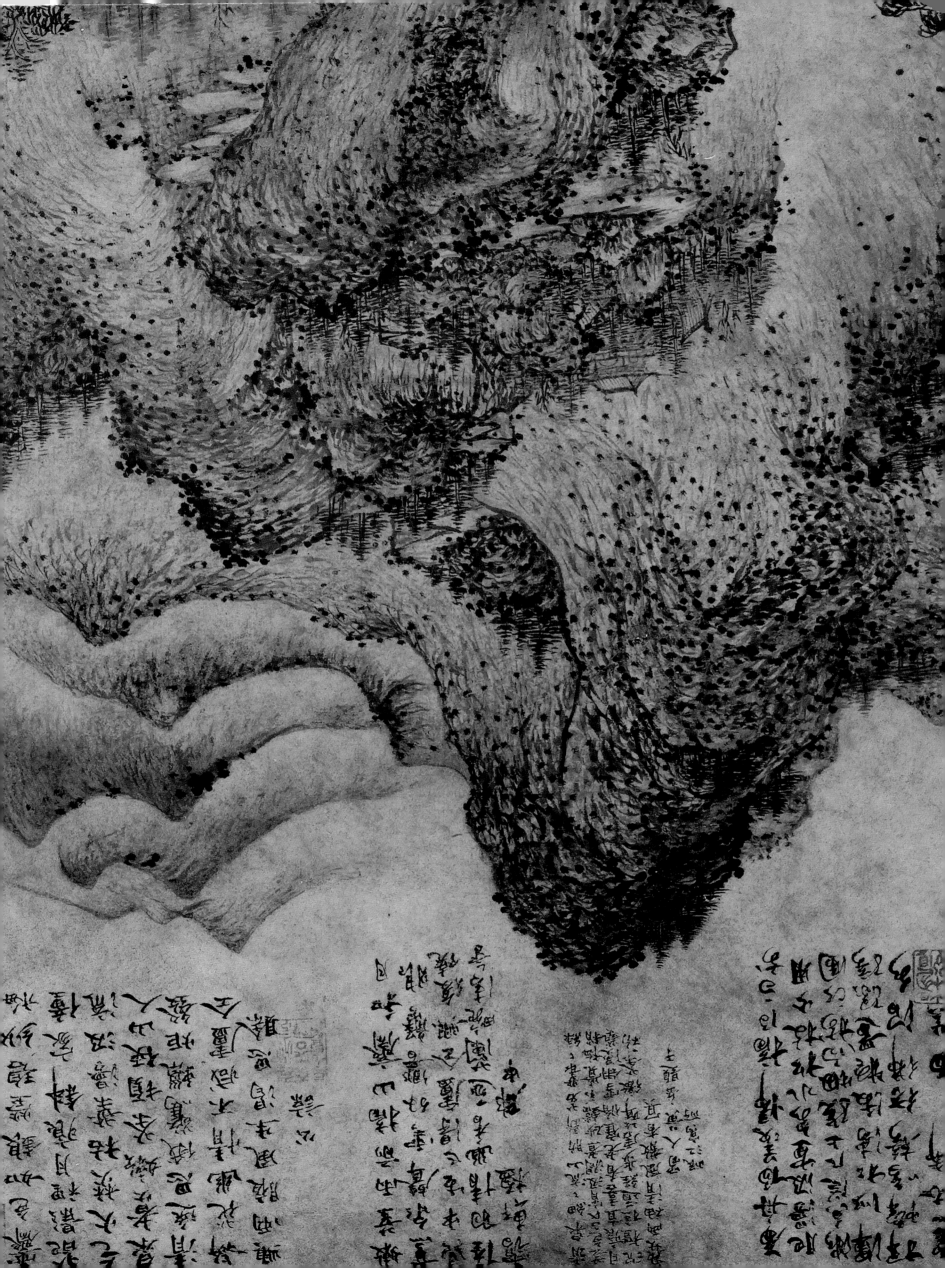

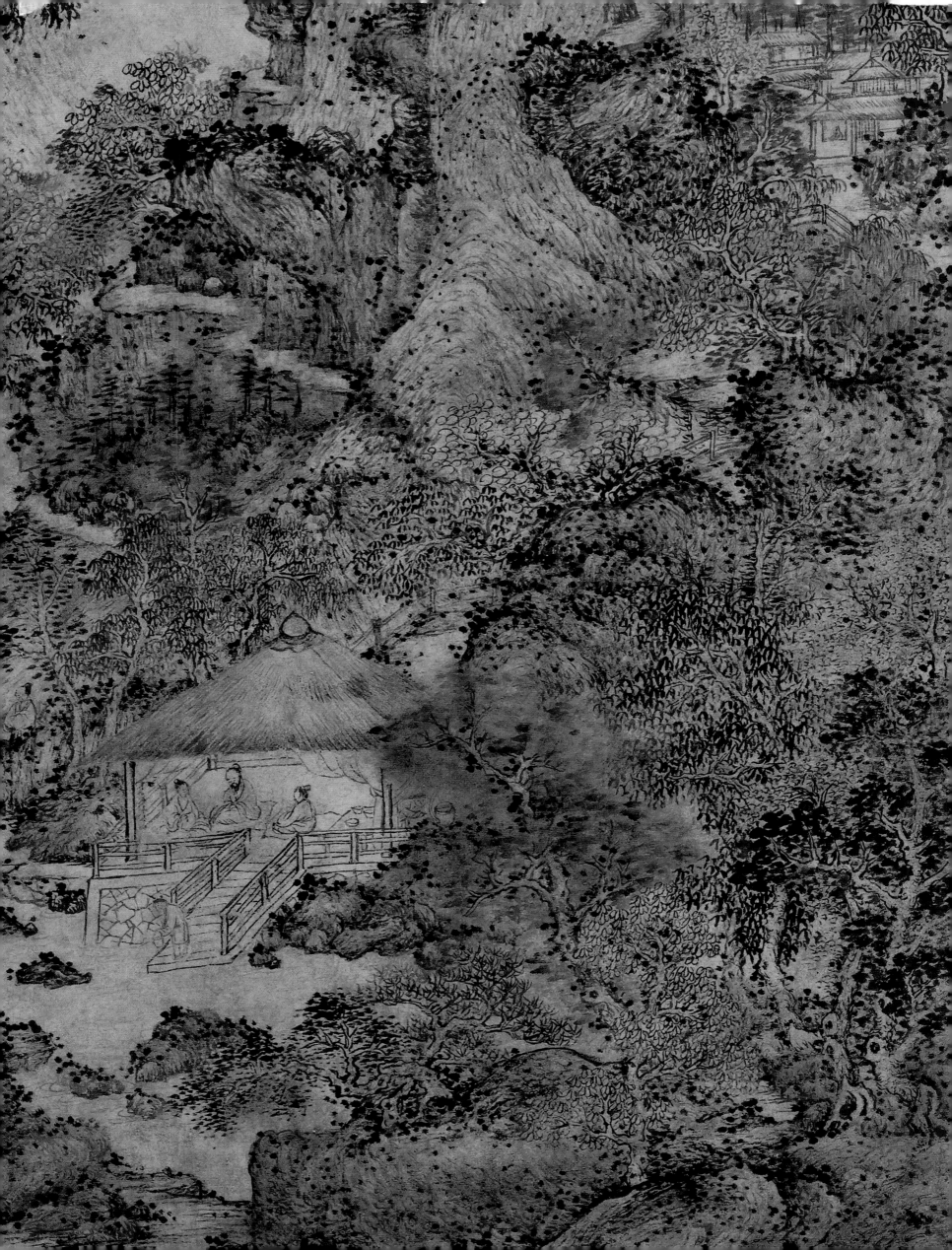

RIGHT TO THE HEART OF THE MATTER

Wang Meng (b. 1934)

Emperor's Yellow Court Robe, **anonymous court artists (1662–1722). Patterned silk gauze with brocaded metal thread.**

A meeting to discuss cold drinks for summertime was held in a place called "M."

MA put forward his proposal to raise the quality level of osmanthus-flavored sour-plum nectar, and voiced his opinions on the issue of beverage production facilities in general.

MB made a recommendation regarding the opening up of additional sources of cold milk and liquid yogurt.

MC advocated an energetic expansion of the production and supply of bottled beer, ale, and light beer.

MD made known his ideas regarding the production of top-grade soft drinks.

ME demanded the return of the traditional thirst-slaking dried fruit from North China.

MX stood up, pounded the table, raised his index finger, and sounded a warning: "Gentlemen, friends, since we are discussing the issue of beverages, we mustn't forget for a single moment man's most basic, his principal, his most essential, his most important beverage, the one that can never be overlooked: not beer, not fruit juice, not yogurt, and not soft drinks, but H_2O — that's water! Talking about beverages and ignoring water is a perfect example of reversing the relationship between principal and subordinate, which can only lead to chaos. At this rate, before long the people will be drinking urine, lime wash, maybe even lubricating oil. Why? Because they will have forgotten that water is *the* source, that water is at the heart of all things, that they must hold on to water at all costs! If we can tolerate this sort of

All the other, from MA to ME, gazed at each other in blank dismay, not knowing what to do now.

MF was the first to respond to the challenge. "I'm in total agreement with MX's point of view," he shouted, "and I want to go even further by stating that it's not enough just to drink water, that in order to ensure its survival, mankind must also eat! Whether it's flour or rice, vegetables or seafood, makes no difference at all, as long as we eat. Just ponder for a minute the serious consequences of drinking water and not eating! Therefore, of primary . . ."

MA was clearly getting worked up. He unbuttoned his shirt to expose his chest, shouting as he did so: "I want to solemnly declare that I have never opposed the eating of food or the drinking of water, not in the past, not now, and certainly not tomorrow, or the day after, or the day after that. . . . " His declaration thus completed, he took a biscuit out of his pocket, poured himself a glass of cool water, and began eating and drinking right there in front of the others.

MB entered the fray at that moment, calling the others to account: "I want you all to take note that it's not nearly enough just to eat food and drink water. We must also wear clothing! Clothing is necessary to keep us warm and keep our bodies concealed from view. Without clothing we would be no better than beasts!"

And the debate goes on.

THE KITCHEN GOD'S WIFE

Amy Tan (b. 1952)

*A*fter lunch, I told Helen I was going shopping. She said, "Where? Maybe I'll come."

I said, "I don't know where yet."

And she said, "Good, that's where I want to go too."

So then we went next door, to Sam Fook Trading Company. Right away, Mrs. Hong opened up her cash register, thinking we were coming in to trade twenty-dollar bills.

"No, no," I said. "This time I've come here to shop, something for my daughter." Mrs. Hong smiled big. So did Helen. I was standing in front of the porcelain statues: Buddha, Goddess of Mercy, God of Money, God of War, all kinds of luck.

"Do you want something for decoration or something for worship?" Mrs. Hong asked. "For worship, I can give you thirty-percent discount. For decoration, I have to charge the same price."

"This is for worship," said Helen right away.

"Not just for decoration," I said. And then I turned to Helen. "This is true. This is for Pearl. I'm finding something to put inside the little red altar temple. I promised Auntie Du. For a long time already I have been thinking about this, before Pearl told me about her sickness."

And then I was thinking to myself once again — about that time she told me about the MS. Oh, I was angry, I was sad. I was blaming myself. I blamed Wen Fu. After Pearl went home, I cried. And then I saw that picture of Kitchen God, watching me, smiling, so happy to see me unhappy. I took his picture out of the frame. I put it over my stove. "You go see Wen Fu! You go to hell down below!" I watched his smiling face being eaten up by the fire. Right then my smoke detector went off. Wanh! Wanh! Wanh! Oh, I was scared. Wen Fu — coming back to get me. That's what I thought.

But then I listened again. And I knew: This was not Wen Fu's ghost. This was like a bingo blackout. This was like a Reno jackpot. This was Kitchen God's wife, shouting, Yes! Yes! Yes!

"What does your daughter do?" Mrs. Hong was now asking me.

"Oh, she has an important job, working in a school," I said.

"A very high-level position," adds Helen. "Very smart."

"This one is good for her then, Wen Ch'ang, god of literature. Very popular with school."

I shook my head. Why pick a name like Wen Fu's? "I am thinking of something she can use for many reasons," I explained.

"Goddess of Mercy, then." Mrs. Hong was patting the heads of all her goddesses. "Good luck, good children, all kinds of things. We have many, all different sizes. This one is nice, this one is thirty dollars. This one is very nice, this one is two hundred sixty-five dollars. You decide."

"I am not thinking of the Goddess of Mercy," I said. "I am looking for something else."

"Something to bring her money luck," Mrs. Hong suggested.

"No, not just that, not just money, not just luck," says Helen. We look at each other. But she cannot find the words. And I cannot say them.

"Perhaps one of the Eight Immortals," said Mrs. Hong. "Maybe all eight, then she has everything."

"No," I said. "I am looking for a goddess that nobody knows. Maybe she does not yet exist."

Mrs. Hong sighed. "I'm sorry, this we do not have." She was disappointed. I was disappointed. Helen was disappointed.

Suddenly Mrs. Hong clapped her hands together. "Where is my head today?" She walked to the back of the store, calling to me. "It is back here. The factory made a mistake. Of course, it is a very nice statue, no chips, no cracks. But they forgot to write down her name on the bottom of her chair. My husband was so mad. He said, "What are we going to do with this? Who wants to buy a mistake?"

So I bought that mistake. I fixed it. I used my gold paints and wrote her name on the bottom. And Helen bought good incense, not the cheap brand, but the best. I could see this lady statue in her new house, the red temple altar with two candlesticks lighting up her face from both sides. She would live there, but no one would call her Mrs. Kitchen God. Why would she want to be called that, now that she and her husband are divorced?

Kitchen God and Kitchen Goddess (ca. 1918). Ink on paper.

Amy Tan's novel The Kitchen God's Wife *explores mid- to later-twentieth-century Chinese immigrant life via the American-born character Pearl and her Chinese-born mother, Winnie. The daughter grew up in peacetime, while her mother struggled through the terrors of World War II in China and an abusive arranged marriage. The print reproduced here —* The Kitchen God and Kitchen Goddess *— illustrates in colorful detail the pair of domestic deities that held the traditional place of honor over a family's stove. These gods' duties included delivering an account of the family's history to heaven each New Year. Historical examples of such images date back at least to Northern Song dynasty times.*

WAR AND POLITICS

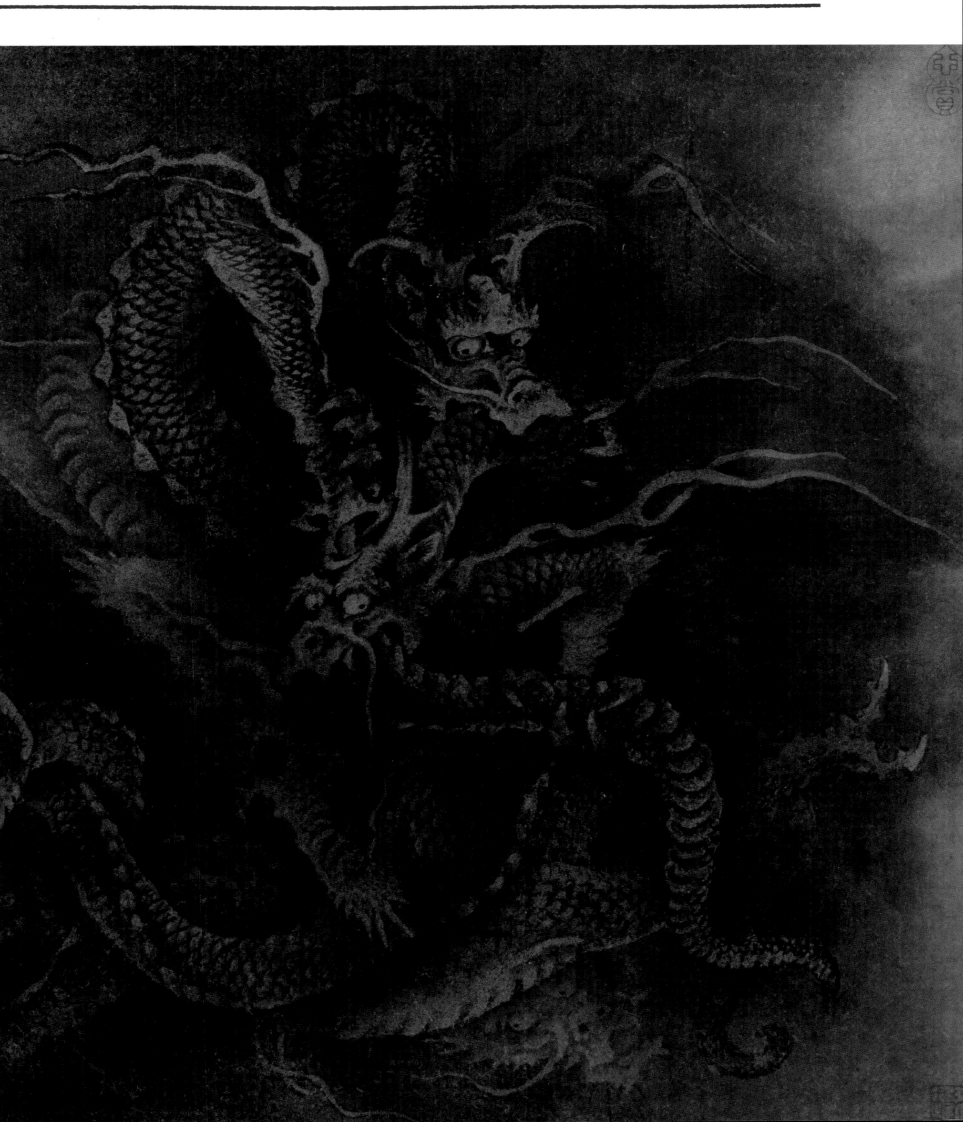

THE DECADE OF TONG GONG

Shijing (ca. 11th century–221 BCE)

The red bows unbent

Were received and deposited.

I have here an admirable guest,

And with all my heart I bestow one on him.

The bells and drums have been arranged in order,

And all the morning will I feast him.

The red bows unbent

Were received and fitted on their frames.

I have here an admirable guest,

And with all my heart I rejoice in him.

The bells and drums have been arranged in order,

And all the morning will I honour him.

The red bows unbent

Were received and placed in their cases.

I have here an admirable guest,

And with all my heart I love him.

The bells and drums have been arranged in order,

And all the morning will I pledge him.

PRECEDING SPREAD:
Five Dragons, Chen
Rong (ca. 1200–1266).
Handscroll, ink on
paper. Detail.

RIGHT: *Illustrations from
the Book of Songs*, Ma
Hezhi (active late 12th
century). Handscroll,
ink and color on silk.
Detail.

The Shijing's *(Book of Odes, Classic of Poetry) three hundred poems provide information about both
daily life and societal values during the Zhou dynasty. The* Minor Odes *section includes the excerpted
discussion of a king ceremonially bestowing red lacquer archery bows on his faithful ministers; in traditional
Confucian terms, the relationship of king to subject mirrors that of parent and child. The detail from Ma
Hezhi's handscroll depicts this particular* Shijing *poem.*

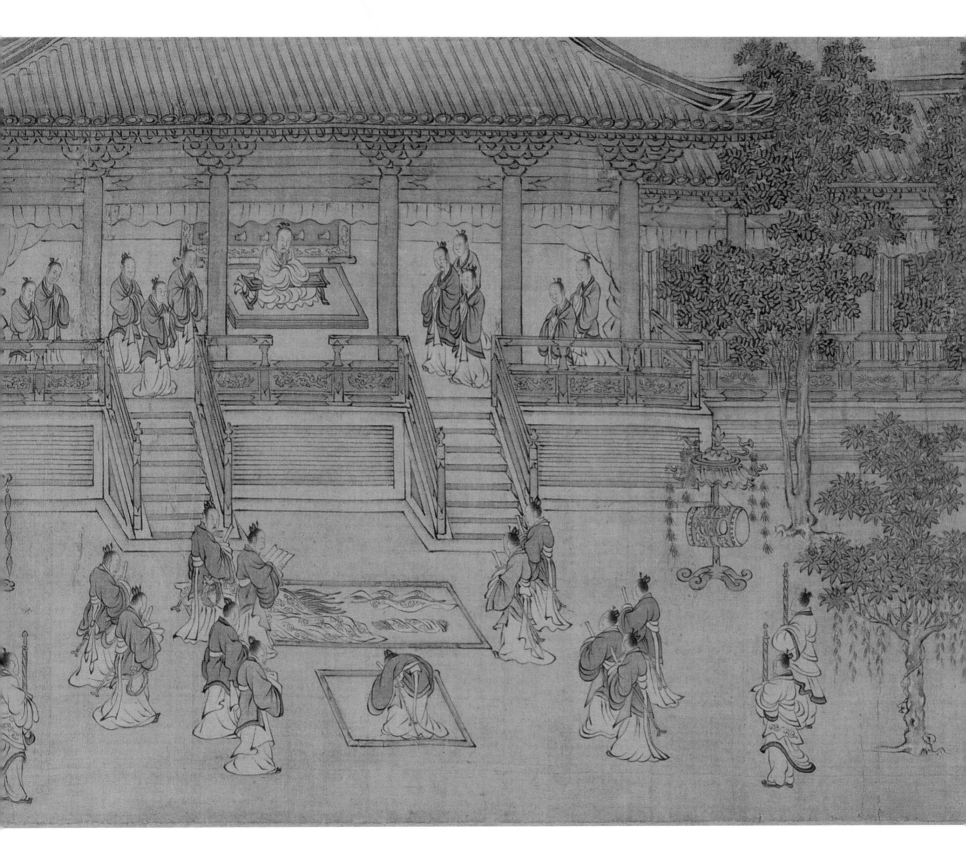

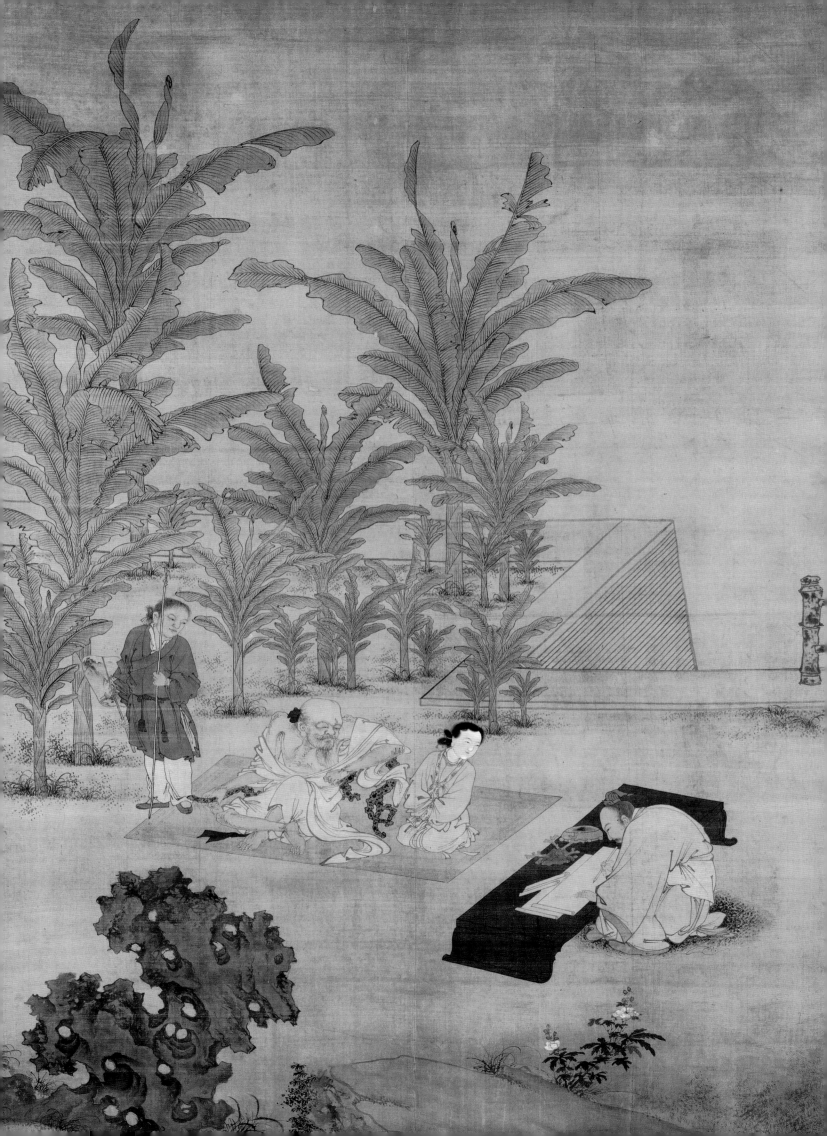

THE GREAT DECLARATION

Shujing (ca. 11th century–221 BCE)

*I*n the spring of the thirteenth year, there was a great assembly at Meng Jin. The king said, "Ah! ye hereditary rulers of my friendly States, and all ye my officers, managers of my affairs, listen clearly to my declaration.

"Heaven and Earth is the parent of all creatures; and of all creatures man is the most highly endowed. The sincere, intelligent, and perspicacious among men becomes the great sovereign; and the great sovereign is the parent of the people. But now, Shou, the king of Shang, does not reverence Heaven above, and inflicts calamities on the people below. He has been abandoned to drunkenness, and reckless in lust. He has dared to exercise cruel oppression. Along with criminals he has punished all their relatives. He has put men into office on the hereditary principle. He has made it his pursuit to have palaces, towers, pavilions, embankments, ponds, and all other extravagances, to the most painful injury of you, the myriad people. He has burned and roasted the loyal and good. He has ripped up pregnant women. Great Heaven was moved with indignation, and charged my deceased father Wen reverently to display its majesty; but he died before the work was completed.

"On this account I, Fa, who am but a little child, have by means of you, the hereditary rulers of my friendly States, contemplated the government of Shang; but Shou has no repentant heart. He abides squatting on his heels, not serving God [Shangdi] or the spirits of heaven and earth, neglecting also the temple of his ancestors, and not sacrificing in it. The victims and the vessels of millet all become the prey of wicked robbers; and still he says, 'The people are mine: the decree is mine,' never trying to correct his contemptuous mind. Now Heaven, to protect the inferior people, made for them rulers, and made for them instructors, that they might be able to be aiding to God [Shangdi], and secure the tranquillity of the four quarters of the empire. In regard to who are criminals and who are not, how dare I give any allowance to my own wishes?

"'Where the strength is the same, measure the virtue of the parties; where the virtue is the same, measure their righteousness.' Shou has hundreds of thousands and myriads of ministers, but they have hundreds of thousands and myriads of minds; I have three thousand officers, but they have one mind. The iniquity of Shang is full. Heaven gives command to destroy it. If I did not comply with Heaven, my iniquity would be as great.

"I, who am a little child, early and late am filled with apprehensions. I have received charge from my deceased father Wen; I have offered special sacrifice to God [Shangdi]; I have performed the due services to the great Earth; — and I lead the multitude of you to execute the punishment appointed by Heaven. Heaven compassionates the people. What the people desire, Heaven will be found to give effect to. Do you aid me, the one man, to cleanse for ever all within the four seas. Now is the time! — it may not be lost."

The Scholar Fu Sheng Transmitting the Book of Documents, **Du Jin (active 1465–1509). Hanging scroll, ink and color on silk.**

The Shujing *(Classic of Historical Documents) offers accounts taken from oral tradition regarding the establishment of the Zhou dynasty by its family leaders. The declaration cited here marks the period when the Zhou kings were about to overthrow the Shang dynasty leaders. Du Jin's scroll illustrates Fu Sheng — seated beside his daughter — orally transmitting these texts to a dutiful imperial scribe for transcription.*

YIJING

(9th–7th century BCE)

HEXAGRAM 1
Qian — The Creative

The Creative works sublime success,
Furthering through perseverance.

The movement of heaven is full of power.
Thus superior man makes himself strong and untiring.

[Explanation of the hexagram lines]

Nine at the beginning means:
Hidden dragon. Do not act.

Nine in the second place means:
Dragon appearing in the field.
It furthers one to see the great man.

Nine in the third place means:
All day long the superior man is creatively active.
At nightfall his mind is still beset with cares.
Danger. No blame.

Nine in the fourth place means:
Wavering flight over the depths.
No blame.

Nine in the fifth place means:
Flying dragon in the heavens.
It furthers one to see the great man.

Nine at the top means:
Arrogant dragon will have cause to repent.

When all the lines are nines, it means:
There appears a flight of dragons without heads.
Good fortune.

HEXAGRAM 2
Kun – The Receptive

The Receptive brings about sublime success,
Furthering through the perseverance of a mare.
If the superior man undertakes something and tries to lead,
He goes astray;
But if he follows, he finds guidance.
It is favourable to find friends in the west and south,
To forego friends in the east and north.
Quiet perseverance brings good fortune.

The earth's condition is receptive devotion.
Thus the superior man who has breadth of character
Carries the outer world.

[Explanation of the hexagram lines]

Six at the beginning means:
When there is hoarfrost underfoot,
Solid ice is not far off.

Six in the second place means:
Straight, square, great.
Without purpose,
Yet nothing remains unfurthered.

Six in the third place means:
Hidden lines.
One is able to remain persevering.
If by chance you are in the service of a king,
Seek not works, but bring to completion.

Six in the fourth place means:
A tied-up sack. No blame, no praise.

Six in the fifth place means:
A yellow lower garment brings supreme good fortune.

Six at the top means:
Dragons fight in the meadow.
Their blood is black and yellow.

When all the lines are sixes, it means:
Lasting perseverance furthers.

The Yijing (Classic of Changes) is a divination text with 64 hexagrams that assist one with life's queries for the future. The hexagram lines represent wood strips that were thrown and divined according to how they landed. Later, members of the early Zhou hierarchy cited it to justify overthrowing the Shang dynasty. It was also important for Confucius and Laozi. Confucius selected texts that confirmed hierarchical social arrangements, while Laozi highlighted the role of the Dao through nature. Here, too, we learn that rulers and emperors were associated with the symbol of the dragon.

DAODEJING

Laozi (Lao Dan, compiled ca. 500 BCE–250 BCE)

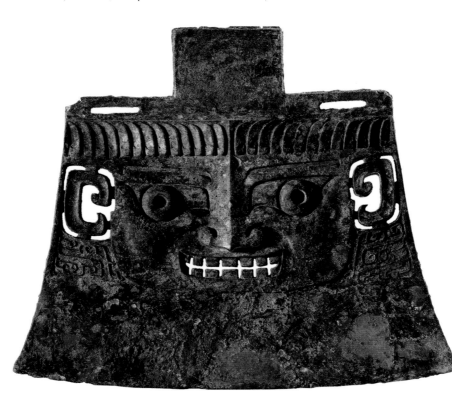

Ceremonial Battle Ax,
**Shang dynasty (ca.
1600–1046 BCE). Bronze.**

ine weapons are instruments of evil.

They are hated by men.

Therefore those who possess Dao turn away from them.

The good ruler when at home honors the left [symbolic of good omens].

When at war he honors the right [symbolic of evil omens].

Weapons are instruments of evil, not the instruments of a good ruler.

When he uses them unavoidably, he regards calm restraint as the best principle.

Even when he is victorious, he does not regard it as praiseworthy,

For to praise victory is to delight in the slaughter of men.

He who delights in the slaughter of men will not succeed in the empire.

In auspicious affairs, the left is honored.

In unauspicious affairs, the right is honored.

The lieutenant-general stands on the left.

The senior general stands on the right.

That is to say that the arrangement follows that of funeral ceremonies.

For the slaughter of the multitude, let us weep with sorrow and grief.

For a victory, let us observe the occasion with funeral ceremonies.

The Daodejing *or* Laozi (The Classic of the Way and Its Virtue) *— roughly 5,250 characters in all — is fundamental to Daoism and takes nature as its model for ethical behavior (see page 210). Here, it makes an important point against taking up arms lightly.*

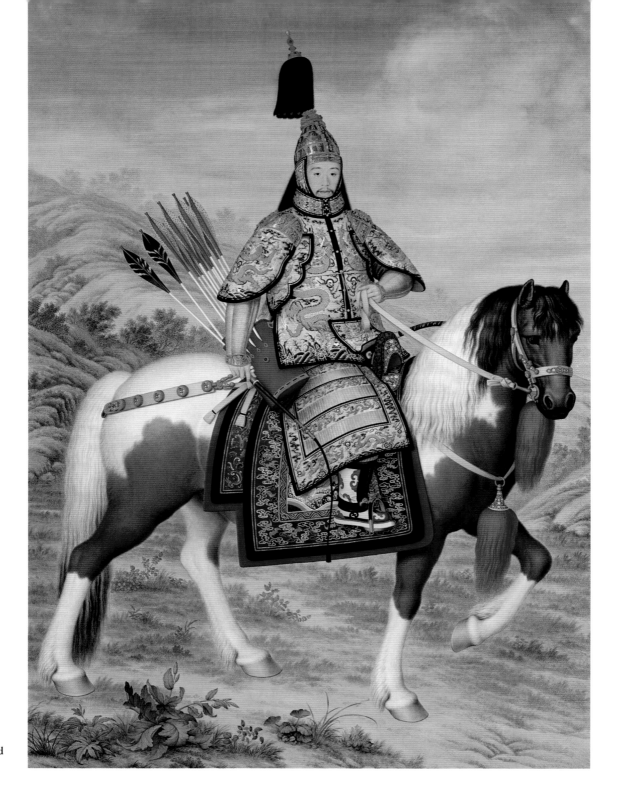

Emperor Qianlong in Ceremonial Armor on Horseback, Giuseppe Castiglione (Lang Shining; 1688–1766). Hanging scroll, ink and color on silk.

THE ART OF WAR

Sun Wu and Sun Bin (ca. 4th century BCE)

unzi said:

1. Generally in war the best policy is to take a state intact; to ruin it is inferior to this.

2. To capture the enemy's army is better than to destroy it; to take intact a battalion, a company or a five-man squad is better than to destroy them.

3. For to win one hundred victories in one hundred battles is not the acme of skill. To subdue the enemy without fighting is the acme of skill.

4. Thus, what is of supreme importance in war is to attack the enemy's strategy.

5. Next best is to disrupt his alliances.

6. The next best is to attack his army.

7. The worst policy is to attack cities. Attack cities only when there is no alternative.

8. To prepare the shielded wagons and make ready the necessary arms and equipment requires at least three months; to pile up earthen ramps against the walls an additional three months will be needed.

9. If the general is unable to control his impatience and orders his troops to swarm up the wall like ants, one-third of them will be killed without taking the city. Such is the calamity of these attacks.

10. Thus, those skilled in war subdue the enemy's army without battle. They capture his cities without assaulting them and overthrow his state without protracted operations.

11. Your aim must be to take All-under-Heaven intact. Thus your troops are not worn out and your gains will be complete. This is the art of offensive strategy.

12. Consequently, the art of using troops is this: When ten to the enemy's one, surround him.

13. When five times his strength, attack him.

14. If double his strength, divide him.

15. If equally matched you may engage him.

16. If weaker numerically, be capable of withdrawing.

17. And if in all respects unequal, be capable of eluding him, for a small force is but booty for one more powerful.

18. Now the general is the protector of the state. If this protection is all-embracing, the state will surely be strong; if defective, the state will certainly be weak.

19. Now there are three ways in which a ruler can bring misfortune upon his army.

20. When ignorant that the army should not advance, to order an advance or ignorant that it should not retire, to order a retirement. This is described as "hobbling the army."

21. When ignorant of military affairs, to participate in their administration. This causes the officers to be perplexed.

22. When ignorant of command problems to share in the exercise of responsibilities. This engenders doubts in the minds of the officers.

23. If the army is confused and suspicious, neighbouring rulers will cause trouble. This is what is meant by the saying: "A confused army leads to another's victory."

24. Now there are five circumstances in which victory may be predicted.

25. He who knows when he can fight and when he cannot will be victorious.

26. He who understands how to use both large and small forces will be victorious.

27. He whose ranks are united in purpose will be victorious.

28. He who is prudent and lies in wait for an enemy who is not, will be victorious.

29. He whose generals are able and not interfered with by the sovereign will be victorious.

30. It is in these five matters that the way to victory is known.

31. Therefore I say: Know the enemy and know yourself; in a hundred battles you will never be in peril.

32. When you are ignorant of the enemy but know yourself, your chances of winning or losing are equal.

33. If ignorant both of your enemy and of yourself, you are certain in every battle to be in peril.

BATTLE

Qu Yuan (ca. 340–278 BCE)

"We grasp our battle-spears: we don our breast-plates of hide.

The axles of our chariots touch: our short swords meet.

Standards obscure the sun: the foe roll up like clouds.

Arrows fall thick: the warriors press forward.

They menace our ranks: they break our line.

The left-hand trace-horse is dead: the one on the right is smitten.

The fallen horses block our wheels: they impede the yoke-horses!"

They grasp their jade drum-sticks: they beat the sounding drums.

Heaven decrees their fall: the dread Powers are angry.

The warriors are all dead: they lie on the moor-field.

They issued but shall not enter: they went but shall not return.

The plains are flat and wide: the way home is long.

Their swords lie beside them: their black bows, in their hand.

Though their limbs were torn, their hearts could not be repressed.

They were more than brave: they were inspired with the spirit of Wu.

Steadfast to the end, they could not be daunted.

Their bodies were stricken, but their souls have taken Immortality —

Captains among the ghosts, heroes among the dead.

Detail of Terra-cotta Soldier Pit, First Emperor's Mausoleum (210 BCE). Terra-cotta with color pigments.

Composed during the Warring States period, Qu Yuan's Battle begins with a firsthand account of going off to war, but concludes in another voice as the speakers become casualties. The Warring States period not only changed the political landscape of vast areas of China, but also deeply influenced future leaders, philosophers, poets, and artists. The First Emperor of the Qin dynasty (Shihuangdi, r. 246–210 BCE) emerged from this period as Emperor of a unified China, a system that would continue to 1911. Although the mausoleum of the First Emperor, outside Xi'an, has yet to be excavated, the surrounding necropolis has disclosed many treasures, including nearly ten thousand life-size terra-cotta figures of soldiers and horses. Buried in military battle formations, the warriors will ensure victory for the Emperor even in the afterlife.

SONG ON ENDURING THE COLD

Cao Cao (155–220)

North we climb the Taihang Mountains;

the going's hard on these steep heights!

Sheep Gut Slope dips and doubles,

enough to make the cartwheels crack.

Stark and stiff the forest trees,

the voice of the north wind sad;

crouching bears, black and brown, watch us pass;

tigers and leopards howl beside the trail.

Few men live in these valleys and ravines

where snow falls thick and blinding.

With a long sigh I stretch my neck;

a distant campaign gives you much to think of.

Why is my heart so downcast and sad?

All I want is to go back east,

but waters are deep and bridges broken;

halfway up, I stumble to a halt.

Dazed and uncertain, I've lost the old road,

night bearing down but nowhere to shelter;

on and on, each day farther,

men and horses starving as one.

Shouldering packs, we snatch firewood as we go,

chop ice to use in boiling our gruel —

That song of the Eastern Hills is sad,

a troubled tale that fills me with grief.

Travelers in Snow-covered Mountains, **Jing Hao** (active ca. 870–ca. 930). Hanging scroll, ink, white pigment and color on silk.

Song on Enduring the Cold *captures the physical, emotional, and psychological trauma of military expeditions in winter. Cao Cao was a Han dynasty military leader as well as a realistic poet. Accounts of his campaigns were later incorporated into the literary classic* Romance of the Three Kingdoms *(see page 171).*

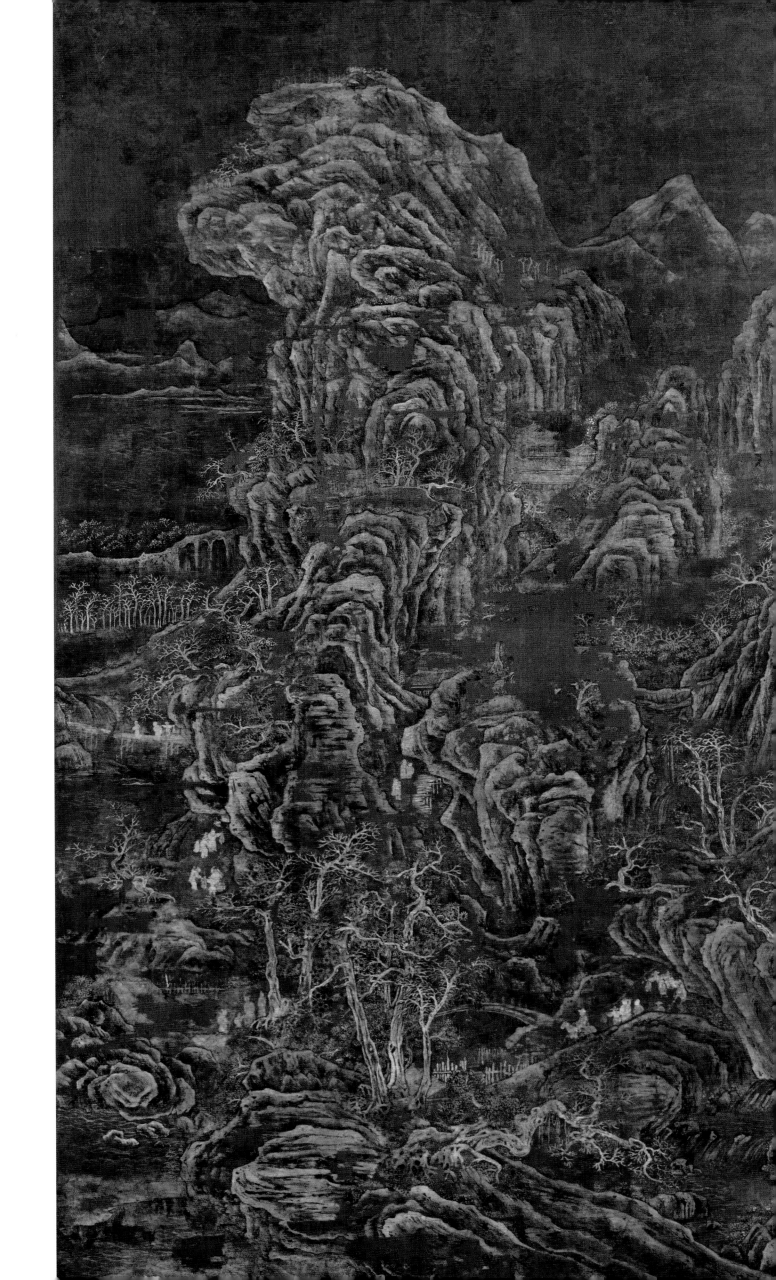

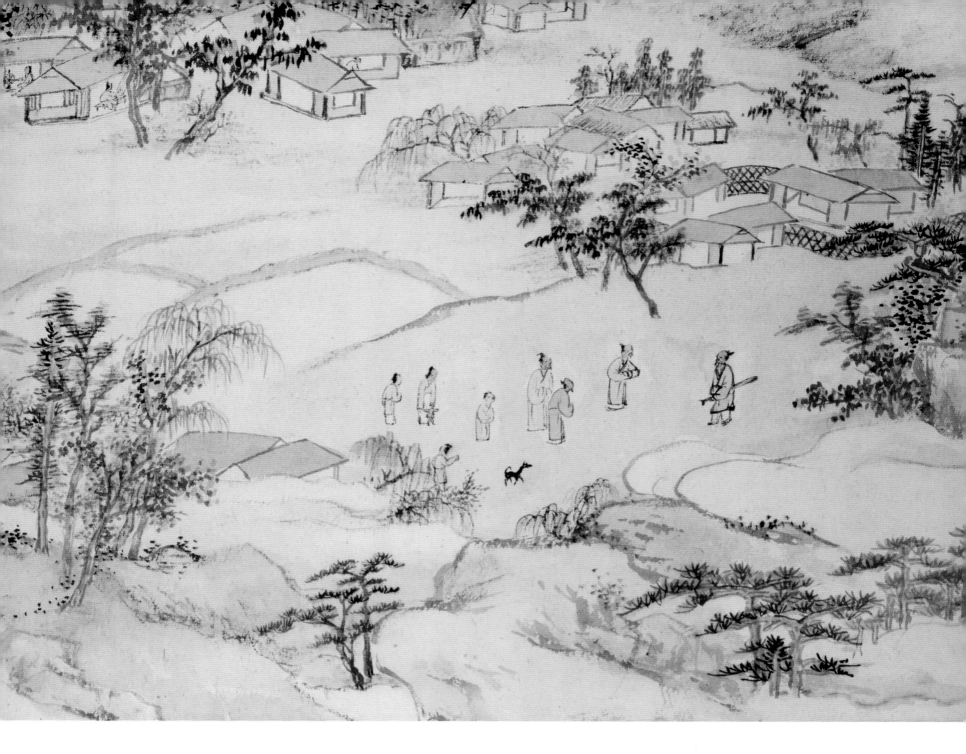

PEACH BLOSSOM SPRING

Tao Yuanming (Tao Qian, 365–427)

During the Taiyuan era [376–397] of the Jin dynasty, there was a man of Wuling who caught fish for a living. Once he was making his way up a valley stream and had lost track of how far he had gone when he suddenly came upon a forest of peach trees in bloom. For several hundred paces on either bank of the stream there were no other trees to be seen, but fragrant grasses, fresh and beautiful, and falling petals whirling all around.

The fisherman, astonished at such a sight, pushed ahead, hoping to see what lay beyond the forest. Where the forest ended there was a spring that fed the stream, and beyond that a hill. The hill had a small opening in it, from which there seemed to come a gleam of light. Abandoning his boat, the fisherman went through the opening. At first it was very narrow, with barely room for a person to pass, but after he had gone twenty or thirty paces, it suddenly opened out and he could see clearly.

A plain stretched before him, broad and flat, with houses and sheds dotting it, and rich fields, pretty ponds, and mulberry and bamboo around them. Paths ran north and south, east and west across the fields, and chickens and dogs could be heard from farm to farm. The men and women who passed back and forth in the midst, sowing and tilling the fields, were all dressed just like any other people, and from white-haired elders to youngsters with their hair unbound, everyone seemed carefree and happy.

The people, seeing the fisherman, were greatly startled and asked where he had come from. When he had answered all their questions, they invited him to return with them to their home, where they set out wine and killed a chicken to prepare a meal.

As soon as the others in the village heard of his arrival, they all came to greet him. They told him that some generations in the past their people had fled from the troubled times of the Qin dynasty (221–207 BCE) and had come with their wives and children and fellow villagers to this faraway place. They had never ventured out into the world again, and hence in time had come to be completely

The Peach Blossom Spring, Zha Shibiao (1615–1698). Handscroll, ink and color on paper. Detail.

cut off from other people. They asked him what dynasty was ruling at present — they had not even heard of the Han dynasty, to say nothing of the Wei and Jin dynasties that succeeded it. The fisherman replied to each of their questions to the best of his knowledge, and everyone sighed with wonder.

The other villagers invited the fisherman to visit their homes as well, each setting out wine and food for him. Thus he remained for several days before taking his leave. One of the villagers said to him, "I trust you won't tell the people on the outside about this."

After the fisherman had made his way out of the place, he found his boat and followed the route he had taken earlier, taking care to note the places that he passed. When he reached the prefectural town, he went to call on the governor and reported what had happened. The governor immediately dispatched men to go with him to look for the place, but though he tried to locate the spots that he had taken note of earlier, in the end he became confused and could not find the way again.

Liu Ziji of Nanyang, a gentleman-recluse of lofty ideals, heard the story and began delightedly making plans to go there, but before he could carry them out, he fell sick and died. Since then there have been no more "seekers of the ford."

Tao Yuaming lived during the Six Dynasties (or Southern and Northern Dynasties) period. As the names aptly suggest, this era saw several dynastic changes that divided China in half. It was a difficult time for Tao, who tried to attain a meaningful bureaucratic post but ultimately resigned to work as a farmer. Peach Blossom Spring is arguably his most famous work, alive with hope for a better future while mindful of the current state of flux. The metaphoric journey to the hidden-away land that Tao describes is reminiscent of tales of Shangri-la.

MULAN

Anonymous (5th or 6th century)

Tsiek tsiek and again tsiek tsiek,

Mulan weaves, facing the door.

You don't hear the shuttle's sound,

You only hear Daughter's sighs.

They ask Daughter who's in her heart,

They ask Daughter who's on her mind.

"No one is on Daughter's heart,

No one is on Daughter's mind.

Last night I saw the draft posters,

The Khan is calling many troops,

The army list is in twelve scrolls,

On every scroll there's Father's name.

Father has no grown-up son,

Mulan has no elder brother.

I want to buy a saddle and horse,

And serve in the army in Father's place."

In the East Market she buys a spirited horse,

In the West Market she buys a saddle,

In the South Market she buys a bridle,

In the North Market she buys a long whip.

At dawn she takes leave of Father and Mother,

In the evening camps on the Yellow River's bank.

She doesn't hear the sound of Father and Mother calling,

She only hears the Yellow River's flowing water cry tsien tsien.

At dawn she takes leave of the Yellow River,

In the evening she arrives at Black Mountain.

She doesn't hear the sound of Father and Mother calling,

She only hears Mount Yan's nomad horses cry tsiu tsiu.

She goes ten thousand miles on the business of war,

She crosses passes and mountains like flying.

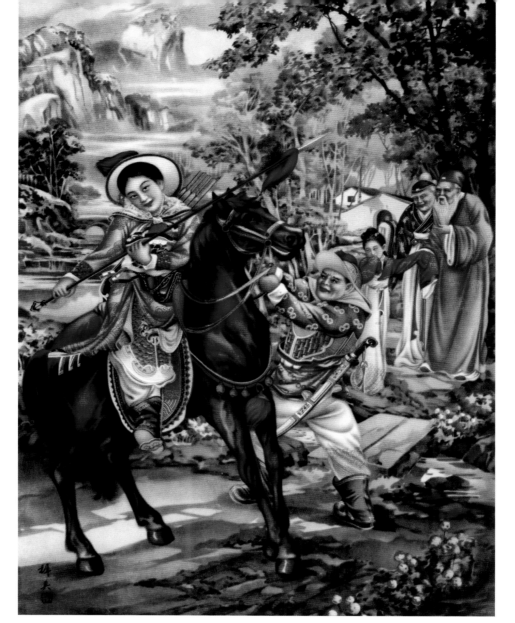

Mulan Enlists in the Army (1954). Poster, ink on paper.

Northern gusts carry the rattle of army pots,

Chilly light shines on iron armor.

Generals die in a hundred battles,

Stout soldiers return after ten years.

On her return she sees the Son of Heaven,

The Son of Heaven sits in the Splendid Hall.

He gives out promotions in twelve ranks

And prizes of a hundred thousand and more.

The Khan asks her what she desires.

"Mulan has no use for a minister's post.

I wish to ride a swift mount

To take me back to my home."

When Father and Mother hear Daughter is coming

They go outside the wall to meet her, leaning on each other.

When Elder Sister hears Younger Sister is coming

She fixes her rouge, facing the door.

When Little Brother hears Elder Sister is coming

He whets the knife, quick quick, for pig and sheep.

"I open the door to my east chamber,

I sit on my couch in the west room,

I take off my wartime gown

And put on my old-time clothes."

Facing the window she fixes her cloudlike hair,

Hanging up a mirror she dabs on yellow flower-powder

She goes out the door and sees her comrades.

Her comrades are all amazed and perplexed.

Traveling together for twelve years

They didn't know Mulan was a girl.

"The he-hare's feet go hop and skip,

The she-hare's eyes are muddled and fuddled.

Two hares running side by side close to the ground,

How can they tell if I am he or she?"

This folk story tells of Mulan, a girl who poses as a young man to join the army. The figure of Mulan continues to fire the Chinese imagination today, having been adapted to the stage and film.

DIALOGUE IN THE MOUNTAINS

Li Bo (701–762)

*Y*ou ask me why it is

 I lodge in the sapphire hills;

I laugh and do not answer —

 the heart is at peace.

Peach blossoms and flowing water

 go off, fading afar,

and there is another world

 that is not of mortal men.

Emperor Taizong Arriving at Jiucheng Palace, **Ming dynasty (1368–1644). Hanging scroll mounted on panel, ink, color, and gold on silk.**

Echoing the themes and imagery of Tao Yuanming's Peach Blossom Spring *(see page 164), Li Bo finds solace while journeying in the mountains. The flight away from bustling cities full of merchants and officials allows the poet to fantasize about transcending the common world to be among immortals in the heavens.*

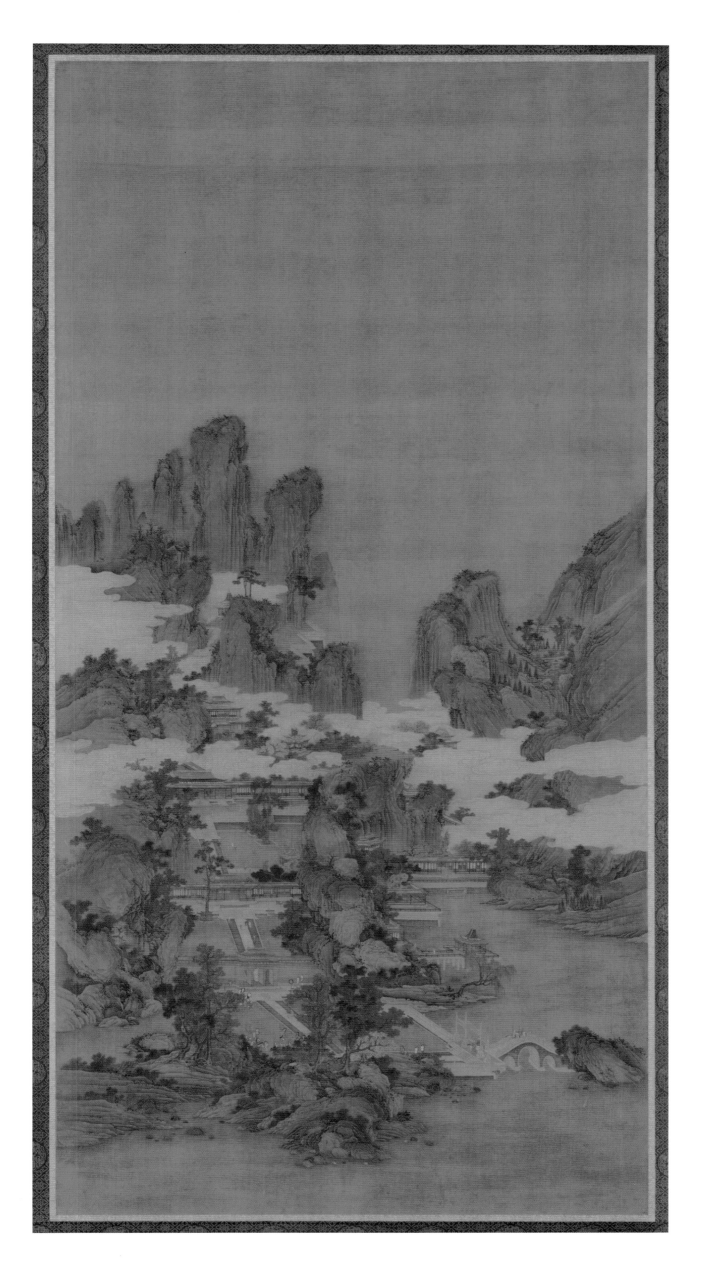

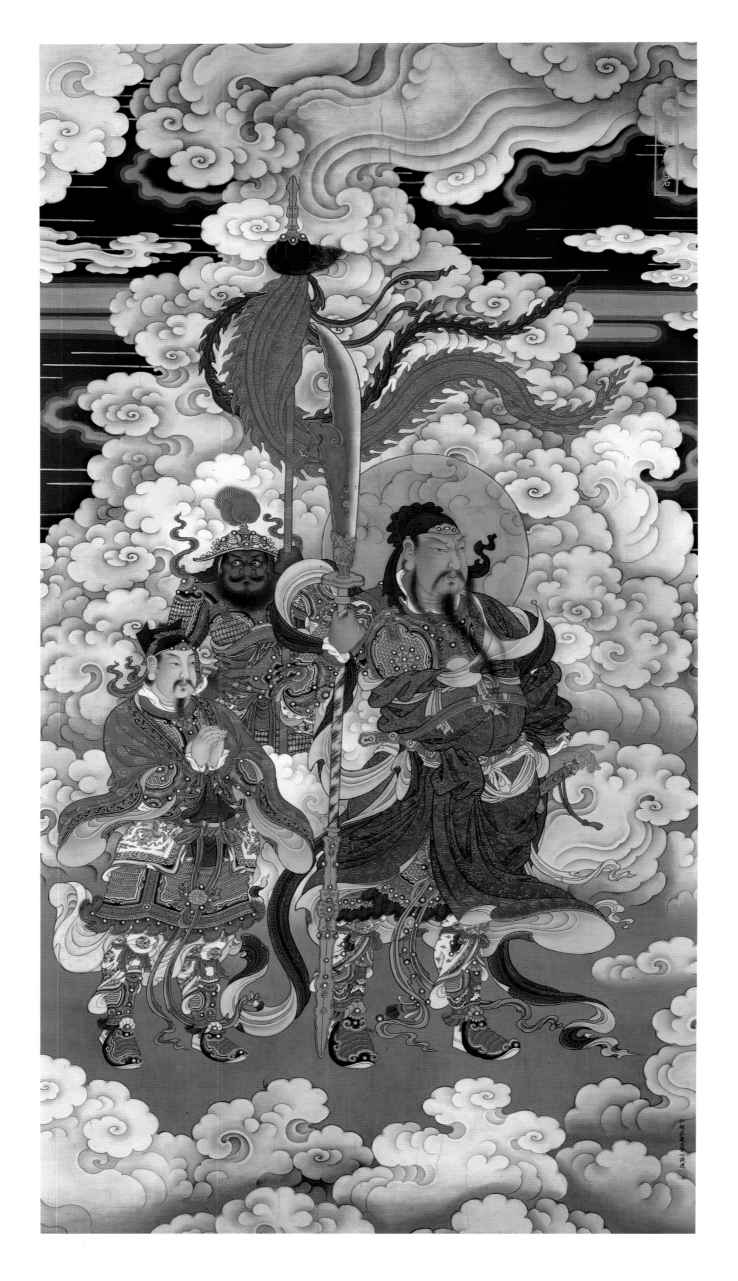

ROMANCE OF THE THREE KINGDOMS

Luo Guanzhong, attrib. (ca. 1330–ca. 1400)

*H*ere begins our tale. The empire, long divided, must unite; long united, must divide. Thus it has ever been. In the closing years of the Zhou dynasty seven kingdoms warred among themselves until the kingdom of Qin prevailed and absorbed the other six. But Qin soon fell, and on its ruins two opposing kingdoms, Chu and Han, fought for mastery until the kingdom of Han prevailed and absorbed its rival, as Qin had done before. The Han court's rise to power began when the Supreme Ancestor slew a white serpent, inspiring an uprising that ended with Han's ruling a unified empire.

. . . .

. . . As they drank, they watched a strapping fellow pushing a wheelbarrow stop to rest at the tavern entrance. "Some wine, and quickly — I'm off to the city to volunteer," the stranger said as he entered and took a seat. Xuande observed him: a man of enormous height, nine spans tall, with a two-foot-long beard flowing from his rich, ruddy cheeks. He had glistening lips, eyes sweeping sharply back like those of the crimson-faced phoenix, and brows like nestling silkworms. His stature was imposing, his bearing awesome. Xuande invited him to share their table and asked who he was.

"My surname is Guan," the man replied. "My given name is Yu; my style, Changsheng, was later changed to Yunchang. I am from Jielang in Hedong, but I had to leave there after killing a local bully who was persecuting his neighbors and have been on the move these five or six years. As soon as I heard about the recruitment, I came to sign up."

. . . .

. . . Amid the smoke of incense they performed their ritual prostration and took their oath:

We three, though of separate ancestry, join in brotherhood here, combining strength and purpose, to relieve the present crisis. We will perform our duty to the Emperor and protect the common folk of the land. We dare not hope to be together always but hereby vow to die the selfsame day.

Emperor Guan, Qing dynasty (ca. 1700). Hanging scroll, ink, color, and gold on silk.

Romance of the Three Kingdoms is an early Ming dynasty novel that may in fact date to the Yuan dynasty, but has traditionally been attributed to author Luo Guanzhong (ca. 1330–ca. 1400) with probable editorial and content contributions from later writers. With its earliest woodblock edition dated to 1522, the novel's 120 chapters encapsulate in rich detail the dissolution of the Han dynasty's empire and the subsequent battles among three warring kingdoms.

Three important characters are Zhang Fei, Liu Xuande, and Guan Yu. Excerpted here are the novel's opening paragraphs, an introduction to Guan Yu, and the trio's famous "brotherhood" oath initiating their historical journey. The vibrant Qing dynasty hanging scroll depicts Guan Yu as "Emperor Guan," a designation popularly bestowed on him during the Ming dynasty. In addition, Guan Yu was adopted by both Daoists and Buddhists as an important figure in the heavenly pantheon.

RIGHT: *Chrysanthemum-shaped Porcelain Saucer,* Qing dynasty (dated 1774). Molded porcelain with clear glaze, overglaze cinnabar and black enamel decoration, and gold inscription on reserved ground.

OPPOSITE: *Chrysanthemum-shaped Lacquer Saucer,* Qing dynasty (dated 1774). Lacquered wood over silk armature with painted inscription.

POETIC INSCRIPTION

Emperor Qianlong (1711–1799; r. 1736–1795)

The varnishers of Wu [Suzhou] may be compared with ingenious arithmeticians.

The lacquer wares imitated from ancient pieces are probably better than the originals.

They make molds without using wood or tin.

They finished the wares without carving and polishing.

The color of this plate is like an Immortal drunken, with red face.

This is [the reason] that in everything one should study the ancients.

I have tried to express my ideas in verse,

But I am afraid that I have already said too much.

The exquisite works created for Qing dynasty Emperors by the Imperial Palace Workshops hold clues into the tastes of these elite few. In general, the saucer shape evoking the chrysanthemum suggests the beauty of this autumn-blooming flower as well as its usage in traditional Chinese medicinal concoctions and to flavor tea. The saucer commissioned by the Emperor Qianlong continues a Chinese tradition of lacquerwork that extends back to the Hemudu Culture (5000–3200 BCE) in Zhejiang province along China's southeast coast. The "publication" of the verse on such finely crafted works suggests that poem and chrysanthemum pleased Emperor Qianlong, who both composed the verse and executed the saucer's calligraphy.

吳下髤工巧算偽仿
爲或以奮還過脫胎
郎用木耶錫成器同
勞琢喻與磨博士品局
謝肯事喻仙人顏侶斯
朱熲酌宜師古靈侶多
謂欲摘吟慨即
乾隆甲午御題

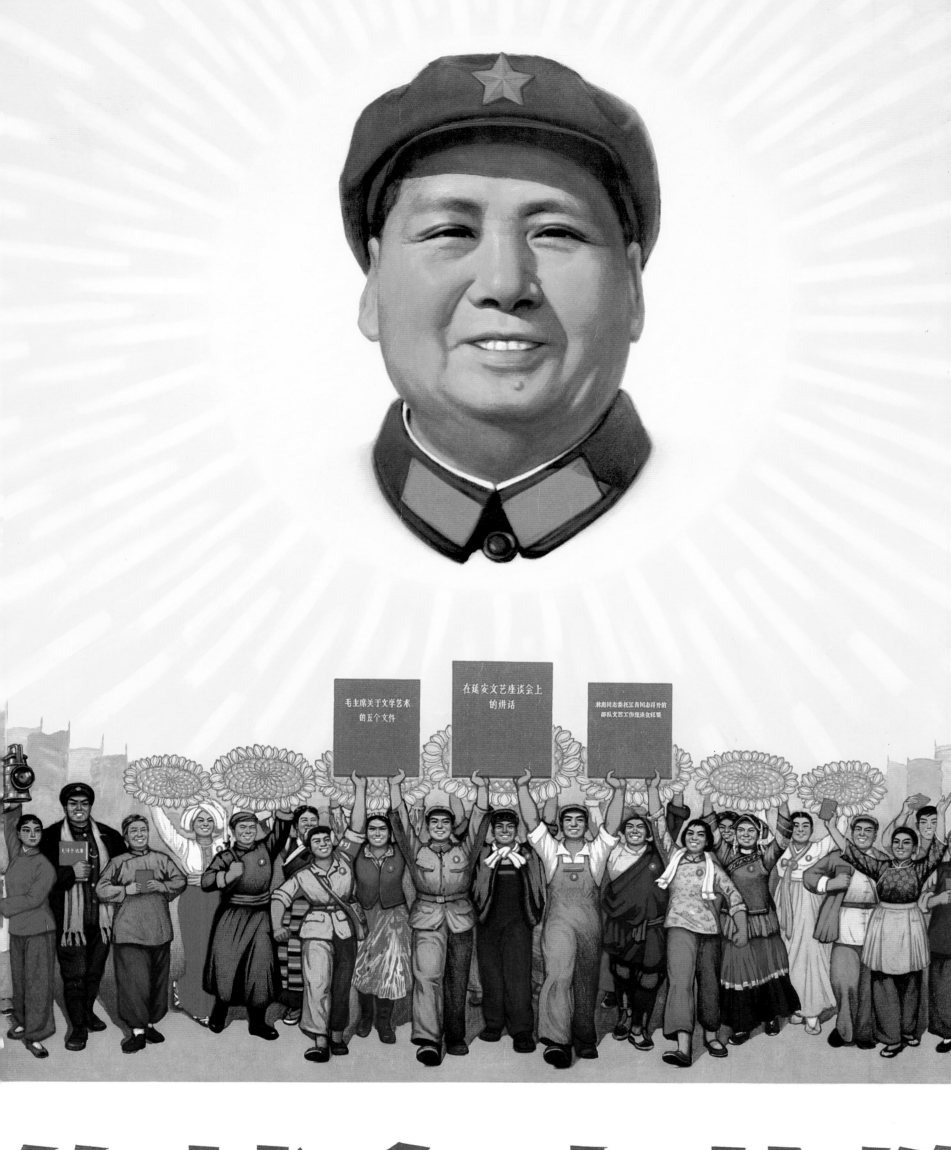

的革命文艺路

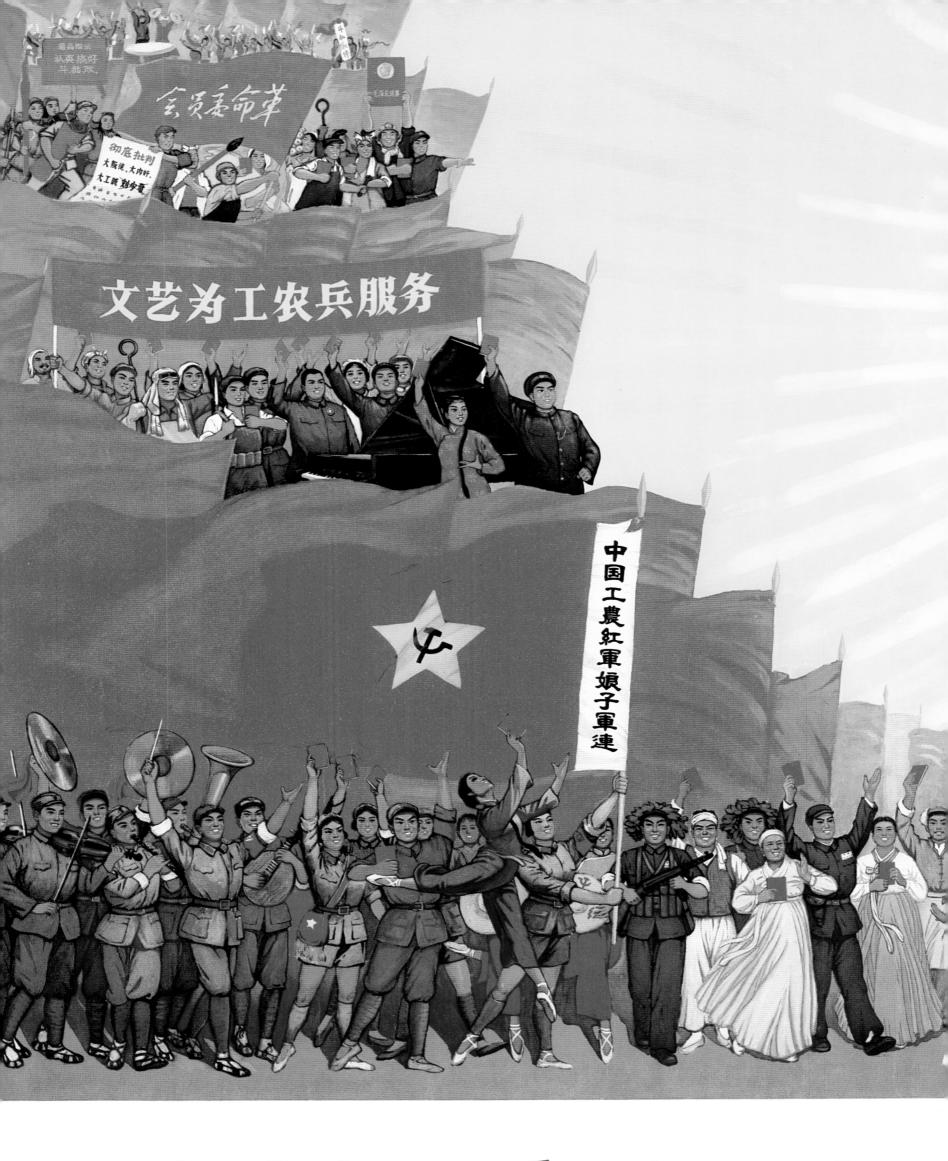

YAN'AN FORUM ON LITERATURE AND ART

Mao Zedong (1893–1976)

\mathcal{A}lthough man's social life is the only source of literature and art and is incomparably livelier and richer in content, the people are not satisfied with life alone and demand literature and art as well. Why? Because, while both are beautiful, life as reflected in works of literature and art can and ought to be on a higher plane, more intense, more concentrated, more typical, nearer the ideal, and therefore more universal than actual everyday life. Revolutionary literature and art should create a variety of characters out of real life and help the masses to propel history forward. For example, there is suffering from hunger, cold and oppression on the one hand, and exploitation and oppression of man by man on the other. These facts exist everywhere and people look upon them as commonplace. Writers and artists concentrate such everyday phenomena, typify the contradictions and struggles within them and produce works which awaken the masses, fire them with enthusiasm and impel them to unite and struggle to transform their environment. Without such literature and art, this task could not be fulfilled, or at least not so effectively and speedily.

Advance Victoriously While Following Chairman Mao's Revolutionary Line in Literature and the Arts, **(1968). Triptych poster, ink on paper.**

In China, literature and art have intertwined with politics since time immemorial. Mao Zedong, chairman of the People's Republic of China from 1949 until his death in 1976, understood these close relationships and manipulated them to achieve his vision. Like leaders before him, he revisited the past to critique the present and shape the future. The brightly colored political poster seen here embodies revolutionary art. The massive parade highlights China's many minority groups, military, and politicians all marching in unison beneath the bright sun of Chairman Mao. Such posters and writings endowed Mao with the visual and literary gravitas he needed to remain in power.

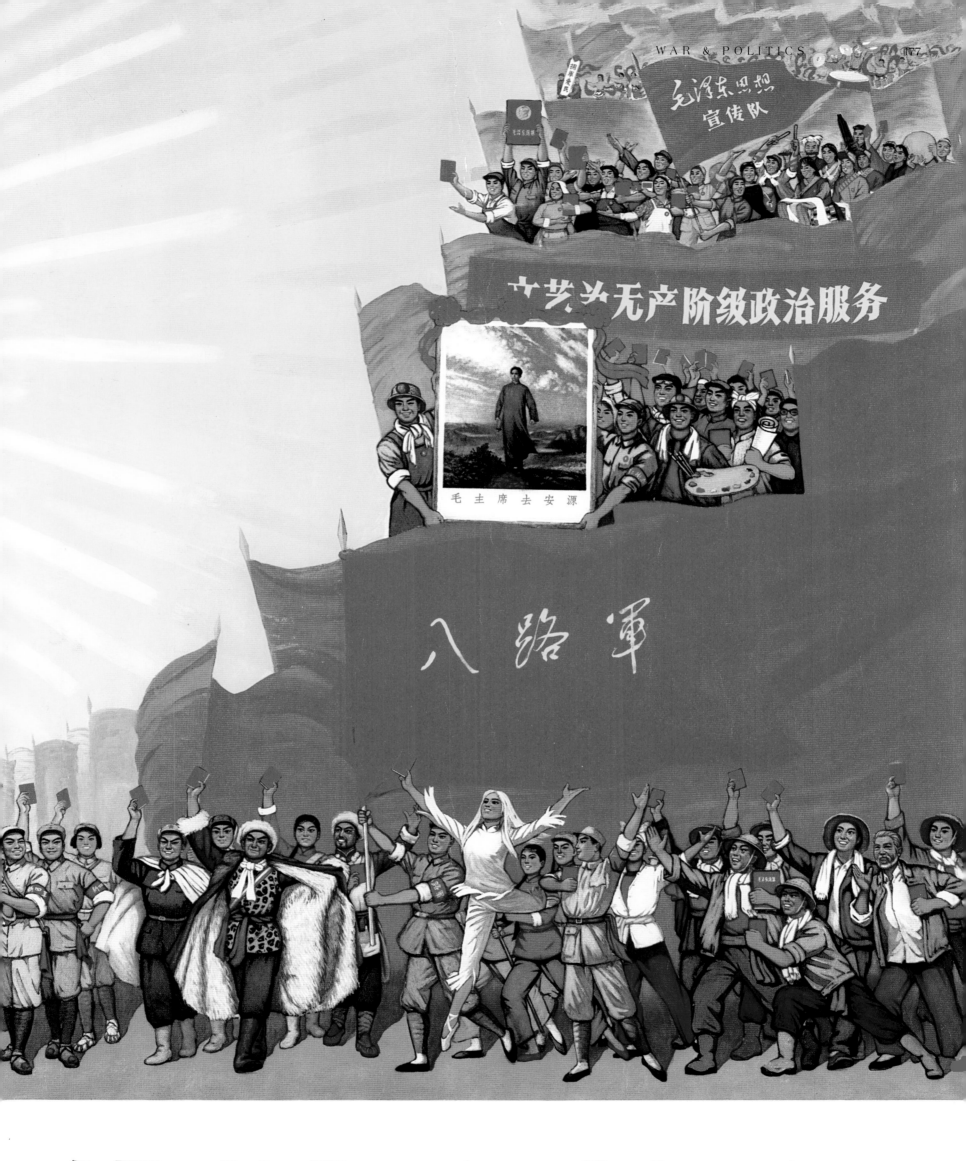

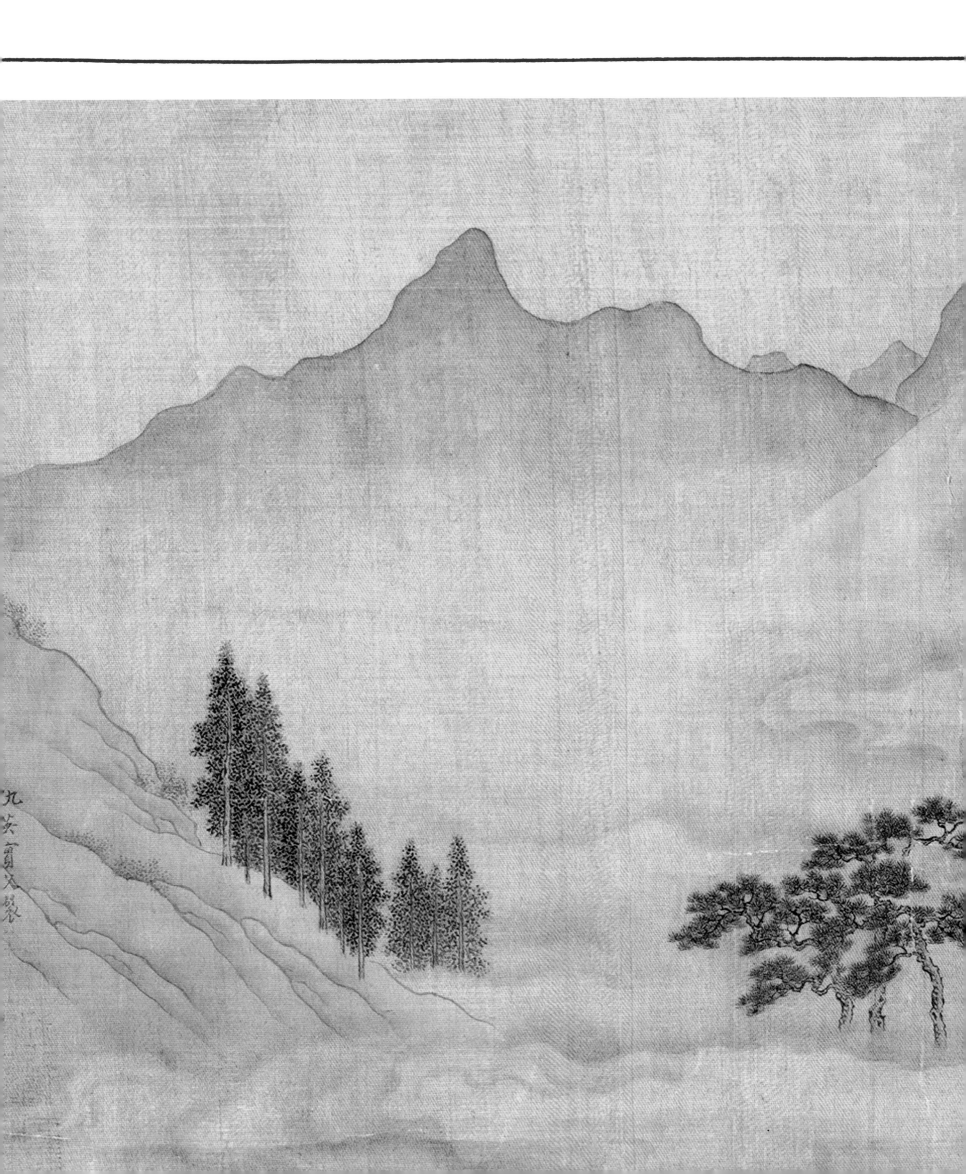

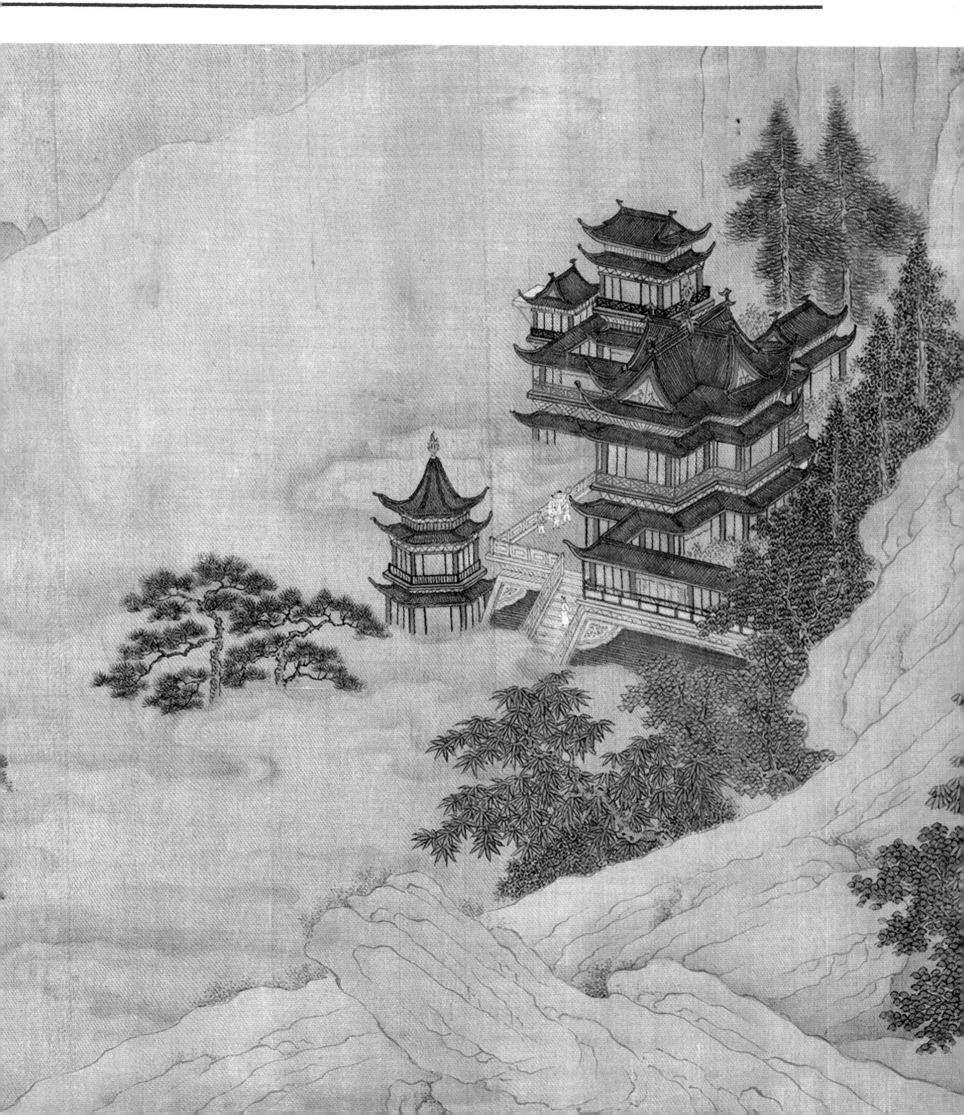

LOTUS SUTRA

(composed in India 1st century BCE to 1st century CE, translated into Chinese by 255)

At that time the bodhisattva Inexhaustible Intent immediately rose from his seat, bared his right shoulder, pressed his palms together and, facing the Buddha, spoke these words: "World-Honored One, this Bodhisattva Perceiver of the World's Sounds — why is he called Perceiver of the World's Sounds?"

The Buddha said to Bodhisattva Inexhaustible Intent: "Good man, suppose there are immeasurable hundreds, thousands, ten thousands, millions of living beings who are undergoing various trials and suffering. If they hear of this bodhisattva Perceiver of the World's Sounds and single-mindedly call his name, then at once he will perceive the sound of their voices and they will all gain deliverance from their trials.

"If someone, holding fast to the name of Bodhisattva Perceiver of the World's Sounds, should enter a great fire, the fire could not burn him. This would come about because of this bodhisattva's authority and supernatural power. If one were washed away by a great flood and called upon his name, one would immediately find himself in a shallow place.

"Suppose there were a hundred, a thousand, ten thousand, a million living beings who, seeking for gold, silver, lapis lazuli, seashell, agate, coral, amber, pearls, and other treasures, set out on the great sea. And suppose a fierce wind should blow their ship off course and it drifted to the land of rakshasa demons. If among those people there is even just one who calls the name of Bodhisattva Perceiver of the World's Sounds, then all those people will be delivered from their troubles with the rakshasas. This is why he is called Perceiver of the World's Sounds.

"If a person who faces imminent threat of attack should call the name of Bodhisattva Perceiver of the World's Sounds, then the swords and staves wielded by his attackers would instantly shatter into so many pieces and he would be delivered.

"Though enough yakshas and rakshasas to fill all the thousand-millionfold world should try to come and torment a person, if they hear him calling the name of Bodhisattva Perceiver of the World's Sounds, then these evil demons will not even be able to look at him with their evil eyes, much less do him harm.

"Suppose there is a person who, whether guilty or not guilty, has had his body imprisoned in fetters and chains, cangue and lock. If he calls the name of Bodhisattva Perceiver of the World's Sounds, then all his bonds will be severed and broken and at once he will gain deliverance.

"Suppose, in a place filled with all the evil-hearted bandits of the thousand-millionfold world, there is a merchant leader who is guiding a band of merchants carrying valuable treasures over a steep and dangerous road, and that one man shouts out these words: 'Good men, do not be afraid! You must single-mindedly call on the name of Bodhisattva Perceiver of the World's Sounds. This bodhisattva can grant fearlessness to living beings. If you call his name, you will be delivered from these evil-hearted bandits!' When the band of merchants hear this, they all together raise their voices, saying, 'Hail to the Bodhisattva Perceiver of the World's Sounds!' And because they call his name, they are at once able to gain deliverance. Inexhaustible Intent, the authority and supernatural power of the bodhisattva and mahasattva Perceiver of the World's Sounds are as mighty as this!

"If there should be living beings beset by numerous lusts and cravings, let them think with constant reverence of Bodhisattva Perceiver of the World's Sounds and then they can shed their desires. If they have great wrath and ire, let them think with constant reverence of Bodhisattva Perceiver of the World's Sounds and then they can shed their ire. If they have great ignorance and stupidity, let them think with constant reverence of Bodhisattva Perceiver of the World's Sounds and they can rid themselves of stupidity.

"Inexhaustible Intent, the Bodhisattva Perceiver of the World's Sounds possesses great authority and supernatural powers, as I have described, and can confer many benefits. For this reason, living beings should constantly keep the thought of him in mind.

"If a woman wishes to give birth to a male child, she should offer obeisance and alms to Bodhisattva Perceiver of the World's Sounds and then she will bear a son blessed with merit, virtue, and wisdom. And if she wishes to bear a daughter, she will bear one with all the marks of comeliness, one who in the past planted the roots of virtue and is loved and respected by many persons.

"Inexhaustible Intent, the Bodhisattva Perceiver of the World's Sounds has power to do all this. If there are living beings who pay respect and obeisance to Bodhisattva Perceiver of the World's Sounds, their good fortune will not be fleeting or vain. Therefore living beings should all accept and uphold the name of Bodhisattva Perceiver of the World's Sounds."

PRECEDING SPREAD: *Enchanted Dwelling in the Hills,* Qiu Ying (1494–1552). Hanging scroll, ink and color on silk. Detail.

RIGHT: *The Water and Moon Guanyin Bodhisattva,* Liao dynasty (916–1125). Wood with paint.

The name of the bodhisattva Avalokitesvara can be translated from its original as "Perceiver of the World's Sounds." A bodhisattva chooses not to enter nirvana so as to help all beings reach enlightenment. Originally a male bodhisattva, the figure of Avalokitesvara — Guanyin in Chinese — arrived in China along with missionaries from India, who carried with them Lotus Sutra texts. It was translated into Chinese by the year 255, but the 406 translation by Kumarajiva, a Central Asian Buddhist monk, widely increased its circulation. Over time, Avalokitesvara assumed more feminine characteristics in Chinese visual arts and was eventually depicted as a female, occasionally accompanied by a child. The painted wood example shown here dates to the Liao dynasty and is one of the most spectacular examples of this figure in any collection, in or out of China.

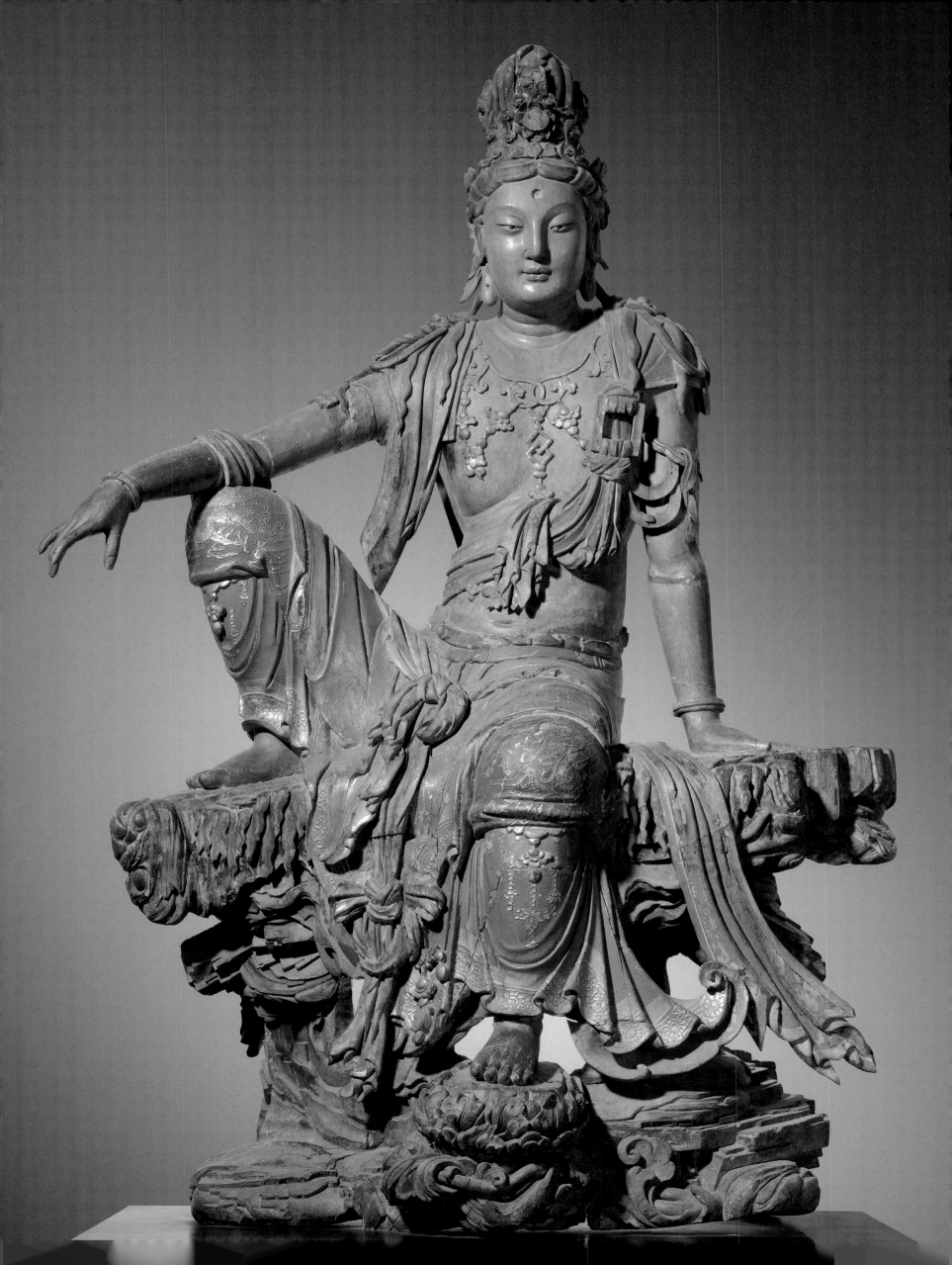

廣壽子

老君於祝融時號廣壽子說按摩通精經教安
神之道祝融行之重禮樂配陰陽陶鑄為器以
變生冷之毒時有慶雲見朱鳳呈祥

廣成子

老君於軒轅黃帝時在崆峒山號廣成子說至
道泰生經帝詣山親問理國之道戰蚩尤鑄九
鼎鼎成而白日上昇

TRANSFORMATION OF LAOJUN

Anonymous (3rd–6th century)

*L*ord Lao [Laojun] transformed himself

during the Wuji era.

Imperceptible, he left and stayed in

the Palace of the Yellow Chamber,

his purified body, clear and luminous,

the emptiness alike.

Its bright radiance diffused

through the Eight Extremities.

As soon as the True Lord had appeared

he met the Nine Dukes.

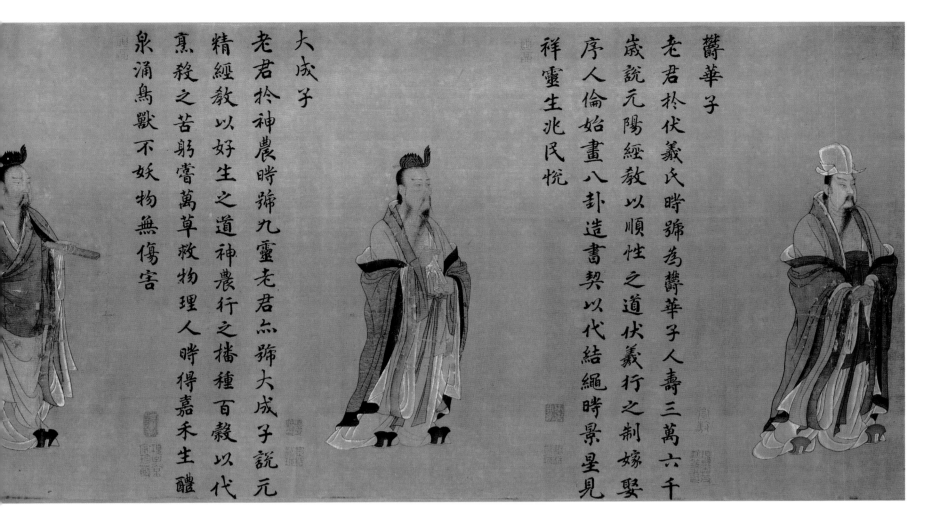

大成子 鬱華子

泉涌烏獸不妖物無傷害 烹殺之苦躬嘗萬草救物理人時得嘉禾生醴 精經教以好生之道神農行之播種百穀以代 老君扵神農時號九靈老君亦號大成子說元

老君扵伏羲氏時號為鬱華子人壽三萬六千 歲說元陽經教以順性之道伏羲行之制嫁娶 序人倫始畫八卦造書契以代結繩時景星見 祥靈生兆民悅

The Transformations of Laojun, Wang Liyong (active 1120–after 1145). Handscroll, ink and color on silk. Detail.

The journey was long,

the joy without end.

Driving a team of nine dragons

with a retinue of carriages and horses,

he ascended the eight layers (of Mount Kunlun)

up to the Jade Portal

From the Golden Tower Terrace

he gazed at Mount Hua.

On the Mount a True Man

transmitted me a book,

teaching me that for the study of the Way

one has to be pure.

Take heed lest unlawful desires

destroy your body.

Purify and cleanse your body

and you will live long. . . .

The 369-line poem Laojun Bianhua Wuji Jing (Transformation of Laojun) *is preserved in the Ming dynasty's 1445 edition of the* Daozang. *The manifestations of Laojun, or Laozi, are described as occurring across the spectrum of time and place. Daoist texts suggest that he emerged during primordial times, then was born to educate imperial leaders and transmit the Daodejing to followers (see pages 157 and 210). Wang Liyong's handscroll depicts in exquisite detail physical transformations of Laojun while noting his extraordinary feats in the adjacent texts.*

佛說

蜜多心經

般若波羅蜜多心經

觀自在菩薩，行深般若波羅蜜多時，照見五蘊皆空，度一切苦厄。舍利子，色不異空，空不異色，色即是空，空即是色，受想行識，亦復如是。舍利子，是諸法空相，不生不滅，不垢不淨，不增不減。是故空中無色，無受想行識，無眼耳鼻舌身意，無色聲香味觸法，無眼界，乃至無意識界，無無明，亦無無明盡，乃至無老死，亦無老死盡，無苦集滅道，無智亦無得。以無所得故，菩提薩埵，依般若波羅蜜多故，心無罣礙，無罣礙故，無有恐怖，遠離顛倒夢想，究竟涅槃。三世諸佛，依般若波羅蜜多故，得阿耨多羅三藐三菩提。故知般若波羅蜜多，是大神咒，是大明咒，是無上咒，是無等等咒，能除一切苦，真實不虛。故說般若波羅蜜多咒，即說咒曰：揭諦揭諦，波羅揭諦，波羅僧揭諦，菩提薩婆訶。

THE HEART SUTRA

(ca. 1st century, translated into Chinese by end of 2nd century)

LEFT: *The Heart Sutra,* Weng Fanggang (1733–1818). Album leaf, ink on bodhi-tree leaves and paper.

OPPOSITE, LEFT: *The Heart of the Perfection of Wisdom* (9th century). Ink and color on paper.

[I. The invocation]
Homage to the Perfection of Wisdom, the lovely, the holy!

[II. The prologue]
Avalokita, the holy Lord and Bodhisattva, was moving in the deep course of the wisdom which has gone beyond. He looked down from on high, he beheld but five heaps, and he saw that in their own-being they were empty.

[III. The dialectics of emptiness. First stage]
Here, O Sariputra, form is emptiness, and the very emptiness is form; emptiness does not differ from form, form does not differ from emptiness; whatever is form, that is emptiness, whatever is emptiness, that is form. The same is true of feelings, perceptions, impulses, and consciousness.

[IV. The dialectics of emptiness. Second stage]
Here, O Sariputra, all dharmas are marked with emptiness; they are not produced or stopped, not defiled or immaculate, not deficient or complete.

[V. The dialectics of emptiness. Third stage]
Therefore, O Sariputra, in emptiness there is no form, nor feeling, nor perception, nor impulse, nor consciousness; no eye, ear, nose, tongue, body, mind; no forms, sounds, smells, tastes, touchables or objects of mind; no sight-organ-element, and so forth, until we come to: no mind-consciousness-element; there is no ignorance, no extinction of ignorance, and so forth, until we come to: there is no decay and death, no extinction of decay and death; there is no suffering, no origination, no stopping, no path; there is no cognition, no attainment, and no non-attainment.

[VI. The concrete embodiment and practical basis of emptiness]
Therefore, O Sariputra, it is because of his indifference to any kind of personal attainment that a Bodhisattva, through having relied on the perfection of wisdom, dwells without thought-coverings. In the absence of thought-coverings he has not been made to tremble, he has overcome what can upset, and in the end he attains to Nirvana.

[VII. Full emptiness is the basis also of Buddhahood]
All those who appear as Buddhas in the three periods of time fully awake to the utmost, right and perfect enlightenment because they have relied on the perfection of wisdom.

[VIII. The teaching brought within reach of the comparatively unenlightened]
Therefore one should know the Prajnaparamita as the great spell, the spell of great knowledge, the utmost spell, the unequalled spell, allayer of all suffering, in truth — for what could go wrong? By the Prajnaparamita has this spell been delivered. It runs like this: Gone, Gone, Gone beyond, Gone altogether beyond, 0 what an awakening, All Hail!

This completes the Heart of Perfect Wisdom.

Comprised of just 260 Chinese characters, the Heart Sutra *is is widely regarded as one of the most important works in Buddhist literature. It challenges the reader to remember the brevity of all nature and existence while also highlighting the interdependence of all nature and existence. Such interconnectivity is well represented in a ninth-century scripture in the shape of a five-story pagoda (left). Above, calligrapher Wang Fanggang's* Heart Sutra *album leaves demonstrates that the text was incorporated into the imperial collection. The work is written on leaves of the bodhi tree—significant ever since Shakyamuni Buddha meditated beneath one during his enlightenment.*

THE ESTABLISHMENT OF THE WHITE HORSE TEMPLE

Yang Xuanzhi (fl. 555)

The establishment of the Baima Temple (Temple of the White Horse) by Emperor Ming (58–75) of the Han marked the introduction of Buddhism into China. The temple was located on the south side of the Imperial Drive, three tricents outside the Xiyang Gate.

The emperor dreamed of the golden man sixteen Chinese feet tall, with the aureole of sun and moon radiating from his head and his neck. A "golden god," he was known as Buddha. The emperor dispatched envoys to the Western Regions in search of the god, and, as a result, acquired [Buddhist] scriptures and images. At the time, because the scriptures were carried into China on the backs of white horses, [White Horse] was adopted as the name of the temple.

After the emperor's death, a hall for meditation was built on his tomb. Thereafter stupas were sometimes constructed [even] on the graves of the common people.

The scripture cases housed in the temple have survived until this day; to them incense was often burned and good care was given. At times, the scripture cases gave off light that illuminated the room and hall. As a result, both laymen and Buddhist devotees reverently worshiped as if they were facing the real Buddha.

In front of the stupa were pomegranate trees and grapevines that were different from those grown elsewhere: they had luxuriant foliage and huge fruits. The pomegranates [each] weighed seven catties, and the grapes were bigger than dates. The taste of both was especially delicious, superior [to all others] in the capital. At harvest time the emperor often came in person to pick them. Sometimes he would give [some] to ladies in the harem, who in turn would present them as gifts to their relatives. They were considered rare delicacies. The recipients often hesitated to eat them; instead, the fruits would be passed on and on to several households. In the capital there was a saying:

> Sweet pomegranates of the White Horse,
> Each fruit is as valuable as an ox.

Luohan Demonstrating the Power of the Buddhist Sutras to Daoists, **Zhou Jichang (active late 12th century). Hanging scroll mounted as panel, ink and color on silk.**

Yang Xuanzhi's record of the religious, social, and political atmosphere of Luoyang, Henan province remains an important source of information on daily life in China. Yang's fluid narrative blends historical fact with local flavor and local Buddhist lore, such as the sutra cases illuminating the sacred halls. Zhou Jichang's hanging scroll depicts sutras emitting rays of light, which Buddhist monks use to overwhelm arguments by Daoists.

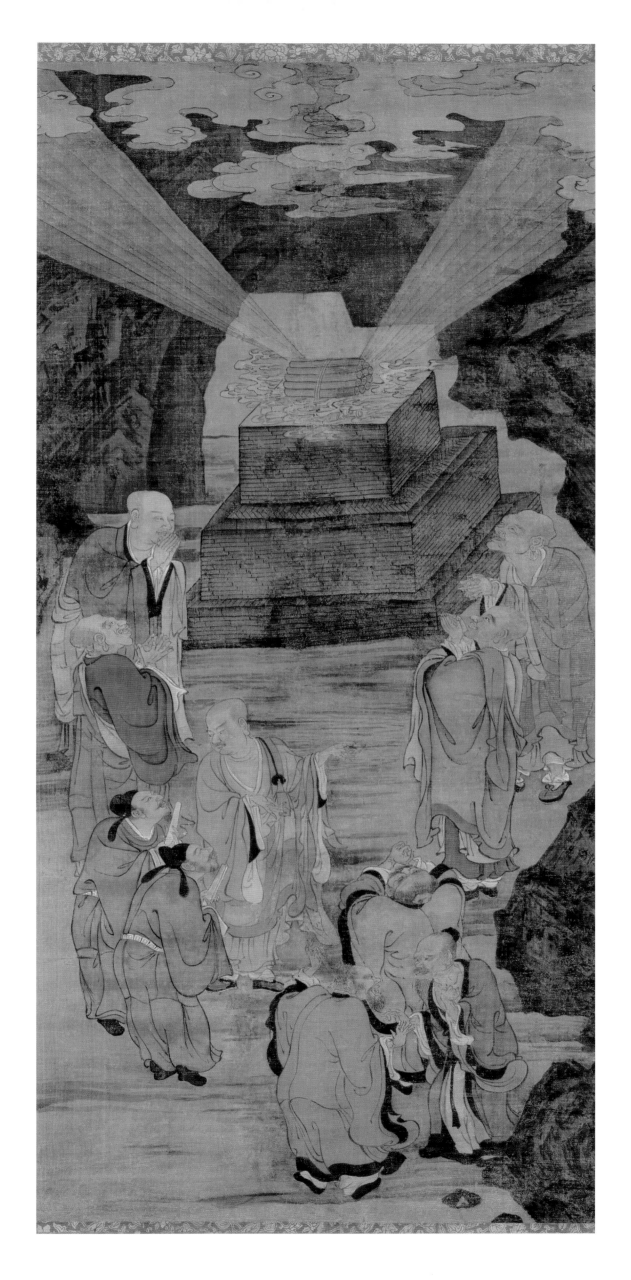

TRAVELING ACCOUNT OF BUDDHIST PILGRIM MONKS HUISHENG AND SONG YUN

Yang Xuanzhi (fl. 555)

*I*n the Wenyi Ward was Song Yun's residence. [Song] Yun, a native of Dunhuang, went with Huisheng as [Wei dynasty] envoys to the Western Regions. In the winter, that is, the eleventh month, of the first year of Shengui period [December 518–January 519], the empress dowager dispatched Huisheng of the Chongling Temple (Temple of Respect for the Efficacious) to go to the Western Regions [i.e., to India] in search of [Buddhist] sutras. Altogether they acquired one hundred seventy titles, all the best of Mahayana classics.

After leaving the capital and traveling westward for forty days, they reached the Chiling (Bare Mountain Range), the western boundary of the state and the location of frontier passes [of present-day Qinghai province].

The Chiling was so named because no vegetation would grow there. On the mountain, birds and mice shared the same caves.

They belonged to different species but the same zoological family. The male birds and female mice mated together; hence the name "the cave where birds and mice cohabited."

Leaving Chiling, and traveling westward for twenty-three days, they crossed the Liusha (Shifting sands) [desert] area, and arrived at the kingdom of Tuyuhun. While they were en route, it was very cold, windy, and snowy. Blowing sand and flying pebbles filled their eyes. The city of Tuyuhun and its vicinity were the only places warmer than elsewhere. The kingdom had a writing system, and costumes similar to those of the Wei. But their customs and political system were of the barbarian type.

Traveling Monk (10th century). **Ink and color on paper.**

Here Yang Xuanzhi — who also authored the previous entry — documents important historical events in enough detail to allow for a partial reconstruction. As local monks journeyed to India to retrieve original Buddhist scriptures, the treacherous and desolate landscape conditions took a severe toll on their bodies, clothing, and gear, illustrating the importance of their mission. The masterpiece Traveling Monk, *which depicts a determined but weary traveler with scriptures in tow, was discovered in one of the ancient libraries secluded in the Dunhuang caves along the Silk Road, which connected China to Central Asia and India.*

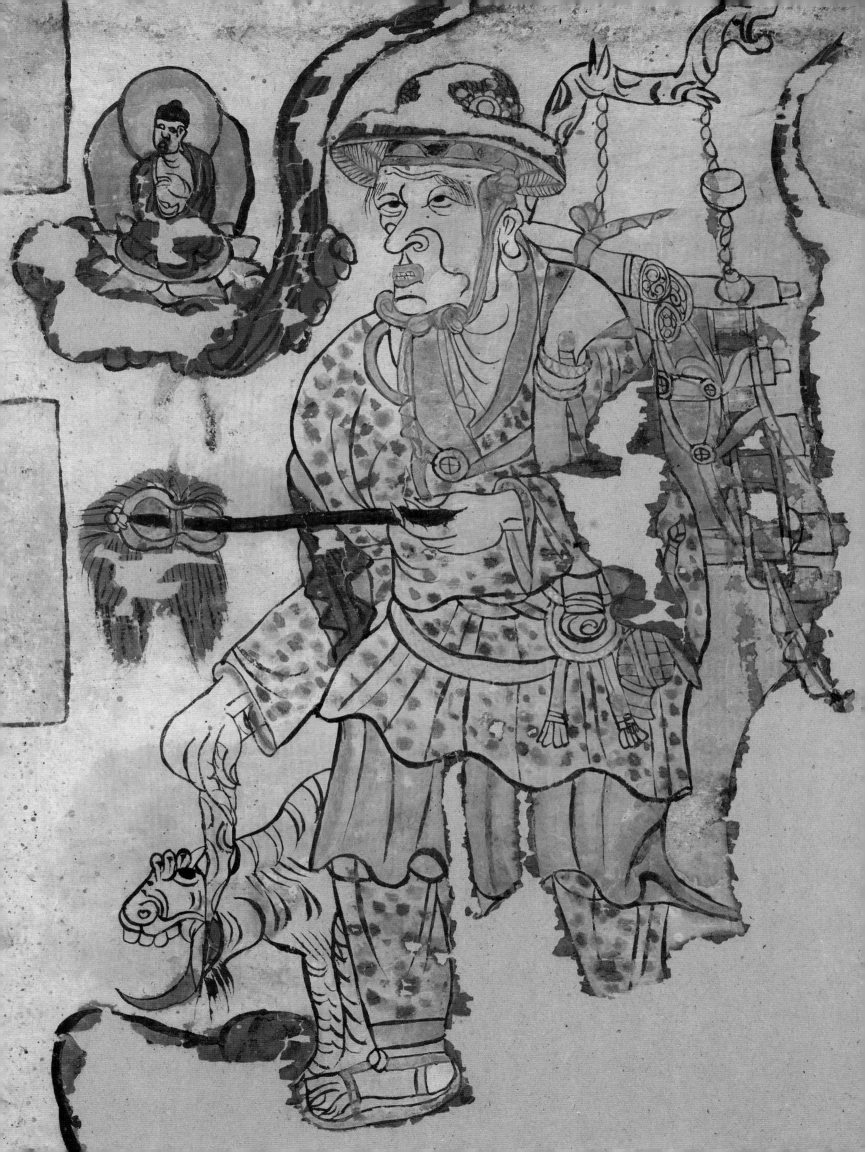

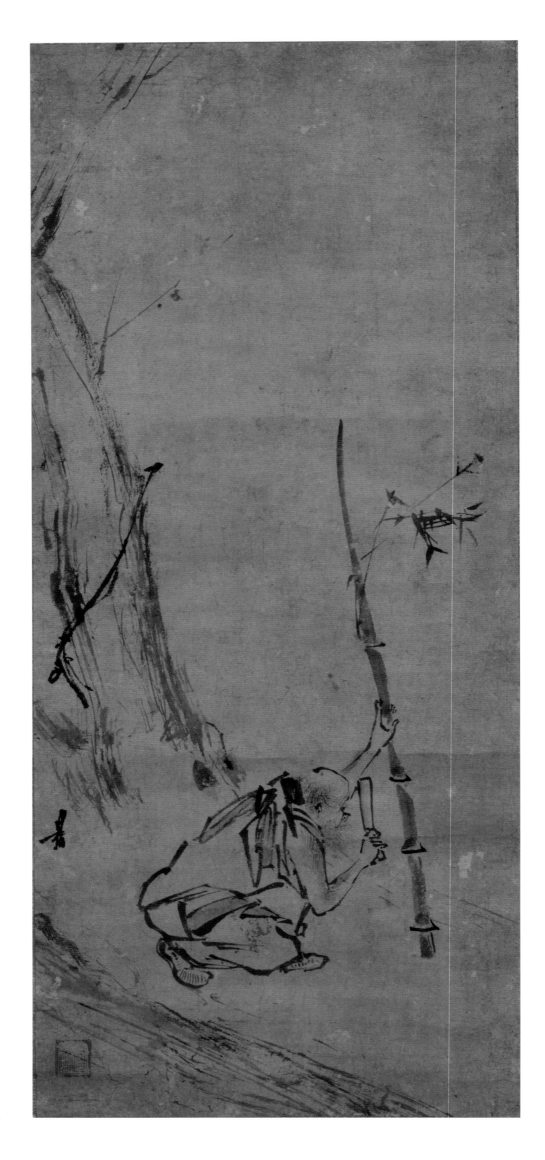

THE PLATFORM SUTRA

Huineng, the Sixth Patriarch (638–713)

The Sixth Patriarch said: "Hear me as I explain to you. If men in later generations wish to seek the Buddha, they have only to know that the Buddha mind is within sentient beings; then they will be able to know the Buddha. Because the Buddha mind is possessed by sentient beings, apart from sentient beings there is no Buddha mind.

*D*eluded, a Buddha is a sentient being;

Awakened, a sentient being is a Buddha.

Ignorant, a Buddha is a sentient being;

With wisdom, a sentient being is a Buddha.

If the mind is warped, a Buddha is a sentient being;

If the mind is impartial, a sentient being is a Buddha.

When once a warped mind is produced,

Buddha is concealed within the sentient being.

If for one instant of thought we become impartial,

Then sentient beings are themselves Buddha.

In our mind itself a Buddha exists,

Our own Buddha is the true Buddha.

If we do not have in ourselves the Buddha mind,

Then where are we to seek Buddha?"

The Sixth Patriarch Chopping Bamboo, **Liang Kai (Southern Song dynasty, 1127–1279). Hanging scroll, ink on paper.**

Huineng, the Sixth Patriarch of a discipline of Buddhism known as Chan (or Zen in Japan), was born to a poor family. At age three, his father died, leaving Huineng and his mother penniless; the boy collected wood for their income. During his youth, he came into contact with the Fifth Patriarch. Although Huineng was illiterate, he understood the teachings of the Fifth Patriarch and was allowed to carry them on. He went on to develop understandings of Buddhism that remain influential today. Huineng lectured about the Buddha within each person and how one can come to be enlightened instantaneously through simple tasks, such as daily wood gathering. The Platform Sutra of the Sixth Patriarch is a record of his spoken teachings as compiled by his followers. The Song dynasty artist Liang Kai captures Huineng continuing his rigorous daily work to achieve enlightenment.

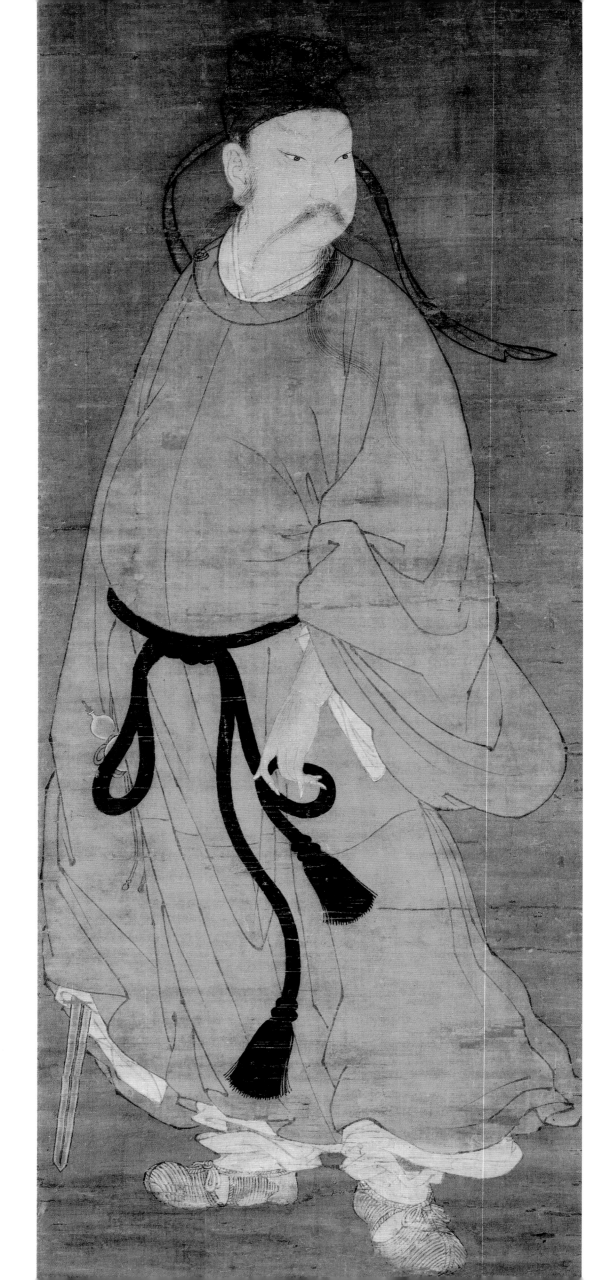

LÜ DONGBIN HUNDRED-CHARACTER STELE

Lü Dongbin, attrib. (8th–9th century)

By nature I enjoy peace and quiet,

In order to care for and stabilize the monkey of the mind.

I have no need of wine,

My sexual desires have ceased.

I no longer covet wealth,

Nor do I rage in anger.

Seeing and yet not seeing,

Hearing and yet not hearing.

I criticize not others' errors,

Just search for my own faults.

I need not serve as an official,

For I can survive on my own credit.

During good times I am not frivolous,

In bad times I hold to my task.

[My mind] cares not for the world of mortals,

Transcending all worries and cares.

Softening [my?] glare and settling in the dust,

And mingling with ordinary people.

Because I do not strive for fame,

I have conversed with the exalted ones.

The Daoist Immortal Lü Dongbin, **Yuan dynasty (1271–1368). Hanging scroll, ink and color on silk.**

Steles are large, upright stone monuments carved with figures and texts; they can be placed in public spaces, atop tombs, and on the grounds of religious temples. The immortal Lü Dongbin is an important Daoist figure known for his meditation practices and as one of the Eight Immortals in popular folk stories, where he is celebrated as a hero of martial arts, literature, medicine, and the Daoist pantheon of deities. This stele-carved poem, attributed to Lü, explains his ideas on meditation and finding solace in one's place in the world.

EVENING BELL FROM A
MIST-SHROUDED TEMPLE

Chan Monk Juefan Huihong (1071-1128)

*L*ight mist covers the evening, twilight comes on,

Sonorous distant bell carries to a remote village;

Small bridge spans a stream, signs of men are gone,

A barely visible flag flutters at the foot of the mountain.

**A Solitary Temple
Amid Clearing Peaks,
Li Cheng (919–967).
Hanging scroll, ink and
color on silk.**

Chan Buddhism in China (known as Zen in Japan) evokes spontaneity and naturalness. The Chan movement began to gain popularity from the sixth century onward. It stresses the importance of seated meditation, deliberation on difficult questions, and focusing on daily activities to gain enlightenment. Although Chan texts are numerous, the doctrine teaches that sutra scriptures, words, and even language are not required to enter nirvana. The Chan Monk Juefan Huihong's poem, therefore, limits its word and captures what is immediately noticed when approaching a temple hidden away in the mountains.

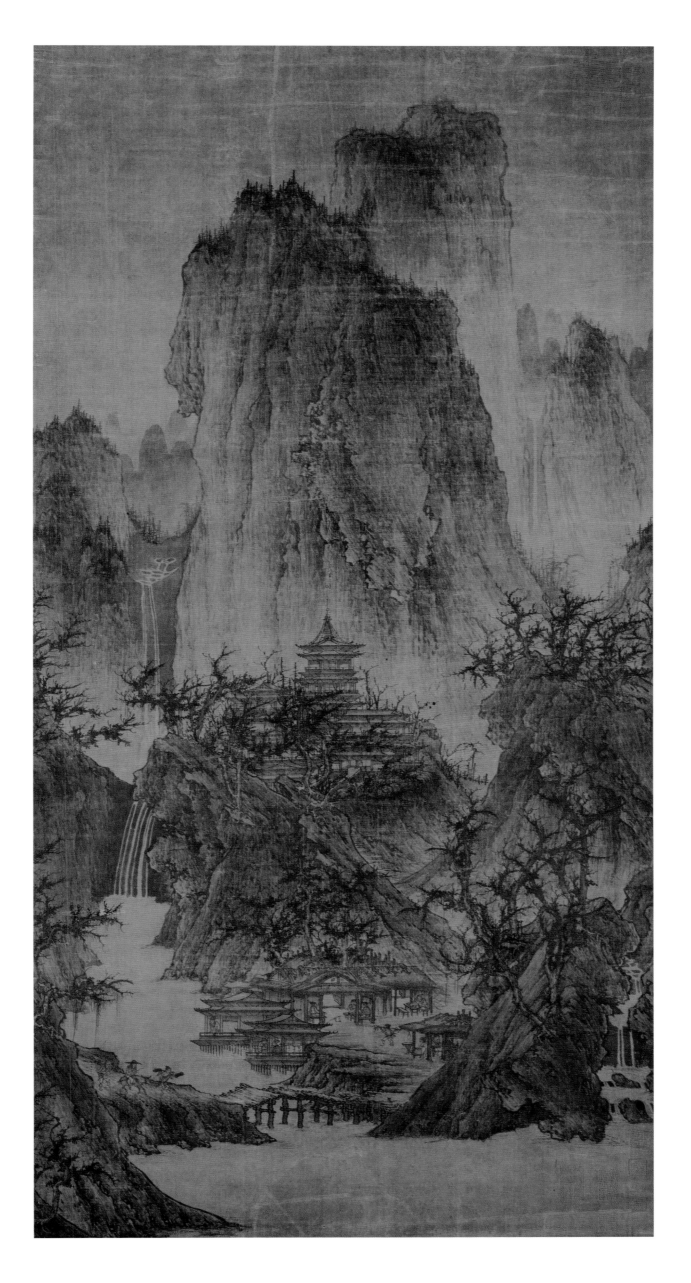

HOW TRIPITAKA BROUGHT BACK THE SUTRAS

Anonymous (13th century)

They proceeded to Nine Dragon Pond. Monkey Pilgrim said: "Look, Master! This is the abode of the nine-headed lizard-dragons. They often cause mischief and harm humans. Be careful, Master!" Suddenly, vast stretches of nasty waves reared up and white foam thundered endlessly. For a thousand tricents of raven river flowed myriad ranks of black combers. There were the nine-headed dragons roaring, their fiery whiskers shooting out rays of light as they advanced. Monkey Pilgrim transformed the cap of invisibility into a curtain which obscured the sky, and sucked all the thousand tricents of water into the begging-bowl. Then he transformed the magic staff into an iron dragon. Regardless of night or day the two sides fought. Monkey Pilgrim straddled the nine-headed dragons. "I want to pull out the sinews from your spine to present to my master as a belt." The nine dragons surrendered. All had the sinews of their spines pulled out and all suffered in addition eight hundred blows with the iron cudgel on their backs. "From now on, be good; and if you resume your former bad actions, you will all be annihilated." The dragons were exhausted half to death. They hid their traces and disappeared. Monkey Pilgrim braided a belt from the sinews and gave it to the Dharma Master to tie around his waist. As soon as the Master of the Law put it on, he could walk as fast as flying, and when he came to any difficult place, he would leap over it. The dragons' sinews were possessed of supernatural power. With them one could assume any shape. Later, when Tripitaka returned to the Eastern Lands the belt went back up of its own accord to the Heavenly Palace. This is what monks nowadays refer to as "watered-satin-brocade fabric." With it, the Master of the Law did many wondrous things.

Nine-Dragon Pool, Mei Qing (1623–1697). Hanging scroll, ink and light color on paper.

Written in China around the thirteenth century, this particular text was eventually lost, only to be rediscovered in the early twentieth century in the Kozanji Temple near Kyoto, Japan. Relating directly to Journey to the West *(see page 201), it demonstrates that the story of Monkey King's trek to India after Buddhist scriptures existed in China several hundred years before the famous Ming dynasty version was formally printed. The fantastic battle scene between the Monkey King and dragons exemplifies why the story captivates audiences to this day. The scroll's inscription tells how a powerful dragon awakes, making thunderclaps and splitting mountains along mighty rivers.*

PETITION REGARDING
THE THREE DOCTRINES

Monks Yongdao, Wuming and Huiri
Nianchang (1282–1323)

The teachings of the Sages of the Three Doctrines *[sanjiao]* have only one common purpose — to direct the people to do good. Hatred and hostility arose out of jealousy of their followers, who sought revenge even for an angry look, and the rulers were sometimes confused. After the golden ages of the Three Emperors and Five Kings, people became less sincere, and there was no more primitive simplicity. The road to the Great Principle also became blocked. Laozi, the historiographer under the pillars of the Zhou household, wrote his *Daodejing* in five thousand characters, teaching the people the merits of Dao and virtue [De], the benefit of being weak and reticent, kind, frugal and non-active, and urging them to recover their original simplicity. But the House of Zhou was decaying gradually, people became accustomed to emptiness and falsehoods, and no one would listen to him. Then Confucius arose. He advocated the ways of humanity and righteousness, edited *Book of Odes [Shijing]* and *Classic of Historical Documents [Shujing]*, and rectified the rituals and music, with the aim of rescuing the people from darkness and ruin. Unfortunately, this was followed by the period of the Warring States. Peripatetic scholars offered advice to the rulers. Indulging themselves in free criticism, they treated humanity and righteousness with contempt, as being impracticable and bombastic, to say nothing of Laozi's Dao and virtue. When the Han dynasty began, its policy was still tinged with the theory of hegemony and autocracy. Even a benign ruler like Emperor Wen was unable to talk about rituals and music, while in the hands of the ambitious Emperor Wu, the economy of the country was ruined, because of his military campaigns. At this juncture, if Buddha's teaching had not come to China to fulfil its predestined mission, Dao and virtue, and humanity and righteousness would have gone to the dogs.

Masters of the Three Doctrines, Ding Yunpeng (1547–1621). Hanging scroll, ink and color on paper.

As the first line of the text argues, the Three Doctrines of Daoism, Confucianism, and Buddhism are intended to benefit the common people, who can adapt the teachings to their circumstances. The hanging scroll captures harmony among the Three Patriarchs, who are grouped to suggest a lively discussion. Each figure is stately, while as a group they embody philosophy, literture, and art, with Confucius on the left, Shakyamuni in the middle, and Laozi on the right.

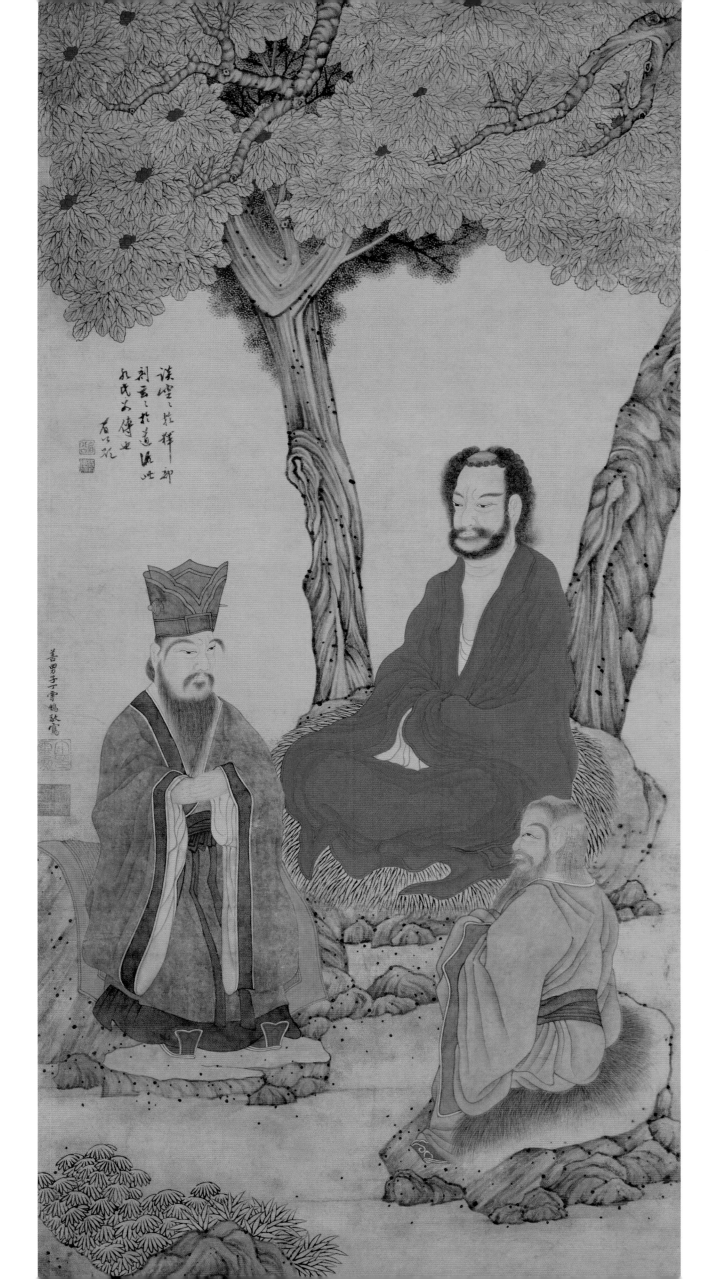

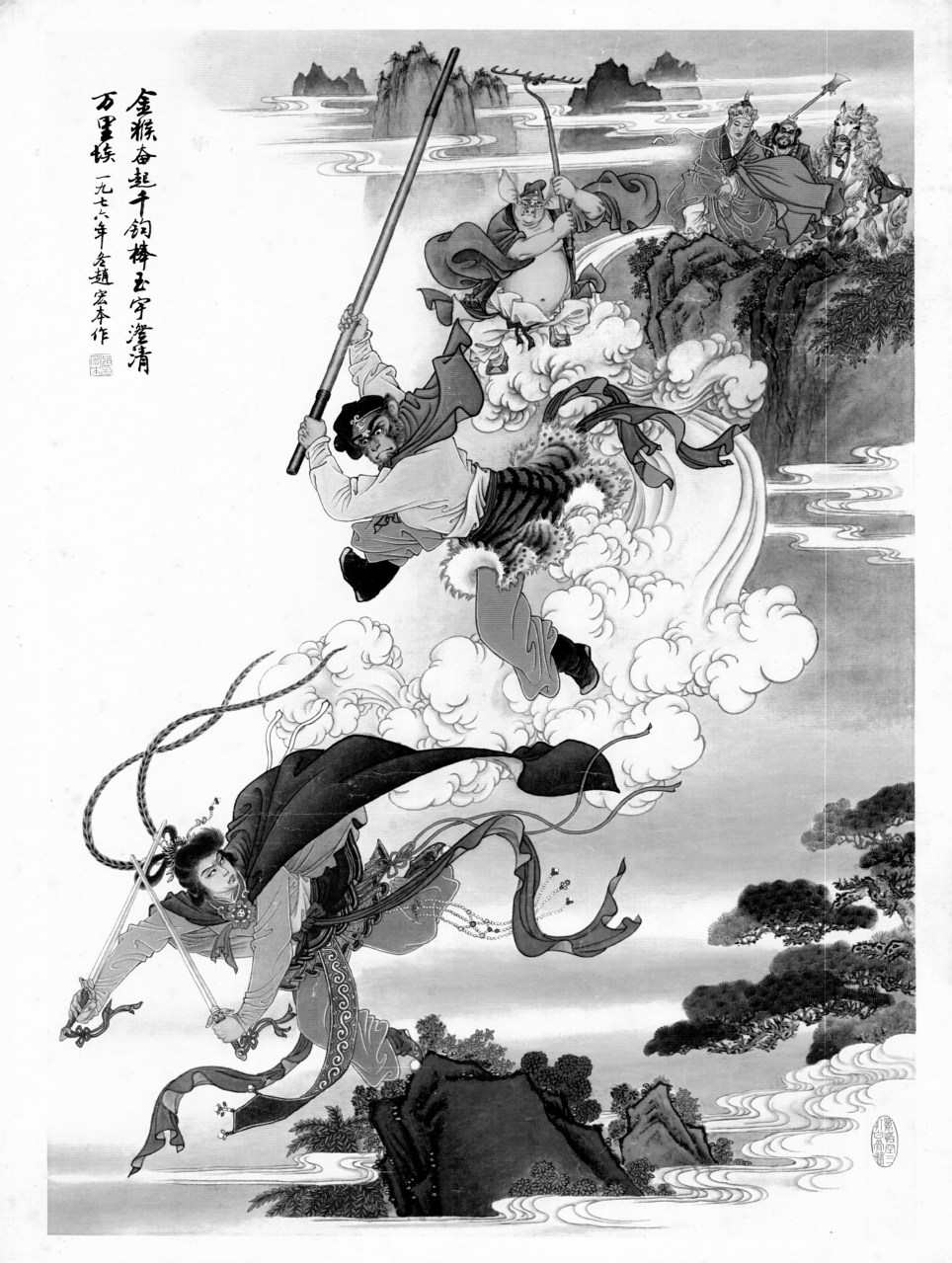

金猴奋起千钧棒玉宇澄清
万里埃 一九七六年冬赵宏本作

JOURNEY TO THE WEST

Wu Cheng'en, attrib. (ca. 1506–1582)

*N*ow, the proverb says: A tall mountain will always have monsters; A rugged peak will always produce fiends.

In this mountain there was indeed a monster-spirit, who was disturbed by the Great Sage Sun's departure. Treading dark wind, she came through the clouds and found the elder sitting on the ground. "What luck! What luck!" she said, unable to contain her delight. "For several years my relatives have been talking about a Tang monk from the Land of the East going to fetch the Great Vehicle [e.g., Buddhist sutras]. He is actually the incarnation of the Gold Cicada, and he has the original body which has gone through the process of self-cultivation during ten previous existences. If a man eats a piece of his flesh, his age will be immeasurably lengthened. So, this monk has at last arrived today!" The monster was about to go down to seize Tripitaka when she saw two great warriors standing guard on either side of the elder, and that stopped her from drawing near. . . . Instead, the monster said to herself, "Let me make fun of them a bit, and see what happens."

Dear monster! She lowered her dark wind into the field of the mountain, and, with one shake of her body, she changed into a girl with a face like the moon and features like flowers. One cannot begin to describe the bright eyes and the elegant brows, the white teeth and the red lips. . . .

The girl's appearance was something to behold!
Ice-white skin hides jadelike bones;
Her collar reveals a milk-white bosom.
Willows brows gather dark green hues;
Almond eyes shine like silver stars.
Her features like the moon are coy;
Her natural disposition is pure.
Her body's like the willow-nested swallow;
Her voice's like the woods' singing oriole.

A half-opened *haitang* [fragrant flower] caressed by the morning sun.

A newly bloomed peony displaying her charm. . . .

[The demon monster employed three disguises: a young girl, old woman, and old man. The Monkey knew it was the demon and hit it when it was the girl and old woman, but failed to kill it. Later on, the Monkey meets the demon when it is the old man. Monkey is determined to eradicate it once and for all.]

[Monkey addressed the demon:] "How dare you sneak up on me and try to deceive me with something up your sleeve? You can't fool me. I can see that you are a monster." The monster was so startled that she could not utter another word. Wielding his rod, Pilgrim was about to strike, but he said to himself: "If I don't hit her, she's going to pull some trick again, but if I hit her, I fear that Master will recite that spell again [that hurt me]." He thought to himself some more: "But if I don't kill her, she can grab Master the moment she has the opportunity, and then I'll have to make all that effort to save him. I'd better strike! One blow will kill her, but Master will surely recite that spell. Well, the proverb says: 'Even the vicious tiger will not devour its own.' I'll have to use my eloquence, my dexterous tongue, to convince him, that's all." Dear Great Sage! He recited a spell himself and summoned the local spirit and the mountain god, saying to them, "This monster made fun of my master three times. This time I'm going to make sure I'll kill her, but you must stand guard in the air. Don't let her get away." When the deities heard this command, neither dared disobey it, and they both stood guard on the edge of the clouds. Our Great Sage lifted up his rod and struck down the demon, whose spiritual light was extinguished only then.

Monkey Thrice Beats the White Bone Demon, Zhao Hongben (b. 1915). Poster, ink on paper.

The Ming dynasty Journey to the West *may be China's most dynamic fantasy novel. The hundred chapters richly describe a sixteen-year trek to acquire Buddhist scriptures from India. Encountering demons and mystical scenarios, the four travelers Chen Xuanzang (Tripitaka), Monkey (Sun Wukong), Pig/Pigsy (Zhu Ganglie), and Sha Monk (Sandy) are exposed to dangers and magical spells (see page 197). The novel deals with themes of life and death, religion, good and evil, and society. It continues to inspire comics, cartoons, movies, theatrical plays, and publications. This colorful poster from the mid-1970s illustrates Monkey in the act of hitting a demon masquerading as a young girl; the remaining three main characters watch from above.*

THE DHARANI SUTRA OF FIVE MUDRAS OF THE GREAT COMPASSIONATE WHITE-ROBED ONE

Qu Ruji (1548–1610)

Bowing my head to the Great Compassionate One,

Practicing meditation with the sense of hearing,

[the bodhisattva] entered samadhi [meditative ecstasy]

Raising the sound of the tide of the ocean,

Responding to the needs of the world.

No matter what one wishes to obtain

[She] will unfailingly grant its fulfillment.

Five Forms of Guanyin Bodhisattva, Ding Yunpeng (1547–1621). Handscroll, ink, color and gold pigment on paper. Detail.

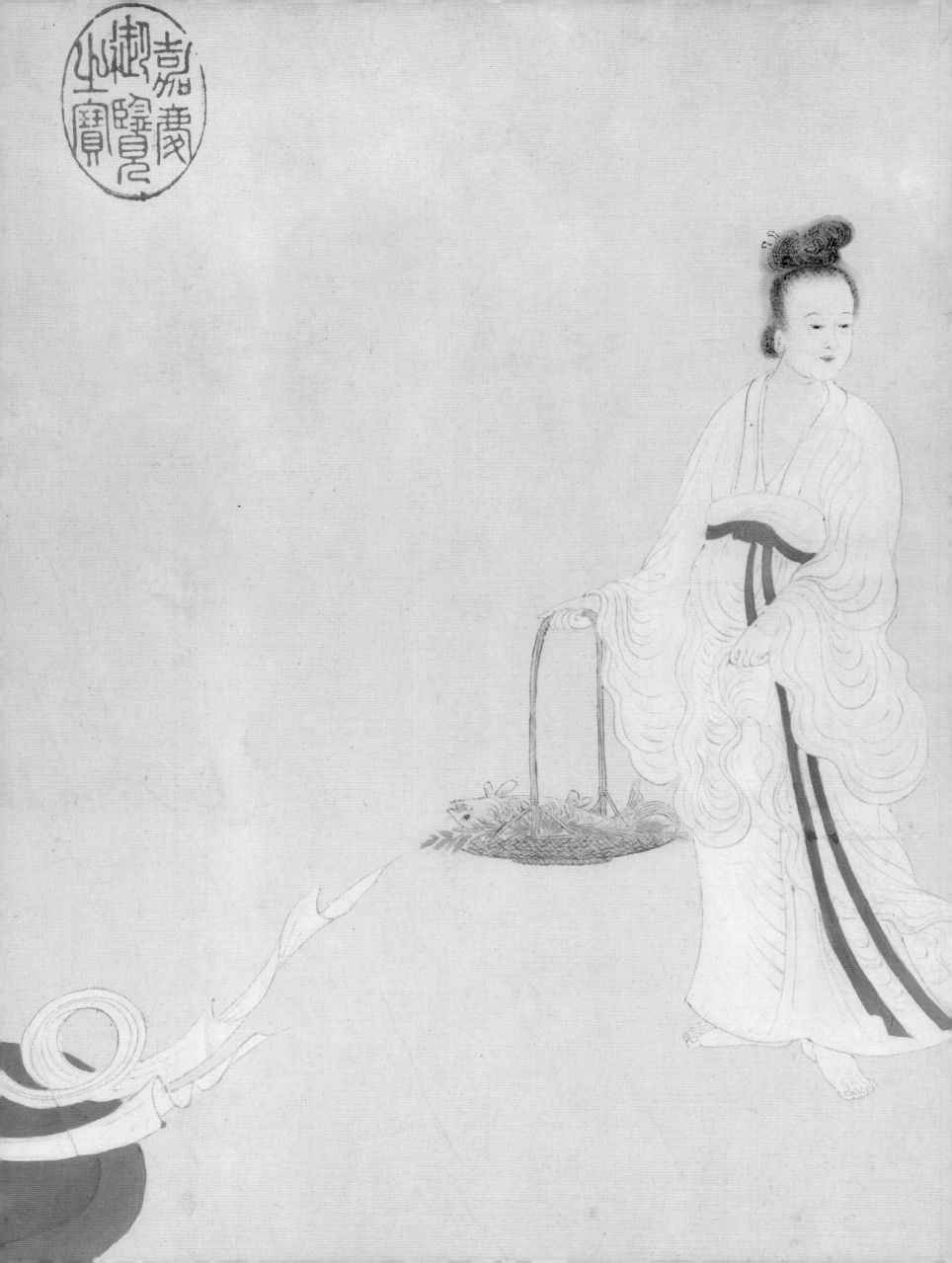

SOUL MOUNTAIN

Gao Xingjian (b. 1940)

In the snow outside my window I see a small green frog, one eye blinking and the other wide open, unmoving, looking at me. I know this is God.

He appears just like this before me and watches to see if I will understand.

He is talking to me with his eyes by opening and closing them. When God talks to humans he doesn't want humans to hear his voice.

And I don't think it at all strange, it is as if it should be like this. It is as if God is in fact a frog. The intelligent round eye doesn't so much as blink once. It is really kind that he should deign to gaze upon this wretched human being, me.

His other eye opens and closes as it speaks a language incomprehensible to humans. Whether I understand or not is not God's concern.

I could of course think maybe there is no meaning at all in this blinking eye, but its significance could lie precisely in its not having meaning.

There are no miracles. God is saying this, saying this to this insatiable human being, me.

Then what else is there to seek? I ask of him.

All around is silence, snow is falling soundlessly. I am surprised by this tranquillity. In Heaven it is peaceful like this.

And there is no joy. Joy is related to anxiety.

Snow is falling.

I don't know where I am at this moment, I don't know where this realm of Heaven comes from, I look all around.

I don't know that I don't understand anything and still think I know everything.

Things just happen behind me and there is always a mysterious eye, so it is best for me just to pretend that I understand even if I don't.

While pretending to understand, I still don't understand.

The fact of the matter is I comprehend nothing, I understand nothing. This is how it is.

La Montagne de Reve
(Dream Mountain),
Gao Xingjian (b. 1940).
Ink on paper.

Soul Mountain (Lingshan) *by Gao Xingjian — the first Chinese author to win the Nobel Prize for Literature — invites the reader to explore what is universal in the human condition. The novel's narrator travels to physical destinations and mental destinations, meeting along the way everyone from Daoists and fellow travelers to anonymous individuals known only by the pronouns* she, he, you, *and* I. *Free from conventions like plot or climax, Gao deals with everyday life and thoughts that, when taken as a whole, are complex and philosophical. Gao was also an accomplished painter. His* Montagne de Reve (Dream Mountain) *similarly asks what life means.*

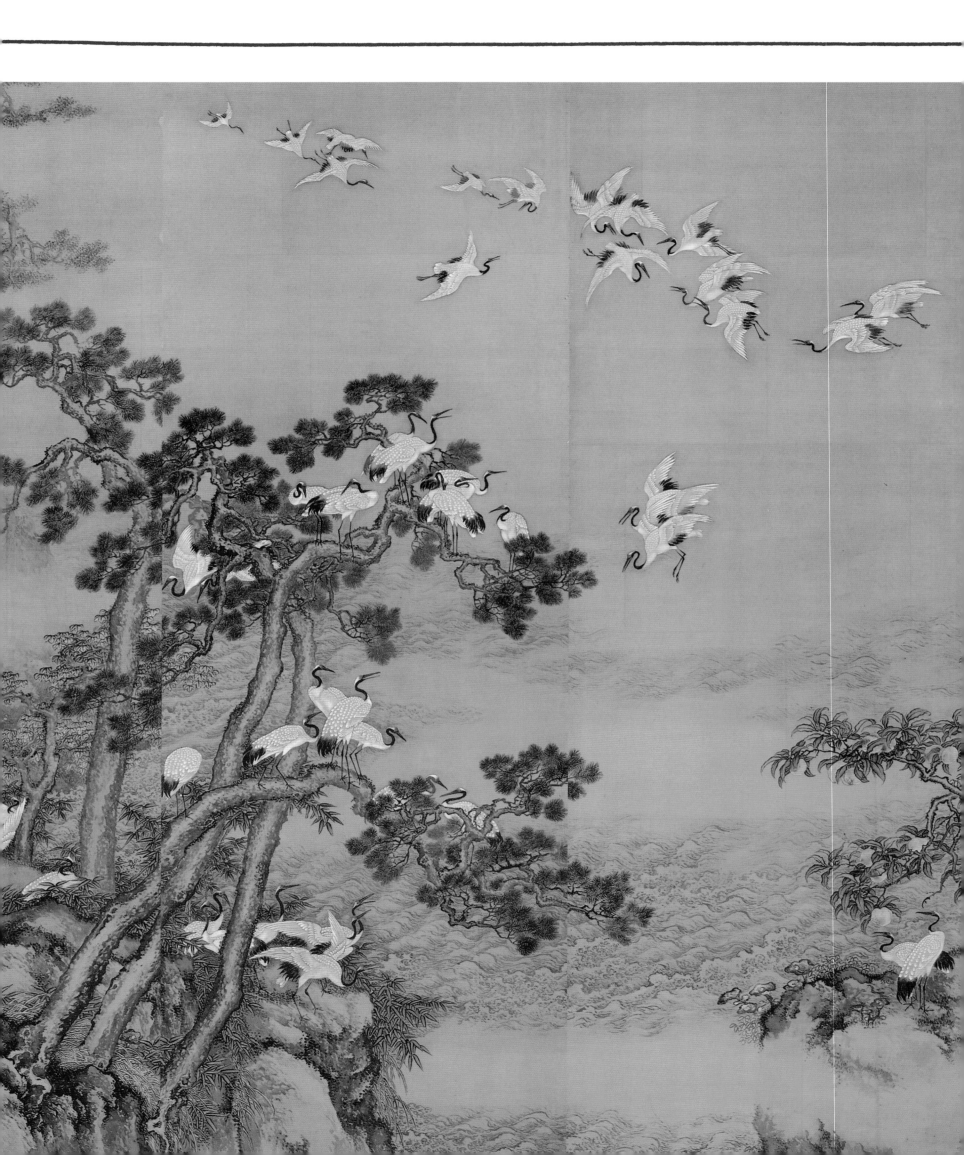

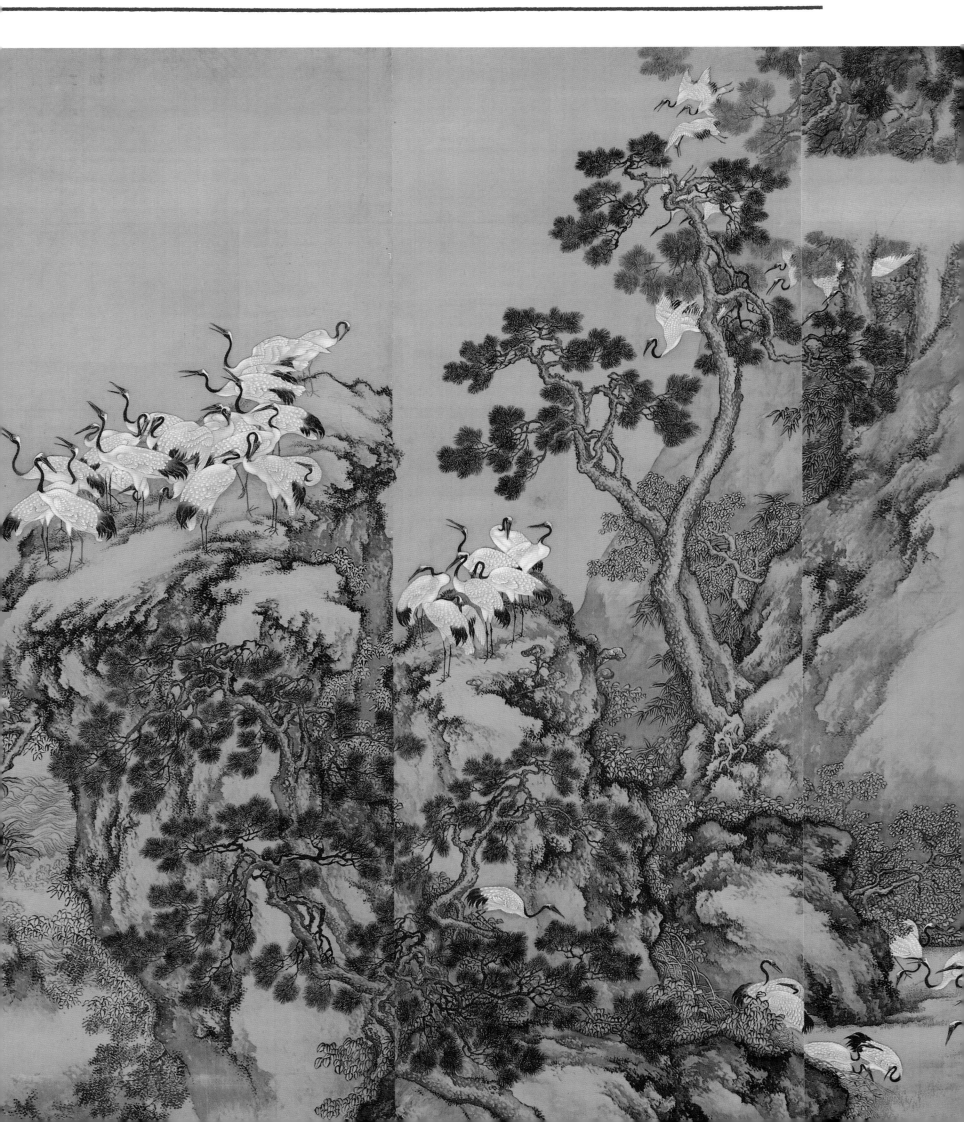

DAODEJING

Laozi (Lao Dan, 6th century BCE)

Man comes into life and goes out to death.

Three out of ten are companions of life.

Three out of ten are companions of death.

And three out of ten in their lives lead from activity to death.

And for what reason?

Because of man's intensive striving after life.

I have heard that one who is a good preserver of his life

will not meet tiger or wild buffaloes,

And in fighting will not try to escape from weapons of war.

The wild buffalo cannot butt its horns against him,

The tiger cannot fasten its claws in him,

And weapons of war cannot thrust their blades into him.

And for what reason?

Because in him there is no room for death.

PRECEDING SPREAD:
Cranes of Longevity,
**Shen Quan (1682–after
1762). Paneled screens,
ink and color on silk.
Detail.**

RIGHT: *Laozi Riding an
Ox,* **Chen Hongshou
(1598–1652). Album
leaf with ink and color
on silk.**

The Daodejing, also known as the Laozi, sets out to ensure that readers follow nature through their lives (see page 157). The Dao, or Way, is found in all nature; to follow it is to complete one's destiny in the world. Birth, life, and death comprise the natural and eternal course of all things. Significantly, the text includes the phrase "there is no room for death," which emphasizes that death is nothing to fear. The work is attributed to the author known as Laozi, a philosopher-sage often depicted as a graceful elderly man in nature or in the company of other great leaders, such as Confucius and the Buddha (see page 198). Chen Hongshou's lively album leaf depicts him atop a striding ox. Both man and beast are content, even smiling slightly.

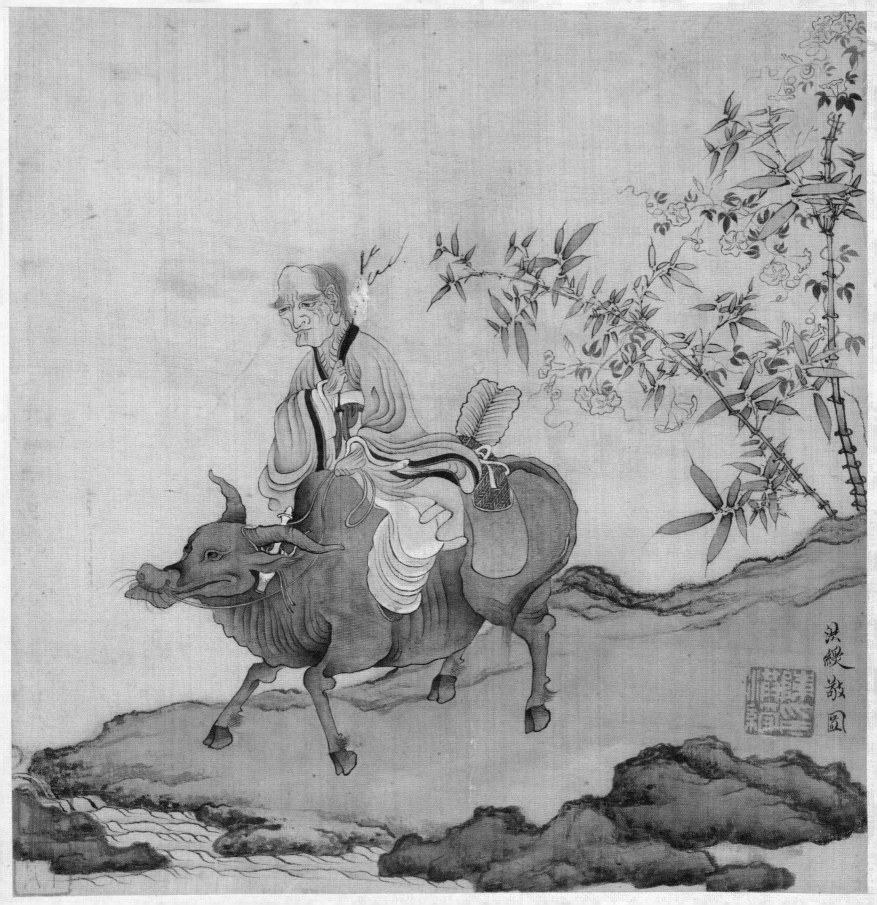

子曰孝者明王事父孝故事天明事母孝故事地察長幼順故

上下治天地明察神明彰矣故雖天子必有尊也言有父也

必有先也言有兄也宗廟致敬不忘親也修身慎行恐辱先

也宗廟致敬鬼神著矣孝悌之至通於神明光于四海

張不通許云自西自東自南自北無思不服

CLASSIC OF FILIAL PIETY

(compiled 350–200 BCE)

*T*he Master said, "Anciently, the intelligent kings served their fathers with filial piety, and therefore they served Heaven with intelligence; they served their mothers with filial piety, and therefore they served Earth with discrimination. They pursued the right course with reference to their [own] seniors and juniors, and therefore they secured the regulation of the relations between superiors and inferiors [throughout the kingdom].

"When Heaven and Earth were served with intelligence and discrimination, the spiritual intelligences displayed [their retributive power].

"Therefore even the Son of Heaven must have some whom he honours; that is, he has his uncles of his surname. He must have some to whom he concedes the precedence; that is, he has his cousins, who bear the same surname, and are older than himself. In the ancestral temple he manifests the utmost reverence, showing that he does not forget his parents; he cultivates his person and is careful of his conduct, fearing lest he should disgrace his predecessors.

"When in the ancestral temple he exhibits the utmost reverence, the spirits of the departed manifest themselves. Perfect filial piety and fraternal duty reach to (and move) the spiritual intelligences, and diffuse their light on all within the four seas; they penetrate everywhere.

"It is said in the Classic of Poetry:
'From the west to the east,
From the south to the north,
There was not a thought but did him homage.'"

The Classic of Filial Piety, **Li Gonglin (ca. 1041–1106). Handscroll, ink on silk. Detail.**

As a record of sayings by Confucius (see page 132), the Classic of Filial Piety (Xiaojing) *is a crucial canon of Confucianism since it applies not only to individual relationships but also to state affairs and leaders. Li Gonglin's masterwork illustrates the text; the image here is inspired by the sixteenth chapter, which details how a king performs sacrificial rites honoring his parents.*

BIAN HE'S JADE

Han Fei (ca. 280–ca. 233 BCE)

\mathcal{T}here was a man of Chu, of the family He, who found a piece of jade in the rough out in the mountains of Chu. He presented it to King Li, who had his jade expert examine it. The jade expert said, "This is ordinary stone." The king thought that Bian He was trying to deceive him and had his left foot cut off as a punishment. When King Li passed away and King Wu took the throne, Bian He again took his jade and presented it to King Wu. King Wu had his jade expert examine it, and again it was pronounced to be ordinary stone. This king too thought Bian He was trying to deceive him and had his right foot cut off. When King Wu passed away and King Wen ascended the throne, Bian He took his jade in his arms and wept at the base of Chu Mountain. For three days and three nights he wept until he had no more tears left, until blood fell from his eyes. The king heard of this and sent someone to find out the cause. The envoy said, "There are many people in the world whose feet have been cut off. Why are you weeping about it so sadly?" And Bian He answered, "I'm not sad about having my feet cut off; I'm sad because this precious piece of jade has been judged a mere stone and because a most honorable gentleman has been called a fraud — this is what makes me sad." The king then had his own jade expert work on the stone, and he found the gem within. Consequently the king commanded that it be called "Bian He's Disk."

BIOGRAPHIES OF LIAN BO AND LIN XIANGRU

Sima Qian (ca. 145–ca. 86 BCE)

\mathcal{I}t was in the days of King Huiwen that Zhao got the jade disk of Bian He of Chu. King Zhao of Qin heard of this and sent a man with a letter for the King of Zhao, conveying his wish to exchange fifteen walled cities for the jade disk. Upon hearing this, the King of Zhao took counsel with his grand general Lian Bo and with his other great officers. When they considered presenting the jade to Qin, they feared that they would not get Qin's cities in return, that they would be cheated and left empty-handed. And yet when they considered refusing to present the jade, there was the danger that Qin's troops would come upon them.

Ritual Disk with Dragon Motif, **Eastern Zhou (770–221 BCE). Jade.**

Jade has held a prominent place in China for millennia due to its beauty and association with immortality; jade pieces have been found in significant tombs dating as far back as 3000 BCE. Bian He's jade, having been painstakingly crafted into a ritual disk (bi) by imperial commission, became quite famous and was sought after by the leaders of competing states. It ended up in the collection of the king of Zhao, where the great historian Sima Qian noted that the value of this disk was equal to that of entire cities. The fact that two eminent writers separately mention the disk demonstrates its importance. The stunning Ritual Disk with Dragon Motif *offers today's viewer a glimpse of the beauty of jade fashioned into the bi shape.*

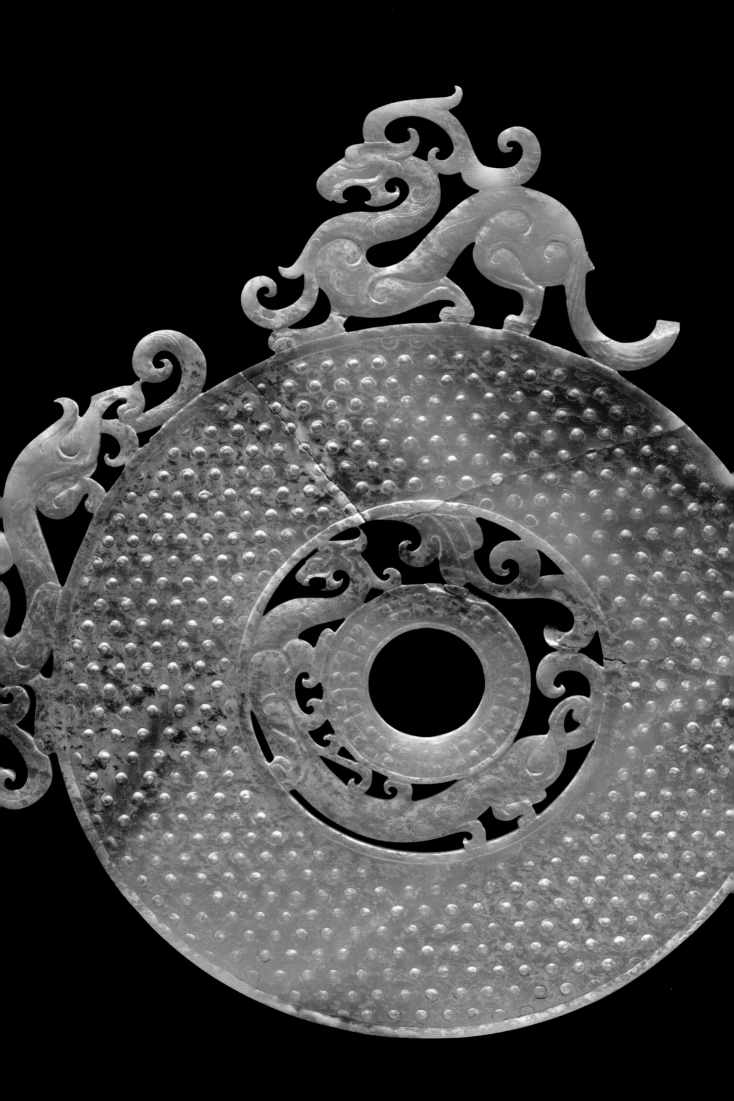

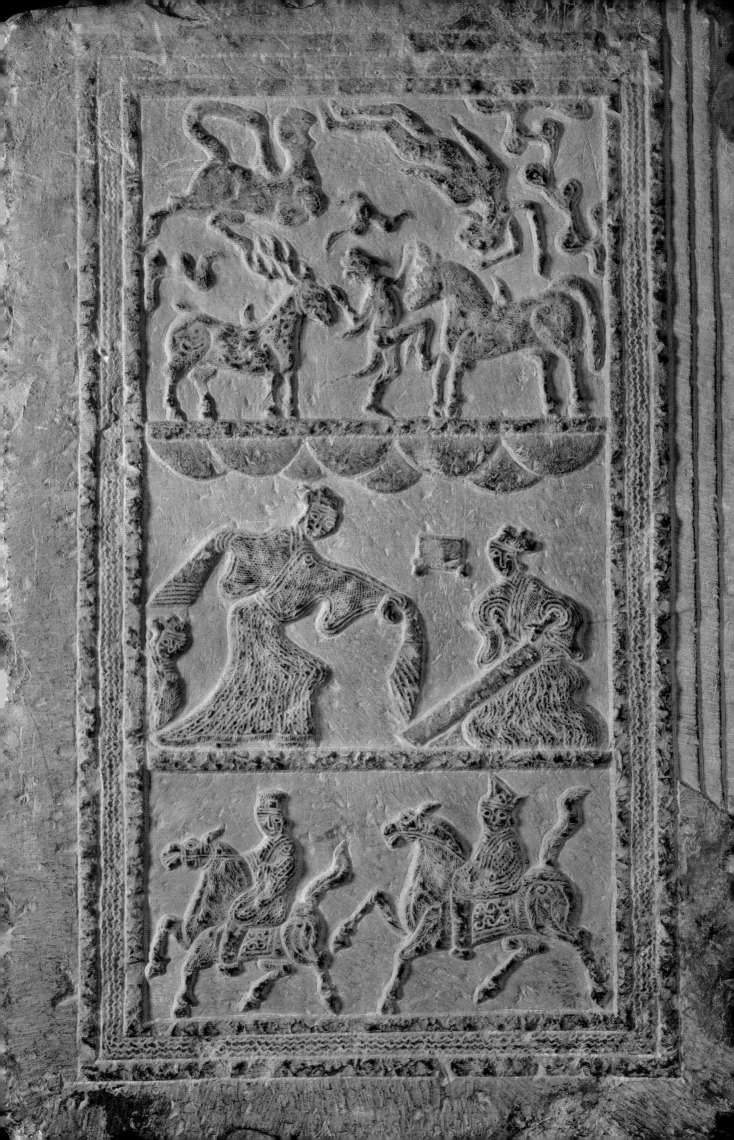

ON THE DEATH OF HIS FATHER

Cao Pi (187–226)

I look up and see his curtains and bed:

I look down and examine his table and mat.

The things are there just as before.

But the man they belonged to is not there.

His spirit suddenly has taken flight

And left me behind far away.

To whom shall I look on whom rely?

My tears flow in an endless stream.

"Yu, Yu" cry the wandering deer

As they carry fodder to their young in the wood.

Flap, flap fly the birds

As they carry their little ones back to the nest.

I alone am desolate

Dreading the days of our long parting:

My grieving heart's settled pain

No one else can understand.

There is a saying among people

"Sorrow makes us grow old."

Alas, alas for my white hairs!

All too early they have come!

Long wailing, long sighing

My thoughts are fixed on my sage parent.

They say the good live long:

Then why was *he* not spared?

Casing Slab of Tomb Chamber, Eastern Han dynasty (25–220). Limestone.

Son of the great warlord Cao Cao (see pages 40 and 162), Cao Pi laments the loss of his illustrious father in verse. The limestone slab from a tomb chamber illustrates the type of work that went into a mortuary site during Cao's day. It is divided into three sections. Starting at the bottom, mounted warriors and their steeds gallop across the slab. In the middle, a musician plays a qin harp-zither while an entertainer with flowing robes dances. Finally, airborne acrobats are depicted with deer and horse — both auspicious animals. Such slabs would encase an entire tomb chamber and were meant to serve as tableaux that the departed could enjoy in the afterlife.

DAOIST SONG

Xi Kang (223–262)

I will cast out Wisdom and reject Learning.

My thoughts shall wander in the Great Void.

Always repenting of wrongs done

Will never bring my heart to rest.

I cast my hook in a single stream;

But my joy is as though I possessed a Kingdom.

I loose my hair and go singing;

To the four frontiers men join in my refrain.

This is the purport of my song:

"My thoughts shall wander in the Great Void."

**Daoist Deities Paying
Court** (14th century).
Hanging scroll, ink and
color on silk.

*Xi Kang was an eccentric poet-musician who searched for elixirs of immortality and worshipped a pantheon of Daoist immortals whom he believed
populated the earth and heavens. Although he knows that he is getting older and will die, Xi is also steadfast in this poem in his conviction that beyond
death, he can be one with the immortals in the Great Void.*

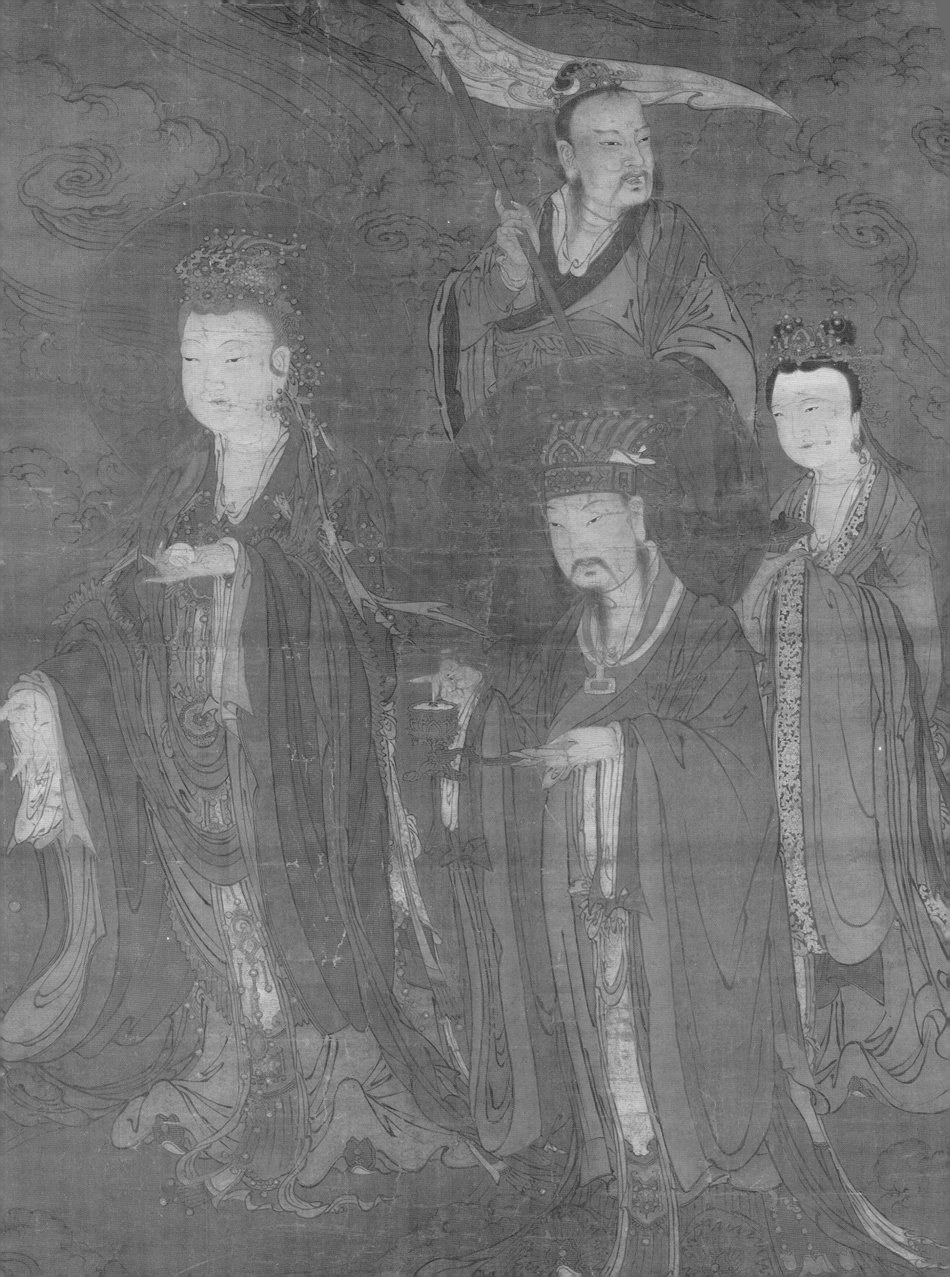

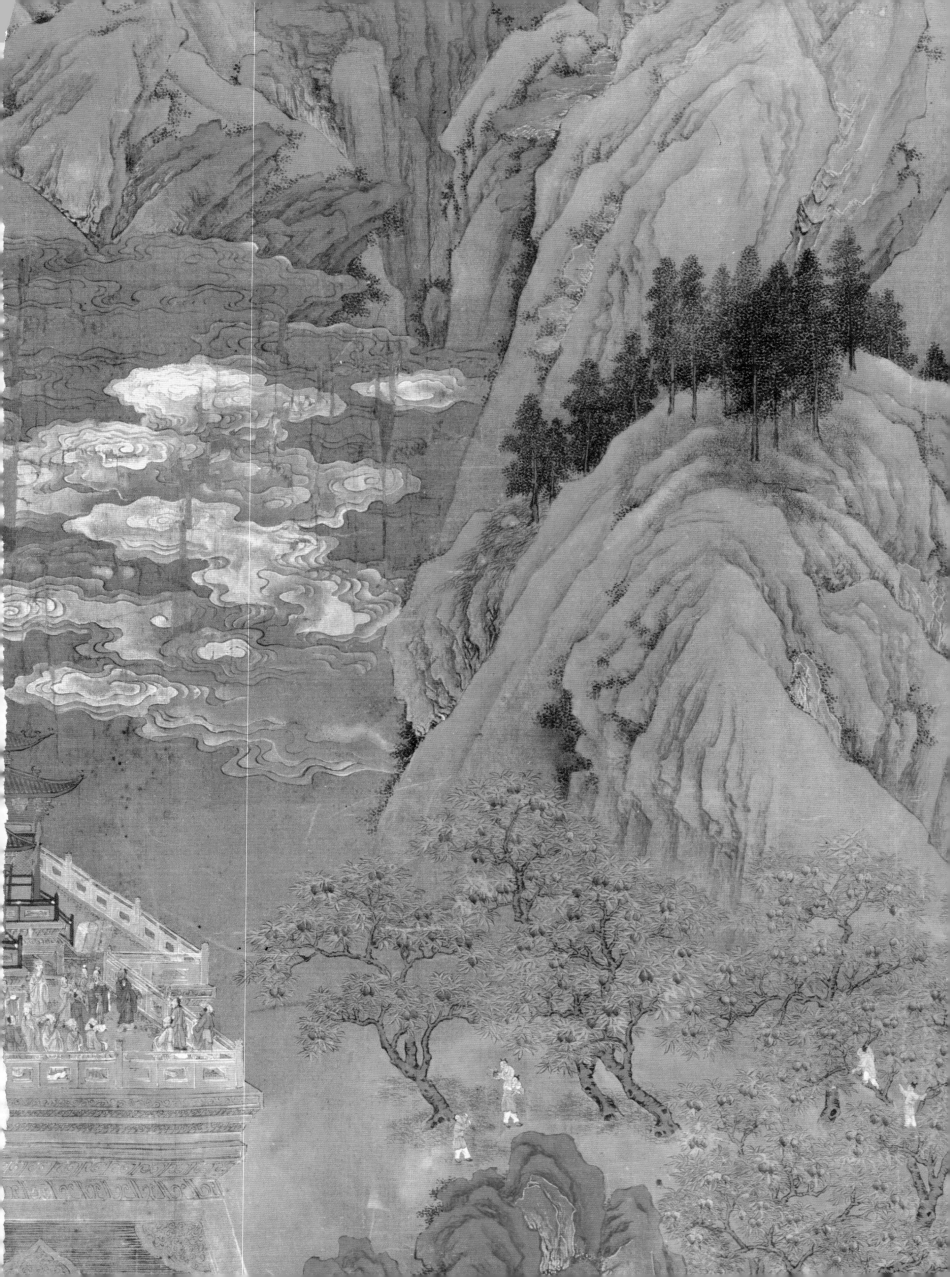

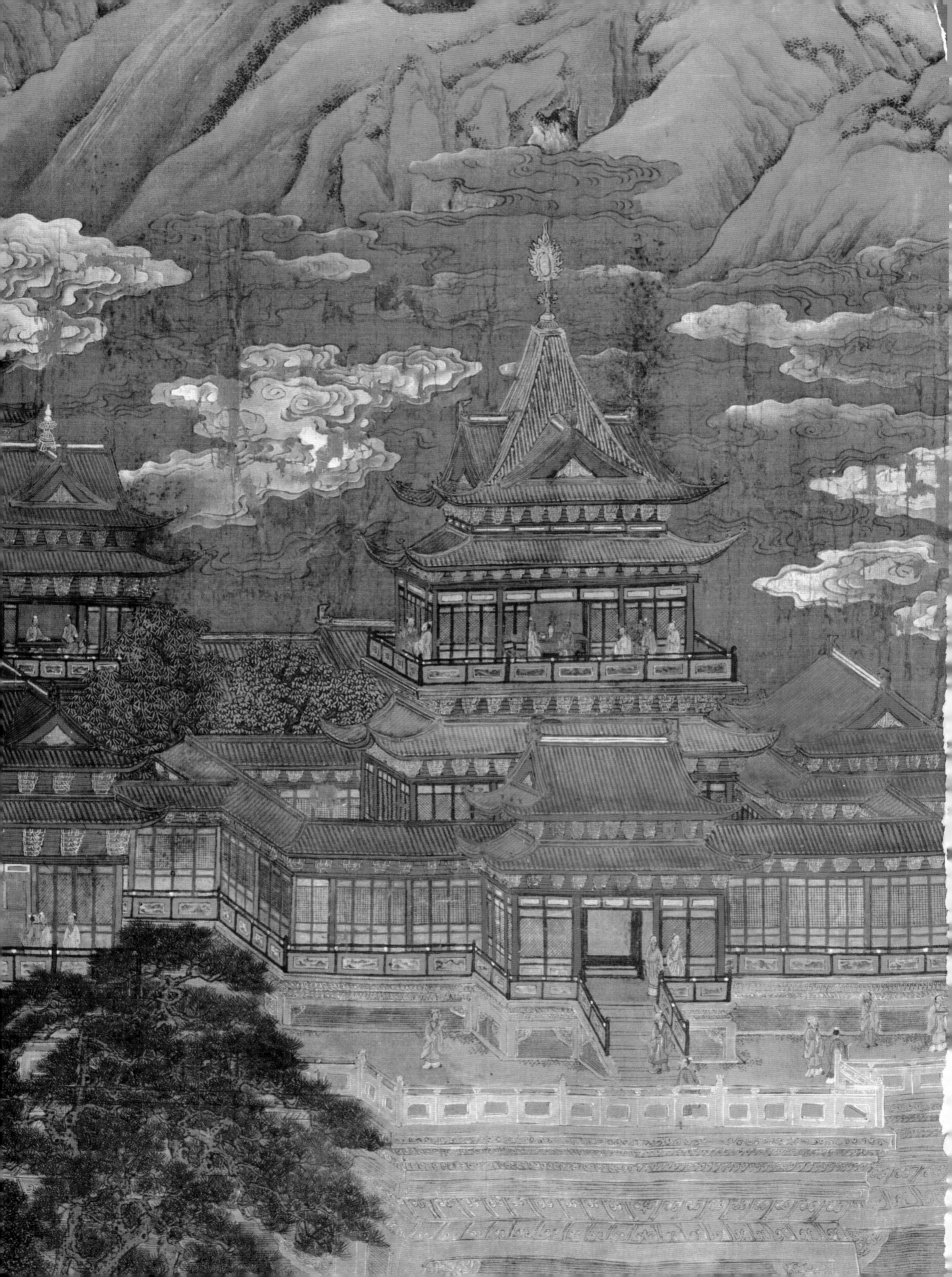

MONOGRAPH ON BROAD PHENOMENA

Zhang Hua (232–300)

*O*ne time the Queen Mother of the West sent her messenger on a white deer to inform the emperor that she would certainly come. In preparation he furnished the Ninefold Floriate Basilica with curtains and waited for her. Then on the seventh day of the seventh month, at the seventh notch of the clepsydra, the Queen Mother, riding a purple cloud chariot, arrived west of the basilica, and sat on the south facing eastwards. On her head she wore seven layers of blue pneuma, dense like clouds. There were three blue birds as big as crows. Messengers and attendants flanked her. Then they set up the Ninefold Tenuity Lamp. The thearch sat on the east facing westwards. The Queen Mother asked her attendants for seven peaches. They were as big as crossbow pellets. Giving five to the thearch [Han dynasty Emperor Wu, r. 141–87 BCE], the Mother ate two. The thearch ate the peaches, then immediately took their pits and put them in front of his knees. The Mother said, "Why are you taking these pits?" The thearch replied, "These peaches are so sweet and lovely. I want to plant them." The Mother laughed and said, "These peaches bear fruit once in three thousand years." The Mother and the thearch were sitting by themselves, opposite one another. None of their followers got to approach. Then Dongfang Shuo stealthily spied on the Mother from the southern side room of the basilica, through the Vermilion Bird window lattice. The Mother saw him. She said to the thearch, "This small boy is spying through the window lattice. Formerly he came three times to steal my peaches." The thearch then greatly marveled at him. On account of this, people of the world say that Dongfang Shuo is a divine transcendent.

Festival of the Peaches of Longevity, Ming dynasty (1368–1644). Handscroll, ink, color and gold on silk.

Like King Mu of the Western Zhou dynasty (see page 53), the Queen Mother of the West (Xiwangmu) enjoyed an audience with Emperor Wu of the Han dynasty. This famous meeting would forever associate her with the peaches of immortality. Mount Kunlun, believed to be in the far northwest of China, hosted not only these imperial visitors but also the Monkey King (see pages 197 and 201). In all these stories, the longing for immortality is intermixed with politics, religions, wars, and humanity's urge to understand it all. Festival of the Peaches of Longevity brightly illustrates the palace of the Queen Mother of the West and the harvest of the peaches.

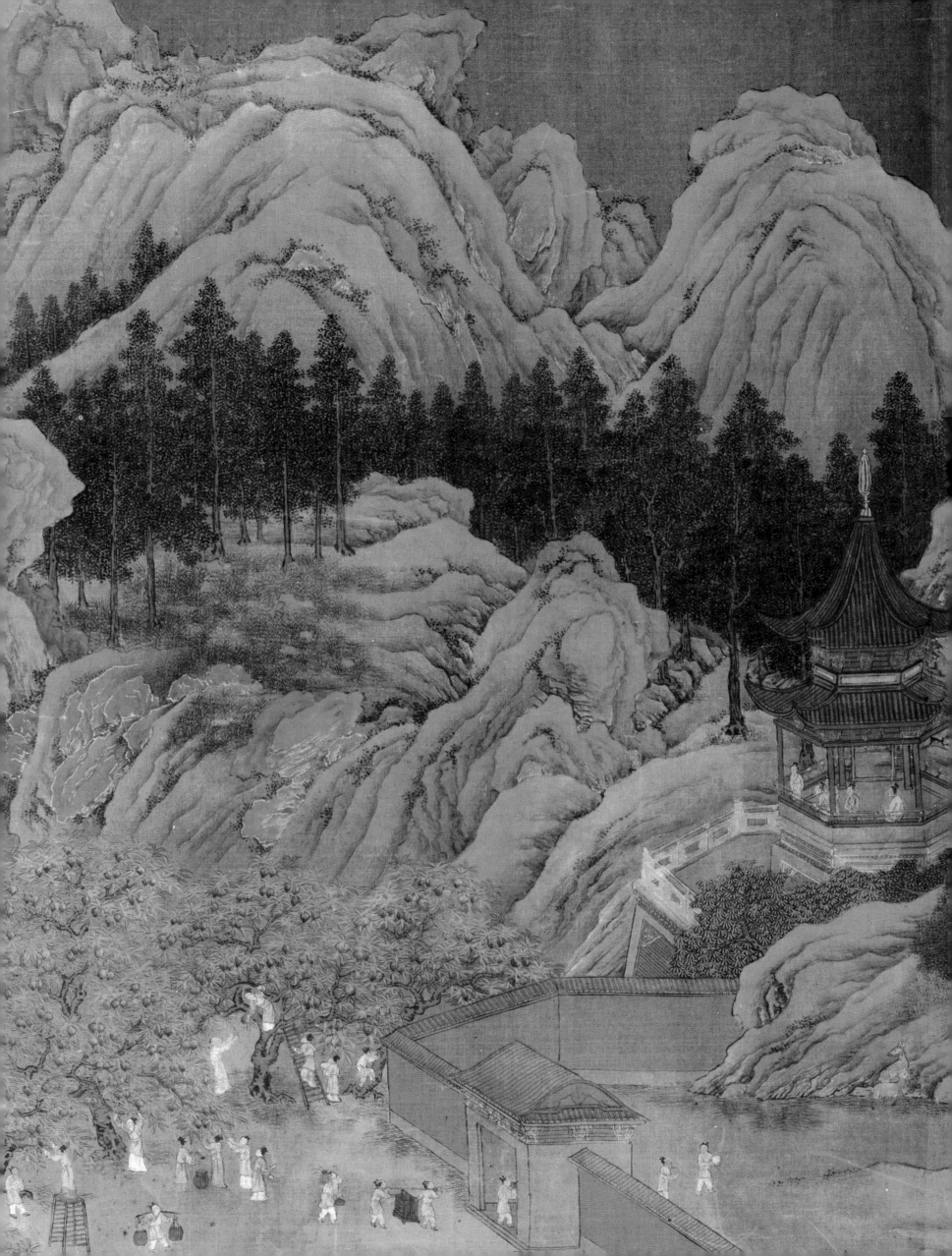

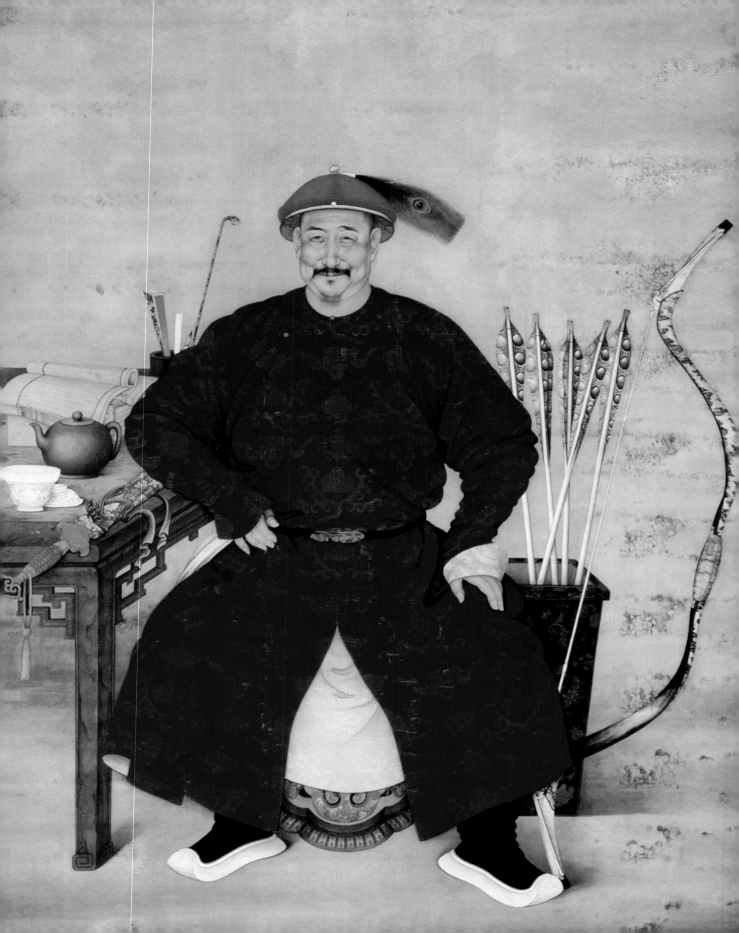

THOUGHTS ON THE ANNIVERSARY OF MY WIFE'S DEATH

Nara Singde (Nalan Xingde, 1655–1685)

When will this misery end?

Dripping on empty stairs, the rain of night's coldest hours is done,

a weather for funerals of flowers.

These past three years went on and on, her soul, too far to come in dreams,

and may I wake from this dream soon!

I guess by now I've grown aware this mortal world holds no appeal.

Better to be below the soil in those halls of endless night,

cool there and clear, a plot of earth to bury care.

The pact of love, hairpin and box,

is forsaken in the end.

If I could get a letter from streams in the world below,

I'd like to know her joys and sorrows this past year,

who she's staying with. For me

it's restless tossing all night long;

I cannot bear to hear strings of marriage played again.

I hope we'll be true lovers in a life to come, then fear

we both have luckless destinies,

and future fate will be unkind in last moonlight and failing wind.

My tears are gone,

ashes of paper rise.

Bannerman, Qing dynasty (1644–1911). Hanging scroll, ink and color on silk.

As an Imperial Manchu bannerman to Qing dynasty Emperor Kangxi (1654–1722; r. 1662–1722), Nara Singde often traveled on official state business. Educated at the Imperial Academy, he composed prose and poetry while away from his young wife and friends. Following his wife's early death, he expressed his melancholy via lyrics set to music from the Song dynasty.

AMID PALE BLOODSTAINS

Lu Xun (Zhou Shuren, 1881–1936)

In memory of some who are dead, some who live, and some yet unborn.

At present the creator is still a weakling.

In secret, he causes heaven and earth to change, but dares not destroy this world. In secret, he causes living creatures to die, but dares not preserve their dead bodies. In secret, he causes mankind to shed blood, but dares not keep the bloodstains fresh for ever. In secret, he causes mankind to suffer pain, but dares not let them remember it for ever.

He provides for his kind only, the weaklings among men; using deserted ruins and lonely tombs to set off rich mansions; using time to dilute pain and bloodstains; each day pouring out one cup of slightly sweetened bitter wine — neither too little nor too much — to cause slight intoxication. This he gives to mankind so that those who drink it weep and sing, are both sober and drunk, conscious and unconscious, eager to live and eager to die. He must make all creatures wish to live on. He has not the courage yet to destroy mankind.

A few deserted ruins and a few lonely tombs are scattered over the earth, reflected by pale bloodstains; and there men taste their own vague pain and sorrow, as well as that of others. They will not spurn it, however, thinking it better than nothing; and they call themselves "victims of heaven" to justify their tasting this pain and sorrow. In apprehensive silence they await the coming of new pain and sorrow, new suffering which appals them, which they none the less thirst to meet.

All these are the loyal subjects of the creator. This is what he wants them to be.

A rebellious fighter has arisen from mankind, who, standing erect, sees through all the deserted ruins and lonely tombs of the past and the present. He remembers all the intense and unending agony; he gazes at the whole mass of congealed blood; he understands all that is dead and all that is living, as well as all yet unborn. He sees through the creator's game. And he will arise to save or destroy mankind, these loyal subjects of the creator.

The creator, the weakling, hides himself in shame. Then heaven and earth change colour in the eyes of the fighter.

Sun Declining Amidst Clouds and Mountains, Li Shizhuo (ca. 1690–1770). Album leaf, ink and color on paper.

Lu Xun's prose poem was written during a time when warlords controlled portions of China while Japanese troops moved to take control of the northeast. The early 1920s were a difficult time for this great author, and his writings capture his anguish at the situation. Amid Pale Bloodstains is a moving work about searching for both meaning and a leader for the future.

臣李世倬恭繪

DEATH

Wen Yiduo (1899–1946)

O, my soul's soul!

My life's life!

All my failures, all my debts

Now have to be claimed against you,

But what can I ask of you?

Let me be drowned in the deep blue of your eyes.

Let me be burnt in the furnace of your heart.

Let me die intoxicated in the elixir of your music.

Let me die of suffocation in the fragrance of your breath.

Or may I die ashamed in front of your dignity,

Or frozen in your unfeeling chill,

Or crushed between your merciless teeth,

Or stung by your relentless poison-sword.

For I shall breathe my last in happiness

If my happiness is what you decree;

Otherwise I shall depart in endless agony

If my agony be your desire.

Death is the only thing I beg of you,

And to you I offer my life, my supreme tibute.

Binding the Lost Souls:
Memory Loss, Zheng
Lianjie (b. 1962).
Chromogenic print.

In Death, Wen Yiduo longs to know how his life will end. It is a haunting poem, since Wen was assassinated in 1946.
Although the poem poses personal questions, Wen asked his readers to pose the same of the nation. Zheng Lianjie's
Binding the Lost Souls: Memory Loss captures a surreal image of a timeless figure atop the Great Wall of China,
the monolithic structure that protected China against invaders for generations.

COLD NIGHTS

Ba Jin (Li Feigan, 1904–2005)

Gradually he shifted his gaze toward her face. His eyes seemed to say, "I'm in great pain." His body moved about in the bed, shaking and trembling.

She asked again, "Xuan, is the pain very bad?"

He nodded and managed to free his hand from her grasp. Seeing his fingers gesturing wildly in the air, she did not know what he wanted.

"Xuan, what do you want?" she asked.

His eyes slowly shifted to the pencil by the pillow.

"You have something to say? You want the pencil?" As she handed him the pencil, he grabbed it, but his fingers were shaking so violently that he nearly dropped it on the floor. She gave him a book. "You can write on the back of this book."

One hand holding the pencil, the other holding the book, he wrote one single word: "Pain." Though he had used all the strokes necessary for the word, they were written so shakily it scarcely resembled the original word.

Tears burst from his mother's eyes. "Xuan, be a little patient," she said again. "Soon Xiao Xuan will come home with the doctor." As soon as she finished speaking, she began sobbing.

He was lucid and understood everything. He acutely felt the pain and realized how feeble he was; he knew that his organs were dying and that his condition was critical. But as the end approached, his love of life grew stronger than his fear of death. He saw the sorrow he brought to his mother; just now he saw her walking to the window and weeping. What could he do? If only he could say or write some last words. "What wrongs have I committed? I'm just an ordinary law-abiding citizen: why am I being punished? There is my mother. After my death, how is she to survive? How is Xiao Xuan to live? What bad deeds have they committed?" Full of grievances, he wanted to cry, to scream, but he could not produce a sound. No one could hear him. He demanded justice, but where could he find it? He could not even shout out his grievances; he must die in silence.

A couple was squabbling in the street: the woman screaming, the man striking her and cursing, a third person trying to mediate between the warring couple; and another man, passing by his window, was singing an aria from a Sichuan opera.

"Why should they be living? Why should I be dying? And dying so painfully?" he thought. "I want to live!" he cried soundlessly.

His mother turned to look at him. Her eyes were swollen and her face ashen; she looked as though she might collapse at any moment.

"She has had a hard life," he painfully reflected. And even as he moved his head slightly, he was attacked by a sharp pain. Simultaneously his throat and his lung hurt him so intensely that his two hands clawed the air. He opened his mouth as much as he could. He tried his utmost to open his mouth, but no sound came out. He was sweating. He felt his hands were being tightly held, and he thought he heard his mother saying something. . . . The pain was so intense that he finally fainted.

. . . .

His life was coming to an end minute by minute. Although he could not do much thinking, he was lucid. During these last moments, he was unwilling to take his eyes away from his dear ones whose faces gradually became blurred. He imagined he saw a third person's face by his bedside: that of Shusheng, whom he had not forgotten. But even the third person's face could not reduce the pain, which stayed with him until his last breath. His last breath lingered and he could not die for some time. His mother and his son held one of his hands and watched him draw his last breath.

China Dreams,
Wang Jin (b. 1962).
Photograph.

Wang Jin's Chinese Dreams *focuses on the nude figure underneath a traditional Peking opera robe, which is composed of transparent polyvinylchloride (PVC) with fishing line. The white halo engulfing the seated body suggests the fraility of the human condition.*

HAN BO CHOPS WOOD

Feng Zhi (1905–1993)

The nineteenth of the first lunar month,
It had been raining several days and nights.
Suddenly it stopped after midnight,
Leaving a waning moon in the sky.

Moonlight filled the whole room
The old woman was startled from her dream,
She woke up her son and said
"There is a man's shadow outside."

The son said, "So late at night,
How could there be anybody?"
"You young people don't know," said she,
"This is the spirit of Han Bo.

"Han Bo was a woodcutter
All day long he chopped wood in the mountain,
He owed his landlord more usurious debt
Than he could expect ever to pay back.

"He chopped wood all his life
So that his landlord might cook and eat;
He chopped wood all his life
So that his landlord could keep warm with a fire.

"But he himself never
Ate or wore enough;
No matter how bad the weather was,
He never ceased chopping for a day.

Slumber,
**Zeng Shanqing
(b. 1932). Colored
ink on rice paper.**

"As it is now, it was that year,
The rain had lasted several days and nights,
By the nineteenth of the first lunar month,
The rain had turned into heavy snow.

"He was frozen to death
For many days afterwards nobody bothered,
Later even the tatters on his body
Were rotten in the storm.

"But his spirit after death
Still had to continue working;
Since he was stark naked he could
Come out only late at night.

"Every year on the day of his death
There was always moonlight after midnight,
To shine on the deep valleys,
Turning them as bright as day.

"Our spring rain here
Falls one whole month in a stretch;
Only on this special occasion
It would stop for half a night."

She told this story, sending
Chills down others' spines;
Outside, in the moonlight, there
Seemed really to be a man's shadow.

Her son said, "Mother,
Han Bo's death was really sad,
But this was a story of the old days,
It is not our present time.

"In the past in our village
Everyone was a Han Bo
But now among all of us
There is not a single one like him.

"So many Han Bo's in the past
Died in cold and hunger;
And we expressed our sympathy
Only through a half night's moonlight.

"In the moonlight now perhaps
There is still the spirit of Han Bo;
But he is coming out not to chop wood
Rather, to avenge his old grievance.

"Tomorrow we'll struggle against the landlords,
He will also clear his account with them;
No longer will he be timid,
He will appear in broad daylight."

Feng Zhi studied at Beijing University and in Germany between 1930 and 1935. Later, he taught at several universities in China. Of particular interest to Feng was the retelling of folklore in verse. A noted ink painter of agrarian and nomadic scenes, Zeng Shanqing depicts in the monumental Slumber *a man curled up to keep warm while sleeping.*

AUTUMN WATERS

Mo Yan (Guan Moye, b. 1956)

One fine spring morning in my grandfather's eighty-eighth year, all the people of the village saw him seated on a folding stool, leaning against the wall of our vegetable garden, eyes closed, resting his spirit. At about noon, my mother sent me out to fetch him for the midday meal. I ran up and shouted my message loudly, but got no response. I gave him a push with my hand, and only then did I discover that he could not move. I ran in to tell everybody. They rushed out and clustered around him, pushing and pulling and shouting to him, but in the end all their efforts were to no avail. Grandfather had died in the most dignified fashion, his face as ruddy as if he were still alive, in a way that made people venerate him. The people of the village, every one, said that he must have accumulated many meritorious deeds in his previous existence, because only that way could one enjoy such a comfortable death. Everybody in our family shared in the glory of my grandfather's death.

It was said that Grandfather, when he was young, had killed three men, set the house on fire, and run off with a girl. They had then fled here from Baoding and become the first pioneers to settle in our village in Gaomi County. At that time, the northeastern part of Gaomi was still untamed land, much of it marshland, with wild grasses growing knee-high, a series of connected pools, home to brown rabbits, red foxes, speckled ducks, white egrets, and many other unnamed creatures who filled this marshy land that man had rarely penetrated. It was here that Grandfather came, bringing the girl with him.

That girl, in due course, became my grandmother.

They fled here in the spring of the year, and after they had nested in the grass for a few days, Grandmother pulled a gold hairpin from her hair, took the jade bracelet from her wrist, and sent Grandfather to a far-off place to sell them and buy farming tools and the household utensils they needed. Then they moved to an odd-shaped hillock right in the middle of the marsh and built a shanty to live in. Once they had done that, Grandfather began breaking the soil and Grandmother caught fish, thus disturbing the calm of the great marshland. Word of what they were doing slowly spread, news that was talked about rather like a fairy-tale: a young couple in the marshland, the man dark, tall, and strongly built, the woman fair-skinned and pretty; and there was also a child, who was neither dark nor fair . . . and later bands of brigands and bandits moved into the area, set up their villages and hamlets, and created a world unto themselves but that comes later in the story.

By the time I was old enough to understand things, that odd-shaped hillock had been leveled by the "poor and lower-middle" peasants of eighteen villages round about, and the swamp had, as it were, grown up. Year by year there had been less rainfall, and it was now hard to find water. Every four or five miles there was a village. I listened to people of Grandfather's generation talk about the past of this place, ranging from geographical descriptions of the environment to strange tales, and I always felt in these stories a wild surge of ghostly rain and supernatural winds, glimmering now here, now there like will-o'-the wisps. Real or false? How was I to know?

Portrait of an Elderly Couple, Qing dynasty (1644–1911). Hanging scroll, ink and color on cotton canvas.

Mo Yan, roughly translated as "don't speak," is the pen name of Guan Moye. In the first few paragraphs of Autumn Waters, *the reader is introduced to the grandparents of the narrator; the story goes on to tell the family's history. The dual ancestor portrait illustrates Chinese ancestral veneration, with grandparents maintaining a role in the lives of their descendants via not only oral histories but also vivid, colorful, nearly life-size portraits.*

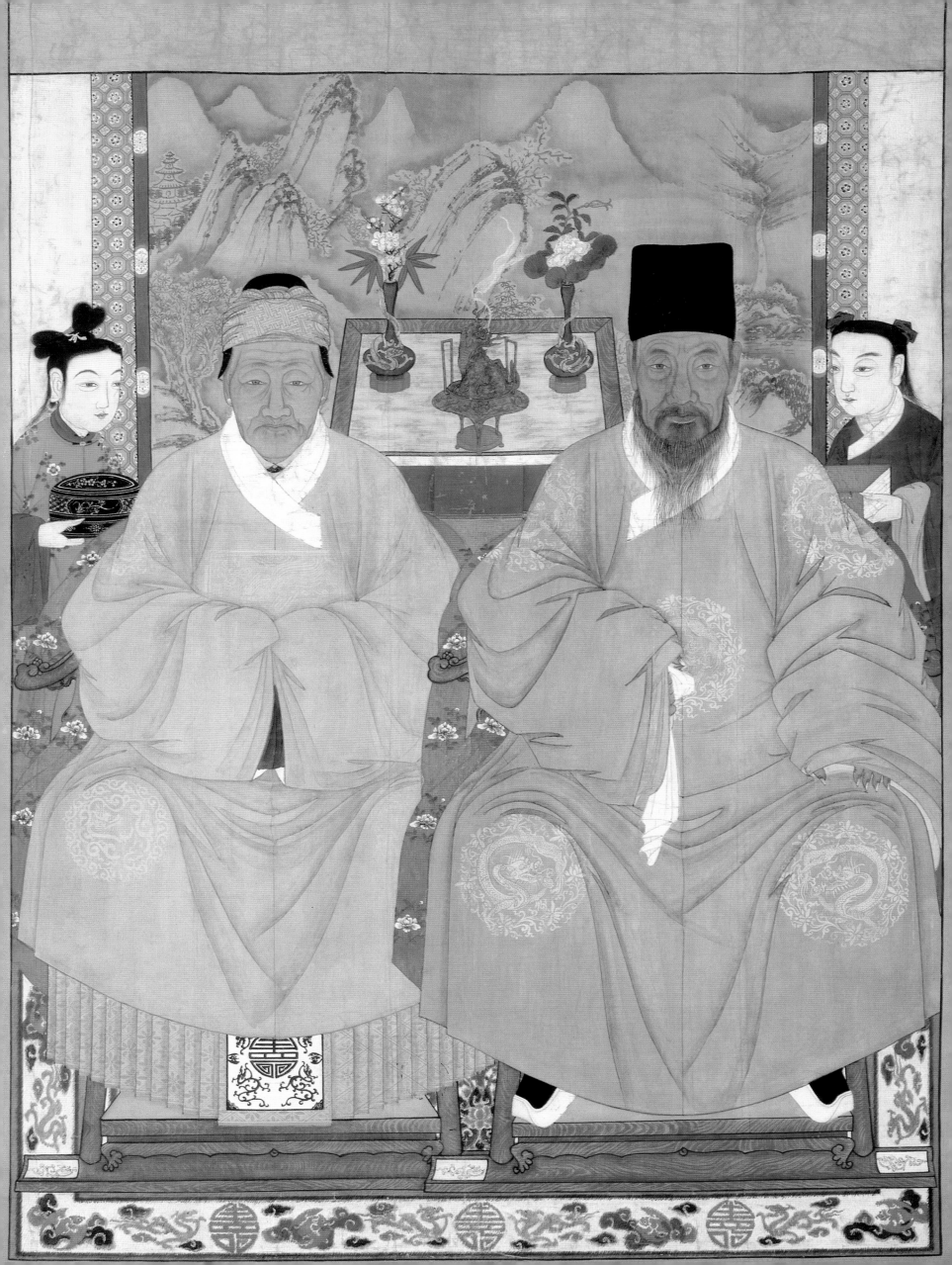

MAP OF CHINA

CHRONOLOGY

Hanging scroll, Chinese ink on paper, 154.3 x 47 cm, Goedhuis Contemporary; Page 97: Wu Jun, *Spooling*, Album leaf, watercolor and ink on paper, 41 cm x 30.3 cm, Victoria and Albert Museum (D.919-1901); Page 98: Xing Danwen, *Duplication, Image 6*, Photograph, 148 cm x 120 cm, Xing Danwen; Pages 100-101: Qiu Ying (1494-1552), *Immortals Playing Chess* (detail), 29 x 93.5 cm (11 1/3 x 36 3/4 in.) Copyright of Christie's Images Ltd., 2006; Pages 102-103: Lu Zhi, *Dreaming of a Butterfly*, 29.4 cm x 51.4 cm, from the collection of The Palace Museum; Page 105: *Waterfall*, China, Song dynasty (960-1279) – Yuan dynasty (1271-1368). Hanging scroll, ink and slight color on silk; 83.8 x 36.6 cm © The Cleveland Museum of Art, Gift of Mary B. Lee, C. Bingham Blossom, Dudley S. Blossom III, Laurel B. Kovacik, and Elizabeth B. Blossom, in memory of Elizabeth B. Blossom 1972.157; Page 107: Xu Bing, *A Book From the Sky*. Photograph on Mylar, 60.96 cm x 73.66 cm, (Frederick L. Gordon Collection); Page 108: Liang Kai (Southern Song dynasty, late 12th- early 13th c.), *Li Bo*, Hanging scroll, ink on paper, Hanging scroll: Ink on paper, 81.1 cm H x 30.5 cm, Tokyo National Museum; Pages 111-112: Qiu Ying (1494-1552), *Saying Farewell at Xunyang*, Handscroll, Ink and full color on paper,33.7 cm x 399.7 cm, The Nelson-Atkins Museum of Art, (46-50); Page 115: Li Song (active 1190-1230). *The Red Cliff*, Southern Song Dynasty (1127-1279). Album leaf mounted as a hanging scroll, ink and color on silk, ivory roller, 9 ¾ x 10 ¼ in (24.76 x 26.03 cm). The Nelson-Atkins Museum of Art, Kansas City, Missouri. Purchase: Nelson Trust, 49-79. Photograph Jamison Miller; Pages 116-117: Qiao Zhongchang (active late 11th-early 12th century). *Illustration to the Second Prose Poem on the Red Cliff* (detail), Northern Song Dynasty (960-1127). Handscroll, ink on paper, 12 x 223 in (30.48 x 566.42 cm). The Nelson-Atkins Museum of Art, Kansas City, Missouri. Purchase, (F80-5). Photograph by Robert Newcombe; Pages 118-119: Liu Guandao (active 1279-1300). *Whiling Away the Summer* (detail), Yuan Dynasty (1279-1368). Handscroll, ink and watercolor on silk; silk mount, 11 5/8 x 21 1/8 in (29.52 x 71.43 cm). The Nelson-Atkins Museum of Art, Kansas City, Missouri. Purchase: Nelson Trust, (48-5). Photograph by Jamison Miller; Page 121: *The Emperor Kangxi Reading*, Anonymous, 138 cm x 106.5 cm, from the collection of The Palace Museum; Page 122: Hung Liu, *Resident Alien*, Oil on canvas, 60 in. x 90 in., Hung Liu; Page 125: Qi Baishi (1864–1957), *Viewing Antiquities at the Studio of Humility*, Album leaf, ink and color on paper, 28 cm x 33.7 cm, The Metropolitan Museum of Art, Gift of Robert Hatfield Ellsworth, in memory of La Ferne Hatfield

Ellsworth, 1986, (1986.267.214) Photograph © 2000 The Metropolitan Museum of Art; Page 126: Luo Ping, *Tadpoles and Crayfish*, 20.8 cm x 27.5 cm, from the collection of The Palace Museum; Page 128-129: *Tea Sipping under Willows*, Anonymous Qing dynasty (1644-1911), Album leaf, color on silk, 26.0 cm x 27.3 cm, The Freer Gallery of Art, Gift of Charles Lang Freer, F1909.247e; Pages 130-131: Copy after Zhou Fang (active 766-after 796 CE) *Palace Ladies Tuning the Lute* (detail), 12th century. Handscroll, ink and color on silk, 11 x 29 5/8 in (27.94 x 75.26 cm). The Nelson-Atkins Museum of Art, Kansas City, Missouri. Purchase: Nelson Trust, (32-159/1); Page 133: *Ritual Food Vessel* (gui), Early Western Zhou Dynasty (1100-1090 BCE). Bronze, 13 x 15 ½ in (33.02 x 39.37 cm). The Nelson-Atkins Museum of Art, Kansas City, Missouri. Purchase: Nelson Trust, (47-26). Photograph by Jamison Miller; Pages 134-135: Sheng Maoye, *Orchid Pavilion Gathering*, Museum purchase made possible by the Margaret Watson Parker Art Collection Fund, 1974/1.244; Page 137: Zhou Chen (c. 1450-1535), *Beggars and Street Characters* (details), dated 1516, Handscroll, Ink and colors on paper, 12.5 in. x 8 ft., Honolulu Academy of Arts, Gift of Mrs. Carter Galt, 1956 (2239.1); Pages 138-139: Copy after Xie Huan, *Elegant Gathering in the Apricot Garden* (detail), Handscroll: ink and color on silk, 36.7 cm x 240.7 cm, The Metropolitan Museum of Art, Purchase, The Dillon Fund Gift, 1989. (1989.141.3) Photograph © 1995 The Metropolitan Museum of Art; Pages 140-141: Wang Fu (1362-1416), *Bamboo and Rocks* (detail), Ming Dynasty (1368-1644). Handscroll, ink on paper, 14 x 91 ½ in (35.46 x 232.41 cm). The Nelson-Atkins Museum of Art, Kansas City, Missouri. Purchase: Nelson Trust, (58-8). Photograph by Jamison Miller; Pages 144-145: Wang Meng (1308-1385), *Brewing Tea*. 100 X 46 cm. (39 3/8 X 18 1/8 in.) Copyright of Christie's Images Ltd., 2006; Pages 146-147: *Emperor's Yellow Court Robe*, Anonymous court artists, 146 cm, from the collection of The Palace Museum; Page 149: *Kitchen God and Kitchen Goddess*, Anonymous (ca. 1918), Ink on paper, 33 cm x 22.9 cm, Special Collections, Yale Divinity Library; Pages 150-151: Chen Rong (ca. 1200-1266). *Five Dragons*, Southern Song Dynasty (1127-1279 cm). Handscroll, ink on paper, 13 ½ x 23 ½ in (34.29 cm x 59.69 cm). The Nelson-Atkins Museum of Art, Kansas City, Missouri. Purchase: Nelson Trust, (48-15); Page 153: Attributed to: Ma Hezhi, Chinese, second half of 12th century, Inscription attributed to: Emperor Gaozong, Chinese, ruled 1127-1162, died in 1187, Frontispiece by: Qianlong Emperor of the Qing dynasty, Chinese, ruled 1736-1795, Seal of: Qianlong Emperor of the Qing dynasty, Chinese, ruled 1736-1795, Colophon by: Qianlong Emperor of the Qing dynasty, Chinese, ruled 1736-1795, Colophon by: Wen Zhengming, Chinese, 1470-1559, *Illustrations to six texts from the Xiaoya section of the Book of Songs* (detail), Chinese, Southern Song dynasty, datable to the 1160s, Ink and color on silk, 27 x 383.8 cm (10 5/8 x 151 1/8 in.), Museum of Fine Arts, Boston, Marshall H. Gould Fund, 51.698; Page 154: Du Jin (active circa 1465–1509), *The Scholar Fu Sheng Transmitting the Book of Documents*, Hanging scroll, Ink and color on silk, The Metropolitan Museum of Art, Gift of Douglas Dillon, 1991 (1991.117.2) Photograph © 1992 The Metropolitan Museum of Art; Page 157: *Ceremonial Battle Ax*, Shang dynasty, Staatliche Museen zu Berlin, Stiftung Preußischer Kulturbesitz, Museum für Asiatische Kunst, Ostasiatische Kunstsammlung, Photo: Jürgen Liepe; Page 158: Giuseppe Castiglione (Lang Shining, 1688-1766), *Emperor Qianlong in Ceremonial Armor on Horseback*, 322.5 cm x 232 cm, from the collection of The Palace Museum; Pages 160-161: Detail of Terra-cotta Soldier Pit, First Emperor's Mausoleum (210 BCE), Terra-cotta with color pigments, (Courtesy of Xiaoneng Yang); Page 163: Jing Hao (active 870-880). *Travelers in Snow-Covered Mountains*, Five Dynasties (907-960). Hanging scroll with ink, white pigment and color on silk, 53 ½ x 29 ½ in (135.89 x 74.93 cm). The Nelson-Atkins Museum of Art, Kansas City, Missouri. Purchase: Nelson Trust, (40-15); Pages 164-165: Zha Shibiao (1615-1698). *The Peach Blossom Spring* (detail), 1696, Qing Dynasty (1644-1911). Handscroll, watercolor on paper, 16 x 123 in (40.64 x 312.42 cm). The Nelson-Atkins Museum of Art, Kansas City, Missouri. Purchase: Nelson Trust, (72-4). Photograph by Robert Newcombe; Page 167: First Community Picture Publishing House Shanghai, *Mulan Enlists in the Army* (1954), Poster, Ink on paper, (Photograph by Wolf/Laif, Camera Press London); Page 169: *Emperor Taizong Arriving at Jiucheng Palace*, Anonymous (Ming dynasty, 1368-1644), Hanging scroll mounted on panel, Ink, color, and gold on silk, 185.9 cm x 91.5 cm, Freer Gallery of Art, Gift of Charles Lang Freer, F1917.99; Page 170: *Emperor Guan*, Unidentified Artist, The Metropolitan Museum of Art, Purchase, The

Oracle Bone, **Shang dynasty (ca. 1600–1046 BCE). Bovine scapula fragment.**

B. Y. Lam Fund and Friends of Asian Art Gifts, in honor of Douglas Dillon, 2001 (2001.442) Photograph © 2001 The Metropolitan Museum of Art;Page 172: Saucer (Die) Glazed in imitation of a Fuzhou Chrysanthemum-Shaped Lacquer, Qing dynasty, Qianlong mark and period, dated 1774, Los Angeles County Museum of Art, Gift of Jo Ann and Julian Ganz, Jr. Photograph © 2006 Museum Associates/LACMA; Page 173: *Dish in Shape of a Chrysanthemum*, Qing Dynasty (1644-1911). Lacquer over silk armature, 4 ¾ in (12.06 cm). The Nelson-Atkins Museum of Art, Kansas City, Missouri. Purchase: Nelson Trust, (76-23). Photograph by Jamison Miller; Pages 175-177: Central Academy of Industrial Arts, *Advance Victoriously While Following Chairman Mao's Revolutionary Line in Literature and the Arts* (1968), Triptych poster, Ink on paper, 76.5 cm x 154 cm, IISH Stefan R. Landsberger Collection (http://www.iisg.nl/~landsberger); Pages 178-179: Qiu Ying (1494-1552), *Enchanted Dwelling in the Hills* (detail). Each scroll measures 33 x 51.6 cm. (13 x 20 1/4 in.) Copyright of Christie's Images Ltd., 2001; Page 181: *The Water and Moon Guanyin Bodhisattva* (Liao dynasty, 11th-12th century),Wood with paint, 241.3 cm, The Nelson-Atkins Museum of Art, (34-10); Pages 182-183: Wang Liyong (active 1120-1145). *The Transformations of Laojun* (detail), Southern Song dynasty (1127-1279). Handscroll, ink and color on silk, 17 5/8 x 152 ½ in (44.78 x 387.35 cm). The Nelson-Atkins Museum of Art, Kansas City, Missouri. Purchase: Nelson Trust, (48-17). Photograph by Robert Newcombe; Page 184: *The Heart of the Perfection of Wisdom*, Anonymous (9th century), Ink and color on paper, 41.5-42 cm x 21.5-21.6 cm, The British Library (Or. 8210/S. 4289); Page 185: Weng Fanggang, *The Heart Sutra*, Album leaf, ink on bodhi-tree leaves and paper, 16.5 cm x 9.2 cm, from the collection of The Palace Museum; Page 187: Zhou Jichang, Chinese, second half of 12th century, *Lohan demonstrating the power of the Buddhist sutras to Daoists*, Chinese, Southern Song dynasty, about 1178, Ink and color on silk, 111.5 x 53.1 cm (43 7/8 x 20 7/8 in.), Museum of Fine Arts, Boston, Denman Waldo Ross Collection, 06.290; Page 189: *Traveling Monk*, Anonymous (Five Dynasties or Northern Song Dynasty, 10th century), Ink and colors on paper 41 cm x 29.8 cm. From Cave 17, Mogao, near Dunhuang, Gansu province, The British Museum, AC 1919,0101,0.168; Page 190: Liang Kai (Southern Song dynasty, late 12th- early 13th c.), *The Sixth Patriarch Chopping Bamboo*, Hanging scroll, Ink on paper, 72.7 cm x 31.5 cm (Tokyo National Museum); Page 192: *The Daoist Immortal Lü Dongbin*, Anonymous (Yuan dynasty, 13th-14th century), Hanging scroll, Ink and color on silk, 110.5 cm x 44.4 cm The Nelson-Atkins Museum of Art, (62-25); Page 195: Li Cheng (919-967), *A Solitary Temple Amid Clearing Peaks*, Northern Song Dynasty (960-1127). Hanging scroll, in and slight color on silk, ivory roller, 44 x 22 in (111.76 x 55.88 cm). The Nelson-Atkins Museum of Art, Kansas City, Missouri. Purchase: Nelson Trust, (48-17). Photograph by Robert Newcombe; Page 196: Mei Qing (Chinese, 1623-1697, Qing dynasty), *Nine-Dragon Pool*, Hanging scroll, ink and light color on paper; overall 200.7 x 71.1 cm © The Cleveland Museum of Art, Leonard C. Hanna, Jr. Fund 1968.213; Page 199: Ding Yunpeng (1547-1621), *Masters of the Three Doctrines*, Hanging scroll, Ink and colors on paper, 115.7 cm x 55.8 cm, from the collection of The Palace Museum; Page 200: Zhao Hongben, *Monkey Thrice Beats the White Bone Demon* (1977), Poster, Ink on paper, 77 cm x 55 cm, IISH Stefan R. Landsberger Collection (http://www.iisg.nl/~landsberger); Pages 203-205: Ding Yunpeng (1547-1621), *Five Forms of Guanyin* (detail), Handscroll, Ink, color and gold pigment on paper, 28 cm x 134 cm, The Nelson-Atkins Museum of Art (50-22); Pages 206-207: Gao Xingjian, *La Montagne de Reve (Dream Mountain)*, Ink on paper, 146 cm x 206 cm (Goedhuis Contemporary); Pages 208-209: Shen Quan (1682- after 1762), *Cranes of Longevity* (detail). 154.8 x 56.4 cm (60 7/8 x 22 1/4 in.). Copyright of Christie's Images Ltd., 2003; Page 211: Chen Hongshou (Chinese, 1598-1652, Ming dynasty), *Paintings after Ancient Masters: Lao-tzu Riding an Ox*, Album leaf, ink and color on silk; 24.3 x 22.6 cm © The Cleveland Museum of Art, John L. Severance Fund 1979.27.1.2; Pages 212-213: Li Gonglin (ca. 1041-1106), *The Classic of Filial Piety* (detail), Handscroll, Ink on silk, 21-22 cm x 473 cm, Metropolitan Museum of Art, Ex coll.: C.C. Wang Family, From the P.Y. and Kinmay W. Tang Family Collection, Gift of Oscar L. Tang Family, 1996 (1996.479) Photograph © 2000 The Metropolitan Museum of Art; Page 215: *Ritual Disc with Dragon Motif (Bi)*, Eastern Zhou Dynasty (771-256 BCE). Jade (nephrite), 6 ½ in (16.51 cm). The Nelson-Atkins Museum of Art, Kansas City, Missouri. Purchase: Nelson Trust, (33-81). Photograph by E.G. Schempf; Page 216: *Casing Slab of a Tomb or Offering Chamber*, Eastern Han Dynasty (25-220).

Limestone, 39 x 24 ¼ x 4 in (99.06 x 61.59 x 10.16 cm). The Nelson-Atkins Museum of Art, Kansas City, Missouri. Purchase: Nelson Trust, (34-73). Photograph by Jamison Miller; Page 219: *Daoist Deities Paying Court*, Anonymous (Yuan Dynasty, 1279-1368), Hanging scroll, Ink and color on silk, 50 ½ x 35 ¼ (128.27 x 89.54 cm). The Nelson-Atkins Museum of Art, Kansas City, Missouri. Gift of Laurence Sickman, 73-29. Photograph by Jamison Miller; Pages 221-223: *Festival of the Peaches of Longevity*, Anonymous (Ming dynasty, 15th century), Handscroll, Ink, colors and gold on silk, 52 cm x 476 cm, The Nelson-Atkins Museum of Art, Gift of the Herman R. and Helen Sutherland Foundation Fund (F72-39); Page 224: *Portrait of Bannerman*, Anonymous (Qing dynasty, 1644-1911), The Mactaggart Art Collection © University of Alberta Museums, University of Alberta, Edmonton, Canada; Page 227: Li Shizhuo (c. 1690-1770), *Sun Declining Amidst Clouds and Mountains*, Album leaf, Ink and color on paper, 24.1 cm x 14.5 cm, The Nelson-Atkins Museum of Art, (78-18/4); Page 228-229: Zheng Lianjie, *Binding the Lost Souls: Memory Loss*, Chromogenic print, 99 cm x 150 cm (Goedhuis Contemporary); Page 232-233: Zeng Shanqing, *Slumber*, Colored ink on rice paper, 68 cm x 124.5 cm, (Goedhuis Contemporary); Page 230: © Wang Jin (b. 1962). *China Dreams–Wangfujing* (2004). Photograph 136 cm x 139 cm (Chinese Contemporary); Page 235: *Portrait of an Elderly Couple*, Anonymous (Qing dynasty, late 19th-early 20th century), Hanging scroll, Ink and color on cotton canvas, 158.1 cm x 119.8 cm (Freer Gallery Smithsonian Collections Acquisition Program, and partial gift of Richard G. Pritzlaff, S1991.128); Page 236: China – Political Map © International Mapping Associates; Page 238: *Oracle Bone*, Bovine scapula fragment, Shang dynasty, of 2 in. x 1 in. x 3 in. (5.1 x 2.5 x 7.6 cm). The Nelson-Atkins Museum of Art (2000.12.8); Page 240: Geng Jianyi, *The Second State*, Oil on canvas, 145 cm x 200 cm (The Farber Collection, New York, Courtesy of China Avant-Garde Inc.).

TEXT CREDITS

Page 53: "Night-shining White" by Lu Guimeng, translated by Suzanne E. Cahill, originally published in *T'ang Studies* No. 4 (1986). Used by permission of the Tang Studies Society; Page 60: "Black Muzzle;" Page 18: "Calligraphy Practice;" Page 54: "Four Untitled Poems;" Page 46: "Fulling Cloth for Clothes;" Page 65: "I Had Occasion to Tell a Visitor about an Old Trip I Took Through the Gorges of the Yangzi;" Page 22: "The Merchant's Joy;" Page 17: "An Offering for the Cat;" Page 164: Excerpt from "Peach Blossom Spring," Page 17: "An Offering for the Cat;" Page 164: Excerpt from "Peach Blossom Spring," Page 118: "Relaxing in the Evening in my Study;" Page 75: "Returning to My Home in the Country;" Page 76: "Sent to My Two Little Children in the East of Lu;" Page 162: "Song on Enduring the Cold;" Page 110: "Song of the Pipa Lute;" Page 66: "The Stone on the Hilltop;" Page 49: "Viewing the Waterfall at Mount Lu" from *The Columbia Book of Chinese Poetry: From the Earliest Times to the Thirteenth Century*, by Burton Watson. Copyright © 1984 Columbia University Press. Reprinted with permission of the publisher; Page 70: "Epigraph" from *Wild Grass* by Lu Xun (translated by Ng Mau-sang), first published in *Renditions 26* (Autumn 1986), pp. 151-152. Reprinted by permission of the Research Centre for Translation, The Chinese University of Hong Kong; Page 77: "Moonlit Night;" Page 50: "On Seeing a Horse-painting by Cao Ba," from David Hawkes, *The Little Primer of Tu Fu* (1967) by permission of Oxford University Press; Page 81: Excerpt from *Master Tung's Western Chamber Romance* by Li-li Ch'en. Copyright © 1994 Columbia University Press. Reprinted with permission of the publisher; Page 82: Excerpt from *The Romance of the Western Chamber* by S.I. Hsiung. Copyright © 1968 Columbia University Press. Used by permission of the publisher; Page 86: "Song of White Linen" from *Writing Women in Late Imperial China* by Ellen Widmer and Kang-I Sun Chang. Copyright © 1997 by the Board of Trustees of the Leland Stanford Jr. University. Used by Permission of Stanford University Press; Page 96: "Spring Silkworms" by Mao Dun (tr. Sidney Shapiro) from *The Shop of the Lin Family and Spring Silkworms* © 2003 Chinese University Press. Reprinted by permission of the Chinese University of Hong Kong; Page 99: "Curvaceous Dolls" by Li Ang (tr. Howard Goldblatt) first printed in *Renditions 27 & 28* (Spring & Autumn 1987). Reprinted by permission of the Research Centre for Translation, The Chinese University of Hong Kong; Page 39, 103: "Zhuangzi" from *Chuang Tzu: Basic Writings* by Burton Watson. Copyright © 1964 Columbia University Press. Used by permission of the publisher; Page 114: "Rhapsody on Red Cliff" from

The Second State, Geng Jianyi (b. 1962). Oil on canvas.

Windows Forensic Analysis DVD Toolkit 2E

Harlan Carvey
Eoghan Casey Technical Editor

PUBLISHED BY
Syngress Publishing, Inc.
Elsevier, Inc.
30 Corporate Drive
Burlington, MA 01803

Windows Forensic Analysis DVD Toolkit 2E

Copyright © 2009 by Elsevier, Inc. All rights reserved. Printed in the United States of America. Except as permitted under the Copyright Act of 1976, no part of this publication may be reproduced or distributed in any form or by any means, or stored in a database or retrieval system, without the prior written permission of the publisher, with the exception that the program listings may be entered, stored, and executed in a computer system, but they may not be reproduced for publication.

Printed in the United States of America
1 2 3 4 5 6 7 8 9 0

ISBN 13: 978-1-59749-422-9

Publisher: Laura Colantoni
Acquisitions Editor: Angelina Ward
Technical Editor: Eoghan Casey
Developmental Editor: Gary Byrne
Indexer: SPI

Project Manager: Heather Tighe
Page Layout and Art: SPI
Copy Editors: Audrey Doyle and Dan Hays
Cover Designer: Michael Kavish

For information on rights, translations, and bulk sales, contact Matt Pedersen, Director of Corporate Sales, at Syngress Publishing; email m.pedersen@elsevier.com.

Library of Congress Cataloging-in-Publication Data
Application submitted